ROBERT ALTMAN

Ferg,

Happy Birthday 2018
Robert Altman was 45
when he made
MASH... You've got
plenty of time!

Loads of love,

Lil X

ROBERT ALTMAN

IN THE AMERICAN GRAIN

FRANK CASO

REAKTION BOOKS

For Katherine and Vladimir,
my favourite sounding boards

Published by Reaktion Books Ltd
Unit 32, Waterside
44–48 Wharf Road
London N1 7UX, UK

www.reaktionbooks.co.uk

First published 2015
Copyright © Frank Caso 2015

Printed and bound in Great Britain by Bell & Bain, Glasgow

A catalogue record for this book is available from the British Library
ISBN 978 1 78023 522 6

Contents

PART THREE EXILE

PART FOUR THE PRODIGAL'S RETURN

Introduction

'ICONOCLAST' AND 'MAVERICK' are perhaps the two most common epithets attached to the film director Robert Altman (1925–2006), but really he was purely and simply an artist. He strove continually to extend his creative boundaries in the face, it seemed, of his often stated belief that the perfect film 'would be one which, after seeing, the audience would be unable to talk about'.[1] Yet people have always talked about Altman's work, going back to his earliest efforts. He learned his craft directing industrial films in Kansas City, Missouri, for the Calvin Company and then toiled in episodic television prior to becoming one of the important American film directors of the latter part of the twentieth century. (Of his craftsmanship, long-time colleague Tommy Thompson commented in an interview in 1979 that Altman 'knows that camera. He knows lenses, filters, and the film itself. He is really a master of all the tools of his trade.'[2]) Nevertheless, of those directors responsible for the resurgence of American cinema in the 1970s, Robert Altman's career oscillated the most, critically and commercially. He has been described as being in exile during the 1980s, and perhaps from a Hollywood standpoint he was, but he never stopped directing. Altman spent his so-called 'time in the wilderness' exploring new genres and new narrative structures. It was a decade during which he directed theatre and opera as well as six theatrical adaptations for television and five feature films adapted from plays.

Robert Altman was one of those directors whose films people 'recognize'; but what exactly are the recognizable elements of an Altman film? The naturalism, certainly. In the great debate among film theorists about realism and expressionism (with the work of the Lumière brothers serving as the paradigm for the former and that of Georges Méliès for the latter), Altman's work is most usually grounded in the realist mode. But if one considers naturalism

as a determinist aspect of realism, then Altman's death-is-the-only-ending films are surely examples of his naturalist style. His other work has often been described as hyperrealist. But here again it is a mistake to pigeonhole the film-maker. Certain of his films are expressionist, and there are certain elements and scenes within his more naturalist cinema that are expressionistic, even fantastic.

Robert T. Self, who understands Altman's process better than most, has concluded that among other qualities Altman's films have 'complex and chaotic stories' that 'disorient in their quirkiness, confuse in their narrative structure, challenge in the complexity of their stories, and depress in the cynicism of their vision'.[3] In the late 1970s Judith Kass described the major-ity of Altman's films as 'plotless and eventful'.[4] As early as 1971 Altman's biggest booster, *New Yorker* film critic Pauline Kael, described his film-making style as 'intuitive, quixotic, essentially impractical'.[5] Around the same time, *New York Times* film critic Vincent Canby in a review of Altman's *Thieves Like Us* characterized Altman as an explorer of American culture and what it means to be an American – a characterization that has been taken up by critics and countless Altman fans.

Altman was a satirist of the first rank and an ironist before irony descended into overuse, and because of that the knowledgeable viewer brings aesthetic expectations to his films. Irony in Altman's films is both a complement to and a conduit of the aforementioned cynicism. It facilitates acceptance by the audience, especially as it is woven into the *mise en scène*. His primary target, of course, was American society, and one of his favourite targets of satire was Americans' infatuation with celebrity and show business. Being deeply mired in the latter and somewhat in the former, Altman was in effect exploring his own thoughts and feelings about his life and profession as much as he was pointing out the ludicrousness of the audience's passion.

His love–hate relationship with the entertainment industry and celebrity-hood is evident almost from the outset of his career. In 1957 he co-directed *The James Dean Story*, a documentary that set out to demythologize the late actor but during the making of the film the tone revolved 180 degrees. Some of Altman's best-known work deals with show business and celebrityhood and these films form a subset of the director's oeuvre. They include *Nashville*, *Buffalo Bill and the Indians, or Sitting Bull's History Lesson*, *Come Back to the 5 & Dime, Jimmy Dean, Jimmy Dean*, *The Player*, *The Company*, and *A Prairie Home Companion*.[6] To a lesser extent *Vincent & Theo* and *Kansas City* may be included as well. Of this group *Nashville* is his masterpiece and *The Player* his most commercially successful. *Nashville* is a synecdoche wherein the

city, its inhabitants and its culture (country music) symbolize the larger United States. *The Player*, on the other hand, is more narrowly focused, using the methods of the American filmmaking industry to satirize that industry. It has been called Altman's revenge film, although the director took pains to deny that publicly.

Another element of many of Altman's films, evident from the beginning of his career, is that he liked to film groups of people. Often these groups came together at parties, which is no surprise given Altman's predilection for partying.[7] There were also dinner parties, simple get-togethers, reunions and formal receptions. Sometimes it was a reflected party atmosphere, as in the club scenes in *Nashville* and *Kansas City*. These group scenes are responsible for a good deal of the overlapping dialogue that became an Altman hallmark (the element of an Altman film most film-goers point to immediately is the sound).

Altman's philosophy of sound and dialogue was simple: 'Sound is supposed to be heard, but words are not necessarily supposed to be heard. I think in film it's what the character does not say, what you don't hear that is important.'[8] Overlapping dialogue and foregrounding dialogue within a scene's natural sounds evokes a 'three-dimensional' quality. Overlapping dialogue did not originate with Altman. As others have pointed out, Howard Hawks, Orson Welles and even Alfred Hitchcock all utilized overlapping dialogue, but Altman's use of the technique was relentless. The textured sound in many of Altman's films forces the viewer to focus and choose what to listen to. It is also a source of frustration for some. He occasionally had slipped in overlapping dialogue in his earlier television days, but it was essentially a product of the eight-track technology developed at his Lion's Gate studio in the 1970s. This technology used radio microphones instead of the boom mike, and this in turn allowed for even more mobility of Altman's already curious camera. Discussing Altman's treatment of sound in his films, Ryan Gilbey observed: 'No one has challenged and revolutionized the way in which we watch and listen to movies like Altman . . . In his hands [cinema] has become an autonomous art form, and audiences have undergone a corresponding emancipation.'[9] But the overlapping dialogue was counterpointed by numerous silent characters, or simply silence when used to punctuate the on-screen action. Helene Keyssar touched on this when she wrote, 'In the corpus of Altman's work, which is so distinguished by its luxuriant use of sound, the presence of mute characters becomes particularly noticeable.'[10] Some of the mute characters, such as *Nashville*'s Tricycle Man or *3 Women*'s Willie Hart, are more noticeable than others.

Camerawork is another technical aspect that characterizes an Altman film. From his earliest days as an industrial film director, Altman favoured camera movement. His Calvin Company mentor, Frank Barhydt, declared years later: 'Camera movement, he's crazy about. Always has been. He can't stand to have the camera standing still. That's probably a reflection of his own nervous personality.'[11] Perhaps, but Altman's view was that, 'Film is a two-dimensional view. And the only way you can get the sense of the third dimension is to have things in the foreground or to have the camera moving out.'[12] To go along with his signature overlapping sound and as part of his endeavour towards a more naturalistic look for his films, Altman made heavy use of the zoom lens. His roving camera and zoom lens sometimes made the actors uneasy, especially in the early days, but it kept them wary and in character even if they were not projected to be the focal points of the scene. It also explored and legitimized people, objects, actions and colours on a given scene's periphery. He often instructed his camera operators to keep the film rolling after the scene ended, hoping to catch a serendipitous moment. The camera could also catch the unplanned within a scene, and it was Altman's working philosophy to maintain a generous eye towards 'mistakes', sensing the inherent naturalism within them. In discussing what moments in his films he most cherished, he admitted, 'The things that happen that are totally uncalculated, unprepared for, unanticipated, and take on the guise of a discovery.'[13]

Altman also favoured reflective surfaces – usually mirrors, but not always. These reflections commented on reality (sometimes repositioning it), edged the story along more dramatically, revealed an aspect of a character's psyche or, when shown with their 'actual' counterparts, simply increased the number of people and things on-screen. Often, reflected images in Altman's films served more than one purpose.

Another Altman element is the panoramic narrative structure of films such as *Nashville*, *A Wedding* and *Short Cuts*. These films contain large ensemble casts and multiple storylines that hold only vague, usually geographic, connections to one another. Altman referred to these films as 'murals'. (He generally likened his work to painting.) In his chapter on Robert Altman (titled 'Buffalo Bob and the Van Goghs') in *Faces in the Crowd: Players and Writers*, Gary Giddins pointed out that *Nashville* and *A Wedding* really are filmic apologues, or allegorical narratives. (The book pre-dates *Short Cuts*.) As Giddins noted, the critic M. M. Liberman had resurrected the term to describe the narrative structure of Katherine Anne Porter's novel *Ship of Fools*. Of course allegory weaves in and out of fiction, be it literary or filmic,

and in Altman's case provides the warp and weft of many of his films – a fact that Altman himself has affirmed.

Altman began the 1970s, a frenzied decade during which he directed thirteen films, by relying on a repertory company of his own devising. By and large this was an amorphous group of non-stars who helped seal his reputation for allowing actors leeway in developing what their characters would say and do during the course of the story. Still, the question of how much improvisation he allowed his actors is debatable. Vis-à-vis the script, probably more so in his early films, less in his middle work since many of his theatrical and television films during this period were adaptations from the stage, and returning to a freer style in the final fourteen years. Furthermore, as Altman described the technique (referring specifically to *Nashville*), 'The improvisation part of it usually is the rehearsal.'[14] This method did not endear the director to the writers with whom he worked, and he had contentious relationships with many of them. Altman had a tendency to view the script as a starting point from which to launch his (communally con-structed) version of the story, this being in line with his philosophy of creating a movie organically. Thus, the writing credits do not necessarily reflect who did the actual writing of some of his films. Some have contended that Altman's 'intrusions' damaged his films – the assassination at the end of *Nashville* being a case in point for a few of his critics – or eliminated important dramatic transitions. In at least one instance Altman took the heat for a script that riled critics and more than a few film-goers for turning a respected genre on its head. Yet *The Long Goodbye*, Altman's first excursion into film noir, was written by Leigh Brackett, whose pedigree when it came to Philip Marlowe, the cynical Los Angeles detective and film's protagonist, was second only to the character's creator, Raymond Chandler. Years earlier, Brackett had co-written with William Faulkner and Jules Furthman the best-known translation of Marlowe to the screen, *The Big Sleep*.

Film noir was not the only genre Altman refashioned beyond its bound-aries: the western (*McCabe & Mrs Miller*), psychological drama (*Images*), science fiction (*Quintet*) and romantic comedy (*A Perfect Couple*) were a few of the tried-and-tested Hollywood genres with which he opened dialogues through his own work. In this attitude of homage on his own terms he was not unlike, say, François Truffaut. Furthermore, his flexibility placed him in an aesthetic class that included Howard Hawks, who moved easily between screwball comedy, film noir and westerns.

Script controversies aside, what Altman did with regard to the actors and their dialogue, sometimes initially using only a bare outline for a story, was

modified *commedia dell'arte* technique. In the Italian Renaissance, theatrical form improvisation was the key as the actors 'followed a plot outline, called a scenario, rather than written dialogue'.[15] In 1971 an article quoted Altman as saying: 'In my films the actors can be creative. I don't think one person can write dialogue for 15 people.'[16] At least one critic, Helene Keyssar, has noted the connection between Altman's characters and the *commedia*: 'Like the commedia players and not unlike most characters in Altman's films, the figures . . . hold our attention or fail to do so, by virtue of the skill of their improvisation within the limits of the stock or "type" characters.'[17] Actors' improvisation also affected Altman's shooting schedule. He once declared, 'I try to shoot in sequence and try to have all the actors available for the shoot, mainly so that we have the freedom to change our minds about what we are going to shoot.'[18] It also allowed for continuity with previous improvisation.

Yet if they had been strictly improvising in the *commedia* style, Altman's characters would have quickly become tiresome. That they did not had as much to do with the actors' and director's quirks as with an important Altman device – secrets. Secrets in Altman's films percolate from deep within his characters' psyches, driving their actions and reactions. In some instances they even drive the plot. There is humour, wistfulness and sadness in these secrets. There is sublimity and disturbing psychological pathology. It is the secrets that lie at the heart of the reality from which Altman's vaunted naturalism sprang.

Improvised or not, Altman's women are almost always more interesting than his men. Many of them are enigmatic characters wandering exterior and interior landscapes sometimes armed with wry insights into their conditions, other times vulnerable and simply winging it. In a number of his films a female character is dressed or cloaked in innocence-signifying white. These women in white may be innocents wronged (as in *Nashville*), or their presence may provide the catharsis for innocence lost (*Come Back to the 5 & Dime, Jimmy Dean, Jimmy Dean*), or they may be the catalysts of a perfect Altman ending – death (*A Prairie Home Companion*). Also, various Altman films contain female triumvirates, a trope for which *3 Women* is the apotheosis.

Improvisation was not Altman's only tactic when it came to working with his cast. He employed a communally holistic method that ranged from everyone gathering to view and comment on the dailies, to set design and costumes. It was an Altman strategy, for example, to include on the set objects that 'belonged' to the characters but were hidden from the otherwise wandering, prying camera (and therefore the viewer). He believed this was essential

in helping the actor to create the character's backstory. For this technique he acknowledged his debt to Leon Ericksen, who was Altman's set designer, officially and unofficially, on all his films from *That Cold Day in the Park* (1969) to *Images* (1972): 'He [Ericksen] was a big, big influence on me in terms of how to approach that kind of reality. Just to walk on the set and have there be trash in the trash can. He'd have stuff in the drawers, whether or not those drawers were going to be opened.'[19] This verisimilitude was extended to wardrobe on at least one occasion. Prior to shooting *McCabe & Mrs Miller*, Altman had the actors choose their own costumes under the assumption that they would know best what clothing their characters would be likely to wear. Carrying the notion further, they had to patch the clothing themselves for a more realistic frontier look.

Beginning with *California Split*, Altman began mixing reality into his fictions.[20] This almost always entailed celebrities playing themselves but interacting with a film's fictional characters. This technique reached its height in two of his later television works, *Tanner '88* and *Tanner on Tanner*, both of which are set during u.s. presidential election years and feature actual political candidates, reporters, snippets of speeches and, in a nod to *cinéma-vérité*, concerned citizens. In his penultimate film, *The Company*, which features Chicago's Joffrey Ballet, the fiction interacts with, indeed interrupts, the 'reality'.

Part of that reality is to take the camera behind the scenes in various ways: rehearsals, the dressing room, or backstage during a performance. The technique expands on Altman's behind-the-scenes camerawork for his Public Broadcasting special a decade earlier, 'Black and Blue' (which reproduced the Broadway revue). It is also a tamer version of another of Altman's recurring elements – voyeurism. In film after film Altman allows the camera and the microphone to manipulate the audience into performing the role for which it has paid its admission, and one becomes, if only briefly, a voyeur or an eavesdropper. It is hardly prurient, though. With Altman this voyeurism and eavesdropping make the naturalism of his films intimate, akin to theatre. For some viewers, however, it might have an opposite effect.

The Company is somewhat anomalous in Altman's oeuvre in that it contains no violence, murder or natural death. Excluding his work in episodic television, only nine of Altman's 48 feature films and non-episodic television pieces are free of violence or the hint of it. Two of these were plays reworked for cable television, two others were musical re-creations for the Public Broadcasting Network, and a fifth was an episode for the multi-director film *Aria*. Undoubtedly it is the violence, usually but not always on-screen, or the hint

of it, that most readily puts Altman's cynicism on display. When Altman emerged in the late 1960s from his 'journeyman' period, the United States had experienced a decade in which violence permeated the culture on many fronts – war, race riots and political assassination added their dispiriting, though in some cases cathartic, influence to a society of more than 250 million people. The greatest industrial society the world had yet known experienced murder, rape, mayhem and thievery on a scale that such a society would naturally engender.

It is not altogether surprising that in more than two dozen of Altman's films, murder, suicide or other forms of death occur.[21] Often they predominate, sometimes they startle, coming as they do at the end of the film. Car crashes, stabbings, shootings, drowning, blunt instruments, snakebite or simply old age all take their toll on characters peripheral or important.

This dovetails with another general aspect of Altman films in that the ending often does not conform to dramatic expectations (especially when it is out-of-the-blue violent). Altman was fond of repeating throughout his career his belief that death was the only true ending to a story, so it stands to reason that for someone with this sensibility, and who disliked a straight narrative story to begin with, the endings of his films could be problematic, pessimistic and inventive. In fact, so inventive were some of his film endings that they broke through the modernist mode and, in their reflexivity, became avatars of postmodern cinema. Although it must be admitted that the reflexive ending of 1970's *M*A*S*H* (in which the announcement is made that the movie the viewer has been watching is *M*A*S*H*) captivated the audience more than its counterpart for *The Player* (in which the murderous Hollywood producer gives the go-ahead for the script of the film one has just watched), probably because of the increased sophistication the intervening 22 years brought to the film-going public – or at least Altman's public. In much of his work, but especially his apologues, Altman discarded straight beginning–middle–end plot in favour of characters who were the driving forces of the stories. Needless to say, many of the problems in Altman's endings often had to do with narrative sensibilities (the critics' and audience's) rather than artistic coherence.

Excluding his early industrial films and his efforts in episodic and anthology television, Altman worked in black-and-white only twice – in his first two films in the 1950s. Yet his colour palette could be striking or muted and he sometimes inserted monochromatic shots, or scenes, into the films for contrast. A colour motif that recurs in a number of his films is yellow – a counterpoint (from the Jungian point of view, anyway) to the cynicism

and violence that permeate his work. The colour also serves as a clue to his characters' personalities, and occasionally the circumstances within a scene.

Robert Altman claimed he seldom actually watched films (other than his own, which, by most accounts, he seemed never to tire of viewing), but there were at least four directors whose work he admired: Ingmar Bergman, Federico Fellini, Akira Kurosawa and Martin Scorsese. Certainly, there are obvious influences of the first two in Altman's work. Yet there were two other directors who, if they did not actually influence Altman, nonetheless shared an attitude and an aesthetic: Robert Bresson and Preston Sturges. Altman's use of Christian (particularly Roman Catholic) imagery and symbology was far more subtle than was Bresson's Catholic existentialism, though the humanism (and cynicism) evident in the work of both men stems from a religious background that each ultimately rejected. Their working methods were different: Bresson, for example, ran through many takes or rehearsals, something Altman avoided if he could; nor do most of Altman's films reflect Bresson's minimalist style. Their attitudes towards different aspects of the completed film, however, such as sound and music, silence and improvisation, were strikingly simpatico. Altman's earlier films better reflect the Bressonian approach, including his use of non-actors or first-time film actors in his desire to elicit naturalist performances, a method for which Bresson was noted. Bresson famously called his actors models, while Altman explained: 'What I'm really trying to do with the actors is to get them to be less creative and just use their own natural selves more, as if they were the character [*sic*] in that circumstance . . . Behavioral is what it is.'[22] Each used sound to heighten the naturalism: Altman with the aforementioned overlapping dialogue and Bresson with heightened sound that offset minimal dialogue (*Au hasard Balthasar*, 1966, and *Mouchette*, 1967, come to mind). Indeed, in his *Notes on Cinematography*, Bresson wrote: 'The noises must become music.'[23] For Altman, that happened literally in 'Black and Blue', his televised production of the famed Broadway revue.

Preston Sturges's films blended humour, irony and cynicism – all three elements being key components of Altman's style. Though more of a Bressonian perfectionist than an Altman freewheeler, on the technical side Sturges preceded Altman with his use of mirrors (and ersatz mirrors), particularly in *The Lady Eve* (1941). Sturges, too, had a similar career arc to Altman, and like Altman he employed a repertory company in his early films.

Altman's claim of seldom watching other films was disingenuous, because from *M*A*S*H* onwards his films are sprinkled with references and sometimes outright quotations from the films of Hollywood's Golden Era.

They include the 'B' war films mentioned in $M^*A^*S^*H$ and the films of Alfred Hitchcock alluded to in *The Player*. In his later years, Altman often referenced his own films so that the newer work was dialogic in intent, much like his genre films of the 1970s, only now the dialogue had extended to include the work of his younger self.

IN ANY DISCUSSION of Robert Altman's work there is always the pull of the auteur versus the anti-auteur. It was François Truffaut who first enunciated the auteur theory (*politique des auteurs*) in the January 1954 issue of the influential French film journal *Cahiers du cinéma*. However, André Bazin's definition is the most serviceable: 'The *Politique des auteurs* consists, in short, of choosing the personal factor in artistic creation as a standard of reference, and then assuming that it continues and even progresses from one film to the next.'[24] With regard to Altman's work, Robert Kolker has observed: 'Few American filmmakers have so confirmed the fragile legitimacy of the auteur theory with such a visible expression of subjectivity in their work. Few have, with this expression and insistence on control, so annoyed producers and distributors.'[25] Yet Altman's deferral to actors and set designers, and in some cases even writers, belies the classic notion of the film auteur. One feels that he took pleasure in confounding those who would pigeonhole him, all the while delighting in the title.

PART ONE
APPRENTICE AND JOURNEYMAN

1 Kansas City

BY 1925, the year of Robert Altman's birth, Kansas City, Missouri, was firmly entrenched as the 'Paris of the Plains', and among those who had contributed to the city's lofty reputation was Frank Altman Sr (originally Franz Altmann), the future film director's grandfather, who had relocated his already thriving jewellery business there in 1882. Frank Sr eventually diversified into a number of businesses including real estate in the booming city, and within a dozen years he had a net worth of approximately $200,000.[1] While Frank Sr's self-confidence was a trait passed down to his sons and famous grandson, Robert Altman's outsized personality closely reflected his father's. Bernard Clement Altman (known as B.C.) was a gregarious insurance man with connections throughout Kansas City. B.C. set the tone for his son's approach to life. He enjoyed success and encountered failure and never let the latter affect him for very long; he lived a kind of high life that under most circumstances might seem like pretence. Robert's high-wire act was more precarious than his father's, but then the stakes were always higher for Robert Altman: he spent most of his life avoiding Hollywood's shoals while finding backers for more than three dozen projects.

Briefly, then, Robert Altman was born on 25 February 1925, grew up in a middle-class enclave and acquired a Roman Catholic education. His father, like his grandfather, was a mover and shaker within the Roman Catholic community of Kansas City. By the time he was at high school, though, Altman began to rebel against the religion, and he eventually graduated from the Wentworth Military Academy. Whatever military training he received at Wentworth must have served him well because he ended up as a co-pilot on a U.S. Army Air Force bomber with the 307th Bomber Group in the Pacific theatre during the Second World War. Altman flew more

than 50 missions and received the Air Medal. He was a prototype of sorts for Hawkeye Pierce or Trapper John McIntyre in *M*A*S*H*, more friendly to the enlisted men than most officers, even fraternizing with them. By his own account Altman 'didn't like anything about' the military.[2]

That Altman would choose to make a career in film was not so clear-cut after his return to civilian life in 1945, although one film released that year, *Brief Encounter*, provided him with an epiphany in which he first understood the medium as art and not purely entertainment. But breaking into the Hollywood establishment was nearly impossible for the Kansas City war veteran with few connections. He played an extra in *The Secret Life of Walter Mitty* (1947) and managed to sell an original story co-written with George W. George (son of the cartoonist Rube Goldberg) that was the basis for the film *Christmas Eve* (1947), although neither Altman nor George was credited; and another story that became *Bodyguard* (1948), for which they were given screen credit. Altman later admitted that he begged to write the screenplay but was rebuffed.[3] Married (to LaVonne Elmer) and with a daughter, Altman returned to the friendly confines of Kansas City where he serendipitously met an old friend, Robert Woodburn, who introduced him to Forest Calvin, the owner of the Calvin Company, the leading industrial film producer in the United States. It did not hurt Altman's prospects that the Calvin Company was located on the corner of Fifteenth and Troost streets in the seven-storey building known locally as the Altman Building.

The Calvin Company was Robert Altman's film school. It was there that he learned the basics of his craft: writing, editing, working with actors, and camera and sound techniques under the supervision of Frank Barhydt and others. It was also in this environment that he met the woman who became his second wife, the local actress Lotus Corelli. (Altman's marriage to LaVonne Elmer ended in 1949.) Altman's earliest directorial effort for Calvin, the somewhat comic *Honeymoon for Harriet* (1948), featured Corelli as a newlywed farm housewife trying to convince her husband to take her on a honeymoon rather than purchase farm equipment.[4] Altman also wrote the script for the 21-minute colour short for International Harvester. Altman claimed he was allowed to direct the film because he had come up with a method of recording its open-road dialogue.

Altman's career at Calvin encompassed some 60 films and he remained with the company until 1956, although he took intermittent leaves of absence to move to Hollywood and pursue his dream. Each time he failed he returned to Kansas City and the Calvin Company. Among his notable Calvin films

was *Modern Football* (1951), a short documentary (which he also wrote), sponsored by Wheaties breakfast cereal and Wilson Sporting Goods, on the rules of American football, that featured a daydream sequence.[5] Dreams, of course, and the surreal atmosphere reminiscent of dreams, would be prominent in some of Altman's later work. In 1952 he directed *The Sound of Bells*. It was essentially a sales and informational film in the form of a Frank Capra-esque fantasy in which Santa Claus (driving a car instead of guiding a sleigh) assists a good Samaritan gas station attendant by sending customers to the station. The jingle of bells (again reminiscent of Capra) announcing a new customer is the only soundtrack. That same year he directed *King Basketball*, an informational on how to improve one's basketball technique. Altman appeared in the film's framing device as a Hollywood director come to watch a game.

Among the films Altman directed in 1953 was *The Last Mile*, which opened with a scene of a condemned prisoner walking the so-called last mile to his execution. Playing on similar scenes in prison films of the 1930s and 1940s, Altman's last-mile scene is also ironic. The film is actually about highway safety, and Altman cuts between shots of the convicted man's footsteps and 'spectacular car crash-ups that were the meat and potatoes of these safety films'.[6] The film's strangely made argument was that more deaths occur on highways than in prison execution chambers. At any rate, *The Last Mile* was visually striking enough to win national safety awards.

Crime and fast cars were on Altman's mind a lot in 1953. Collaborating with Robert Woodburn, he directed some of the fifteen-minute segments of *Pulse of the City*, an anthology crime series set in Kansas City that occasionally used some of the Calvin actors. The show was broadcast over the Dumont Network from September 1953 until March 1954. *Modern Baseball* (also 1953) did for that sport what his earlier football and basketball films had done for theirs, namely teach fundamentals. While there was nothing as stylish as a dream sequence in *Modern Baseball*, it did have the attraction of cameo appearances by some well-known players and managers of the era, including Kansas City native Casey Stengel, who at the time had managed the New York Yankees to five consecutive championships. In 1954, in addition to *The Builders* for the Southern Pine Association, Altman directed *Better Football* and *The Dirty Look*, both of which starred the noted comedy actor William Frawley. When he appeared in these Calvin productions the 67-year-old Frawley was at the height of his fame for his role of Fred Mertz in the hit television show *I Love Lucy*. For *The Dirty Look* Altman broke new ground at Calvin. It was the company's first picture to use three

cameras. The film was sponsored by Gulf Oil and written by Altman's boss, Frank Barhydt.

In 1955 Altman directed the noir-tinged *The Perfect Crime*, sponsored by the Caterpillar Corporation and the National Safety Council. As with *The Last Mile*, to which it is something of a prequel, *The Perfect Crime* makes a comparison between senseless automobile deaths and murder in American society. An unshaven young man walks into a respectable grocery store, his unkempt appearance clearly a sign of menace in the otherwise spotless store environment. To drive this point home the camera lingers on him a bit, framed in the doorway. Impatient, the young man shoves a girl away from the counter and pulls out a gun, demanding the money from the cash register. In a series of quick cuts we see the owner's face (from a perspective looking over the thief's shoulder), a medium shot of a stunned woman and the girl, the thief, and again the store owner, who then moves over to the cash register and removes the bills. 'It's only fourteen dollars', he tells the thief. The frustrated thief then reaches across the counter and hits the store owner on the head with his gun. Seeing this the woman rushes to aid the fallen man, but the thief panics and shoots her and she collapses on the side of the counter, with only her legs extending into the frame. Meanwhile the girl begins screaming and the thief shoots her twice before running out of the store. As Mark Minett points out, Altman used rapid cutting and 'perceptual subjectivity' in this scene.[7] The slightly too rapid editing creates the edgy feeling, while the perspective of the shooting is that of the injured store owner who has risen slightly behind the counter.

These killings, however, are not perfect crimes. There is a public outcry and the killer is caught. The perfect crime is committed by a reckless driver who crashes his car, killing his wife and child. The narrator of the film intones, 'Yet there is no public indignation, so the killer gets away scot-free.'[8] But what does this have to do with the Caterpillar Corporation, the film's co-sponsor? Better roads, built by workers using Caterpillar equipment, in conjunction with safer driving would lead to fewer highway deaths. *The Perfect Crime* turned out to be the perfect industrial film of 1955. It won eighteen association awards that year.

The Magic Bond (1956) is Altman's best-known effort at Calvin. It was sponsored by the Veterans of Foreign Wars (VFW) and delivers the kind of patriotic message for which Altman was not known. Following the opening scene (stock footage of night-time artillery fire followed by the Calvin credit and logo), the film cuts to a soldier lying on a sofa and, simultaneously, in the right foreground the back of a typist in uniform. Altman's

peripatetic camera moves closer to the soldier on the sofa while also panning first to the right and then to the left. Thus the viewer sees most of the platoon lying around a bombed-out French farmhouse as indicated by the cheesy props: wine bottles and empty wine bottles used as candle holders, a photograph on the wall of the Eiffel Tower, peeling wallpaper and a broken railing leading to the second floor. Dramatic music highlights the shot; otherwise the only sound is the clacking of the typewriter.

Suddenly, the rest of the platoon bursts in, assisting a wounded soldier who displaces the resting soldier on the sofa. The wounded soldier turns out to be the platoon sergeant (Kermit Echols), and as the film unfolds it is revealed that the sergeant was saved by the efforts of another soldier, the 'Swede', who lost his own life in the otherwise successful rescue. The typing stops (no overlapping here), and the sergeant recounts how the Swede ignored his order to leave him behind. As he speaks the camera pans across the faces of some of the other soldiers, providing only tight head shots so that the viewer can make no mistake about the soldiers' emotions. The squad had been together for a long time, having forged among them a 'magic bond', of which the Swede made the ultimate sacrifice. A little later Altman provides a shot of the Swede lying dead in the mud. His corpse, with helmet

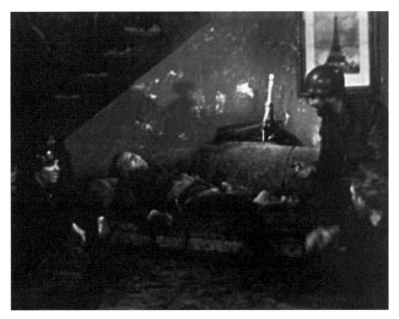

The Magic Bond: surviving members of the platoon in the abandoned farmhouse.

partially off, is upside down in the frame, making it appear at once more dramatic and natural. This non-speaking role was played by Altman.

The sergeant then addresses the typist, implying that he is a war correspondent. After a little bantering by the squad members the camera cuts to the typewriter as the correspondent types 'November, 1944 / Somewhere in Europe / by: Bob Considine'. This dissolves to another typewriter, and another piece of paper with the article title, 'On the Line'. The byline is also Considine's, and underneath that is typed 'International News Service', the Hearst-owned agency for which Considine worked.

The shot switches to Considine, who stops typing and speaks directly to the camera. Considine was a well-known conservative journalist and author, so it was natural that he would be chosen to narrate a film sponsored by the VFW. He discusses the 'magic of comradeship' he had witnessed first-hand as a correspondent during the Second World War and the Korean conflict. We also learn that Considine 'witnessed' the scene dramatized at the beginning of the film. While Considine, in voiceover, quickly lists the various types of 'magic' it 'takes to win a war', Altman includes stock footage of tanks, naval ships, military aircraft, even generals Eisenhower and MacArthur. Lastly, Considine returns to the magic of comradeship, which, he laments, seems to have dissipated in peacetime America.

But first there is the prime enemy – about which no loyal American had to be told twice during the mid-1950s. However, in case the viewer missed the point Altman adds parade scenes with marchers touting banners that identify them as being from the Russian Anti-Communist Center, and floats signifying the horrors of the aftermath of the failed uprising in Hungary against the Soviet-backed regime. (Not all the marchers are there to whip up patriotic fervour; Altman also includes some children carrying signs that read 'Thank you Dr Salk' to honour the discoverer of the polio vaccine.) But Cold War America has other enemies, and as Considine lists America's new, peacetime foes, Altman illustrates them: juvenile delinquency, political apathy, neglect of veterans and smugness. The last is a blatant call for increased military spending to a country whose nerves were already on edge from the ongoing Cold War.

The rest of the film highlights VFW programmes to combat these enemies while a different, stentorian, narrator describes the benefits of a marbles tournament, baseball games, boy scout troops, youth clubs, a drum-and-bugle corps parade, voter turnout drives, Veterans Administration hospitals, children reciting the Pledge of Allegiance in class, the USO and anti-Communist civil defence and legislation for military defence.

Altman's best work in the film reveals his empathy for the plight of veterans, particularly those who are disabled. One scene opens with a prosthetic hand (actually a hook back then) working the side of a lathe. The camera swings around and pulls back to show the machinist, who then stops his work to speak directly to the viewer. All the time he is speaking his prosthesis is in the frame, so that one never forgets the sacrifice he made in battle. The scene is a reflection of *The Best Years of our Lives* (1946), the post-war film about the travails of returning veterans and their families that featured supporting actor Harold Russell, a double amputee. No doubt viewers in 1956 watching this unnamed veteran, portrayed by the actor James Lantz, tell his story would immediately recall Russell's fine performance.[9]

Interestingly, the film takes a turn towards self-realization. A man behind a grocery-store counter (perhaps the same set used in *The Perfect Crime*) announces that he is 'the service officer of our post, and what that vet says is true. But it goes beyond that.' He then describes a couple of VFW programmes before the stentorian narrator returns to describe the organization's good works in veterans' hospitals. We also see children playing in the playground of the VFW national home. The film is again self-reflective as the narrator mentions journalist Considine's quest to find the answers to America's societal problems through the VFW. The film ends with commentary from Considine intercut with a swearing-in ceremony for new VFW members, and the penultimate shot is simply a hand on a partially folded U.S. flag, next to which is an open Bible. This dissolves to the VFW logo. In his later years Altman decried this and all of his early work, but actually the super-patriotism is toned down in the film in favour of the organization's assistance of veterans.

AFTER ALTMAN HAD been working with the Calvin Company for a time he gravitated to the Resident Theater, based in Kansas City's Jewish Community Center. At first he was a sort of factotum, but he eventually directed plays, including *Portrait of a Madonna* featuring Lotus Corelli in a role that would become an Altman archetype – the shy, introverted and broken woman. Altman and Corelli married in 1954 and had two sons, Michael (b. 1955) and Stephen (b. 1957), each of whom worked with their father to varying degrees.

Altman also managed to convince modelling agency owners Elaine Ford and her husband, Gerald, to travel to Kansas City from New York to film a 30-minute pilot for a television show that he hoped to sell to one of

the networks. The show would feature the Fords providing tips on grooming, posture and exercise to aspiring models or women who wanted to look like models. The pilot, titled 'The Model's Handbook', was unearthed in the 1980s by author Patrick McGilligan.[10] It foreshadows popular television exercise programmes that would debut within a few years and, decades later, the multitude of fitness videos and DVDs that crowded the market. However, Altman was unsuccessful in selling the pilot to a network. The idea for 'The Model's Handbook' most likely came to him after shooting commercials in Kansas City for the Nellie Don garment company. He also shot the 30-minute *Fashion Faire*, essentially a one-off fashion show that also failed to make it to the small screen.

Altman's Kansas City apprenticeship was marked by two feature films. The first of these was *Corn's-a-Poppin'* (1951), a film Altman probably had in mind when he characterized everything from his pre-*M*A*S*H* days as garbage. *Corn's-a-Poppin'* was a musical written by Altman and directed by Robert Woodburn. Some references and commentators list Altman as co-director or assistant director, probably because he and Woodburn had alternated directorial duties for various episodes of the short-lived *Pulse of the City*, but they are unlikely to have shared the director's role on the same project.[11] However, Altman did co-write this fiasco about a country-and-western musical programme sponsored by a popcorn company. In the late 2000s the film began making its way to various annual screenings, where audiences, partly because of the Altman association, and partly because of their own ironic sensibilities, have come to embrace its badness.

Altman's other feature project in Kansas City, and the first feature he directed, was *The Delinquents* (1957). He also produced the film and wrote the script. The film sought to capitalize on the success of a pair of films released in 1955: *Rebel Without a Cause* and *The Blackboard Jungle*. *The Delinquents* was bankrolled by Elmer Rhoden Jr, whose father owned a chain of cinemas in Missouri, Arkansas, Iowa, Kansas, Nebraska and South Dakota. It was shot in Kansas City during a two-week period on a budget of approximately $60,000.[12] The cast was an interesting blend of Calvin regulars, including James Lantz and Kermit Echols from *The Magic Bond*, Altman family members (Lotus Corelli and Christine, his nine-year-old daughter from his first marriage) and young professional actors such as Tom Loughlin, who portrayed the film's hero, Scotty, and who a dozen or so years later gained international fame in a series of films as the moral vigilante Billy Jack. The two lead members of the juvenile delinquent gang were also professionals, Peter Miller (who had bit parts in both *Rebel* and *Blackboard Jungle*)

and Richard Bakalyan. In numerous interviews discussing this film, Altman always recollected how difficult it was to work with Loughlin, who acted the prima donna on the set. In fact, Loughlin, Miller and Bakalyan each had more experience in commercial film than did Altman. But Altman had all the Calvin work under his belt; his direction and preparation were equal to that of any first-time feature director. Unfortunately the film's plot and some of the dialogue were roughly what one would expect from a low-budget film. Where *The Delinquents* excels is in the interrelation of the characters and the glimpses it provides of Altman's nascent technique.

A young man, Scotty, has been dating Janice (Rosemary Howard) for some time. One evening, as Scotty arrives at Janice's house to pick her up for a date at the local drive-in, she calls to him in tears from her second-floor bedroom window. It is revealed that her parents feel she is too young to be seeing Scotty exclusively and have taken the drastic step of forbidding her to see him at all. Altman has two things going on with this scene. First, it echoes Shakespeare's *Romeo and Juliet*. There is Janice framed in her bedroom window, knowing that because of her parents' edict she can no longer see Scotty. This references the well-known 'Wherefore art thou Romeo?' balcony scene (Juliet's balcony also leads to her bedroom) in Act II, Scene 2 of *Romeo and Juliet*. Even more precisely, Janice in her bedroom window recalls Act III, Scene 2 of the play, in which Juliet, seated near *her* bedroom window, proclaims, 'mine [tears] shall be spent, / When theirs are dry, for Romeo's banishment.' Second, when Janice's father (James Lantz) – whom we first see as he opens the front door, not merely framed by it as his daughter is framed by her bedroom window, but practically filling the space in an angled three-quarter shot (a menacing visual that echoes *The Perfect Crime*) – explains to Scotty why he cannot take out Janice, the script hooks the viewer, especially the adolescent one. Janice is sixteen years old, but about to turn seventeen. Scotty sees her as a seventeen-year-old, but her parents (Lotus Corelli played Janice's mother) still refer to her as sixteen – too young for a serious relationship. Altman has exposed the contrast between perception and reality that adolescents and their parents bump up against. But this film, like *Romeo and Juliet*, sides with the young lovers. And Altman has already given the viewer enough visual and narrative evidence to side with them too.

Scotty's parents are almost caricatures of James Dean's parents in *Rebel Without a Cause*. His mother (Helen Hawley) is a neurotic who, on seeing the delinquent gang making a U-turn on their front lawn, quickly concludes that all teenagers are or have the capacity to be delinquent and connects her

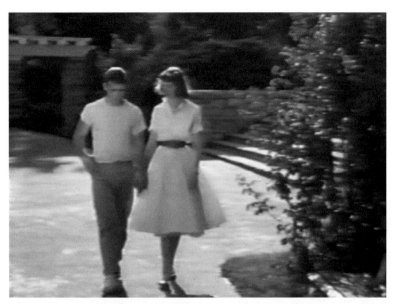

The Delinquents: Scotty and Janice meet clandestinely in the park.

son to their actions. His father (Leonard Belove) concludes that the delinquents are his friends, even though Scotty explains that he does not know who they are. Scotty's father is ultra-passive, and we glimpse him framed by the arms of his easy chair, in contrast to Janice's more dynamic father. Scotty's father doesn't even bother to inspect the damage to his lawn; he rises from the chair only to adjust the volume on the television, which his wife had turned down in the middle of her anti-juvenile rant. Thus, in his first feature Altman used sound in a naturalistic manner to show people in modern homes talking over the television sound (both the mother and father do so) or any other sound. The scene, however, depicts the use of television as a defence mechanism to retreat from family strife or tension.

As wrongheaded as they are, Scotty's mother's fears do foreshadow Scotty's involvement with the gang. Scotty's initial involvement with them comes in a drive-in movie lot where a teenage brawl ensues. The events immediately preceding the brawl are primarily shot from a crane, distancing the viewer from the action. However, when the irate driver and his friends pull Scotty from his car we see this at medium angle, enough to sympathize with his plight. As the fight winds down Scotty and Cholly (Peter Miller), the gang leader, jump into Scotty's car and drive away, as does the gang in their car. After some distance the two cars pull over and they

get out and talk, whereupon tension develops between Scotty and Eddy (Richard Bakalyan), an obvious sociopath. The friction between the two builds throughout the film – exactly as the audience expects. Left alone, Scotty explains to Cholly his dilemma with Janice's parents, and Cholly conceives of a plan whereby he will pretend to be her date the next evening and deliver her to Scotty. It is a plan destined to go wrong.

When Cholly delivers Janice to Scotty we already know that the tension between Eddy and Scotty has increased, but Cholly manages to downplay it and talk Scotty into going to the all-night party the gang has planned in a recently discovered abandoned house. The gang leaves but Scotty and Janice remain to argue; she rightly fears Cholly and the gang and is actually more sensible in this matter than Scotty, whose naivety is but a flimsy plot device.

The party scene is pure Altman. The camera is quite active, beginning with an exterior crane shot that pans the house to emphasize the solitude and contrast it with the pandemonium inside. One of the scene's extras recalled that Altman 'told us to pretend we were having the wildest party of our lives, while he moved the camera from room to room and just filmed whatever was going on. We didn't know when the camera was going. We were just having a wild party.'[13] As with the earlier scene where Scotty's father turns up the volume on the television, Altman again follows his instincts and allows the dialogue to run over the party sounds (music and talking) in the background – although this is much more subdued than the overlapping for which he would be known twenty years later. Even when the action takes place in another room of the house – Eddy and one of the delinquent girls proffering whisky to Scotty – the music is still heard faintly. In fact Eddy and Cholly are working together to separate Scotty from Janice – Cholly now has designs on her. But the party and the crowd, especially Cholly, are not to her liking, and when Cholly pretends to go off in search of Scotty, Eddy grabs Janice and begins dancing wildly with her, whereupon she screams and runs out to the car. Moments later Scotty joins her. Soon after they have left the party the police arrive and arrest everyone.

The next morning Scotty is waylaid by the gang and taken to the home of one of the members. Scotty's punishment for supposedly tipping off the police is to drink a bottle of whisky. There are two things going on in this scene. As Cholly forces the whisky on Scotty, Altman, utilizing a larger depth of field as he did in some of the party scenes, shows Eddy, knife in hand, crossing over to another gang member, standing in an interior doorway. He is the only other person who knows Scotty is innocent of tipping off the

police. Eddy plays with the knife against the doorjamb, a silent warning to keep quiet about the truth.

The film's climax comes at the home where Janice is being held. Scotty bursts in and begins fighting with Cholly, who slashes Scotty across the stomach with a knife. The two continue fighting until Scotty punches Cholly unconscious as sirens signal the arrival of the police.

From this the film cuts to an establishing shot of the police station, the camera tilting upwards to a window. This dissolves to the waiting area where an interior long shot reveals a bandaged Scotty with Janice and their fathers. Scotty is called into another room by a police officer, and Janice's father comes and sits next to Scotty's father, much as Lord Capulet, Juliet's father, makes the first overture to Romeo's father, Lord Montague. Lastly, we see the front of the police station once again. The narrator, whose voice-over frames the story, intones: 'Delinquency is a disease but the remedies are available: patience, compassion, understanding, and respect for parental and civil authority.' The two men emerge through the glass doors of the station followed by Scotty and Janice. The narration continues and the film ends not so much on the hopeful note that was probably intended, but on an ironic one – especially considering the age of the target audience.

The Delinquents is certainly not in the class of Rebel Without a Cause or The Blackboard Jungle, but it is better than Altman's assessment of it after he had gained fame with M*A*S*H. The didactic narrative frame mars it, but otherwise it is more than adequate for its 1950s teenage audience. Furthermore, it was deemed good enough to be picked up for distribution by United Artists and shown on double bills with 'A' films such as Night Passage starring James Stewart. Most of all it allowed Altman to flex his directorial muscles. Altman's naturalism is seen in the pacing of this film, and in some of the shots, especially close-ups that highlight awkward moments for the characters. Judith Kass noted, 'The trade papers . . . praised the technical acumen with which the film was made.'[14]

Altman's naturalism also developed from the actors themselves. His famous reputation for being in tune with the actors in his films was launched at Calvin, where he was used to directing semi-professionals, and thus having to coax out of them performances that were neither slick nor affected. The careers of most of the actors in The Delinquents were confined to primarily Calvin industrials or that film only. The latter category included Rosemary Howard, the actress who played Janice. Her unstylized performance without a doubt foreshadows the work of Shelley Duvall, perhaps Altman's most naturalistic actor, and, much later, Liv Tyler.

THE DELINQUENTS PROVED that Altman was ready for Hollywood, after having tried and failed a number of times to crack the industry town. Altman legend has it that the film turned out to be his entrée, since it was seen by none other than Alfred Hitchcock, who gave Altman his first break directing teleplays for his anthology series *Alfred Hitchcock Presents.*

2 Journeyman's Blues

ALFRED HITCHCOCK DID NOT immediately embrace Robert Altman for his work on *The Delinquents*. Before going to work for the horror master, Altman reunited with George W. George to hash out the details for a biographical documentary about the late James Dean, the star of *Rebel Without a Cause*, who had died in a car crash on 30 September 1955 at the age of 24. For extra juice they hired Stewart Stern, a friend of Dean and one of the screenwriters of *Rebel*, to write the script. The character actor Martin Gabel was hired as the narrator and interviewer. According to Altman, he and George set out to demythologize Dean, but as research and filming progressed they came to admire Dean's artistry and commitment to his craft. However, the hiring of Stern to write the script belies that story. In the end, *The James Dean Story* (1957) contributed to the actor's increasing hagiography.

Altman and George combined still photographs, film footage, interviews, audio tape and re-enactments (there is also a bit of animation prior to the title credit). The stills include some of the iconic photos of Dean, as well as photos his grandmother had saved from the different stages of his life. The producers called their still-photo technique a 'dynamic exploration', enhancing the narrative in much the same way as a sudden prolonged close-up enhances a fictional or documentary film. Among the archival film footage are clips from the premiere of Dean's final, posthumously released film, *Giant* (1956), punctuated by dubbed crowd noise and close-ups of 'fans'. But also there is film of teenagers, of Dean's hometown and of Dean himself – an out-take from *East of Eden* and an ironic interview, conducted by the actor Gig Young, in which Dean warns teenagers to drive safely: 'The life you might save may be mine', he declares snarkily. Towards the end there is the tabloid-like appearance of the California highway

patrolman who arrived on the scene of Dean's fatal accident. From his desk he reads the accident report he had filed. His reading is punctuated by photos of Dean's wrecked Porsche. Stills of Dean's funeral and grave are shown as Gabel eulogizes the actor.

The interviews are the heart of the film: Dean's aunt and uncle in Fairmount, Indiana, with whom he lived after his mother died; his paternal grandparents; and friends from Fairmount, New York City and Los Angeles. But the interviews are stilted, with Gabel interviewing family members and friends who speak directly to the camera. (Gabel does not appear on-screen.) There is also a re-enactment of the crash that pretty much frames the film; Altman claimed to have driven one of the cars during the re-enactment.

On the whole *The James Dean Story* was good enough for Warner Bros. to pick up for distribution. But for Altman it was a side effort. He did not actually direct actors, and he never mentioned having any input in Stern's script. It was something to add to his growing résumé, but not what secured him a job in Hollywood – or at least the television branch of the entertainment industry.

Eventually Hitchcock personally interviewed Altman and hired him as a production consultant for an episode of a television show shot in New York City, *Suspicion*. The episode was titled 'Heartbeat'. Altman brought along two people who had worked on *The Delinquents*, his brother-in-law Chet Allen as art director, and the film editor Lou Lombardo. Following this, Altman was hired to direct episodes of *Alfred Hitchcock Presents*.

The James Dean Story: Altman's re-creation of James Dean's white Porsche speeding down the highway.

The two episodes he directed were 'The Young One' (1957) and 'Together' (1958).[1] Both deal with murder and have the ironic endings for which the show was known. In the former an adolescent girl (Carol Lynley), who has been living with her strict aunt, dreams of leaving the small-town environment and striking out on her own. She latches on to a drifter (Vince Edwards) she meets in a roadhouse as her ticket to freedom. In reality the girl is a sociopath, who murders her aunt, then tries to pin the murder and a claim of attempted rape on the drifter when she is on the brink of being discovered by the police. However, her erstwhile boyfriend, who had stumbled earlier upon the dead aunt, reveals the truth at the last minute.

The 30-minute drama was a nice segue from *The Delinquents*, as the producers most likely intended, in that it featured a disaffected adolescent who is even more deranged than the juvenile delinquents Cholly and Eddy. In fact Janice (a nice coincidence for Altman) harks back to them in that she is manipulative and edgy, making the viewer nervous just watching her. She is a force of evil, and the 1950s audience is made aware of that from the opening scene: not only does she try to order drinks for herself and her boyfriend (as did the delinquents) but also she is insulted when she fails (as were they). Altman fostered the edginess by his own camera movement, which sweeps down from a sign on the wall of the roadhouse prohibiting minors from being served alcoholic beverages, to a three-quarter shot of a man rolling dice on the bar for fun to a couple dancing to jazz music from the jukebox, and finally settling on the teenagers – Janice and her boyfriend, Stan (Stephen Joyce). When she dumps Stan to flirt with the drifter (who is the man rolling the dice), it appears as though his magnetic personality has attracted her rather than her manipulative behaviour reeling him in.

This initial scene has some overlapping sound, but the jukebox music, heard throughout, is suppressed in favour of the dialogue. The sponsors would have howled otherwise. The next scene follows Janice and Stan as they enter Janice's aunt's home, where she lives. Once inside, Altman switches perspective with an overhead shot, from the stairway landing leading to the second floor. First Janice then Stan climb the stairs partially to the landing; as they embrace the camera again switches perspective, and the two are seen as if from the bottom of the stairs. But both angles reveal the double nature of Janice (Janus?) in her face: her youth (emphasizing innocence) and her duplicitous nature. Close-ups emphasize that dual nature and expose the frustrations of adolescence. A moment later the dialogue and the camerawork complement each other in the scene between Janice and her

Aunt Mae (Jeanette Nolan) in which Janice's delusions of her past are revealed as well as her dreams and demands for her present life. This is essentially the high point of the drama, and the end of the first act.

Regular viewers of this series no doubt worked out what was coming in the second act: Janice's seduction of the drifter, the revelation of the murder of her aunt, the false rape scene, and Janice's ironic downfall at the hands of the person who loved her. In the final shot, where Janice confesses to the murder, she is lying on the sofa. The camera zooms in on her, and Janice turns her body so that her head, again in close-up, is at a 45-degree angle – stuck between good and evil.

Altman's second effort for Hitchcock gave him the opportunity to direct one of Hollywood's best-known actors, Joseph Cotton. Cotton plays Tony Gould, a man who murders his mistress (Christine White), who has been pressuring him to leave his wealthy wife. The twist is that the murder is set in her boss's office just after the firm's Christmas party. Most of the teleplay takes place in the office as the killer accidentally breaks off the key in the lock and finds himself trapped with the corpse. Altman managed to slip in overlapping dialogue twice in the course of the show: both were brief telephone conversations amid party revellers. Altman keeps the audience at a distance but still renders a sense of Gould's claustrophobia by the fact that the majority of the best shots reveal the world outside – either from Gould's perspective looking out of the office windows or simply contrasting it with that of his happy-go-lucky friend Charlie (Sam Buffington). In the end it is Charlie who unwittingly foils Gould's bid for freedom – a slight variation on the ending of 'The Young One'.

It was during the early part of his television period that Altman met and married Kathryn Reed; they remained married until his death. Reed had a daughter, Konni (b. 1946), and she and Altman had a son (Robert Reed Altman, b. 1960). In 1966 the couple adopted another boy (Matthew) at birth. Like Altman's older three children, they became involved in working on his and other films to varying degrees. Of the six siblings and half-siblings, Stephen, Robert Reed and Michael Altman have enjoyed the longest careers in the industry as, among other things, set designer, camera operator and set dresser.

Despite the falling out he had with a producer that ended his association with *Alfred Hitchcock Presents*, Altman did such credible work that he was able slowly to build his résumé directing episodic television drama and the occasional comedy. The list of shows on which he worked covers the spectrum of u.s. television from the late 1950s to the mid-1960s.

During that time Altman directed about 100 episodes.[2] There were long-forgotten dramas like *The Millionaire* (eleven episodes, in which every week someone would receive one million dollars from the same unseen benefactor, the story being how they dealt with their newfound wealth); *u.s. Marshal* (ten episodes, a modern-day police drama set in the south-west that Altman proclaimed 'dreadful'); *Troubleshooters* (fourteen episodes, about heavy-construction machinery workers); and *Whirlybirds* (nineteen episodes, something of a precursor to M*A*S*H in that it involved heli-copters and rescues). He directed popular shows of the period: *M Squad* (one episode, a police drama starring Lee Marvin); *Hawaiian Eye* (one episode, a private detective drama set in Hawaii); *Maverick* (one episode, a western comedy-drama starring James Garner and Jack Kelly as loveable rogue brothers; the episode Altman directed starred Roger Moore as their cousin); *The Roaring 20s* (nine episodes, about Chicago during Prohibition); and *Bus Stop* (eight episodes, an anthology series that focused on the lives of peo-ple who enter a town through the local bus stop). Of this last series, the most notable, and controversial, episode Altman directed was 'A Lion Walks among Us', broadcast in 1961. The title refers to the biblical quotation from 1 Peter 5:8 – 'Be sober, be vigilant because your adversary the devil, as a roaring lion, walketh about, seeking whom he may devour.' The character who comes to town, eighteen-year-old Luke Freeman (Fabian), is a sociopathic antagonist. Further outside society's norms than any of the gang members in *The Delinquents*, or even Janice in 'The Young One', Luke commits robbery and two murders, including that of the lawyer who got him off the first murder. He also attempts to molest the wife (Diane Foster) of the local prosecuting attorney (Richard Anderson). The woman's alcoholism is played up as a point for the teen's defence. Because of its violently graphic content and the psychological ramifications – there is an intense trial scene in which Altman switches back and forth between close-ups of the defendant, the witness and the attorneys – more than a year after it was broadcast the episode became part of a u.s. Senate subcommittee hearing on media's negative influence.

Altman also worked on some of the classic shows of American episodic television, including *Route 66* (one episode, television's answer to Jack Kerouac's *On the Road*); *Bonanza* (eight episodes, a western featuring the Cartwright family and much sought after in DVDs today; many of the episodes directed by Altman were humorous); and *Combat!* Altman was also a producer of some of the *Combat!* episodes he directed, as well as writing one of them, 'Cat and Mouse'.

Combat! was a popular Second World War drama that ran from 1962 to 1967. It featured an ensemble cast as a U.S. Army platoon fighting its way across France in 1944–5. Robert Altman directed ten episodes during the show's first season, including the first two – 'Forgotten Front' and 'Rear Echelon Commandos' (in addition to these and the episodes mentioned below, Altman directed the series' seventh episode, 'Escape to Nowhere'). The show was known for its gritty realism, occasionally mixing in actual combat footage. And in an era where American triumphalism still held sway in popular culture, *Combat!* broke ground by revealing the psyches of the soldiers, in particular their fears.[3] For Altman, it served as a platform for moving beyond the simplistic message of *The Magic Bond*. Indeed, it allowed him to move beyond the simplistic and formulaic plots that characterized much of the episodic television in which he had worked up to that time. Thus, the show was a bridge for his career.

That *Combat!* was set in France, an ostensibly Roman Catholic country, allowed Altman to make use of the Catholic imagery that his upbringing had ingrained in him. He acknowledged that he was drawn to such imagery and settings: 'We used a lot of churches and a lot of graveyards and nuns and priests. I don't know . . . [they] seemed to go together for me.'[4] The opening scene of the episode entitled 'Cat and Mouse' shows the platoon pinned down on a hillside cemetery. Crosses and headstones askew from the bombing signify the gateway to the other side of the 'no man's land' where a heavy concentration of German troops has made it unsafe for the American platoon. As the Americans dig in on the hillside (a gruesome enough experience), two soldiers are spotted returning to their lines, one carrying the other on his shoulders. Their path of return is framed between two headstone crosses. As the scene fades out moments later the camera focuses on, but keeps its distance from, a stone crucifix. Another episode, entitled 'I Swear by Apollo' (the opening words of the classic Hippocratic Oath), is pretty much framed by nuns working in a cemetery. Initially they are keeping the grounds clean, but in the end they bury and hold a service for one of the American soldiers in the platoon. Most of the dramatic action of 'Any Second Now' takes place in a church where an unexploded German bomb has landed, and where the platoon's Lieutenant Hanley (Rick Jason) lies injured and caught under a fallen beam. As a British demolitions expert works in the foreground to deactivate the bomb, Altman uses deep focus that allows us to see the parish priest in the background open the tabernacle and remove the chalice and, presumably, the consecrated host within it to protect it should the bomb explode. At the end of the episode the priest, again in the background, returns the chalice to the tabernacle.

In some instances the Catholic imagery served to enhance the naturalistic effect that Altman always strove for, but in others it commented on or foreshadowed the episode's events, even as the imagery lay in the back of the visual field. When the priest returns the chalice to the tabernacle after the bomb in his church has been defused, his action signifies a return of the building to its sacred condition – though the actual structure is in need of repair. The crucifix at the end of the introductory scene of 'Cat and Mouse' symbolizes the general sacrifice of soldiers and civilians during wartime and foreshadows the individual sacrifice that one man, a career soldier, will make to save the life of Sergeant Saunders (Vic Morrow) and thereby allow him to return with the vital information about where the Germans intend to attack the Allied lines.

But not all the episodes directed by Altman contained religious imagery. In fact, not all the Altman episodes stuck to the gritty aspects of war. 'The Prisoner', featuring Las Vegas comic Shecky Greene (who was a semi-regular cast member during the show's first season), has a comic tone that foreshadows *M*A*S*H*. The plot centres on Greene's character, Private Braddock, who is captured by the Germans and mistaken for the colonel for whom he served as a driver. As a 'colonel' he manages to make circumstances a little better for three captured enlisted men. The German officers easily work out that Braddock is the private he originally claimed to be, and propose to swap him and two of the three enlisted men for their own captured colonel and his aide. (The third enlisted man has been sent across to the American lines to convey the proposed swap.) In the meantime the missing colonel shows up at his headquarters and agrees to the swap, but dresses up two captured German privates in officers' uniforms. In the end the Americans recover four enlisted men to the Germans' two. It was the perfect happy ending for an episode devoid of death that was aired on Christmas night 1962. But it was un-Altmanlike.

'Off Limits' begins comically with members of the squad pulling up to an evacuation hospital in a jeep and spying on female nurses, but it quickly turns melodramatic when it is revealed that one of the nurses is married to a soldier in Saunders and Hanley's squad. Through visual treatment, mainly close-ups, of Lieutenant Amelia Marsh's (Peggy Ann Garner) cool demeanour the audience is clued in that the romance, for her, is over. Later in the episode her husband is seriously wounded and undergoes emergency surgery performed by the doctor who is the new love of her life. 'Off Limits' was the penultimate episode of *Combat!* that Altman directed. It was bracketed by two of the best episodes he directed, 'The Volunteer' and 'Survival'.

In these Altman displayed an evolving aesthetic. Certainly the camera movement was there as well as the subjective shots, but the use of sound was subdued, the overlapping dialogue replaced by silence. It was as though Altman, who always thought of his one-hour dramas in filmic terms, was introducing the u.s. television audience to a conspicuous technique of Italian neo-realism or French *nouvelle vague*.

'The Volunteer' concerns an orphaned thirteen-year-old French boy, Gilbert (Serge Prieur), who decides to join Hanley and Saunders's squad after they pass through his newly liberated village. The villagers' celebration is revealed through medium shots of the townspeople hugging, kissing and dancing with the soldiers, interspersed with shots of their feet as they trample and dance on the swastika or move deftly around empty wine bottles. Then Altman delivers a long shot of seemingly the one person not engaged in the celebration, Gilbert. Dressed in ragged clothes, he is leaning against the corner of a building watching the merriment. As the camera closes in on him, the viewer perceives a vague sadness in his face. Then he turns and runs into his house, where from an old trunk he removes two pouches which he slings around his neck in order to carry his supplies (wine and bread), a beret and a rifle – the last two items symbolizing his membership, in his own mind, of the Resistance. Only it is the American squad he seeks to join. Thus bedecked he leaves his house, passing a slightly askew framed reproduction of the Madonna and Child. Since the boy does not speak English and Caje (an abbreviation of Cajun, portrayed by Pierre Jalbert) is the only squad member who speaks French, there is minimal dialogue. What results is Altman pulling out all the stops as we observe the rise and fall of Gilbert's career as a soldier.

Altman's moveable camera follows Gilbert as he shadows the squad from a discreet distance. Employing a visual pun, Altman doesn't merely settle for a long shot of the boy but instead shows his shadow, rifle slung over the shoulder, moving steadily down the road. In a scene reminiscent of Robert Bresson's *Mouchette*, the camera focuses on the boy's feet as he moves along the road, then on Saunders's combat boots, then on the boy's shoes again – their steady, measured walking a contrast to the earlier dancing, although the background music makes the scene's tone less portentous than it might have become. Gilbert finally overtakes the squad during a skirmish in which Lieutenant Hanley is slightly injured; Saunders decides to entrust Gilbert with escorting the wounded lieutenant back to the village. On the way the lieutenant falters and passes out by the side of the road. Gilbert leaves him to head for the village for help but spots a German patrol. Returning to the

lieutenant, he helps him take cover then runs through the woods towards his village, but is captured by the bemused Germans. One German snatches Gilbert's wine and takes a drink, then tries to scare the boy. In close-up he makes a threat and runs his finger underneath his throat by way of emphasis.[5] A second German soldier (Ted Knight) returns the wine bottle to the boy and attempts to befriend him. We see this in long shot but Altman, after the boy and soldier are seated for a while side by side on the ground, gives us close-ups of the German as he attempts to communicate with the boy. Happiness, bewilderment, sadness, bemusement – all these emotions play across his face during their brief conversation. In short, this German soldier, we discover, is human too, not a monster. He even tosses chocolate to Gilbert as the patrol leaves. Gilbert then proves his mettle as a soldier by getting Hanley safely to the village – to his own house, in fact.

But the German patrol has entered (or perhaps re-entered) the village, which now seems deserted. After helping the lieutenant hide under the bed, Gilbert moves swiftly through the village – the camera from many angles exposing the place to be little more than a collection of rubble. Gilbert eventually overtakes Sergeant Saunders and the others, and they head back to rescue the lieutenant. Sneaking back into the village the group passes a statue of a Madonna and Child tilted against a wall amid the rubble. In the village a firefight ensues in which Gilbert, now considering himself a fully fledged member of the American squad, takes part. From a window in his house he shoots one of the Germans and, of course, the dead man turns out to be the soldier who briefly befriended him. Altman uses flashbacks to convey Gilbert's recognition of the soldier. These flashbacks encompass scenes that relay Gilbert's point of view, but also reveal (in the third person) his youth: for instance, his running legs as he cannot wait to catch up with the others and become a soldier. This fades to a close-up of Gilbert's face, now shocked with the realization that he has taken a life. In the end, as the squad moves out of the village for the second time, Gilbert has removed his soldierly accoutrements and is again the orphaned ragamuffin in a torn sweater, but one whose soul is now troubled, which is revealed in the tight close-up that ends the episode.

'Survival' was the final episode of *Combat!* Altman directed, after which he was fired from the series. It involves the squad being captured and tied up in a barn, which is then shelled by Allied artillery. During the shelling a German soldier cuts free all the squad members but is killed in the bombing before he can free Sergeant Saunders. The barn catches fire as the others run towards a river. Having crossed it they rest for a while before deciding

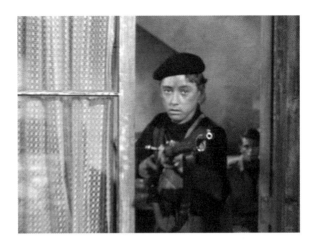

Combat!, 'The Volunteer': Gilbert realizes he has killed a man.

that Saunders is dead. The scene then cuts to the burning barn from which an obviously shell-shocked Saunders emerges, his hands badly burned, his clothes smoking. He moves in a daze towards the river, and from here on the episode divides into two subplots: the squad seeking to return to the American lines, and Saunders lagging behind by an hour or so.

The episode was a tour de force for Vic Morrow, the actor who played Sergeant Saunders, as it followed the character's frustration and descent into pain-induced madness. The Saunders subplot featured no dialogue and only minimal speaking, as Saunders becomes hallucinatory. In the end he mistakes a dead German soldier for his younger brother and is discovered by an American tank crew carrying the soldier down a road. The tank crew is leading a column of troops that has already rescued the other surviving members of Saunders's squad. At the end of the episode a crazed and burned Saunders is lying by the side of the road, accompanied by two soldiers as they await medical help.

Altman shot the script over the objections of Selig Seligman, head of production for *Combat!*, who thought it too graphic and depressing. In a video commentary on the episode, Altman claimed he was able to do so because Seligman was out of town when shooting began, and that when he returned he fired Altman.[6] Altman also acknowledged in that commentary that part of the problem with adhering to a realistic portrayal of war was that the audience knew that the stars and regular cast members were not going to be killed. However, this may have been disingenuous of Altman, considering that the tension of 'Any Second Now', the episode of the unexploded bomb in a church, rests on the ability of an overwrought demolitions man to

defuse the bomb and save Lieutenant Hanley's life. In the same commentary Altman also mentioned how he began using long takes to 'defend' his work from the editors. Clearly by then Altman was in, or at least saw himself in, an adversarial position vis-à-vis the show's production company.

'Survival' was broadcast in March 1963. By the end of the year Altman had directed an episode of the hour-long anthology series *Kraft Suspense Theater* – 'The Long, Lost Life of Edward Smalley', which he produced, also co-writing the story. For Altman, 'The Long, Lost Life of Edward Smalley' takes up where his *Combat!* episodes left off. It touches on similar themes that *Combat!* had explored and continued to explore, particularly stress. And as with *Combat!*, Altman was again drawn to Roman Catholic imagery: the bombed-out church and its broken contents. But he also explored the religion's psychological effect. The body of the story is told in flashback, framed by a man, Edward Smalley (Richard Crenna), who has come to the office of a high-powered and seemingly amoral lawyer with the intention of killing him. The flashback reflects the wartime backstory of Smalley and the man he has come to kill, who, years earlier, had successfully defended Smalley on a murder charge in a court martial. But Smalley had been agonizing over the incident for two decades and decided to exact his own twisted justice.

Like the bombed-out church in which, in flashback, Smalley and an army buddy have come to meet a French woman who has brought them liquor, the troubled Smalley declares, 'I feel like I'm gonna bust in a million pieces.' However, one unbroken item, the crucifix, continues to hang on a wall, and Altman shows it in the background, echoing his earlier pattern for revealing these sacred objects: usually in the background but in deep focus,

Combat!, 'Survival': a badly burned and crazed Sergeant Saunders mistakes a dead German soldier for his brother.

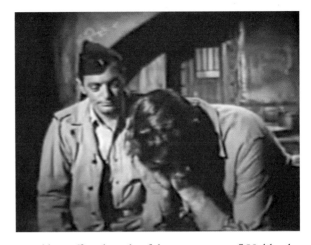

'The Long, Lost Life of Edward Smalley': Smalley rejects the psychological overtures of the army chaplain.

or else in the foreground but off to the side of the composition.[7] Unlike the bombed church in the *Combat!* episode 'Any Second Now', this church will not in the foreseeable future regain its status. Eventually Smalley storms out, but when he returns later, drunk, his buddy and the woman are no longer there. In his drunken ramblings he threatens to set off a grenade in the church, thinking his friend is hiding from him. Here we also see an undamaged Madonna and Child statue, which seems to be one of Altman's favourite visual motifs from this period. In fact, standing next to the statue Smalley declares that he is going to kill another soldier in their platoon, Sergeant Bender (Arch Johnson), who has been tormenting him. He turns around and looks at the crucifix, which we see in a medium shot bathed in a circular lighting that gives it both the effect of a halo and the old-fashioned iris shot, and swears (to God) that he will kill Bender – a vow that repudiates the message of *The Magic Bond*. Smalley then leaves the church.

Drunken and exhausted, Smalley collapses into his foxhole and falls asleep. Here, within the flashback, Altman gives us a dream sequence and another flashback interspersed with close-ups of the crucifix from the bombed-out church that relays the confusion in the mind of the somnambulant Smalley. He awakens in Bender's foxhole after having stabbed him to death. Smalley insists that he thought his now dead antagonist was a German soldier but is quickly overcome with remorse for his crime. For the pious Smalley the guilt is compounded because he vowed to kill the sergeant in a church, violating the sanctity of the place. Only a Roman Catholic priest can expiate his sin, and Smalley, in his cell, rejects the psychological overtures of the Protestant chaplain (Bernard Kates). The not-guilty verdict

because of a legal technicality rendered by the military judges at his court martial sets him on a path where all he can do is feel guilty.

So inverted does Smalley's psyche become that only his killing of the military lawyer, many years later, can make up for his not having paid the price for his own crime (or sin). Thus the win-at-all-costs lawyer (James Whitmore) becomes a Christ figure in Smalley's mind, not as a positive symbol (as Christianity conceives of it) but as a negative symbol of fatal sacrifice. This is just about 180 degrees from the philosophical position taken in the *Combat!* episode 'Cat and Mouse', broadcast approximately one year earlier. No longer does the crucifix (in the church) prefigure heroic wartime sacrifice. Instead it foreshadows a twisted interpretation of the Christ story – peacetime murder to expiate a wartime murder. But Altman delivers an ambiguous ending: Smalley points the gun away from his intended victim and is quickly disarmed and hustled out of the lawyer's office to await arrest. He remains a broken man, spiritually and psychologically. The lawyer, Marvin Bean, himself undergoes a spiritual and psychological transformation, reflecting on Smalley's story and his own near death while staring at his image in a bathroom mirror. This scene references an earlier one where the cocksure Bean forced Smalley to look at himself in a mirror in his prison cell – Altman, here, maturing in his use of this motif. Now Bean is no longer self-assured. He orders one of his subordinates to let Smalley go before the police arrive, and as he passes through the reception area of his office the focus of the story is now on his shoulders. He is the only moving figure in the shot. His subordinates, his secretary and Smalley are composed like a *tableau vivant*. The final shot shows Bean heading for the elevator, where he presses the 'down' button. The window of his office on which his name and 'Attorney at Law' are stencilled frames his tired figure. Except, from the perspective of the shot, the words are reversed.

Altman was fired from the *Kraft Suspense Theater* for disparaging remarks about the show, the sponsor and the culture of television in general made in an interview published in the trade newspaper *Variety*. Nevertheless, economics dictated that Altman complete a project he had already begun, 'Once Upon a Savage Night'. It had some nice elements to it, but overall is weaker than 'The Long, Lost Life of Edward Smalley'.

Set primarily in and around Chicago during the Christmas season, 'Savage Night' involves a manhunt for a serial killer (Philip Abbott) who has been leaving a trail of strangled blondes. He gruesomely kills his final victim with her scarf as he is kissing her in a strip bar in downtown Chicago. They are sitting in a corner next to the catwalk, where a stripper is performing

to a brassy, instrumental version of 'Frankie and Johnny'. Added to this is a subplot in which a military convoy is transporting a weaponized missile cross-country and is en route on the Illinois Tollway. The two plotlines inevitably converge.

The twisted psyche of the killer, revealed in voiceover memories, is simplified Freud, cut and dried compared to that of Edward Smalley, but Altman has some nice touches – notably his use again of reflected images. On an elevated train into Chicago, where he spots his final victim, both killer and victim are seen in profile, reflected in the night-darkened windows. The killer's reflection of his left profile is shown simultaneously with his right profile, a visual symbol of his split psyche, while a voiceover memory of his mother stepping out with a strange man dominates the soundtrack and the clacking of the train wheels provides a steady, nervous rhythm. Soon after the murder, the killer escapes from Chicago and takes brief refuge in a highway diner. There we see reflections of a mousy waitress, her unappreciative boyfriend and a tough-talking new waitress as they banter near some floor-to-ceiling windows in a romantic triangle subplot that fizzles out before it really gets going. Later, after the killer has deliberately caused a spectacular pile-up on the Illinois Tollway to divert police attention, one of the burning cars is reflected in his dark glasses. (He suffers from photosensitivity.) Stripped of those glasses, he is eventually captured at a toll stop by police officers bearing down upon him out of the darkness with bright torches. It is a scene worthy of horror master James Whale.

After it was broadcast on television, Universal Studios retitled it *Nightmare in Chicago* and released it as a 'B' movie for double features, with

'Once Upon a Savage Night': the killer stalks his next victim on a Chicago elevated train.

more than twenty minutes added to its run time that had been cut from the broadcast version. It is doubtful that Robert Altman had any input into which of the edited scenes were added to the theatrical release. Although he was thankful to be out of television, his career was in limbo. Nevertheless, on to the technical expertise he had acquired at Calvin was grafted a narrative sensibility from his television experience. In a 1971 *Atlantic Monthly* article he pointed out, 'In television, I learned how to say things without saying them directly.'[8]

'Savage Night' was broadcast in April 1964; Altman directed nothing for the rest of the year. In 1965 he directed two short films – *The Katherine Reed Story* and *Pot au feu* – and the pilot of the television series *The Long Hot Summer*, based on William Faulkner's fiction. He also directed four proto-music videos, called ColorSonics. They were to be shown on 'small television-type screen[s] attached to the jukebox'.[9] Unfortunately the company that was to manufacture the video-jukeboxes went out of business soon afterwards. In 1967 he signed to do a film version of the Hank Searls novel *The Pilgrim Project* for Warner Bros., in whose television division he had worked. The film he directed was *Countdown*.

COUNTDOWN (1968) IS SET during the final weeks of the race to the moon between the United States and the Soviet Union. The U.S. has been secretly training an astronaut for an emergency moon launch, but there is a catch: NASA has not developed the technology for a round trip. Instead the plan is to send up a 'shelter capsule' a week ahead of time for the astronaut to live in for ten months to a year, until NASA can get the Apollo programme up and running to effect a lunar rescue. As it turns out the astronaut in training, Chiz (Robert Duvall), is a well-respected colonel also training for an Apollo mission. His Apollo capsule mates are Rick Lincoln (Michael Murphy) and Lee Stegler (James Caan), a civilian astronaut. While the three are on an Apollo training mission, Chiz gets word that the Pilgrim Project has been ramped up because the Soviets have just launched a manned flight that is going to slingshot around the moon before returning to Earth.

As Chiz begins his preparations it is discovered that the Soviets have added a new twist to things. The cosmonaut they have sent up is a geologist and not a military pilot as have been all the cosmonauts and astronauts up to then. Faced with a political dilemma – the United States does not want to appear to militarize the space race – the decision is made to replace Chiz with the civilian astronaut Lee Stegler. An upset Chiz agrees to serve as

Countdown: Chiz informs his colleagues of the change of plan to send him to the moon.

Stegler's backup. Rick also assists in the training and tracking of the space flight in Houston.

In the aborted training mission scene, Altman mixed in overlapping dialogue between the astronauts and mission control, although it is blunted. However, the film does have two other notable instances of what critics would later realize was Altman's signature sound technique. During a party someone is playing guitar and singing an astronaut version of 'John Henry' to a small group of partygoers. The singing is foregrounded and clear, but the background noise and conversations are not eliminated. The camera then moves from the interior to the exterior so that the singer's voice becomes backgrounded, replaced by a drunken Walter Larsen (the NASA spokesman) offering a woman a drink while Gus (the flight doctor opposed to the Pilgrim Project) simultaneously vents his frustration with the mission. Walter (Ted Knight) and Gus (Charles Aidman) argue about the mission's validity, but when their argument dies down the guitar player is again foregrounded as the camera returns to the interior just in time for the viewer to catch the humorous ending of the song. The second overlap occurs after the launch of the lunar shelter. Lee and Mickey Stegler (Joanna Moore) and some other astronauts and a few wives are sitting together in a restaurant. While Mickey is inundated with questions from her husband's friends, Gus approaches Lee (in the foreground) and tells him that the Soviet Union has launched a manned lunar flight a few hours earlier.

Altman also makes use of static and poor reception during the conversations between Lee as he approaches the moon and Chiz in mission control in Houston to enhance the film's realism. Earlier in the film, though, as if taking a page from the composer John Cage, the screen is silent as the film

cuts to different shots of people watching Lee Stegler's lunar lift-off. Conveying the enormity of the event for the onlookers, the silence is broken by Chiz's countdown and then the sudden roar of the rocket engines as lift-off commences.

Interestingly, there is Christian symbolism denoting Lee Stegler as a voluntary sacrificial victim, if not for humanity then for the United States of America. As commentators have noted, when he enters the capsule just prior to lift-off, and in the capsule afterwards, light reflecting on his visor makes at times a large cross and at other times two, and even three, crosses.

Countdown unveils a confident director who understood that he wanted to reveal the story and, in particular, its characters, hesitatingly through windows and doorways. In other words, from the onset of his feature film career Altman set up the audience as voyeurs – which, in effect, audiences are by their very nature. But what Altman has exposed here is not subliminal prurience but the ragged sentiments of acculturation, specifically loyalty and patriotism, and the underpinning emotion of these: love. In the context of the small, closed society of the astronauts and their immediate families these emotions become very tribal. But no matter how communal the individual has become, or how brave the astronaut or the astronaut's wife, one cannot fully suppress the personal doubts and fears of the unknown. All the fancy technology cannot erase the atavistic impulses.

Altman strings along the audience. Sometimes the viewer is a direct witness to the fears; at other times the fears are hinted at. The former occurs in a scene at the home of Chiz and his wife, Jean, when Chiz has called his Apollo team together to explain the Pilgrim Project. At this point he is still the astronaut of choice to fly the mission. As the men gather and converse in the sun room – separated from the living room by sliding glass doors that are left open – we spot Jean (Barbara Baxley) in the background framed by the open doors. Her own fears for her husband seem to coincide with his explanation of the flight: she stops and turns and looks at him before proceeding into the kitchen. Later she turns again when Chiz, now sitting closer to the open sliding doors, repeats that he is going to the moon – her initial fears justified. Backgrounding a scene or a part of it through windows and doorways is a recurring motif throughout the film.

This eavesdropping on a character's fear is repeated after the launch when we see Mickey and Jean behind the viewing glass of the mezzanine as they silently watch the stressed engineers in the Houston control room. In the foreground the plot moves forward as Chiz and the other men working the mission from the ground seek to solve a flight problem. But behind

the window the women, excluded from the tasks of problem-solving, stand not as portents (indeed, Mickey's faulty 'intuition' marks her as anything but a portent) but as personifications of fear.

Inside the space capsule, as it makes its way to the moon, Lee Stegler's mood transforms from cocky to fearful to dedicated. Because of the need to conserve power in the capsule he has to switch off all non-essential electrical currents, including the one that provides oxygen. Thus he must don his helmet, and (in close-up) his facial reactions to most fearful moments are seen behind the glass of the helmet's visor. This marks the scene as a visual link with his wife, whose anxious moments, as noted, are also seen behind glass. Wife and husband are espied in their emotionally rawest moments, especially Lee, whose fear of his own death (and of the mission's failure) is the more visually palpable.

Altman could not resist two instances of voyeurism vis-à-vis Mickey Stegler. As a television announcer discusses the Soviet lunar orbiting flight she is putting things away on a cupboard shelf. The shot, since she is standing on an ottoman, is voyeuristic in the usual sense since it focuses on her backside. The voyeurism recurs when we see Mickey in her bra as she finishes dressing. Her back is to the camera, and she is framed by the open shelf above the television set. That she is displayed in an adolescent manner is not so much the point (although a valid enough point since the restrictive film code was losing its power) as the way we are forced to view it. Mickey even steps out of the changing area to greet Lee when he returns and leads him back into it, and into the frame of the open bookshelf, so he can zip up her dress.

The viewer also eavesdrops on an argument between Chiz and the mission chief, Ross Duellan (Steve Ihnat), about the plan change that has taken him off the mission. This is seen through the open doorway of Chiz's office. In fact, the argument is a continuation of their discussion as they walk down the hallway towards his office, past the camera that allows us to eavesdrop on their discussion in the office. After a secretary approaches the open door to announce a telephone call Ross follows her and shuts the door – thereby excluding the viewer from the rest of their exchange – and the scene ends.

In two instances Altman used television to further the plot so that the audience is told as well as shown what is happening. In the first case, the news is of the Soviet lunar flight. In the second instance a shot of the moon is accompanied by an announcer's voice disclosing a three-man Soviet lunar flight and the u.s. government's 'decision to go ahead with Project Pilgrim'.

Much was made by Altman of his disavowal of *Countdown* after Warner Bros. changed his ending. Altman claimed his ending was ambiguous, but in it Lee Stegler, with only minutes of oxygen left, mistakenly heads off in the opposite direction from the lunar shelter's signal beacon. The film's ending, as printed, is ambiguous (and in line with Searls's ending) because Stegler spots the lunar shelter's beacon. The ambiguity concerns whether or not he would survive his year alone on the moon before the Apollo rescue mission could arrive. In fact there is no reason to believe that he could survive a whole year – just hope that he makes it. It also affirms the humanistic attitude with which Altman approached his work, and which some have argued characterizes *Countdown*.[10] Nevertheless, the ending change signified Altman's status vis-à-vis the studio powers and no doubt contributed to his antagonism towards any aspect of institutional Hollywood that interfered with or hampered his aesthetic process. However, while *Countdown* is among the least Altmanesque of his films (excluding *The Delinquents* and *The James Dean Story*) – and even that consideration is arguable – it does display incipient patterns and techniques that characterized his career.

IN AN ARTISTIC SENSE, Altman's next film, *That Cold Day in the Park* (1969), which starred Sandy Dennis, was his breakout piece, and the film Altman considered his first. The story of a lonely, sexually repressed woman who one day picks up a teenage boy (Michael Burns) in a park near her apartment in Vancouver and gradually makes him her psychological and de facto prisoner is as creepy as the Richard Miles novel of the same name on which it is based. But Altman and cinematographer László Kovács gave the film a visually introverted moodiness – especially in the close-ups of Dennis – that not only causes claustrophobia but seduces the viewer by its creepiness. Johnny Mandel's score heightens this effect. A variety of mirrors (or a reflecting surface such as a shiny glass table or darkened, night-time windows) are the film's primary motif, and these appear in many of the scenes. The voyeurism, which for the audience is pivotal given such a creepy plot premise, is often shown as reflected reality. But that reality is also a mirror of the hemmed-in and empty world of a woman, Frances Austen (Dennis), for whom control – self- or otherwise – is at the heart of her existence, including whatever romantic nature she feels she possesses. In one scene, Frances is having coffee and a cigarette in her kitchen when in walks the housekeeper, who has just arrived. The housekeeper (Rae Brown) proceeds through the kitchen to a hallway where she changes out

of her overcoat and into her housecoat. A triptych mirror against the wall reflects not only the housekeeper as she changes but also Frances through the open doorway. In their brief conversation Frances is framed entirely within the right-hand mirror while the housekeeper stands in the foreground and her reflection, as she changes, spills over from the larger, middle mirror to the one on the right, thus crowding and even blocking Frances's reflection.

Early in the film, Altman's 'window shots' have a reverse effect. Rather than manipulating the audience towards viewing the action within a confined area, they provide a glimpse into Frances Austen's mind, specifically her desire to escape the confines of a dinner party she is hosting. These shots are from within her luxury apartment to the outdoors – initially the park and the nameless young man sitting on a bench in the cold rain. Later, Altman returns to exterior-to-interior window shots, notably when the young man has snuck out briefly from Frances's apartment and visits his sister, who is in bed with her boyfriend (Suzanne Benton, John Garfield Jr). Breaking in on their lovemaking, he retreats up some exterior stairs but can spy them through a window (as can the film viewer). However, he primly blocks the view. The other notable scene in which Altman used the camera and the microphone as tools of the audience's voyeurism is when Frances visits a women's health clinic to be fitted for a diaphragm. Seen and heard through a (presumably open) waiting-room window are not only Frances (she is actually silent in this scene), but also the clinic's other clients, who engage in candid chatter about sex and male genitalia. Besides the voyeurism, Altman, as Robert Kolker points out, 'is imposing peripheral action onto

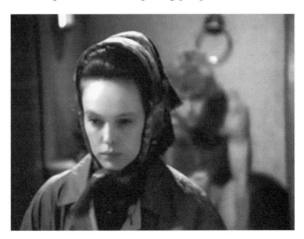

That Cold Day in the Park: an emotionally and sexually repressed Frances stares at the reflection of her young guest.

the central focus of the sequence' to enhance the scene's naturalism.[11] Just as importantly, Frances has been shunted briefly to the periphery, a space she had occupied towards the end of her own dinner party and where, one imagines, she has felt comfortable throughout her backstory. Interestingly, the segue to the clinic shows Frances in a taxi while her voice, as explication for the young man (and the viewer), reveals that she has to go out and will not be back until the evening. The visual is one scene ahead of the aural, a device Altman used again, and critics would notice, in M*A*S*H and elsewhere.

The various mirrors and reflective surfaces serve purposes of plot and psychological revelation. Sometimes they heighten a seemingly innocuous plot point, as when the highly polished glass table in Frances's foyer reflects first the departure of her dinner guests, all of whom are older than she (with the youngest of the group her shy suitor), and then the arrival of the young man, whom she has coaxed into coming out of the cold rain and into her apartment. Later, submissive, very much repressed and something of a mother figure, Frances glances at him in the bathroom mirror as he undresses for a warm bath. And that evening Frances herself is reflected in the mirror of her bedroom as she turns down her bed, while the young man, leaning in the doorway next to the mirror, watches. This has the effect of placing both characters within the viewer's field of vision. The scene is one of mild seduction of one passive-aggressive character towards another; the young man, all this time and during the ensuing days he is with Frances, puts on a mute act.

The most visually complicated of the 'reflection scenes' occurs in Frances's childhood bedroom (this follows some quick, disorientating editing that leaves the viewer confused as to exactly where she is), which she has given over to her 'guest'. The confusion is expressionistic in that Frances and the young man are stoned on hashish-laced cookies (baked by his sister) and wine. In the bedroom there is a triptych dressing mirror, and after retrieving a small vanity case she sits on the floor before the mirror. The opened case reveals a small mirror inside, which in turn reflects Frances in close-up.

Frances then returns to the living room, where the young man is dozing on the floor. We hear a scream and the startled young man jumps up, and Frances coyly asks, 'Did I frighten you?' At that moment she is removing her scary get-up (scary to the stoned young man, and the viewer, as Frances emerges from her staid character) and acting coquettish. Around her head a necktie is tied. When the boy, from behind, ties the necktie around her neck she looks away and proclaims, 'Oh yes. Yes', then gives him a quick

peck on the cheek. Not exactly Molly Bloom, but a long-repressed aspect of her personality is emerging. The scene takes other playful and, for Frances, sorrowful turns. Using the necktie as a blindfold they play blind man's buff, but when it is Frances's turn to be blindfolded the boy abandons her in the living room. Frances's discovery of her abandonment is highlighted by Altman's zooming out to show her alone in the spacious room. Moments later she is at his bedroom door, and in a role-reversal parody of Bob Dylan's 'She Belongs to Me' she peers through the keyhole. Whereupon the camera zooms in for an extreme close-up.

The next evening the young man makes a second escape from Frances's apartment. Meanwhile, after rejecting the advances of her suitor, Frances enters her guest's room and offers herself to him – only to discover the old ruse of an extra pillow beneath the blanket, with the added touch of one of Frances's childhood dolls, with blond hair just like the young man's. She lets out another scream exactly as the previous, but this time not as an off-kilter joke, but as an evocation of her emotional and sexual frustration. This leads to another important scene, shot primarily in a mirror's reflection.

The following morning the boy finds – in wonderful combinations of zooms, close-ups and quick cutting – that he is now truly trapped in the apartment. Not only are the doors locked, but the windows have been nailed shut. He enters her bedroom – the two of them now trapped in the reflection in her bedroom mirror – and in anger and defiance speaks to her for the first time. When he leaves Frances's reflection remains silent, as Sandy Dennis's controlled stare reveals Frances's deepening psychosis. Still in reflection, Frances leaves her bedroom. She goes to the young man's room, and we spy her reflection in the window he is trying to pry loose. The camera then cuts from the reflected woman to the real one and gradually zooms in for a close-up as she calmly apologizes, but tells him she cannot allow him to leave. Again we see Frances reflected in the window as she walks out of the room and closes the door. In reflection we see the young man rushing to the door too late. Frances has locked him in his room.

That evening Frances cruises Vancouver's seamy neighbourhood looking for a prostitute for her 'guest'. Here again Altman echoes Bresson, this time the latter's early film *Les Dames du Bois de Boulogne*.[12] After procuring a streetwalker (Luana Anders), Frances and the woman ride back to the apartment in a taxi, occasionally stealing glances at each other in the rearview mirror. The prostitute initially thinks Frances wants her for her own pleasure, but once she meets the boy, and after Frances locks them in a guest-room, she figures out the set-up. Frances eavesdrops on their lovemaking

That Cold Day in the Park: an over-the-brink Frances comforts her shocked and silent house guest.

then retrieves a knife from the kitchen, before entering the dark room and attacking the couple on the bed. The only words we hear are the boy's, frightened and confused. But there is a cry – of pain or ecstasy? – and when the boy manages to extricate himself from the entanglement and switch on the light we see what he sees: the prostitute's arm falling limp from an upraised, defensive position, the knife stuck into her ribcage and Frances on top of her. The whole confusion of the murder scene recalls the murder scene in the foxhole for 'The Long, Lost Life of Edward Smalley'.

The young man then runs to his room and puts on his clothes, but he cannot escape the apartment. When the now over-the-edge Frances discovers him in the hallway she attempts to assuage his fear by caressing him and telling him over and over that there is no need to be frightened; that she has told the girl to leave, because he did not want her. His silence is no longer a pose, but now the shock of reality. Frances kisses him on the lips repeatedly and tells him that she wants him to make love to her. As the camera moves in for a final close-up of the boy, the back of Frances's head blots out the scene. No more reflections are needed. The inner Frances has finally emerged.

PART TWO
THE ARTIST IN BLOOM

3 *M*A*S*H* and its Immediate Successors

HINDSIGHT POINTS TO *M*A*S*H* (1970) as being the make-or-break film of Altman's career. Had it failed artistically and commercially, especially the latter, he no doubt would have been consigned to the second or even third tier of directors by the industry powers. Perhaps Altman himself understood it in those terms since the script for *M*A*S*H* was a turn away from the direction in which he had moved with *That Cold Day in the Park*. He may have also understood it in more discreet terms since, according to industry lore, Altman was the fifteenth director to whom producer Ingo Preminger (Otto's brother) offered the script, though it must have been clear all along that *M*A*S*H* was not going to be the kind of gritty, realistic and patriotic war movie from which *Combat!* had taken its cue. By the end of the 1960s Altman had moved beyond that paradigm, and so had much of the country. In Altman's and screenwriter Ring Lardner Jr's hands, *M*A*S*H* was the opposite of those movies – would in fact parody them – and became a symbol for subversiveness. That the film was quite profitable made it all the more palatable to the studio big shots.

The success of *M*A*S*H* allowed the artistic Altman to flourish. It provided him with a cachet upon which he continually built so that even when, by the early 1980s, he had expended his good faith with studio bosses his artistic vision (not to mention his ego) remained intact. But Altman's time in the wilderness lay in the future. By 1969 (when he filmed *M*A*S*H*) various strands of anti-establishment fervour had been percolating within the United States for a number of years. Two of these, personified by Altman and Lardner, merged in *M*A*S*H*.

Lardner's contribution was the film's political strand, the roots of which go back to the nineteenth-century labour strife, the Palmer raids following

the First World War, the Great Depression and, more recent to the film, the Free Speech Movement and the ensuing student activism, the civil rights movement and, of course, the anti-war movement, of which *M***A***S***H* was a visual symbol even as it rode the crest of the movement's wave. Altman, far less political, represented the more youthful anarchic, anti-authoritarian strand that coalesced perfectly with the era's left-wing politics to produce a number of the decade's social upheavals, not to mention its attitude. The result of their collaboration was that *M***A***S***H*, while ostensibly a dark comedy about army doctors and nurses near the front lines of the Korean War, was interpreted by everyone as a condemnation of war in general and the unpopular Vietnam War in particular. But not to be overlooked is that the film, right from the opening scene, trumpets the era's anti-authoritarianism. Primarily it satirizes the hierarchical structure within the U.S. Army, but organized religion and the government come in for their share of lampooning as well.

Fortunately for the film, the overall artistic visions of the two men were in tune, because Lardner was the first of many screenwriters with whom Altman clashed during and after the making of a film. Altman actually downplayed Lardner's contribution to the final cut, even after Lardner had won the Academy Award for best adapted screenplay for *M***A***S***H*.[1] Towards the ends of their lives the two men seemed reconciled as to how much the other had contributed to the film; Lardner even praised Altman in his memoir, *I'd Hate Myself in the Morning* (2000).

The film opens with shots of wounded soldiers being airlifted to the 4077th MASH in helicopters (providing Altman with the opportunity to dust off latent skills from his *Whirlybirds* days) while the ironic theme song 'Suicide is Painless' is overdubbed. (The acronym MASH stands for Mobile Army Surgical Hospital.) As the song ends we are immediately treated to Altman's signature overlapping dialogue, between commanding officer Colonel Henry Blake (Roger Bowen) and Corporal Walter O'Reilly (Gary Burghoff). In fact O'Reilly is an expert at such dialogue, and it is his trademark (along with his keen sense of hearing, for which he has earned the nickname 'Radar'). The rotating helicopter blades can be heard also in the background. Because the dialogue resembles a vaudeville routine Altman manages to make the confusion of incoming wounded darkly funny.

The anti-authoritarian tone is introduced when we see a motor-pool sergeant (Jerry Jones) yelling at a captain, effectively ordering him to wait until his driver is ready to transport him in a jeep to the 4077th MASH, to which the captain good-naturedly accedes. The film's politics are further

driven home by the fact that the sergeant is African American and the captain – in fact it is Hawkeye Pierce – is white. Pierce (Donald Sutherland), waiting for his driver, is slouched against the jeep when another doctor, Captain Duke Forrest (Tom Skerritt), arrives, mistakes him for his driver and orders him to take him to the 4077th MASH where he, too, is stationed. (As a means of reinforcing the film's anarchic and anti-authoritarian tones, Pierce has removed his Captain's bars.) The accommodating Pierce accedes to this request and effectively steals the jeep. Their getaway is spotted by the grouchy sergeant and the ostensible driver, and the sergeant's attempts to sic the military police on them lead to a Keystone Kops-like sequence, the only bit of slapstick in the film. Thus the film's frame is set – the arrival of Duke and Hawkeye at the 4077th MASH; their departure will signal the film's end.

This is pretty close to the source material, *MASH: A Novel about Three Army Doctors* (1968) by the pseudonymous Richard Hooker. Like the novel, the film is episodic, but it devotes less attention to the gore, death and the doctors' stress. The action in the operating room being more powerful visually than written, there is no need to hammer that point home. Furthermore, in 1969, when *M*A*S*H* was filmed, such graphic scenes as the film employed were still groundbreaking – and unheard-of in a comedy.

One important point of divergence between film and book is in the character of Major Frank Burns (Robert Duvall). In the film the Burns character rises above the obviousness that hampers nearly all the other characterizations. The film version of Major Burns is actually an amalgam of two characters in the book: Major Burns, whose literary incarnation is an upper-middle-class snob, and Major Jonathan Hobson, who 'every Sunday preached in the Church of the Nazarene in a small mid-western town'.[2] In fact, the film incarnation of Burns strengthens the character, makes him human in his failure, hypocrisy and ultimate breakdown. None of the other characters in the film can match his multidimensionality. His adherence to army discipline makes him the true nonconformist at the 4077th MASH. The first indication of Burns's humanity comes with the scene in which he kneels at the side of his cot reciting the Lord's Prayer, after which Hawkeye and Duke tauntingly break into 'Onward, Christian Soldiers'. Others passing by their tent, and presumably familiar with Burns's religiosity, hear them, pick up the song and begin marching as proper Christian soldiers ready to do battle with evil, which was essentially how the Korean War (and the Vietnam War, for that matter) was presented to the American public. The close-up of Burns reveals a man under the great stress one would expect

an essentially friendless surgeon (until the arrival of the officious Major Margaret Houlihan, played by Sally Kellerman) to have experienced in a front-line hospital. While facing his cot Burns's eyes (and the camera) move towards the paraders outside the hut; the camera watches them move off and the last person we see is the base chaplain, who, proceeding in the opposite direction, is saluted by a perplexed supply sergeant. The camera then cuts back to the stressed-out visage of Major Burns, the butt of the joke. The scene satirizes both religion and patriotism in a few seconds.

The hypocritical Major Burns is intended to parody evangelical Christianity, but he is only half of the Christian coin presented herein; the other half is Father John Patrick Mulcahy (René Auberjonois), better known as Dago Red. Dago Red is the Roman Catholic chaplain, and his character marks another departure from the book. In his own sphere he is as ineffective as Frank Burns. The term 'dago red', of course, also refers to red wine, which would be consecrated during the Catholic Mass as the blood of Jesus Christ, an act not lost on Altman, with his Catholic upbringing. The film strives to show the ineffectiveness of religion at a military field hospital. The religiosity of Major Burns and Father Mulcahy is futile at the 4077th MASH because they are attempting to re-create the sacred in the most profane atmosphere humans can concoct – war.

Just a few miles from the front, the hospital personnel tend to the negative results of battle, the results of all that profanity. Most of these people have the education and training that would incline them away from belief in miracles. At the 4077th MASH it is science versus religion, and the contest is slanted in favour of the former. This makes the character of Major Burns in the film all the more intriguing. Notwithstanding his overt

*M*A*S*H*: the pious Frank Burns amid the impious Hawkeye Pierce and Duke Forrest.

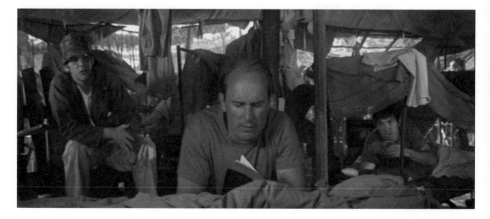

patriotism and adherence to army protocol, he is the embodiment of that divide between science and religion. That he suppresses it while the others exalt in it contributes to his own breakdown, but also points to his humanity – and, within the microcosm, his individuality.

Dago Red has no such problems because religion is his only sphere. He performs his expected role the way the doctors, nurses and enlisted personnel perform theirs. At times he steps outside his role, removes his collar so to speak, to offer minor assistance in the operating room. In one notable instance he is interrupted in his performance of the last rites over a dead soldier who has yet to be removed from the operating room (an act whose lateness marks the chaplain's futility) by Captain Duke Forrest, who asks him to hold a retractor while he operates. 'I'm sorry, Dago,' Duke says, 'but this man's still alive and that man's dead. And that's a fact.' That line is the film's centre, illuminating succinctly its humanistic philosophy. The scene ends with a close-up of Dago Red. At a glance it appears he is doing his best to fight back his squeamishness as he observes the surgery, but presumably he has observed many operations; this is an inner turmoil, not unlike Major Burns's, which Father Mulcahy overcomes because of the flexibility of his own predisposition.

The film's viewers are introduced to Dago Red in one of Altman's signature scenes, when Hawkeye and Duke arrive at the 4077th and proceed directly to the mess tent. What is conveyed to the audience in this scene is a cacophony (mostly unfettered dialogue) sprinkled with some drolly delivered humour. The dialogue, much like at a party or in any room with various groups of people, is sometimes hard to grasp – too many people are speaking at once. It is a technique by which Altman places the viewer inside the mess tent. At one point the camera focuses on Duke, Hawkeye and one of the nurses, who, engaged in conversation with a group of other nurses, purposely ignores Duke's come-ons. One's attention shifts back and forth between Duke's voice in the foreground and the nurses' discussion of a colleague's skin problems. Meanwhile, Colonel Blake and Corporal Radar O'Reilly enact another of their parallel dialogues as the commander meets his two new surgeons. The colonel then introduces the pair to others in the mess tent (including the chaplain) and pandemonium breaks out in a flurry of simultaneous introductions. It is impossible to understand all these introductions, and except for the chaplain's they are mostly mundane anyway. But the babble one hears makes them humorous and entirely natural.

Another bow towards naturalistic sound is the use of public-address announcements. These include news about operations, disclosure of missing

amphetamines, requests for various personnel to report to specific camp areas, all interspersed with American songs sung in Japanese. The announcements occasionally tell of some important news back in the United States (or news that would seem important in 1953 and ironic in 1970), but often simply relay to the MASH personnel which supposedly morale-boosting Second World War film will be playing that evening.[3] The joke of watching war films in a war zone is also a nice comment on reality versus illusion. The announcements' ironic humour and the humour of their delivery over the PA system by a disembodied male voice that sometimes stumbles over words, sometimes repeats itself, and sometimes can barely believe the announcement plays to great effect. Robert T. Self has listed other, more formal, functions of the public address announcements (actually the PA 'voice') in the film: 'to convey the larger presence of the camp compound beyond the visually truncated space delineated by the camera, to establish an effect of military-like realism, to provide a dramatic continuity across contiguous shots of discontiguous spaces'.[4]

In numerous interviews Altman declared that the PA announcements were the 'connective tissue' of the film, whose main purpose was to link scenes. In fact he was downplaying their role. Alhough it is a single voice we hear rather than a small group speaking in unison, the PA announcements in combination with simultaneous camerawork serve as a Greek chorus, or more precisely the *koryphaios* (chorus leader), delegated to link the film's episodic structure and comment upon the film and its subtext, American society.

Sometimes the announcements serve subtle, comic purposes, as when, during the initial mess tent scene, Colonel Blake, after declaring that he is the commanding officer and will get to the bottom of who the strangers are, walks over to where Hawkeye and Duke are sitting. The camera tracks his movement from right to left. As he walks, the announcement comes over the PA that Captain Murrhardt (Danny Goldman) must report to the commanding officer (but Murrhardt has been sitting with the colonel in the mess tent). Unlike most of the other announcements in the film, this one is muffled because of the ongoing dialogues within the mess tent, so the joke of the PA announcer's confusion is lost to the audience. At any rate, the announcer bungles the announcement, stumbling over the words 'commander' and 'commanding officer' as Blake makes his way down the tent, giving us a clue to the character of Blake himself. That he is going to see Hawkeye and Duke instead of the other way around, as the announcement points out is the protocol, is a hint at his malleable nature.

Camera movement almost always accompanies the public-address announcements sprinkled throughout the film. The second time an announcement is made there is a close-up of the public-address loudspeaker high up on a pole. The loudspeaker thus is the 'face' or mask of the *koryphaios*. The camera moves to the left a little as it follows Major Burns walking towards his tent and then moves towards the right, continuing to follow Burns as he enters the tent and proceeds towards his bunk. The camera movement during the announcements in fact mimics the strophe and antistrophe of a Greek chorus. Unlike the tracking of Colonel Blake during the previous announcement, the movement this time is as subtle (to the viewer) as the joke the announcement conveys concerning a venereal disease check-up for non-commissioned officers.[5]

Besides merging two of the novel's characters into the character of Major Frank Burns, another important change is the development of the character of Trapper John McIntyre (Elliott Gould), and it comes at the expense of Captain Duke Forrest. While the film retains Duke as one of the frame characters, it reduces his status to slightly below that of Hawkeye and Trapper John. To give two examples: in the novel it is Duke, not Trapper, who strikes Major Burns after Burns has blamed the death of a patient on Private Lorenzo Boone (Bud Cort); and it is Duke not Trapper who comes up with the idea of Painless Waldowski using the so-called black capsule as a method of suicide. While the novel is primarily about the exploits of three surgeons – Hawkeye, Duke and Trapper John – the film is more and more about the exploits of Trapper John and Hawkeye. They are the focal points of the zaniness at the 4077th MASH. There is much fraternity humour in the film, and the three surgeons frequently act like unreconstructed frat boys. But after the introduction of Trapper John, the film's episodic antics wheel more and more around the Trapper–Hawkeye duo. More so than in the novel, they are the film's Tom Sawyer and Huckleberry Finn. If the alliteration between their names and the two best-known boys in American literature was a coincidence, then it was indeed fortunate, but it is hard to believe that by foregrounding the duo Altman and Lardner were not purposely enhancing the subliminal effects.

Sex percolates to the surface throughout *M*A*S*H* and provides the film with its funniest moments. This is especially true when the film plays off the repressions and hypocrisies of majors Burns and Houlihan – the 'Hot Lips' episode in which their lovemaking is broadcast over the PA system being the apex of this. Among the many things this scene does (such as temporarily removing the *koryphaios* and uniting the audience with the camp members

in voyeurism), it confirms Major Houlihan's latent sexuality. Prior to that, Altman allows the audience a bit of Peeping Tomism in a scene that sets the stage for Burns and Houlihan's tryst. The camera zooms through a tent window as Major Houlihan types a letter with assistance from Major Burns, who sits across the desk from her. The letter is a complaint to their superior officers about camp morale under Colonel Blake. The two sign the letter and end up in a clinch that leaves Burns frustrated when Houlihan breaks away to mail the letter. Their tryst later that night and its revelation to the camp over the PA system leads to Major Burns's nervous breakdown and removal from the compound the next day.

The film downplays Duke's southern roots. In the novel his full name is Augustus Bedford Forrest, clearly a reference to Confederate general and Ku Klux Klan grand wizard Nathan Bedford Forrest. In neither the novel nor the film does the character show any inclination towards the KKK, but in both he must overcome his cultural background with regard to racial equality. When Hawkeye conceives of the plan to have Captain Oliver Harmon 'Spearchucker' Jones (the epithet a 'period' reverse signifier of his inclusiveness), a neurosurgeon and former professional football player, transferred to the 4077th MASH as a 'ringer' in the football game against the 325th Evacuation Hospital, Duke questions where the 'nigra officer' is going to bunk. When Hawkeye suggests their tent Duke reverts to type and complains that it is enough 'that I have to put up with you two Yankees'.

But Duke does outgrow the stereotype. And although it is part of the film's feel-good, buddy-buddy nature, on his departure at the film's end it is clear that he recognizes Spearchucker as a friend as much as he does his Yankee buddies. For Duke the journey matters as much as the destination, for not only does it elevate his spirit, but also as the character succeeds in transcending the stereotype he becomes more fully realized. Not even Trapper John and Hawkeye rise above the comic stereotypes, and in that they are indeed like Tom Sawyer and Huckleberry Finn in *The Adventures of Tom Sawyer*.

The Hot Lips episode aside, *M*A*S*H*'s three best-known scenes are Major Houlihan's 'shower', the Last Supper and the football game, which is the film's climax. The scene in which Major Houlihan, while taking a shower, is exposed to an eager audience is the film's single episode of nudity. The exposure is contrived to settle a $20 bet between Duke and Hawkeye as to whether she is a true blonde – Duke speculating she is not.

Thus, Major Houlihan reaches her nadir vis-à-vis her fellow officers as both the doctors and nurses (not to mention a selection of the enlisted men)

band together to cause her public humiliation. One of the shower tent's canvas walls is rigged so that when a rope is cut a sandbag drops and lifts the wall, revealing the major in the midst of washing her hair. The sixteen people comprising the audience include just about all the main and supporting characters, including Dago Red. When the naked and soapy major is exposed to cheers and applauding she flops to the shower floor and crawls backwards to the side (offstage, so to speak). The four nurses who were in the audience then get up to assist her, but wearing her robe and refusing any help a distraught Major Houlihan marches straight to Colonel Blake's tent and enters without permission. He is in bed drinking champagne with his mistress – one of Altman's silent/near silent characters – and it is here that Houlihan utters her most famous line: 'This is not a hospital, it is an insane asylum.'[6] She thereupon threatens to resign her commission if Colonel Blake does not take steps to rectify the problem. The colonel instead calls her bluff.

This is the final hazing of Major Houlihan. Thereafter her reputation undergoes a rehabilitation, and by the film's end she is fully accepted as 'one of the gang', even joining in to observe Painless Waldowski's poker game. Part of her rehabilitation also comes from the fact that she begins sleeping with Duke.[7]

The film's second well-known episode concerns the 'Last Supper' of camp dentist Walter 'the Painless Pole' Waldowski (John Schuck). Waldowski has already been described as 'the best-equipped dentist in the army', and very early we see voyeuristic soldiers (but, interestingly, no nurses) lined up to peek into the shower tent when he is inside. Thus, his nickname, 'Painless Pole', is actually a double entendre. Waldowski is a womanizer back in the United States, where he has three fiancées, but he has pretty much confined himself to poker in Korea. One night he hopes to break his self-enforced celibacy with a nurse who is passing through the 4077th MASH, but he suffers from impotence. His inability to perform sends him into a deep funk, and presumably guilt, since he confesses his non-indiscretion to the chaplain. Dago Red in turn seeks out Hawkeye to console and advise Painless. When Hawkeye arrives at Painless's dental clinic he surmises the seriousness of the dilemma because Painless has forgone the poker game and is instead lying on his cot in the closed-off back of the tent. The viewer recognizes the (comic) seriousness of the situation because in previous shots Painless has been seen playing poker but never practising dentistry. Painless is inconsolable. Hawkeye attempts to boost his ego by calling him the 'dental Don Juan of Detroit', but Painless declares that he has been reading up on 'Don Juanism' and that it is a cover-up for latent homosexuality and proceeds to argue his point with Hawkeye.[8]

The next scene has the surgeons, the anaesthesiologist and two of Painless's poker buddies discussing Painless's problem when the dentist enters the tent and announces that he plans to commit suicide; he has come to solicit suggestions on methodology. It is here that Trapper John proposes the 'black capsule', allowing that 'it worked for Hitler and Eva Braun.' This scene cuts to the Last Supper itself.[9]

*M*A*S*H*: the Last Supper, one of Altman's most iconic scenes.

The Last Supper is profane, satiric and quite elegant. It is all a scheme devised to trick Painless into believing he is committing suicide, but in Altman's hands it becomes a profound comment on religion, dogma and myth, and a homage to the great Leonardo painting. The scene opens with Hawkeye struggling to convince Dago Red that they are not engaging in an assisted suicide (suicide being a mortal sin under Roman Catholic law), but instead tricking Painless in the hope that he'll recover from his obsession. The camera then pulls back to a long shot of the open-air tent. On the extreme left is Dago Red in a kind of anteroom. Moving right from Dago Red, standing in the foreground, is a trio of nurses. The nurse in the middle plays 'Taps' on the violin, while the two flanking nurses stand solemnly with their hands crossed before them, completing the honour guard. The camera then moves to the right and inward to reveal the 'Last Supper' as composed by Robert Altman. As 'Taps' comes to an end, the various movements of the 'supper' participants for the briefest moment fall into a *tableau vivant* of the Leonardo painting. The six 'apostles' on each side of Painless Waldowski comprise officers, enlisted men and even Ho Jon, the Korean houseboy, who is seated on the far right in the composition.

The shot then cuts to a close-up of Dago Red, peering at them from the anteroom. In the novel, the so-called Last Supper of Painless Waldowski is

a sumptuous affair, but Altman, should anyone have any doubts about the nature of his parody, has pared this down to the traditional bread and wine – the loaves of bread are round and the wine is red.

Duke calls the dinner to order and reminds the others why they have gathered together. As he does so, two guests on the far left rise from the table and move to the back of the shot. Hawkeye then says a few words in Painless's honour, followed by Trapper, who invites Dago Red, representing formal religion, into the scene. (All the while the others are eating the bread and drinking the wine.) Up to this time the entire table and all thirteen participants in the supper have filled the screen, but with the chaplain's entrance the camera moves in and the scene is shot more tightly: only Duke, Dago Red, Painless, Hawkeye and Trapper can now be seen. From the standpoint of Altman's own Roman Catholic background, this is the most profane part of the most profane scene of the film. Dago Red silently approaches Painless and silently gives him Holy Communion. As he does so Trapper offers to Painless the suicide pill, the black capsule. Duke hands Painless a glass of wine (a symbol of the blood of Christ) with which to wash down the pill. Painless decides to lie down in the coffin, which is in front of the long supper table. As he gets up the two dinner guests who had earlier risen from the table begin a reprise of the film's theme song: one singing while the other strums a guitar in accompaniment. 'Suicide is Painless' now takes on a comic irony that was lacking when first heard over the titles and opening shots. (The lyrics that accompanied Johnny Mandel's music were written by Altman's fifteen-year-old son, Michael.) Inside the coffin, Painless removes the gum he has been chewing, sticks it on the side, takes the pill and a drink of wine, and then lies back, his hands properly folded in the attitude of a corpse. After Painless passes out, six masked pallbearers carry the coffin through the night to another tent.

Meanwhile Hawkeye, who had planned a tryst with Lieutenant Maria Schneider (Jo Ann Pflug), aka Lieutenant 'Dish' (the nurse whom Duke had tried to impress in the mess tent, and who is scheduled to return to the United States the next day), instead takes her to the sleeping Painless, effectively pimping her. That the tent Painless is in is bathed in soft red light adds to this effect. Lieutenant Dish baulks at first, but when Hawkeye leaves her alone with the unconscious dentist she cannot resist the opportunity to raise the sheet and see if there is any truth to the legend about him being the 'best-equipped dentist in the u.s. Army'.

The film then cuts to the next morning. Painless is bright and cheery, eating his breakfast as he greets Hawkeye, his woes forgotten. Lieutenant

Schneider sits in a helicopter waiting to depart the 4077th MASH. Her face bears a beatific expression, and as the helicopter lifts off she sighs, no doubt recalling her Magdalene-like role in the priapic resurrection of the Painless Pole.[10]

The third well-known scene is the football game at the film's end between a makeshift team from the 4077th MASH and the powerhouse team of the 325th Evacuation Hospital. The viewer can surmise that after nearly two hours this is probably the film's final extended episode, and the underdog MASH team will win the game and clean up on the bets. But that isn't really the point of the scene, for this is Altman's last chance at satire, and what he chooses to satirize is the clichéd metaphor of football as war and the comfortable myths that had grown up around professional football, which by the time *M*A*S*H* was filmed had overtaken baseball as America's most popular spectator sport.

The satire (and subversion) is embedded in the narrative, in the casting of professional football players, and in the visual shots of those non-actors. The first myth to be burst, even before the game begins, is that of fair play. Both teams use ringers: the 4077th ringer is, as mentioned above, former professional football player 'Spearchucker' Jones (Fred Williamson). During the game the MASH team injects their opponents' star running back with a drug that all but immobilizes him. The second myth, athletic heroism, is exploded by the use of actual professional players. This group included players who would be inducted eventually into the Football Hall of Fame following their retirements. Watching them engage in a comic football game on-screen – a routine that dates back at least to Harold Lloyd's *The Freshman* (1925) and the Marx Brothers' *Horse Feathers* seven years later – was funny enough to many (albeit mostly male) viewers. But Altman, as he would so often do throughout his career, turned the tables on audience expectations. The players act like buffoons throughout the scene, almost, but not quite, engaging in slapstick of their own. Towards the end of the game, when the outcome is still in doubt and afterwards when the MASH team has won, we see a few of these football heroes embracing the zeitgeist (not to mention the Altman ethos) and smoking marijuana on the team bench.

During the game some of the MASH nurses, led by Major Houlihan, serve as cheerleaders, suddenly personifying female ineptitude when attempting to inject themselves into a male fantasy world. (This is the opposite of their medical abilities.) The major, who apparently knows nothing about football, is berated throughout the game by Colonel Blake for her lack of

fundamental knowledge – she has, in fact, transformed herself into a ditzy blonde in order to fit in with the boys.

The three scenes described here engendered, perhaps, the most stinging criticism of the film. And with the passing years that criticism is just as valid, if not more so. This criticism came not from the political right but from the left, specifically from feminists who saw and were rankled by the obvious – the upholding of the patriarchal values underlying what is supposedly a radical, subversive film. In numerous interviews for years afterwards Altman provided a disingenuous answer: that is how males act in the military. But the problem is how the female characters act. For example, Colonel Blake's concubine, Lieutenant Leslie, is nearly silent throughout the film and seemingly always at his beck and call, even exceeding his expectations, as when he asks her to get his Korean batman to sew some missing buttons on to his shirt, and she replies that she would be happy to do it instead.

Hawkeye 'turning out' Lieutenant Maria Schneider is probably the film's worst violation of female probity, while the disintegration of the personality of Major Houlihan from an independent, strong-minded (albeit unsympathetic) military officer to a sycophant and a fool violates Altman's own naturalist aesthetic in favour of farce (and not very good farce at that). Instead of resigning her commission, as she threatens to do after her public humiliation, she does a 180-degree turn. At least one commentator has attributed her rehabilitation (her 'moral salvageability') to her competence as a nurse, as opposed to Frank Burns's incompetence, which consigned him to a nervous breakdown.[11] First, she sleeps with Duke (who, to his credit as a southern gentleman, later defends her to Hawkeye and Trapper as a lady). Then, after supposedly being opposed to football as an extracurricular activity, she organizes the nurses into a cheerleading squad for the big game. During that game her remarks on the sideline about the action on the field are inane, and she makes no protest when Colonel Blake chides her, calling her an idiot and a nincompoop. The humour of the delivery of these epithets and the silliness, especially, of the latter word match her own silliness, but they also serve to cover her character's disintegration. When next we see her back at the MASH compound, she silently sits in on one of Painless's poker games, the only woman at the game. And although it appears she is not playing cards, her excited look as the bets are made and the cards are revealed shows a woman who has entered a different life.

That different life includes love, or at least a crush. The final shot of Major Houlihan is in the operating room tent, where she is assisting Duke and Jones in delicate brain surgery. Hawkeye bursts in to announce to

*M*A*S*H*: Hawkeye Pierce, Hot-Lips Houlihan and Trapper John McIntyre at work.

Duke that the two of them have finally received their orders to return home. Duke momentarily daydreams about his return to his family (one of whom is played by Altman's young son Stephen), but the look on Major Houlihan's face, in another of the film's powerful close-ups, is one of anxiety and sadness. It echoes the close-up of the praying Major Burns at the film's beginning. She is the only one in the scene who does not speak, but for her, unlike Lieutenant Leslie, her silence has not ensured her happiness. (Her silence, and the reason for it, is a reversal of the young man's silence at the end of *That Cold Day in the Park*.) The glance she flashes Duke across the operating table is immediate, emotional and honest, so powerful that it halts Duke's reverie (in which Altman uses a flash-forward technique to show his homecoming) even as it momentarily lays bare her soul and returns her to a more fully realized persona.

The film ends with a light-hearted joke on the audience. As Duke and Hawkeye load up a jeep with their gear we hear one last camp announcement from the loudspeaker. But instead of informing the personnel which tired war film will be showing that evening, it reveals to the audience that 'Tonight's movie has been *M*A*S*H* . . .'. It then goes on to read the film's promotional material, and list its major players as scenes of them are repeated. In fact *M*A*S*H* is a 'war film', but unlike the roll call of films already alluded to, this dark comedy shows us what happened to many of the wounded who survived the battles.

Despite the passing of time, the various criticisms across the political spectrum and the overlong football scene, *M*A*S*H* remains funny. Other,

serious, films may more directly drive home the anti-war point, but none accrues and then conveys such an anti-authoritarian attitude. For a time *M*A*S*H* held the box-office record, and this bottom line, as well as the numerous Academy Award nominations that the film garnered, made Robert Altman the new darling of Hollywood. He took advantage of this status artistically and to nurture his own rebellions against the Hollywood establishment. Decades passed before another of his films, *The Player*, achieved the commercial success of *M*A*S*H*, but along the way he allowed his artistic vision to expand by challenging it and his own preconceptions. It may also be said that he took up the challenge posed by the feminist critique of *M*A*S*H*, for many of his subsequent films became noted for their powerfully realized female characters.

ROBERT ALTMAN LIKED to proclaim in interviews that *Brewster McCloud* (1970), the film he directed after *M*A*S*H* and the first from his own Lion's Gate company, was his favourite. It is an amalgam of classical mythology, commentary on race relations in the United States in the early 1970s, and homage to past films that includes a little of the genre twisting that he would later engage in more fully. That this is a more offbeat film than MGM's usual output is hinted at when the roaring Leo the Lion, which introduces all MGM pictures, 'forgets' his line. Within the film's structure are stylistic resemblances to *M*A*S*H*, the most important of which is the Lecturer (René Auberjonois).

The Lecturer is the *koryphaios* of *Brewster McCloud*, commenting and moving back and forth before the camera. He is a classroom lecturer on ornithology and the film's viewers are his auditors. He takes a different tone from that of the public-address announcer, whose announcements are ironic in and of themselves. The Lecturer presents straightforward ornithological facts interspersed with quotations. His pronouncements become ironic when coupled with the visual. The Lecturer's introductory remarks serve as a brief description of the film itself: 'Flight of birds, flight of man, man's similarity to birds, birds' similarity to man. These are the subjects at hand. We will deal with them for the next hour or so, and hope that we will draw no conclusions, elsewise the subject shall cease to fascinate us.' The Lecturer stands behind a desk when he recites this introduction. On the desk is a stuffed toucan; a live bird has descended upon the desk but falls off as he begins to speak. He then quotes Goethe on the poet's own desire to fly, adding, 'The desire to fly has been ever-present in the mind of man.' As the

scene ends, the Lecturer poses a rhetorical question that presumably the film will attempt to answer: 'We must isolate the dream [of man's flight]. Was the dream to attain the ability to fly, or was the dream the freedom that true flight seemed to offer man?' Here the scene changes to an aerial view of Houston, Texas. 'It may someday be necessary', the Lecturer continues, 'to build enormous environmental enclosures to protect both man and birds. But if so it is questionable whether man will allow birds in or out, as the case may be.' As these last two sentences are spoken the camera pans to a long shot of the Houston Astrodome, the world's first domed stadium, pairing language and image in a way *M***A***S***H* did not. At the time of *Brewster McCloud*'s release, the Astrodome was still considered an architectural marvel, having been titled the 'eighth wonder of the world'.[12]

The story that unfolds is all the Lecturer predicted and more. It is Robert Altman's initial foray into the detective genre, surreal though it is given the film's themes, and it is a bow to European cinema with its Fellini-esque ending. A series of unsolved killings in Houston have prompted a wealthy politician, Haskell Weeks (William Windom), to hire a detective from the San Francisco police department, named Frank Shaft (Michael Murphy). Shaft is a proto-metrosexual all-business detective who holds the Houston police and his employer in equal disdain. Nevertheless the killings continue after his arrival in Houston.

The first to be murdered is a racist woman who, as the film opens, and while the credits are shown on the screen, patronizes and berates an African American marching band that is rehearsing 'The Star-Spangled Banner' in the Astrodome. During her tirade the camera twice pans up to the Astrodome's latticework roof to show us the possibilities of the structure as a giant birdcage. Suddenly the film begins over again, including rolling the credits. In the midst of Daphne Heap's (Margaret Hamilton) second scolding the band rises up in revolt to accompany a recording of the song 'Lift Every Voice and Sing', which Brewster McCloud (Bud Cort) plays over the Astrodome public-address system.[13] This dual opening signifies two films, or at least two paths the film could take, and we are led down the subversive one. Brewster lives in a bomb shelter in the bowels of the Astrodome and is busy designing a pair of wings for himself. His mentor and protector, Louise (Sally Kellerman), has been watching the rehearsal. When she gets up to leave, the scene cuts back to Brewster's workshop, where a raven is perched. As the camera moves in on the bird so that it nearly fills the screen we are shown the final credit, that of Altman as director. In a nice bit of visual humour, not to mention editorializing, the raven

defecates on to the front page of the *Houston Chronicle*, landing on a headline paraphrasing an outrageous and ridiculous proposition by then-U.S. vice president Spiro T. Agnew: 'Agnew: Society Should Discard Some People: A Certain Number Won't Fit In.' The direct reference is to Brewster, but the film displays other candidates for the discard pile – as chosen by Brewster and Louise.

Among these are Daphne Heap and the elderly miser, Abraham Wright (Stacy Keach), the (fictional) youngest of the Wright Brothers. Brewster works as a chauffeur for Abraham. The wheelchair-bound Wright is reminiscent of the avaricious banker Henry F. Potter, the antagonist of the Frank Capra film *It's a Wonderful Life* (1946). If anything he is more avaricious and small-minded than Potter as he makes his rounds collecting payments from a string of convalescent homes that he owns. On the car's radio we hear of the death of Daphne Heap and the introduction of Detective Shaft into the case (another instance of Altman's use of media for plot exposition). But the announcer acknowledges that Shaft has been called in to help solve the 'trio of mysterious murders in Houston', indicating two murders prior to Daphne's and to the film's beginning. When the film finally gets around to revealing the death of Daphne Heap it is a tour de force scene of visual and verbal cross-cutting: Heap's death, the explanation of it by both Frank Shaft's Houston police force liaison, Officer Johnson (John Schuck), and a radio newscaster, all layered with more ornithological information by the Lecturer. Later, when Daphne's strangled body is found covered with bird excrement, she is wearing ruby-red slippers, a reference to Margaret Hamilton's most famous role as the Wicked Witch of the West in *The Wizard of Oz* (1939). Daphne's murder is unique in that she did not directly threaten Brewster, who is never seen committing the crimes. Abraham Wright, on the other hand, threatens to shoot Brewster, but is distracted when a bird, presumably Brewster's raven, which has been tracking him, defecates on his forehead. The next scene shows a dead Wright rolling down the street in his wheelchair, towards and past the camera, and crashing to a halt near Louise.

The myth the film references, and which the Lecturer pointedly avoids mentioning, is of course the ancient Greek tale of Daedalus and his son, Icarus. *Brewster McCloud*'s parallels to the myth are obvious. Brewster is a young man who dreams of flight while living in the labyrinthine bowels of the Astrodome. By the very fact of his youth he reflects the rash Icarus, but by his mechanical know-how in constructing the wings he plans to use he emulates Daedalus. His symbolic ambiguity, like the myth itself, is a counterpoint to the Lecturer's ornithological facts, but from a dramatic

point of view it keeps the audience wondering first if he will get off the ground and, second, if he will escape his own 'birdcage'.

The detective story strand of *Brewster McCloud* has several antecedents, including Arthur Conan Doyle's Sherlock Holmes stories and Dashiell Hammett's *The Maltese Falcon*. Here, though, the black bird is not a legendary statue but a living bird, a raven. Detective Shaft, a member of the San Francisco police department (San Francisco is the setting for *The Maltese Falcon*), is a freelancer in Houston. In the best Holmesian tradition he sees himself as cleverer than the local police, and also within that tradition he has a loyal sidekick, Officer Johnson, who assists in his investigation. Shaft is a modern detective, slightly ahead of the police in his methods, and nearly succeeds in solving the murders. In the end he is literally forced off the track by Louise (in a car chase that parodies *Bullitt*). Like Major Houlihan in *M*A*S*H*, he is a tightly wound character, his facial expressions constantly revealing tension. The temporary setback dealt him by Louise is tantamount in his mind to complete failure on his part to solve the crimes. While still in his car he pulls out his gun and commits suicide. Altman distances the viewer from this act of violence by showing the immobile car in long shot; Shaft is not even seen behind the wheel. Instead Altman provides sensory clues: the crack of the gunshot and, almost immediately thereafter, gun smoke streaming from the car window.

Louise is the first of Altman's enigmatic women. Some commentators have described her as an angel, but if she is, she is either a fallen angel or the angel of death. More likely, Louise is a birdwoman. The camera reveals that she once had wings, for we see the scars on her bare back. We also see her joyously bathing in a fountain while the voice of the Lecturer intones on bird-bathing habits. Although the murders are never shown on-screen, in another wonderful sequence of cross-cutting Brewster admits responsibility to his newfound girlfriend, Suzanne (Shelley Duvall). But Louise and the raven are present at each of the crime scenes, and it seems unlikely that the slightly built Brewster could have single-handedly strangled at least two of his antagonists. Besides Heap and Wright, the wife-abusing rogue narcotics detective, Breen (Bert Remsen), and the original owner of Suzanne's car are also murdered. Both had physically threatened Brewster.

In the scene in which Brewster admits his culpability in the serial murders, the cross-cutting moves back and forth in space and time between tight close-ups of Suzanne and Brewster in bed following sex and Brewster's workshop/living area beneath the Astrodome, where Louise awaits his arrival. Dialogue is used to segue back and forth between the two scenes.

The shots of the three characters are indicative of their relationship to one another, or rather Brewster's changing relationships with the two women. Louise has warned Brewster against falling in love and having sex, arguing that it will keep him wedded to the earth and eventually kill him. In fact, until he meets Suzanne, Brewster has remained celibate, even ignoring the attentions of Hope (Jennifer Salt), a young woman who brings him food and who, herself, becomes so sexually excited while watching Brewster working out to build his upper-body strength that she masturbates underneath a blanket. Louise, Suzanne and Hope constitute Altman's first real female triumvirate, a trope that he would use often, even after exploring it in depth in *3 Women*.

The pivotal sequence of Brewster and Louise's dialogue in the workroom is composed of competing close-up shots with the two separated by a space of ten or fifteen feet. The sequence is actually framed with shots of Brewster and Suzanne lying in each other's arms in bed. Suzanne guesses that it had been Brewster's first sexual experience. She then vows to protect him, essentially replacing Louise (about whom she knows nothing). The frame is composed of tight head shots, actually beginning with an extreme close-up of Brewster's left eye. But when Suzanne realizes that Brewster is serious about his wings and flying, she suddenly begins thinking aloud, less like the naïf she has appeared to be and more like a practical woman, claiming that he could become a millionaire from his invention and that he needs to get a lawyer. The tight close-up of Suzanne that fills the screen is now upside down. As the bedroom scene reverts to a medium shot of the two lovers, things seem to normalize between them, but another close-up reveals Brewster's trepidation about Suzanne's big plans for the two of them. After the love-struck Brewster reveals his responsibility for the recent string of deaths, the camera quickly zooms in on a terrified Suzanne's right eye. These close-ups have a meta-filmic function. They reveal to the viewer that things are not what they appear to be and expose the characters' dawning realization of this. When the scene returns to a shot of Suzanne it again focuses on her eye, but then cuts to another upside-down head shot. Her voice has changed; she is scared.

Louise (in the intercutting) guesses that Brewster has not only slept with Suzanne but also spilled the beans concerning his flying enterprise. She predicts to Brewster that Suzanne will be 'the death of you'. Although the meeting between Brewster and Louise occurs chronologically after Brewster and Suzanne's bedroom dialogue, the cutting is such that we see Louise's prediction after we see Brewster's revelation but before we hear how

frightened Suzanne is. After Brewster leaves her apartment, Suzanne calls her ex-boyfriend, Bernard (William Baldwin), who is Haskell Weeks's assistant. She reveals Brewster's admissions to Bernard. Just prior to that Brewster professes his love to Suzanne, and the scene jumps forward to the workshop, where the camera zooms in on Louise, who utters what can only be described as agonized bird cries. Then she and Brewster turn away from each other. Louise leaves holding the raven on her arm in the attitude of a falconer.

With Louise gone from his life, Brewster's doom is a foregone conclusion. He prepares the wings to fly and awaits Suzanne's arrival at the Astrodome; and in fact she does arrive in the company of Bernard, Weeks and Weeks's chauffeur. Haskell Weeks, with his eye on the positive political ramifications that would ensue should he capture Brewster, enters the Astrodome alone. Suzanne and Bernard begin to make love in the back of the limousine, which the chauffeur has conveniently exited, as the Lecturer, now metamorphosed into a birdman, expounds on the mating habits of certain bird species. But Bernard has second thoughts, and they search for Weeks. When Suzanne and Bernard stumble upon Weeks's body covered in bird excrement (the excrement is a clue in all the serial murders), they call the police.

Moments later, Brewster comes upon Suzanne and Bernard kissing (in her fright she has asked him to kiss her). On seeing Brewster, Suzanne runs away, and the film cuts to a long shot of Louise and the raven exiting the Astrodome into the bright light of the outdoors. Brewster is now alone in his birdcage.

The police arrive just as Brewster enters the upper seating level of the stadium carrying his wings. He quickly dons them and propels himself into flight. And fly he does. Pumping both his arms and his legs, Brewster soars into the upper reaches of the Astrodome; the police give chase but they cannot catch him, even when he swoops low. He circles the Astrodome a number of times, his flight a beautiful thing to watch. But it cannot last. We soon hear the voice of the Lecturer giving a poetic and brief description of bird flight, concluding that evolution has made it possible. And so we see Brewster beginning to tire, then strain to keep his wings beating. He lets out birdlike cries as the effort of staying aloft becomes too much. He plummets earthwards and crashes to his death on the home plate of the baseball field. Brewster has not flown too close to the sun, but it was hubris nevertheless that caused his demise. He died because he thought he could fly without Louise to teach him how it was done, especially how to glide to conserve energy and how to land.

Brewster McCloud:
Brewster briefly
enjoys the freedom
of flight.

Just as in *M*A*S*H*, close-ups in *Brewster McCloud* are used effectively to reveal characters' thoughts and feelings, their expressions (or sometimes lack of them) serving as silent soliloquies. If anything, Altman held the close-ups even longer in *Brewster McCloud*, slowing the film's tempo. Furthermore, his mixing of seasoned professionals with newcomers and non-professionals (as he did in *M*A*S*H*), giving more emphasis to the newcomers' roles – particularly that of Shelley Duvall, who played Suzanne – gave a tilt to the film that was different: slightly unpolished, a *vérité* counterpoint to the surreal act of flying. But with the film's Fellini-esque coda (recalling *8½*), Altman not only one-upped his ending for *M*A*S*H* but also revealed the direction in which his sensibility lay.

As Brewster, mangled wings and all, lies dead at home plate, the camera moves upwards, and we suddenly see a crowd of people in the stands who were not there during Brewster's flight and the police chase. The crowd applauds and we hear circus music and, indeed, a circus parades on to the baseball field – clowns, jugglers and so on, including the marching band that opened the film. But then the camera trains its eye (and ours) on the ringmaster, the actor who played Haskell Weeks. The ringmaster announces, 'Ladies and gentlemen, The Greatest Show on Earth proudly presents the cast of *Brewster McCloud*.' As he introduces the film's main players, most are now circus performers. Last to be introduced is Brewster McCloud, dead at home plate.

WITH *MCCABE & MRS MILLER* (1971), Robert Altman began his genre-bending in earnest.[14] As it turned out, Altman and the actor Warren Beatty had opposing approaches to filmmaking, which caused the inevitable clash of egos. Beatty's style was deliberate while Altman was far more willing to let serendipity take over. Fortunately their problems, some of which have probably been amplified over time because they involved Robert Altman, did not hinder what turned out to be an underappreciated work of art when it was released.

The film (based on the novel *McCabe*, by Edmund Naughton) is set in the mining town of Presbyterian Church in the first years of the twentieth century. Together the setting and time period manifest early the underlying technique used to pull off the film's conceit that the American frontier West, and by extension the western hero, was something different from that usually presented by Hollywood. Altman's aim with *McCabe & Mrs Miller* (as with nearly all his work) was to emphasize mood and character-ization over plot, to create a type of western protagonist who is not exactly an anti-hero (not that Altman was the first to do either of these) and, like a magician, to invest his film with tricks of misdirection, of which the set-ting is the first example but the character of John McCabe (Beatty) the most prominent. The film's look, conveying the tones of early photography and a sense of moody otherness that complements the title characters and their relationship, was achieved using fog filters and re-exposing the negative, a technique known as flashing.

The film opens with a solitary man, whom we soon discover is McCabe, riding a horse through a rainstorm with a packhorse in tow, as Leonard Cohen's mournful 'The Stranger Song' is heard on the soundtrack. McCabe arrives at Presbyterian Church, probably his destination. The town's most prominent architectural feature is the tall church spire still under construc-tion, and it is in the spire's shadow that McCabe dismounts, removes his heavy fur coat and dons his derby hat – in essence assuming a different persona with the costume change. (He does the same thing when he rides into the nearby larger town of Bear Paw to purchase 'chippies' – prostitutes – for his brothel in Presbyterian Church.)

Presbyterian Church is bleak; its appearance has nothing in common with the western towns normally presented by Hollywood.[15] It is a mining town but we never see any of the men go off to prospect, nor do they talk about mining, or even appear to own any mining gear. However, like many western boomtowns of the late nineteenth and early twentieth centuries, it does have a Chinese population, sequestered in its own quarter. Altman

used a number of techniques to sustain the starkness of the setting and an alternating mood of bleakness and hopefulness among the townspeople. First, carpenters built the town's buildings as the film progressed so the viewer catches glimpses of the overall growth and not just McCabe's brothel and saloon. In fact, as McCabe returns from Bear Paw with his prostitutes we see a man with a cross on his back climbing up the side of the church steeple and fitting it into a hole at the top. The symbolism of this juxtaposition is clarified only at the film's end. Also, as noted in the Introduction, Altman had the actors choose their own wardrobes from assorted costumes, and make any necessary repairs and alterations. The cast also lived and slept on the set in the various buildings as they were being constructed.

McCabe has come to town to make money from the boom. He is a businessman, which in that time and place means gambler, saloon keeper and brothel owner. His charm is such that he beguiles everyone (or nearly everyone) in town, including Patrick Sheehan (René Auberjonois), the man who owns the town's original saloon. McCabe quickly settles into Sheehan's saloon and as he deals the first hand of poker (after briefly quarrelling with Sheehan over the cost of whisky and the splitting of the game's profits or losses), the camera zooms in on the gold tooth in the side of his smile as he places a cigar in his mouth. McCabe is a hustler.

But Sheehan recognizes McCabe as the name of the man who shot Bill Roundtree. In an easy-going dialogue with Sheehan in close-up profile and McCabe in three-quarter shot, the newcomer deftly deflects the saloon keeper's query as to whether he is 'Pudgy McCabe, gunfighter'. McCabe shoots Sheehan a look. 'Businessman, businessman', he replies, and on visual evidence alone the viewer is inclined to give him the benefit of the doubt. When

McCabe & Mrs Miller: modernity and Mrs Miller arrive in Presbyterian Church.

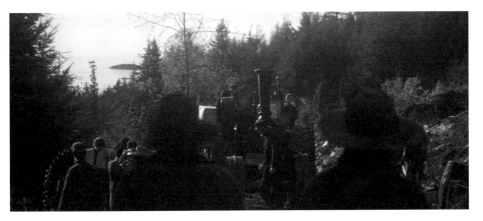

Sheehan persists, McCabe makes a vulgar joke at his expense, at which Sheehan smiles sheepishly. Finally one of the other players – and recall that this is in Sheehan's own saloon – politely asks him to quit bothering McCabe so he and the rest can play poker. McCabe presents himself as a hardnosed businessman and Sheehan, seeing the writing on the wall, later suggests they go into partnership. The offer is refused, but McCabe's charisma is such that he and Sheehan remain on relatively friendly terms.

Eventually McCabe does take on a business partner – the wily Mrs Miller (first glimpsed in Bear Paw when McCabe went there to buy prostitutes), who, in her cockney accent, points out to McCabe her superior knowledge of the art of running a brothel. (The accent also signifies her 'street smarts'.) In its way this dialogue is a bow to the snappy Hollywood comedies of the 1930s and '40s, and from it the viewer can ascertain that love will blossom in their relationship. But of course in an Altman film this 'love' will not have the usual trappings and will be more complex, more in tune with the characters' personalities. Even regarding McCabe, love for Mrs Miller (Julie Christie) comes at a price – five dollars. McCabe's coming to her with flowers, the playful look in Mrs Miller's eyes as she lies in bed, and Altman's zoom of the wooden jewellery box where McCabe stuffs five one-dollar bills (Mrs Miller usually keeps the takings in a heart-shaped box lined with gold satin) leave the viewer in no doubt about the irony, as critics have noted. Mrs Miller indeed lives up to her potential as a madam and transforms that part of McCabe's small-town business empire, which up to then had been run out of three tents, into what is probably the most prosperous business in town. It is with McCabe and Mrs Miller that the struggle between the sacred and the profane takes hold in the town. Prior to their arrivals those two aspects of human existence coexisted peacefully, as evidenced by the construction of the church and the saloon keeper, Pat Sheehan, devoutly praying before a statute of the Virgin Mary. After McCabe and Mrs Miller get their toeholds in the community their saloon and brothel are constructed while the church remains unfinished. The profane (economic) influence expands in other ways. A barber and his wife set up shop and home at the same time that Mrs Miller imports three prostitutes to replace the women who had been working for McCabe. That the barber and his wife are African Americans broadens the town's inclusiveness. It is the barber, Sumner Washington (Rodney Gage), who briefly speaks for them both, introducing himself and his wife to Mrs Miller. Mrs Washington (Lili Francks) is a conspicuously silent figure, as her husband will henceforth be. Their acceptance is a symbol of progress, which in these circumstances means 'civilization', which means prosperity – especially for

McCabe & Mrs Miller: Mrs Miller, about to discuss business with McCabe.

McCabe and Mrs Miller. Yet the Washingtons are never fully members of the town, as they are separated by their skin colour and their sense of dignity.

But civilization, as we know, is not the same as civilized, and one night some drunken townsmen proposition a woman, Ida (Shelley Duvall), thinking her one of Mrs Miller's whores. The mistake has arisen because she had arrived in town with Mrs Miller – by way of a steam-powered vehicle that signals the imposition of modernity on Presbyterian Church – but she is actually the mail-order wife of one of the early townsmen who had come out alone to stake a claim. When he steps out on to the street to defend her honour they beat him to death. (It is the carved headstone at his funeral that identifies the year as 1902.) Ironically, Ida, left with no means to support herself, becomes one of Mrs Miller's prostitutes. Mrs Miller, in convincing Ida to work for her, supplies a different cliché about sex: 'It weren't your duty Ida. [They are discussing the difference, or lack thereof, between Ida having sex with her husband in a legal marriage and having sex with various men in the brothel.] You did it to pay for yer room and board. And you do this to pay for yer bed and board, too. Only you get to keep a little extra for yerself, and you don't 'ave to ask nobody for nothin'.' Mrs Miller decks out the younger woman in the standard-issue white muslin nightgown, which she herself wears. Mrs Miller, in fact, is the first of Altman's 'women in white' – psychologically or emotionally flawed women who usually experience catharsis or epiphany (sometimes in the form of death) or are the agents of it. Mrs Miller's flaw is her opium addiction.

Civilization intrudes upon the not-so-idyllic frontier town in another way when two agents from the Harrison Shaughnessy Mining Company seek out McCabe and offer to purchase all his holdings – an obvious but nevertheless spot-on comment on the plight of the individual versus the

mighty corporation in the Old West and America in general in the era before globalization. The drunken McCabe refuses their initial offer as well as their second one, countering with an outrageous price of his own. Mrs Miller, wiser in these matters than McCabe, urges him to accept the offer or else the company will have him killed. But McCabe contends that the company agents are playing into his strategy. Instead they leave town. Given Mrs Miller's premonition concerning the company's hardball way of doing business there is little doubt what the company's next move will be.

Eventually three gunmen arrive claiming they are bear hunters. However, their ominous presence marks them as an inverse male trio from the $M^*A^*S^*H$ surgeons. That is, their purpose is to take life, not preserve it. Mrs Miller again tries to warn McCabe, but foolish pride gets the better of him and he refuses to take heed. He goes to Sheehan's saloon to try and mollify them, but is thoroughly humiliated before Sheehan and a number of other townsmen by the Englishman Butler (Hugh Millais), the leader of the deadly trio. Sheehan has advised Butler that McCabe is the man who shot Bill Roundtree in a poker game. When Butler confronts McCabe with this accusation, bluffing that Roundtree was 'a friend of a friend', McCabe feebly talks his way around the accusation, though he does admit that he was called 'Pudgy' and was at the poker game. This brings on a direct threat from Butler, and McCabe leaves, trying to salvage his dignity by claiming that he is unarmed. Butler then questions Sheehan about the truth of the story that McCabe had shot Bill Roundtree, and the latter says it was with a derringer. Butler then states his opinion that McCabe 'never killed anybody'.

Butler is a big man made even larger by the fur coat he wears, the cramped area in which the scene takes place and the air of menace he exudes. McCabe, too, has donned his heavy fur coat to cross the rickety bridge from his saloon to Sheehan's, but when he enters Sheehan's saloon he immediately removes it, becoming once again the recognizable frontier businessman. However, McCabe's humiliation is so complete in this scene that he is even threatened by the youngest of the gunmen (Manfred Schulz), a Billy the Kid type who, under Butler's spell, unleashes his own violence, shooting dead an itinerant cowboy.

Following a futile last-ditch effort at consulting a politicking lawyer in Bear Paw (the lawyer's name, Clement Samuels, is an inversion of Mark Twain's real name, Samuel T. Clemens), McCabe chooses to stay and fight rather than decamp. He awakes one morning in Mrs Miller's bed to find her gone and the town hunkered down in the middle of a blizzard. The eerie silence and the continuously falling snow – no 'flashing' was used, so the

scene is stark in its whiteness – set the scene for a gunfight that is both chilling in the build-up of its terror and hauntingly beautiful in its choreography throughout the town. What Altman delivered was the final touch in his naturalistic western. This is not gunfighters facing off in a dusty (or in this case snowy) street in the middle of town, but a hunt that ranges in and out of buildings, including the still unfinished church. It is a battle of wits as much as firepower, where hunter and hunted continually change places as the scene progresses. It is a long scene, and Altman uses each moment to further the action to its logical conclusion, make defining comments on the film's symbolism, and determine once and for all who McCabe really is. Additionally, Altman used various zooms to quickly close space, forcing the viewer off balance and into a zone of discomfort that approximates that of the protagonist.

All four men die in the gun battle in which the three hired killers stalk McCabe through the town. Altman reinforces the trio's ominous undertaking by a fast zoom from an extreme long shot of them moving through the town at dawn to a long shot of them (thus distancing the viewer) as they pause to get their bearings. The film then cuts to a medium shot of McCabe waking up in Mrs Miller's bed and realizing he is alone. A fifth man, the town minister (Corey Fischer), is severely wounded in the arm after relieving McCabe of his shotgun (McCabe had desecrated the 'House of God' by carrying it inside), and ordering him off the premises – thereby playing his part in McCabe's temporal destiny. While carrying the shotgun he is mistaken for McCabe, by Butler, who shoots him. The last to die is McCabe, who has suffered gunshot wounds in the leg, stomach and back. He staggers through the blizzard but collapses in the snow. Before he dies, though, he manages to kill Butler's associates by shooting each in the back and Butler with a dead-on shot to the forehead – delivered by a concealed derringer. During McCabe's final gun battle and last moments the townspeople (including the prostitutes) are engaged with saving the church, which has caught fire. The hastily convened fire brigade is more or less led by Pat Sheehan, Presbyterian Church's first entrepreneur, who rises above his toadying ways. Mrs Miller has not joined them, and in the film's final shot Altman has again turned the viewer into a voyeur (having already done this with earlier shots of the brothel women). She is spied through the open doorway of an opium den in the Chinese section of town, nodding off to the actuality of the gun battle, which she had foreseen.

When it was released *McCabe & Mrs Miller* took some deserved criticism for the inferior sound quality of the prints, which hampered the film's

McCabe & Mrs Miller: a dying McCabe struggles in the blizzard.

overlapping dialogue and McCabe's mumbled soliloquies, the comic aspect of his personality. He was, the viewer discovers at the end, both gunfighter and businessman, a man in over his head, and a charmer who is himself charmed by the fatalistic Mrs Miller. McCabe falls in love with her because he has a touch of the poet about him. Mrs Miller responds in her own manner so that the love-story aspect of the film is always played down (except in a couple of funny scenes); she is the madam/prostitute first, lover second. Unlike McCabe, she has no illusions about herself or McCabe, or about men, women and women's survival in a patriarchal society, be it a quasi-frontier town like Presbyterian Church, the big eastern cities or her native England. Yet because she is free of such societal illusions she must bury herself within the delusions of opium. The final shot is an extreme close-up of Mrs Miller's eye as she nods in her opium dream. As the camera zooms in on her glazed-over pupil the shot takes on recognizable drug overtones. It also illustrates the film theorist Christian Metz's observation that 'the fragment [in this case Mrs Miller's eye] is occasionally unrecognizable.'[16] Unrecognizability was not the case with the close-ups of Brewster's and Suzanne's eyes in *Brewster McCloud*, but then Altman and his cinematographers Jordan Cronenweth and Lamar Boren had to concern themselves with plot revelations. Since the extreme close-up is the very last shot of *McCabe & Mrs Miller*, Altman and cinematographer Vilmos Zsigmond enjoyed the freedom of an intense visual.

While the film is not without its antecedents – *Shane*, *The Man from Laramie*, *Will Penny* and *Butch Cassidy and the Sundance Kid* come to mind for various reasons – *McCabe & Mrs Miller* is strikingly original in the way it weaves setting, mood and individual characterizations to comment on

and play down the myths of the American West – an area, Robert Altman seems to be telling us, settled not by demigods, but by sometimes lonely, sometimes greedy people who for a time fashioned an imperfect paradise for themselves (as humans will) before the big machine overshadowed the landscape. Set in 1902, *McCabe & Mrs Miller* takes place nine years after Frederick Jackson Turner famously pronounced the end of the American frontier, although the denizens of Presbyterian Church had probably not got the message. Nevertheless, it shares a historical space with *Butch Cassidy and the Sundance Kid* (1969) and *The Grey Fox* (1982), that era when hold-out sections of the American West were succumbing to the United States' political and economic manifest destiny. In *McCabe* we see the consequences of that changeover.

IN THE 1970S Robert Altman directed some of the most interestingly weird films of any American director. In 1972 he followed *McCabe & Mrs Miller* with *Images*, a film that seemed to mine the same creative vein from which *That Cold Day in the Park* sprang and which *3 Women* (and *Quintet*) would follow. *Images* was also the first feature film Altman had directed since *The Delinquents* in which the story idea originated with him. And, like *3 Women*, it appears to have been influenced by Ingmar Bergman's *Persona* (1966). It is a psychological thriller in which Altman applied various cinematic techniques to advance a mental disorder – schizophrenia – as a narrative method. And while it is not exactly a homage to *Psycho* – Altman is on record as saying that he did not like Hitchcock's straightforward narrative style – it nevertheless borrows some salient features of that film, including a shower scene that Altman places at the very end to denote the futility of the protagonist's attempt to escape from her own doppelgänger.

The plot centres on a schizophrenic woman, Cathryn, who, overcome with guilt, hallucinates former lovers, dead and living, with whom she carries on numerous conversations. Cathryn also suffers from a multiple person-ality disorder, and this too is visually interpreted on the screen. Interestingly, Altman appears to have named the characters after he had cast the actors who would play them, mixing and matching the names of the actors with the characters as further mirror images of one another. Cathryn is played by Susannah York; her husband, Hugh, played by René Auberjonois; her dead lover, René, played by Marcel Bozzuffi; her living ex-lover, Marcel, played by Hugh Millais; and Marcel's daughter, Susannah, played by Cathryn Harrison. Here again is an example of Altman manipulating the cast to

create a mood that he hoped to translate to the screen. This time, however, it worked to less consequence than with *McCabe & Mrs Miller*.

Altman also used three recurring motifs in this film: mirrors, dangling objects and unicorns. The danglers are symbolic of the dangerous reality of Cathryn's emotional state, and their appearance on screen often portends a breakdown episode for her. The film opens with a shot of wind chimes hanging from the bent branch of a tree whose leaves have turned blood-red. The camera then moves to peer through the window of the extremely high-ceilinged room where Cathryn sits typing her unicorn story. But the most startling features are the enormous chandeliers hanging from the ceiling. The unicorns, pictured on a book cover, in a jigsaw puzzle worked on by Cathryn and Susannah and in a tale that Cathryn recites in a voiceover (she is a children's author), are obvious markers of the intrusion of fantasy into her present existence. But mirrors are the central image of this film, and they are everywhere – huge ones, small ones, even rear-view mirrors in cars, from which hang tiny danglers. They serve to relay the effects of Cathryn's schizo-phrenia and foreshadow the outcome of her mental instability. The confusion they create draws the viewer into Cathryn's state of mind.

While visual manifestations of her illness are the primary symptoms, auditory hallucinations are also present – in fact primary in the opening sequence after the titles have run. The first sound heard is the ringing of a telephone. Are the telephone calls that Cathryn receives, some of which hint at her husband's infidelity, real or imaginary, we soon wonder. (And, thus, is the infidelity real or imaginary?) Actually they are a mixture: Cathryn's hallucinations weave in and out of reality and are at times nearly as discon-certing to the viewer as they are to Cathryn. The disturbing telephone calls follow Cathryn as she moves about the house in her white nightgown – she and her husband have almost as many telephones in that pre-mobile-phone era as they do mirrors – so that the telephone becomes for her an instrument of torture, part of her own mental inquisition. In one call Cathryn's husband, Hugh, has telephoned to say he is working late – the old cliché of infidelity – but a woman cuts into the call (she has already cut into a previous call) to tell Cathryn that Hugh is with another woman, even giving the address. It is only later that one can link Cathryn's guilt over her own infidelity with these calls. There is no backstory to Cathryn's illness other than guilt, and Hugh appears clueless not only to her apprehensions but to her mental ill-ness. His obliviousness is strange in light of the prominence with which the hallucinations play on the screen and therefore in Cathryn's mind and the viewer's visual field.

Images:
Cathryn's split
images make up
two-thirds of a
triptych with her
young alter ego,
Susannah.

The mirrors are so dominant in this intial scene that they are aesthetically vulgar. We first spy two huge advertisement mirrors in adjacent rooms – one horizontal, one vertical, both of them hung on walls above tables laden with books, stationery and writing instruments, and each table with a telephone on it. (Although they have no symbolic bearing on the story, there is also a chalice, some rosary beads and a cross in the apartment.) We next see that the sliding doors to the bathroom are two mirrors, and when Cathryn opens them to retrieve a nail file we can spot another, full-length mirror in the bathroom. It is this mirror that initially displays the dance of images of two of the men in Cathryn's mind.

Hugh returns to find all the telephones disconnected and Cathryn lying in bed. Soon after he has replaced them on their hooks, the one in the bathroom rings, but it is a friend of Cathryn who had spoken to her earlier in the evening and had been trying subsequently to reach her again. Cathryn and Hugh argue briefly about the phone calls and they end their little squabble with a kiss. But when Cathryn pulls back from the kiss she (and we) see that it is not Hugh she has been kissing but a strange man, the sight of whom causes her to run into the bathroom shrieking in fright. We later discover that this man is René, her dead lover. As Cathryn enters the bathroom she closes the sliding mirrored doors but the man (René), his image reflected in these doors, forces them open seemingly in concern for her. As Cathryn races across the bathroom, the camera cuts to him standing in the doorway. But then it cuts back to a hysterical Cathryn as she collapses to the bathroom floor. It then pans upwards to the full-length mirror and it is Hugh's reflection we see standing in the doorway. The scene plays out as one might

expect: a startled and bewildered Hugh trying to comfort his distraught wife and make sense of what is going on.

Up to that point the film has led the audience to believe they are watching either a melodrama or a conventional thriller or some combination of the two. But with the Hugh/René doubling Altman sends the film into an area of weird discomfort for the viewer. In many ways *Images* wanders the existential terrain previously trodden in Fyodor Dostoevsky's story *The Double* (*Dvoinik*) and William Faulkner's novel *The Sound and the Fury*. Like Dostoevsky's protagonist, Golyadkin, Cathryn will experience the trauma of seeing herself – her image – split from her idea of herself (the 'I' that has been walking around as Cathryn). And like Golyadkin she will suffer the pain of wanting to end this trauma. With regard to *The Sound and the Fury*, which is told from four points of view, Cathryn's disjunction parallels that of Benjy. As Faulkner scholar Cleanth Brooks observed, 'Benjy's section is filled with a kind of primitive poetry, a poetry of the senses, rendered with great immediacy, in which the world – for Benjy a kind of confused, blooming buzz – registers with great sensory impact but with minimal intelligibility.'[17] The notions of confusion, sensory impact and minimal intelligibility certainly come into play in *Images*. But it is dangerous to push any comparisons between Altman's Cathryn and Faulkner's Benjy further, for their problems are very different: hers is schizophrenia, his congenital idiocy. Cathryn has more in common with the other narrators of the novel and Faulkner's characters in general, who are stuck in a past that they, of course, cannot alter, as Sartre has pointed out.[18] Cathryn's illness manifests her past, and her attempts to overcome her hallucinations (and thereby render them helpless) will prove futile. Brooks also noted that 'readers [of *The Sound and the Fury*] were shocked at what seemed an almost willful obscurity', referring to Benjy's opening narrative (a tale told by an idiot).[19] That description is not too different from the critical and popular reactions to *Images* and Altman's other idiosyncratic films.

Cathryn and Hugh decide to spend time in their country house. Here the change of scene is marked by a trademark Altman sound transition: we hear the jangling of a dangler before seeing it hanging from the rear-view mirror of the car as they drive to their isolated house. The camera angle is such that we see a sleeping Cathryn in the rear-view mirror, which is framed by a blue Irish sky. For it is indeed in Ireland that this film is set. Just before they arrive at their house the film takes its weirdest turn. With the car on top of a hill, Hugh pulls over and decides to hunt quail. He suggests that Cathryn proceed to the house – which is down below within sight – ahead of him.

After getting out of the car to view the landscape into which Hugh is heading, Cathryn glances down at the house and sees an identical car drive up. She looks back and sees their car still parked where it was left. She looks again towards the house just as the car pulls to a stop and then watches herself emerge from it. The film's point of view then becomes that of Cathryn down below, who emerges from the house to retrieve suitcases and sees her alter ego standing above. Which of these two is the real woman? From here on the film's point of view reflects that of the Cathryn who has arrived at the house.

Soon another former lover, Marcel, arrives with his daughter Susannah, who could pass for a younger version of Cathryn. Altman is not shy about hinting this. In one scene, Cathryn, while sitting on her bed and putting on boots, interrogates Susannah. Behind the girl but slightly off to the side is a three-sectioned vanity mirror with Cathryn's image in all three sections. The camera closes in briefly on Susannah and the reflections so that only three images are on-screen: Susannah and Cathryn's left and centre reflections. (This is a similar shot to that of the housekeeper blotting out Frances Austen's reflection in the right-hand mirror in *That Cold Day in the Park*, except here it is charged with much more psychological underpinning for the protagonist.) When Susannah leaves, the camera again shows Cathryn in three reflected images. Unlike René, Marcel is very much alive and lecherous. Or is it Cathryn's hallucination of Marcel that is lecherous? Or both? Either way, Cathryn has formed her own trio in her mind: a shade (René) and two doppelgängers (Marcel and herself). Cathryn strikes out at her hallucinations, shooting René and stabbing Marcel. The stabbing, unlike the shooting, confuses the viewer: was it the hallucination or the real Marcel? Hugh, ever oblivious to Cathryn's dilemma, has had to return to the city for a couple of days, and Cathryn's isolation precipitates her final breakdown, so complete that she even steps over the bodies of her 'victims' – an act that contributes to the viewer's confusion.

But Cathryn is not finished. She has to destroy one final hallucination, that of her own double. In this she is not unlike Golyadkin, who 'wanted not only to escape from himself, but to annihilate himself completely'.[20] What Cathryn seeks to destroy, however, is not her physical self but the sickness of her ego. She does this by attempting to run down her double with her car – here she and her hallucination are dressed alike in a white belted trench coat – but in the end the person she has run down is the hapless and innocent Hugh, whom Cathryn had hallucinated as herself. Cathryn and the viewer see her final hallucination, again herself, as she is taking a shower after returning to the apartment in town in the belief that she has finally exorcised her

doppelgänger. Incidentally, upon Cathryn's return home her address is shown prominently and the observant viewer might note that it is the one given to her by the mysterious caller (herself) at the film's beginning as the location of Hugh's tryst.[21]

Altman claimed, and others have supported his claim, that he had no insight into schizophrenia or psychology. The inspiration for the film was a poem he had written years earlier about mirrors, and also an idea he had had about the strange potential of mistaken identity.[22] Yet the film is atypical for Altman in that it contains less deviation from the script, less improvisation by the actors.[23] In this mind game of a film in which Altman could not resist playing with actors and audience – it contains a couple of his earliest shots of the camera moving away from the action – there is one last doubling effect, ongoing throughout the film but not revealed to the audience until the final credits are rolled. The story that Cathryn is writing and which she voices over in her thoughts turns out to be a real children's book, *In Search of Unicorns* written by Susannah York, a fact revealed in the end credits as the final part of the tale is recited by Susannah, whom we see completing the jigsaw puzzle.

4 The Neo-noir Director

HAVING COMPLETED *IMAGES*, Robert Altman already had plans to take on film noir. The idea was to film the novel *Thieves Like Us*, written in the 1930s by Edward Anderson. Before that project was set in motion, however, Altman had a look at the screenplay to Raymond Chandler's novel *The Long Goodbye*, and decided to put *Thieves* on hold. *The Long Goodbye* was one of Chandler's late works, winning the 1955 Edgar Award for best mystery novel. Although a teleplay of the novel, starring Dick Powell, was broadcast in 1954, *The Long Goodbye* had never been filmed, thus offering the director the chance to bring a fresh vision to a classic protagonist in a very traditional genre. But there was another reason, asserted Altman: 'Chandler used Marlowe [his protagonist] to comment on his own time, so I thought it would be an engaging exercise to use him to comment on our present age.'[1] Having already expanded the western and war film genres, Altman now examined the great Chandler myth of the modern knight sullied by his job and his associations, but nevertheless sticking to his own private code of ethics. But had those ethics changed over the years? More importantly, could the character adapt to society's changes?

Robert Altman wasn't the first film director to update Raymond Chandler's iconic Los Angeles private investigator, Philip Marlowe. In 1969 Paul Bogart directed *Marlowe*, an adaptation of Chandler's novel *The Little Sister* with James Garner in the starring role. Unfortunately, the critics and audiences of 1969 were ready to accept neither an updated Philip Marlowe, nor a noir film in colour. Yet just a few years later Altman was willing to bet that things were different.

In *The Long Goodbye* (1973) Marlowe again traverses the seaminess of a society whose corruption is hidden under a veneer of success. Los Angeles

was the perfect setting and metaphor for such a theme, as Chandler well knew. Altman, too, came to understand this, and eventually expanded the metaphor to encapsulate the entire country (in *Nashville*). Marlowe's code of ethics is put to the test, since the story, seemingly a murder mystery, is really about friendship, loyalty and betrayal – issues that are at the heart of human interaction.

The film's success as commentary was predicated on two key ingredients: the casting of the actor who would play Philip Marlowe and a script that balanced Chandler's notion of individualism with the early 1970s ethos. Regarding the former, the ideal was Humphrey Bogart, who had played Philip Marlowe in Howard Hawks's *The Big Sleep* (1946). Altman's answer to the unspoken challenge of the ghost of Humphrey Bogart was to hire Elliott Gould, whose image was that of an anti-Bogart. It is from this and other casting decisions that the tenor of the film really gained impetus.

Gould (at that time) bore the image of the rebelliousness of the decade just past: among his films leading up to *The Long Goodbye* were *Bob & Carol & Ted & Alice* (1969), *Getting Straight* (1970) and, of course, *M*A*S*H*. He had also starred with Bibi Andersson and Max von Sydow in the Ingmar Bergman film *The Touch* (1971). So if Altman himself was not enough of a red flag to some critics (many of the outward signs that mark traditional noir went out of the window in this film when Altman came on board), his choice of Gould to play tough guy Philip Marlowe surely raised a few eyebrows. But it is doubtful that Altman's strategy was simply to push Marlowe in the opposite direction. Unlike, say, Mickey Spillane's private investigator, Mike Hammer (whose surname is indicative of his brutish qualities), Raymond Chandler's Philip Marlowe (whose surname recalls the great Elizabethan playwright and man of action, Christopher Marlowe) is a thinking man's private eye.[2] Gould's characters in *M*A*S*H* and *Getting Straight* (respectively, a surgeon and a graduate student on a rebellious campus) somewhat play into that tradition. Furthermore, the script had noir bona fides stretching back to *The Big Sleep*. Leigh Brackett, who wrote the screenplay of *The Long Goodbye*, was also the co-screenwriter, with William Faulkner and Jules Furthman, of the earlier Marlowe film. In fact, Brackett had been brought in on *The Big Sleep* by Hawks on the strength of her noir novel *No Good from a Corpse* (1944).

To the displeasure of many of the critics of the time, the film is framed by 'Hooray for Hollywood', the music to the classic backhanded paean to the U.S. movie industry. This might seem an unlikely choice, although the film is saturated with references to various movies and actors of a bygone

era (a security guard does imitations), marking *The Long Goodbye* as both a commentary about and homage to classical Hollywood.

When Terry Lennox (Jim Bouton), an old friend of Marlowe, comes to see him late one night and asks the detective to drive him to Tijuana, Marlowe obliges. The next day the police question Marlowe concerning the murder of Lennox's wife; we see part of the police-station interview from behind the classic one-way mirror, with wise-ass Marlowe acknowledging the eavesdropping by smearing the glass with his ink-stained hands. He is released only after the police determine that Lennox has committed suicide in Mexico, possibly in remorse for killing his wife. Marlowe is determined to clear his friend's name, but in the meantime takes a paying case: Eileen Wade (Nina van Pallandt) hires him to find her husband, the alcoholic writer Roger Wade (Sterling Hayden), whom Marlowe rescues from a shady sanatorium run by the scheming Dr Verringer (Henry Gibson). In quick time Marlowe receives a thank-you note and $5,000 from Lennox and is visited by the gangster Marty Augustine (Mark Rydell) and his henchmen. Augustine has traced money that was stolen from him to Marlowe – or at least is sure that Marlowe knows where the money is, since Lennox had been Augustine's courier. Now charged by Augustine to find the money, Marlowe begins to connect Lennox and the Wades. He travels to Mexico to confirm Lennox's death and, back in Los Angeles, witnesses Roger Wade's suicide. Later, he is on the point of being killed by Augustine's henchmen when Eileen Wade inexplicably returns the money to the gangster. Marlowe himself returns to Mexico, where he finds that his friend, very much alive, had played him for a sucker, whereupon Marlowe shoots him dead.

The film introduces the viewer to Marlowe with a humorous, Hitchcock-like shuffle of misdirection as the detective is awoken at 3 a.m. by his hungry pet cat. Throughout the next couple of scenes a mumbling and grumbling Marlowe (reminiscent of McCabe) is not at all a tough-guy private investigator but rather a parody of a typical cat owner devoting time and energy to placating his pet. He drives to the closest shop to buy cat food, only to discover that it has sold out of the only brand the finicky cat will eat (the picky cat was a comment on and reference to a popular cat food commercial of the era). He buys a substitute brand and attempts to perpetrate a hoax on the cat by stuffing the cat food into a discarded cat-food tin that he has fished out of his bin. The cat sniffs at it and then leaves the apartment, never to return. Marlowe leaves his apartment, the penthouse of a concrete tower, to drive to the store, and when he returns he greets his neighbours across the catwalk. They are a group of young women who

epitomize the empty-headed California girl stereotype popularized by the media. These women lead a sybaritic lifestyle of partying and yoga. Their sexiness has no effect on Marlowe, and they understand this in terms of a generation gap. The women address him as 'Mr Marlowe', even though he is only about ten years older than them. This perception of age is one of the elements that displaces Marlowe even as it creates his filmic identity – he exists in the early 1970s but he is not of the decade. As such, in an era of sexual revolution he maintains his individuality (one of the essential ingredients of the Marlowe character) by being oblivious to sex. But let us not forget that this is an Altman film and the opening scene could be treated as a long pun in which Philip Marlowe is at once 'pussy whipped' and impotent. Moreover, this scene foreshadows the film's plot.

A second element that identifies and displaces Marlowe is his mode of dress. Along with the police detectives and the shady healer Dr Verringer, he has not been enveloped by the youth-orientated casualness of southern California in the early 1970s. He even puts on his tie when he leaves his apartment to buy cat food. Yet Marlowe evinces his own casualness even as his clothes hark back to the 1950s: his tie is undone, his shirt collar open. A third element that ties Gould's Marlowe to Bogart's is that the character is a chain smoker. There is hardly a scene in the film in which he is not lighting up a cigarette, and to a twenty-first-century viewer this dates the film as much as do the clothes and cars. In fact, Altman pointed out the obvious connection to the traditional 'Philip Marlowe', which the clothing, the out-of-date car Marlowe drives and the chain smoking preserve, seemingly as an answer to those critics who on the film's release complained because it was not set in the 1940s (or in the case of this film, 1950s). Precisely for that reason *The Long Goodbye* is less mannered than the 1975 version of another Chandler classic, *Farewell My Lovely*, which was set in period and starred an ageing Robert Mitchum.

But it is doubtful that that debate was on Altman's mind during filming. One of the things he exposed in this film was the creeping sense of voyeurism that the sexual revolution was evolving into. To that end he used the camera to turn the audience into not merely watchers of the story, but Peeping Toms spying on the characters through windows and doorways. The camera's peering at characters and/or action through windows is a running motif of this film. It is sometimes innocuous, as when we see Marlowe approaching the all-night grocery through the glass of the doors; at other times it is obvious, as when one of the detectives who has come to question Marlowe about the disappearance of his friend Terry Lennox spends part of the time peering

through Marlowe's window at the women across the way. That the viewer is a 'Peeping Tom' only highlights another Altman (and Brackett) departure from two other classic Marlowe films, *Murder, My Sweet* (1940, based on the novel *Farewell, My Lovely*) and *Lady in the Lake* (1940), adapted from the novel of the same name and directed by and starring Robert Montgomery. The former preserved Chandler's first-person narrator technique by having the actor playing Marlowe, Alan Ladd, do voiceover narration, while the latter goes one step further through the use of a subjective camera to depict the story through Marlowe's eyes. Altman, like Howard Hawks previously, eschewed the personal aspect of the Marlowe story (Marlowe's mumbled asides being the closest thing to narration), preferring to keep his tarnished knight at a distance while manipulating viewer indiscretion.

There are times when the camera moves back and forth through windows and other times when, the camera positioned on the outside, we see what is going on indoors as well as the reflection of the exterior. For this effect Altman relied on his cinematographer, Vilmos Zsigmond. It was the resourceful Zsigmond who had created the soft sepia effect for *McCabe & Mrs Miller* and the sharper look for *Images*. For *The Long Goodbye* Zsigmond used the technique known as flashing.[3] The visual strategy for the film was not 'to re-create the Fifties, but to remember them', Zsigmond subsequently declared. 'So what we [Zsigmond and Altman] decided to do was to put the picture into pastels, with a shading towards the blue side. Pastels are for memory.'[4] It has been observed that flashing came into its own in the 1970s, though directors and cinematographers had sporadically employed the technique for decades. Indeed, Colin Burnett in his essay '*Journal d'un curé de campagne:* DVD Review', on Robert Bresson's 1951 film, points out experimental use of this technique by Bresson's cinematographer, Léonce-Henri Burel, to correct at least one exterior shot in 'too little light'.[5] In *The Long Goodbye* the technique enabled Altman to push the film's central motif, windows, in much the way he had used mirrors in *Images*.

The viewer first sees (or spies) some of the characters through windows: Terry Lennox, for example, is seen outside Marlowe's apartment but the camera is inside. It is the opposite with Roger Wade. The audience first sees him through a bungalow window at the sanatorium, the camera taking on the snooping Marlowe's point of view. The detective has come to rescue the writer from the unscrupulous Dr Verringer, with whom Wade is arguing in his room.

The window motif provides a symmetry between two scenes involving Marlowe and Roger Wade. When Marlowe returns to the Wades' beach

The Long Goodbye: Philip Marlowe rescues Roger Wade from the clinic.

house the day after helping Roger escape from the sanatorium, he is asked to step outside while the Wades discuss a private matter. The viewer simultaneously listens to and watches through the glass door their quarrel and Marlowe's reflection wandering along the water's edge. Later, following a party at their house in which a drunken Roger has been publicly insulted, has ordered his guests to leave and has passed out, Eileen Wade asks Marlowe to stay for dinner. Marlowe accepts and that evening, while the two are conversing by a window, the viewer sees Roger Wade, in a long shot through the window, stagger and tumble into the surf, rougher now than when Marlowe had walked near it. (Altman's camera tantalizes the viewer in this scene.) Wade appears intent on committing suicide. Marlowe and Eileen Wade spot him through the window (the camera switches perspective, peering at them through the same window from the outside), and rush down to the water, Marlowe stopping only to remove his tie. They are too late and Wade drowns. His death causes Marlow genuine distress. The motif of the audience sneaking around peeping through windows also dovetails in this film with Altman's use of the camera, which is always on the move. As Altman admitted, his purpose in having the camera move was 'to make the audience think they're a voyeur'.[6]

If the casting of Elliott Gould signalled the direction the film was to take vis-à-vis the genre's tradition, the further casting of Sterling Hayden as Roger Wade, Nina van Pallandt as Eileen Wade and a former major-league baseball player, Jim Bouton, as Terry Lennox gave it its edgy, hyperrealist tone. All three had some notoriety at the time, which would have provided the audience of the early 1970s with a certain frisson external to the film's plot. Hayden's career dated back more than 30 years and included authentic 1950s noir; even these days most film aficionados would recognize him as the

actor who played General Jack D. Ripper in Stanley Kubrick's *Dr Strangelove* (1964). But in the 1950s Hayden was also caught up in the anti-Communist atmosphere of the period and named names of alleged Communists in Hollywood for the House Un-American Activities Committee, an act for which he castigated himself for the rest of his days. He thus brought an extra twist to the role of the tortured writer. In the late 1950s and early 1960s, van Pallandt sang in a folk-music act with her then husband, Baron Frederik van Pallandt. Her brush with international fame came when it was revealed that she was the mistress of the author Clifford Irving, the hoaxer who falsely claimed to have written an authorized biography of the reclusive billionaire Howard Hughes. In *The Long Goodbye* van Pallandt played the mistress of Terry Lennox, who himself perpetrates a hoax. As for Bouton, he was no actor (Terry Lennox would be his only role) but rather a baseball pitcher-turned-author whose inside account of major-league life, *Ball Four*, engendered at least as much criticism from traditionalists as any Altman film ever did. Many of the book's critics accused Bouton of disloyalty to his old teammates and friends – the very act that is at the heart of *The Long Goodbye*.

While the notions of friendship, loyalty and betrayal, as well as the plot device of the faked suicide, are all elements of the Chandler book, Brackett (and Altman) made alterations to the plot and character relationships that gave the film version clarity and symmetry, and fanned the ire of some critics and keepers of the Chandler flame. Most importantly, in the novel it is Mrs Wade, Terry Lennox's wartime (Second World War) bride, who is the killer of Mrs Lennox and of her own husband. In the film she is Terry Lennox's lover, but no killer.

The Long Goodbye: Marlowe and Eileen Wade unable to prevent Roger Wade's suicide by drowning.

In Brackett's updated script, references to the Second World War are removed, which allows the film's supporting characters to remain about the ages they are in the book (Marlowe, if anything, is younger); the character of Mrs Lennox is merely a plot hook, and other semi-important characters are eliminated. The Los Angeles racketeer, Mendy Mendez, has been transformed into the sociopathic gangster, Marty Augustine.

After Lennox kills his wife and makes off with the gangster's money, intending to rendezvous in Mexico with Mrs Wade, Marlowe becomes the fall guy for both the murder and the money. First the police harass him, then Augustine demonstrates to Marlowe the depth of his viciousness by smashing his own mistress in the face with a Coca-Cola bottle. It is a scene that references and one-ups the classic scene – controversial for its time – in which the gangster Tom Powers (James Cagney) shoves a grapefruit half into the face of his mistress Kitty in *The Public Enemy* (1931). Much later, in a scene in which Altman again highlights the window motif, Marlowe finds himself menaced in Augustine's office where, on the gangster's orders, everyone strips except the prudish Marlowe, and where he, again on the gangster's orders, is on the verge of having his penis lopped off. Just in time he is rescued from dismemberment by the arrival of the missing money. When Marlowe leaves the office he spots Eileen Wade driving away and runs after her, only to be struck by a car.

Eventually Marlowe returns to Mexico, where he tracks down his old buddy Terry Lennox, who, upon realizing he cannot pull off any more lies, finally delights in rubbing Marlowe's face in the mud by calling him a 'born loser'. Marlowe's reaction to Terry's false suicide contrasts sharply with his reaction to Roger Wade's real suicide. To the 'born loser' crack he pulls out his gun, replies, 'Yeah, I even lost my cat', and shoots Lennox dead – a move that many critics deplored. This is the only time in the film that Marlowe fires his gun, and, like the film's other acts of violence – Wade's suicide, Augustine's disfiguring of his girlfriend, even Marlowe's being struck by a car – it happens suddenly, keeping it within Chandler's own aesthetic. And while the shooting points to premeditation (Marlowe, after all, does bring his gun to the encounter), the reasoning behind it – vengeance for the murder of Sylvia Lennox and for Terry's betrayal of his friendship with Marlowe – evokes Chandler's Marlovian ethics.

The film's coda finds Marlowe walking down a Mexican lane as Eileen Wade drives past him in the opposite direction (recalling the ending of Carol Reed's 1949 film *The Third Man*, as numerous critics, including Judith Kass, have noted). She stops her jeep to stare at him but he ignores her – a return

The Long Goodbye: Marlowe exacts personal revenge for his friend's disloyalty.

gesture for her ignoring him as he ran after her outside Augustine's office. She is dressed in white, as she was in three previous key scenes: her argument with her husband, the afternoon house party and her husband's suicide that night. In the latter two her dress was accented with yellow; here her jeep is yellow – a colour that Altman seemed to enjoy highlighting throughout his career. After she drives off, the soundtrack reprises 'Hooray for Hollywood' in a scratchy, vocal version. Just before the fade Marlowe even dances in delight, as if the music were inside his head. Thus the movie ends with an emotional valance (towards a bygone era) that was generally misunderstood and disliked.

'Hooray for Hollywood' was not the film's only music. A running motif in the film is a jazzy, bluesy song titled 'The Long Goodbye', written by John Williams and the legendary lyricist Johnny Mercer, who also wrote the lyrics for 'Hooray for Hollywood'. The song is heard often – as straight background music to the film, on various radios, a bar-room piano player rehearses it, the Wades' beach house doorbell rings the first few notes of the melody after Marlowe presses it, someone sings it at a party at the beach house, Marty Augustine sings it in his office just prior to menacing Marlowe, a Mexican mariachi band plays it during a funeral procession. Initially in the background, sometimes subliminal (as with the doorbell) and often embedded among the characters, the repetition points to the film's outcome and the updated Marlowe's hand in it.

AFTER *THE LONG GOODBYE*, Altman returned to his earlier project, *Thieves Like Us* (1974), based on Edward Anderson's novel. It involves a trio of prison escapees – T-Dub (Bert Remsen), Chickamaw (John Schuck) and a young

Thieves Like Us: Chickamaw, Bowie and T-Dub divide the loot after their first bank robbery.

killer, Bowie (Keith Carradine) – who finance their life on the run through further bank robberies. While on the run Bowie falls in love with Keechie (Shelley Duvall), a second cousin of Chickamaw who, with her father, helps the fugitives after their prison escape. Doomed love and loyalty remain the film's themes, with less of the book's coating of Depression-era anti-capitalism.

In directing *Thieves Like Us*, Altman again risked comparison to a well-received film, *They Live by Night* (1948), also adapted from the Anderson novel. According to Patrick McGilligan, neither Altman nor his co-screen-writer, Joan Tewkesbury, 'claim[ed] to be familiar with director Nicholas Ray's earlier version'.[7] Since *They Live by Night* is considered one of the classics of noir, that claim may be disingenuous. No matter, since in many ways *Thieves Like Us* holds to the novel's spirit and structure better than *They Live by Night*. In one important way, however, it differs from the novel and original treat-ment: the setting was changed from West Texas to Mississippi – the trio breaks out of the Mississippi State Penitentiary known as Parchman Farm.

The novel was written and published during the Great Depression, an era in world history when capitalism had failed abysmally. In the United States this failure also led to a shaking of faith in the rule of law and in what the law was meant to uphold and protect. The theme of capitalism's failure was widespread in the American social realist novels of the 1930s, but Anderson's take in *Thieves Like Us* was that the big New York financiers, along with the bankers and politicians, were all thieves – thieves like us, repeats T-Dub, the most experienced of the three. In the present-day United States this sentiment has echoes on the political right and left.

Both the Ray and Altman versions open with long shots: Ray's the more visually dramatic as an airborne camera follows a speeding car down the highway. In the Altman version we see a dozen or so mostly African American prisoners and two guards zipping along on a small, motorized railway carriage with an attached flat wagon. Their slumped postures connote their fates. This shot is immediately contrasted with a placid scene of two men paddling across a pond in a small flat boat as the camera pans away from the railway track. The men discuss fishing, although in true Altman style the dialogue only becomes clear as the men get closer to the far bank, on which the camera has been set. Thus, the viewer's perspective is not simply the camera's, but also the microphone's. After the men reach the bank and drag the boat out of the water we discover they have been fishing as one of them tosses the day's catch on to the ground. They walk up a small hill overlooking a road and await the arrival of a car. It turns out that the two men are Chickamaw and Bowie, and the jalopy (Altman set this film in period) they are waiting for is carrying T-Dub, who has a gun and a change of clothes for them.

The car's driver, a marijuana dealer named Jasbo (John Roper), tells them a joke as T-Dub passes a revolver to Chickamaw, who then hijacks the car. Here their personalities are quickly revealed: T-Dub the planner, Chickamaw the menacing force and Bowie the passive accessory. As the hijacked car, still driven by Jasbo, pulls away, with the credits beginning to flash on-screen, the escapees begin joking among themselves about pulling off the prison break. Simultaneously, in the background we hear the closing strains of 'The Star-Spangled Banner', the film's only music.

The escapees seek refuge in the home of T-Dub's cousin Dee Mobley (Tom Skerritt), a widower who runs a filling station with his grown-up daughter Keechie. While T-Dub and Chickamaw are busy one afternoon reading a newspaper article about their escape and previous exploits (a brief comment on the era of the celebrity bank robber), Altman cross-cuts to Keechie and Bowie on the back porch, initiating courtship. Their budding romance is interrupted when it is time for the escapees to go out and earn their living by the only method they know: bank robbery. Altman set the ironic tone for these robberies in a similar way as he conveyed irony in *M*A*S*H*, through the use of voiceover. Rather than public-address announcements, the voice-overs in *Thieves Like Us* are fragments of old-time radio broadcasts – usually the introductions – that are more direct in their counterpoint. As T-Dub and Chickamaw climb the steps of the first bank they are about to rob, with Bowie circling the block in the getaway car, we hear the beginning of a radio programme called *Gangbusters*. The stentorian narrator intones: 'Gangbusters

at war against the underworld. From coast to coast the gangbusters are G-Men, government agents, marching against the underworld.' The trio pulls off the robbery smoothly; there is not a law-enforcement officer in sight.

Altman uses vintage radio broadcasts for ironic effect a few more times in the film, and once to un-ironic and, possibly unintentionally, comic effect. This last is when Bowie and Keechie make love for the first time. As they lie together in bed a radio narrator provides the introduction to that evening's dramatic adaptation: *Romeo and Juliet*. Following some woodenly delivered dialogue the narrator declares, 'Thus did Romeo and Juliet consummate their first interview by falling madly in love with each other.' Bowie and Keechie make love more than once, and each time the audience is treated to that same tag line – Altman's elbow poke in the ribs. Nevertheless, the scene is classic Altman with three, sometimes four simultaneous currents of sound contributing to the rural Mississippi realism of the hideaway while allowing the viewer to anticipate the scene's outcome. These currents are the dialogue between Bowie and Keechie – sometimes earnest, sometimes goofy – as they search for their identities as each other's lover; the radio play of *Romeo and Juliet* with dialogue of its own between young lovers (and the added narrator); Keechie's rocking back and forth while they listen, the creaky rocking chair a complement to her own winsome smile (and a foreshadowing of the creaking bedsprings over which Altman elides); and the ever-present crickets, whose chirping fades into the background, as does the whistling tea kettle only because one's attention to it fades, as in life.

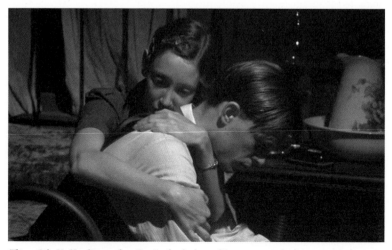

Thieves Like Us: Keechie comforts Bowie after he learns his partners are dead or captured.

A couple of scenes later the background radio clip supplies a bittersweet irony to the story and commentary on American domesticity in the 1930s. Keechie is lying on a bed in their lakeside cabin hideout, glancing at a copy of *McCall's* magazine, listening to the radio and smoking a cigarette. The radio announcer reads a teaser for the upcoming programme: 'A meeting of the Norge Kitchen Committee transcribed for American housewives.' She rises from the bed, obviously bored, and takes a bottle of Coca-Cola from the table; all the while the announcer has been listing various Norge appliances and introducing the programme hostess, described as 'the queen of the Norge kitchen'. Keechie walks out on to the cabin's porch/balcony and looks down at Bowie tossing a baseball with the son of the woman who owns the cabin. From the ensuing dialogue between Keechie and Bowie one infers that Keechie is pregnant (although near the end of the film the idea of it seems to surprise her), though Bowie for the time being remains unaware of this fact. Actually the hideout was Keechie's idea; in effect she has bought into a domesticity that cannot match the romantic notions her youth bestows upon it – especially since domestic life with a wanted man is not much like the word-picture a Norge radio infomercial would make of it.

From here on *Thieves Like Us* adheres more closely to Anderson's novel than does the Nicholas Ray film, and the result is an un-Altmanlike fulfilment of the viewer's dramatic expectations. The bandits meet to pull one last bank robbery, which turns violent. While a speech by President Roosevelt is heard in the background, T-Dub and Chickamaw shoot and kill a clerk. (Adding irony to the moment, Roosevelt has just proclaimed that 'Democratic government has the capacity to protect its people.') Afterwards the police kill T-Dub and capture Chickamaw, information Bowie finds out from his car radio (yet another instance of Altman using mass media to convey plot information) while driving back to Keechie at the cabin hideaway. Keechie is furious that Bowie has robbed another bank, but she is of two minds: the angry, independent, sultry, vampish woman and the plain homebody. This is made startlingly evident by her hair – half pinned up and half down – and by her reflected expression in a mirror.

Bowie and Keechie travel to their final hideout, a motor court owned and operated by Mattie (Louise Fletcher), T-Dub's erstwhile sister-in-law, who had earlier harboured the fugitives. As Bowie parks his car and walks up to the office building yet another background radio broadcast announces a new series, 'The Heart of Gold', something Mattie lacks as she begrudgingly allows them to stay in her most rundown cabin, number thirteen, only after Bowie uncharacteristically threatens her. No sooner does Bowie speak the

threat than Mattie's son lights off a string of firecrackers, a foreshadowing of Bowie's doom. On a wall beside the bed in cabin thirteen is a reproduction of Jesus in his incarnation as the Sacred Heart. The bed, though, is occupied only by Keechie, who had earlier complained of illness. Bowie, still in the dark about her pregnancy, attributes it to her drinking too many Coca-Colas. Towards Keechie, Bowie lacks the compassion that the religious image on the wall symbolizes. As Keechie dozes, Bowie hatches his scheme to break out Chickamaw from the infamous Parchman Farm and return to bank robbery. The breakout is improbably successful, but things quickly go wrong when the sociopathic Chickamaw guns down their unarmed hostage, prompting an angry Bowie to leave his former partner by the side of the road.

When Bowie returns to the motor court the fix is in; Mattie has sold him out to the police in exchange for her husband's early release from prison. This reason is only implied in the Altman film (although her husband's incarceration is not), but it is explicit in both the novel and *They Live by Night*. Furthermore, in each incarnation of the story Bowie's death is handled differently. The novel offers the bleakest version, in which both Bowie and Keechie die in a shootout with the police at the motor court. In neither film does Keechie die. Altman admitted frankly that it would have been too brutal an ending for the pregnant Keechie.[8] In Ray's version the police gun down Bowie at night in front of his cabin, inverting the film's title, *They Live by Night*, but remaining true to the noir tradition. In *Thieves* the final shootout takes place in the daytime, remaining true to Altman's anti-noir vision where almost all of the action takes place in daylight, and the film's expressionism is aural rather than visual. The final 'shootout', entailing half a dozen or so police officers blasting away at cabin number thirteen after Bowie has entered it, recalls the fatal ambush at the end of *Bonnie and Clyde* (1967). The police fire continuously until a ceasefire order is given a few minutes later. Unlike in *They Live by Night*, Bowie is never seen dying. Instead, two officers enter the cabin after the ceasefire order. Through a shot-out window they are seen looking down at the floor, and one signals that it is safe for others to enter. A moment later Bowie's body is carried out wrapped in Keechie's quilt – the same quilt under which Bowie and Keechie had first made love. His head is covered but his feet dangle from the other end, and when he is placed down in the mud the camera focuses on his bloody shoes. All the while Keechie, holding a Coca-Cola bottle in her hand, has been screaming in anguish and yelling his name.

After fulfilling the viewer's dramatic expectation, Altman tacked a coda on to the story. The final scene shows Keechie sitting in a railway station

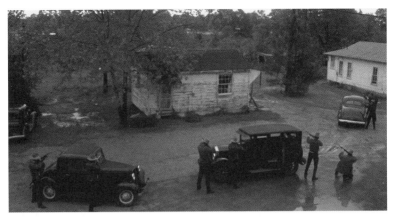

Thieves Like Us: the police fire on Bowie's cabin.

drinking a Coca-Cola and waiting for a train, any train. The next one, she discovers from the woman sitting next to her, will take her to Fort Worth, Texas, and she decides to board it. That she has been affected by her love affair with Bowie and by his brutal death is evident from her shell-shocked demeanour. In the background the radio broadcasts continue to evoke Depression-era America. The final shot in slow motion shows Keechie melting into a crowd that climbs the steps from the waiting area to the tracks. As we follow their movement upwards we hear, simultaneously, their footsteps, a child's crying, the incoming train and the notorious Depression radio preacher Father Coughlin intoning his dystopian vision for the masses.

CALIFORNIA SPLIT (1974) was a return to the contemporary and, except for cameo appearances as himself in *Nashville* and *The Player*, it was the final time Elliott Gould worked with Robert Altman. It has aspects of the two previous films Altman directed in which Gould acted. Like *M*A*S*H* it is a buddy film, although the relationship dynamics in *California Split* are less complicated; and as in *The Long Goodbye* Gould plays a cocksure, wise-cracking character. The friendship of the two protagonists is rooted in the long-time friendship between Gould and screenwriter Joseph Walsh. The story is episodic: two gamblers, Charlie (Gould) and Bill (George Segal) meet first in a California poker club, and afterwards in a bar. After they leave the bar they are beaten, robbed and arrested for drunk and disorderly conduct. Out of this a friendship arises, based strictly on gambling and its kicks, and in small slices *California Split* exposes the psychology that drives gambling

California Split: Charlie and Bill, a friendship born of gambling.

addiction. Charlie lives with two prostitutes, Barbara (Ann Prentiss) and Susan (Gwen Welles), but only as their housemate; his libido is directed towards gambling.

Altman quickly places his stamp on the film in the opening scene in the poker club, where a public-service video shown on a monitor conveys briefly the rules of the house. The narration of the video, which Charlie had been watching to kill time before being seated at a table, carries over as Charlie and Bill are seated at the same table and begin playing. The narration is then overlapped and counterpointed with dialogue from the game, and the viewer sees that the glib Charlie's style disregards most of the narrator's advice. Throughout the long first scene it is ambiguous whether or not Charlie and Bill know each other, and by their actions the viewer is manipulated into going along with a card loser's perception that they are secretly partners in the game. But the next scene reveals that they are strangers to each other when they meet in a nearby bar.

In that bar scene a number of Altman's filmmaking techniques and effects converge. It opens with a shot of the bartender as he walks behind the bar from one end to the other, where Bill is sitting alone, drinking a beer and looking exhausted. All the while the audience is listening to the patrons' various overlapping dialogues. As the camera moves backwards for a wider angle, one particular conversation moves to the forefront as the two speakers themselves now occupy the foreground of the scene.[9] The first of the two we see and hear is a woman hitting up another woman for $30 gambling money. We can see the anger in her face over the humiliation of it all. As the camera continues to pull back and pan to the left we see that the second

woman, with her back to the camera, is sitting on a table with her bare backside exposed. Bill, sitting beneath a sign that advertises 'Go-Go Girls', has turned to watch them half-heartedly. This cuts to Charlie counting his money and talking to himself as he enters the club, passing a sign that advertises 'Dancing for your pleasure' and another that has 'Go-Go Girls' plastered over a previous sign saying 'Topless'. The signs offer an explanation for the weirdness of a woman sitting half-naked in a bar. The bar is The Ticker Tape, its name a commentary on another form of gambling.

The Bill–Charlie dynamic takes hold immediately when Charlie joins Bill at the end of the bar. Their discussion naturally centres on gambling. In fact, so eager are these newfound friends for action that they bet on the identity of a man who turns out to have been the announcer for an old-time radio serial (shades of *Thieves Like Us*). Meanwhile, the two women discussing the loan have moved away from their table. The woman asking for money walks to the door while the dancer heads to the end of the bar where Bill and Charlie are seated. Simultaneous to their discussion she argues with the bartender over advancing her $30. Both dialogues are recorded so as to grab the viewer's attention; neither is important to the plot, but the dancer's arguing with the bartender, since they are slightly more in the foreground, is, aurally, the stronger of the two and the culmination of the previous dialogue on which the viewer was allowed to 'eavesdrop'.

But it is not as easy to listen in this time. One has to focus one's attention, to make a choice between the two overlapping dialogues. This recalls the mess tent scene in *M*A*S*H*, when various officers of the 4077th introduce themselves all at once to Hawkeye and Duke. Bill and Charlie's attention never drifts from their discussion of old-time radio, which makes the scene a little surreal. Not once do they glance at the nearly naked woman next to them, or cast a sideways leer. As with Charlie, gambling and the discussion of it have replaced the sexual drive for Bill. Charlie is glib; Bill quieter with moments of introspection. He is separated from his wife and seems to have lost his appetite for sex. Later in the film he nearly has an encounter with Susan, yet when Barbara interrupts them he loses his desire and leaves the apartment. Charlie and Bill's lack of sex drive recalls Marlowe's in *The Long Goodbye*, but their visceral and possibly tenuous friendship would be foreign to his code.

Perhaps their ignoring the naked woman next to them was meant to illustrate the nonchalance of the sexual politics of the era, but it comes off a bit too mannered. It makes Bill and Charlie's dialogue seem slightly forced. When Charlie finally does acknowledge the woman it is to advise her not

to sign an IOU for the $30 advance. Then the two immediately begin another bet when Bill challenges Charlie to name the seven dwarfs. This, the scene's concluding dialogue, was according to Altman 'improvised pretty much', another hallmark of his style.[10]

From *M*A*S*H* Altman also borrowed the idea of playing a little joke on the audience near the end of the film. Throughout *California Split* a woman sings as the scenes segue, melding the connective-tissue ideas of faceless announcements (*M*A*S*H*) with song (*The Long Goodbye*). Finally in Reno it is no longer a disembodied voice. We see Phyllis Shotwell, an actual cocktail lounge musician, singing, playing the piano and entertaining gamblers in a lounge of the casino that is the film's ultimate setting. Shotwell's voice throughout the film has been the siren lure of the casino. Altman also included a visual motif that was almost a running joke in the film. Whenever Charlie's ugly two-tone shoes appear on-screen, whether or not he is wearing them, he is about to come into money, or else has just won a bet.

Charlie and Bill's gambling odysseys take them from a California poker club to the racetrack, to a private poker game (Bill only), back to the racetrack (Charlie only), to a playground basketball court (again Charlie only) and finally to a Reno casino, where Bill is confident that he will make the big score that he needs to pay off his bookie. By this time, as commentators have noted, Bill has wrested the film from Charlie.

On the Greyhound bus from California, the two gamblers decide to pool their money, but it is Bill who will be gambling. In Reno he embarks on a hot streak of the kind all gamblers dream of. Initially he plays high-stakes poker. In a private room of the casino he and Charlie wait for a seat to open. As they sit at a utility bar, Charlie delivers a spot-on analysis of the other players, even picking which of them will go belly-up first. There is one empty seat,

California Split: Charlie and Bill at the races.

California Split: Bill laments the fact that there is no special feeling to winning.

however, and the viewer initially sees its occupant walking down the hall as he returns to the game. The tall, lanky man is Amarillo Slim – one of the most famous gamblers of the era. This is the first instance in an Altman film (excluding his Calvin work) in which a real person as himself enters the fictional world and interacts with the characters. He speaks briefly to Charlie at the bar and asks the bartender to place a bet on a horse race for him. He then returns to his seat at the table and shakes hands with Bill, who has already taken a seat in the game. But Charlie sitting behind him and watching him play cards makes Bill nervous, and he orders his friend to leave. Eventually, Bill rejoins Charlie in the main room of the casino and announces that he has won $11,000; the streak has begun.

Without any way of getting in on the action that surrounds him, Charlie is bored and at this point merely the comic figure his character has hinted at all along. On hearing the news of Bill's good fortune he is all for returning to California and the racetrack, where he is more comfortable, but Bill will have none of it. He returns to the poker game. When he reappears in the casino he is flashing a larger roll of money, having won another $7,000. Nevertheless, he quits the poker game because he has 'lost the rhythm of the game'. Instead he switches to blackjack, where he loses the first hand – again Charlie beside him makes him nervous – and the viewer gets an inkling that perhaps this is the beginning of the end of the streak. Charlie walks away, and Bill eventually switches to roulette – a game designed to kill any lucky streak. Sure enough, he begins losing consistently. By the time Charlie rejoins him Bill's pile of chips is down and his nerves are frayed. He orders Charlie to get away from him, fearing that he is going 'to kill the streak'. Charlie again looks back at Bill, but this time with a look on his face that reveals he is seeing another side of his friend. Yet almost as soon as Charlie walks away from

the roulette table Bill hits on number 26, and the two are jubilant, clutching each other and jumping up and down for joy like two amateurs. With a restored bankroll Bill is now ready to enter the final stage of his streak, the dice table. And surely, the viewer thinks, this is where it will all come crashing down.

So overjoyed is Bill at hitting at the roulette wheel that he no longer views Charlie as a curse. (Charlie, who had had his nose broken in a fight at the racetrack, looks the part of a shambling bête noire, with his bandage and his darkened eyes.) They work the craps table as a team, glib Charlie laying the bets and Bill throwing the dice. As a team they reach the apex of the streak, but when it comes to an end they have opposite reactions. Charlie is euphoric – planning how to spend his portion of the $82,000 (which he carries from the cashier to Bill in his two-tone shoes) – while Bill is disconsolate. He is sad not because the streak came to an end but because 'there was no special feeling' during the run of good luck. The rush of gambling, he has come to realize, is an illusion. His body language after the streak ends, seen in a long shot, ranges from that of a man on the verge of a breakdown as he empties his pockets of his chips to the empty tiredness of a depressive. This feeling is akin to the feeling of Eddie Felson (Paul Newman) in *The Hustler* (1961), who, after beating the legendary Minnesota Fats (Jackie Gleason) out of $18,000 in straight pool, is left unsatisfied. The action (or the conquest), not the money, is the object for these men. Felson will not quit until Minnesota Fats throws in the towel, and the latter ultimately cleans him out in a marathon match that lasts for more than 24 hours. Bill can and does quit the action, but the reward is meaningless to him – beating the house is not the same as beating an individual. The long shot through which Altman delivers Bill's painful epiphany to the viewer and the empty room in which it takes place provide a psychological jolt to one's expectations. It is a visual indication of the emptiness of his lifestyle and the loneliness that exists at the core of his being. The viewer comes to terms with how sad a figure Bill really is. Indeed, he is one of the saddest figures in the Altman oeuvre.

By the end of *California Split* Bill is even more in contrast to the buoyant Charlie (who, after cashing in their chips, approaches Bill singing 'I've Got the World on a String') than he had been at any other point in the film. Charlie thinks it is his turn to have a go at the dice; Bill merely wants to return to California. He takes his half of the money and leaves a perplexed Charlie (and the viewer) behind. Charlie picks up his money, spins a wheel of fortune we had earlier seen – for it is in the now-empty cocktail lounge that they have been divvying up their winnings – and then also walks out

of the casino. Whatever the viewer's expectation was, this ending most likely was not it.

The ambiguous ending leaves the viewer unsure of the characters' future actions and motivations, and even the state of their friendship. It also renders the film's title ambiguous. Does it refer to their dividing up the winnings evenly? To their return to California? Or to the end of their friendship?

5 Paradise Lost

IF *CALIFORNIA SPLIT* SERVED as a glimpse of the demi-monde of the California gambler, with *Nashville* (1975) Robert Altman began to look more earnestly at the country as a whole, using the capital of country and western music (as the genre was then known) as a synecdoche for American society. The film also marked Altman's first use of the apologue technique – the mural-like allegorical narrative structure that, for better or worse, by the end of his career had become a hallmark. His continued use of the structure was perhaps his acknowledgement of what critics had been proclaiming since 1975: that *Nashville* was his masterpiece. It may also have been an understanding that his 'film murals' allowed for the best use of his two favourite techniques – overlapping dialogue and a camera that was constantly in motion. Because of his further use of apologue structure and its use by subsequent directors, such as Paul Thomas Anderson and Quentin Tarantino, by the second decade of the twenty-first century it is no longer unorthodox. *Nashville* does remain unorthodox, however, because it jolted the viewer's expectations. Masterpiece or not, it was certainly Altman's most written-about film, and thereafter the artistic standard to which he was held.

For Altman, *Nashville* was the platform on which he brought together a number of his cinematic techniques and tropes for a larger audience. He opened the film in an entertaining parody of the way television hucksters of the era sold compilation record albums, only it wasn't music but the film's cast that was introduced. This harked back to the quirky ways he ended *M*A*S*H* and *Brewster McCloud* with roll calls of the casts. Altman again used a disembodied voice to stitch scenes together. The political speechifying of a third-party presidential candidate emanating from a sound truck may not be as dramatically cohesive as the PA broadcasts in *M*A*S*H*,

nor as ironic as the Lecturer in *Brewster McCloud* or the radio broadcasts in *Thieves Like Us*, but their populist note mixed with sentimentality was not so far off in that post-Vietnam, post-Watergate era. He revived the silent character – the Tricycle Man – but this time kept him silent throughout the film. He used eight- and sixteen-track sound systems (the latter for music) to capture multiple, overlapping dialogue to better effect than in *California Split*. Altman's camera technique included 'extended panoramic zoom shots which sweep leisurely and relentlessly across wide, richly textured landscapes and eventually zoom slowly in on the main protagonists'.[1] Probably as revolutionary for the time as his sound systems was his use of the recently developed Chemtone process on his film. As a replacement for flashing, this especially enhanced the night-time and intentionally ill-lit scenes, such as those in the nightclubs or the hospital.[2]

The film tracks 24 characters – introduced at a recording studio, at the airport and during a traffic jam on the highway leading from the airport to the city – over the course of five days in the eponymous Tennessee city. During that time we encounter the alliance and blending of entertainment and politics, and the concomitant cynicism (and occasional naivety) of those who hope to succeed in those fields, and those who simply want to be part of the action. The story occurs in the near future to the film's first run, in the bicentennial (and presidential election) year of 1976. By then the pairing of entertainment and politics was a fact. Not only had entertainers been campaigning openly for politicians for years; some, such as California governor and future U.S. president Ronald Reagan, had crossed the line and become politicians themselves. So in one sense *Nashville* was a satire on the direction political discourse was taking in the post-Watergate era. Its failure in this regard was that it merely touched on the impetus television had already given and would continue to give the blurring of the lines between entertainment and politics. In the final scene – the benefit concert at the Parthenon – we see and hear a portable television brought by one of the concertgoers (this in itself is an interesting comment on the real and the virtual). The television broadcasts a commentary by newsman Howard K. Smith (playing himself) discussing the populist platform of Replacement Party candidate Hal Phillip Walker (Thomas Hal Phillips), whose empty motto is 'New Roots for the Nation'. Smith's commentary is as folksy as the candidate's message.

Out of the pairing of politics and entertainment came the pairing of many of the film's characters. And it is the characters' subtle complexities that lift the film beyond the simple Manicheanism with which it flirts. Some of

these characters are Nashville residents, and of those who are not a few are very much the outsiders. In fact, four of the outsiders make up two very different pairs. One is the silent Tricycle Man (Jeff Goldblum), who tools about town performing the occasional magic trick, transporting other characters to various places and generally giving the audience a quick view of the city and its environs. The ghostly political candidate Hal Phillip Walker also performs the last function. Or rather, his sound truck does, as it roams the city's streets spouting Walker's recorded sound bites. Like the PA announcements in M*A*S*H, the Tricycle Man and Hal Phillip Walker's sound truck take the viewer 'beyond the visually truncated spaces delineated by the camera'.³ We do not actually see Walker, but the viewer can get a handle on him and his populist manifesto from the various truncated speeches. Walker and the Tricycle Man complement each other perfectly: one is never seen and the other never heard. Both capture the viewer's imagination.

A better-known pair of outsiders are Opal (Geraldine Chaplin) and L. A. Joan (Shelley Duvall). Each wants to sidle up to the action, and neither is exactly who she claims to be. The viewer sees Opal when she crashes Haven Hamilton's (Henry Gibson) recording session. She is consequently thrown out, but guided around the studio by Hamilton's son Buddy (Dave Peel), who takes her to a recording session of gospel music wherein, trying to express her amazement at the performance, Opal articulates a racist sentiment. To Haven she identifies herself as a BBC correspondent, working on a documentary about the Nashville music scene. But is she really from the BBC? After all, she misidentifies the media giant's initials as the British Broadcasting Company. Opal is at best a freelancer hoping to cash in on the BBC's name, but more likely a self-absorbed gatecrasher – the funniest, and phoniest, character in the film. She wanders about town with a tape recorder either catching the words of various people or recording her own stream-of-consciousness impressions of the environment in which she has crashed. L. A. Joan is not very different. She has flown to Nashville ostensibly to visit her hospitalized aunt, but it seems her real interest is to make as many sexual conquests as she can. L. A. Joan's real name is Martha, which her uncle, the beleaguered Mr Green (Keenan Wynn), calls her despite her pronouncement that she has changed it. But her promiscuity and narcissism convince the viewer that she really is L. A. ('el lay') Joan, more so than Opal's promiscuity and narcissism convince us that she is a BBC journalist.

A third pairing involves the wannabe singers Sueleen Gay (Gwen Welles) and Albuquerque (Barbara Harris). Sueleen is a Nashvillian, a naive waitress in the airport coffee shop who idolizes the singer Barbara Jean,

Nashville: two superstars, Barbara Jean and Haven Hamilton.

writes her own country and western tunes and harbours dreams of singing them professionally. The drawback is that she has no musical talent. But her close friend and co-worker Wade (Robert DoQui) hasn't the heart to tell her, and her self-delusion is such that when she gets up and sings at an open mike she is not only tone deaf but deaf to the groans from the audience. Later we see her singing and rehearsing her stage presence in front of her vanity mirror. This scene encapsulates two of Altman's favourite motifs of the period: the mirror and Catholic imagery. In a corner of her dressing table are three prayer candles and statues of Jesus, Mary and St Francis of Assisi, the last suggesting Sueleen's own gentle nature. The camera pulls back to show us her reflected image as she shimmies while singing her trademark 'I Never Get Enough of You', ending it with a bump-and-grind. Outsider Albuquerque also shows up at the open mike. She spends most of her time in Nashville evading her husband (Bert Remsen), whom she had abandoned during the massive highway traffic jam, while trying to ingratiate herself with Nashville insiders in the hope of catching her big break. Like L. A. Joan she has remade herself by changing her name (from Winifred).

Character doubling continues with Barbara Jean (Ronee Blakley) and Linnea Reese (Lily Tomlin), both seemingly angelic but neither able to live up to her superficial identity. Barbara Jean is one of the film's two Nashville superstars, dressed always in virginal white (an Altman woman in white), ethereal in her gestures and voice. In her character there is also, intentionally or not, a strong connection to the legend of the medieval Christian martyr St Barbara. Both women are shielded from the outside world by

Nashville: Linnea Reese and Tom Frank the morning after.

domineering men: the saint had to contend with her father; Barbara Jean her manager/husband/father figure Barnett (Allen Garfield). Barnett and Barbara Jean's relationship appears to be primarily a business arrangement with psychological overtones. This is highlighted during a brief argument in her hospital room – Barbara Jean had collapsed at the airport – in which Barnett says to her, 'Don't tell me how to run your life. I've been doing pretty good with it.' There is little affection between them. There is some love on his part, but it is the love of an overprotective father rather than a husband; there is nothing physical between them. Barnett does not even kiss his wife good-bye. Instead, when he leaves her hospital room he infantilizes her in what is the film's creepiest scene. Barnett: 'Now, I'm walkin' out now. What do you say as I walk out? You say bye-bye!' There follows a close-up of a pained, psychologically exhausted Barbara Jean, who responds in a wistful, child-like tone, 'Bye!' Barnett repeats, 'Bye-bye.' And Barbara Jean, as she wipes away her tears, repeats her 'Bye.' Fire is another connection between the singer and the saint. Barbara Jean's arrival at Nashville airport had marked her return from a long recuperation from injuries sustained in a fire. St Barbara is the legendary protector from fire.[4]

Linnea Reese is the only white singer in the Fisk University Bible Choir and the mother of two hearing-impaired children. As an enraptured voice within the choir and not the leader of it, she is the opposite of the racist Daphne Heap in *Brewster McCloud*. On the surface Linnea is a devoted wife, mother and gospel singer, but she, too, is tempted by the cynicism of the age. Linnea finds herself estranged from her husband in a marriage grown stale, combined with the allure of a younger man who shows an interest in

her, which her beleaguered husband, Delbert (Ned Beatty), fails to do. For Linnea the halo briefly slips during a one-night stand.

Cynicism and temptation have their own way of creating doubles – or actually another Altman trio – in *Nashville*. Three of the film's four most cynical characters are linked by their outlooks. These are Haven Hamilton, the film's other Nashville superstar (who also dresses in white), the political operative John Triplette (Michael Murphy) and the narcissistic, womanizing folk singer Tom Frank (Keith Carradine). Haven is the unctuous gatekeeper of Nashville, and it is to him that the equally oily Triplette must pay obeisance if he is to put over his candidate, Hal Phillip Walker. At a get-together barbecue at his home the seemingly apolitical Haven is sceptical when he meets Triplette, who is organizing a benefit concert for Walker. But he agrees to perform after Triplette, a devil in paradise, dangles Walker's support should Haven, in the future, seek the governorship of Tennessee. That's all it takes. Haven is blind to the fact that Walker, in all likelihood, will sink back into political irrelevance after the general election. It is unclear if Triplette is a true believer in Walker's politics or a hired gun. Either way, he is in town to put over his man's name and collect as many celebrities as he can for the Walker bandwagon.

Tom's cynicism bears a close resemblance to Haven Hamilton's in that they are both career-orientated. He is part of the folk-singing group Bill, Mary and Tom, but his personal reason for coming to Nashville is to cut a solo record and hasten the dissolution of the trio. Tom spends most of his time in town avoiding his band mates as he transforms his motel room into the nexus of the film's sexual politics. Whereas John Triplette is a demon whose backroom dealings threaten slowly to poison the city's civic bliss, Tom's equally demonic night-time activities expose the falsity of domestic bliss. Two of the women he seduces (and quickly abandons) are Opal and his singing partner Mary (Christina Raines), who is married to the third member of the trio, Bill (Allan Nicholls). This seduction, more than his attempt at a solo career, destroys whatever harmony the trio had prior to their arrival in Nashville, although Bill and Mary valiantly perform a song with Tom at the Exit/In.

The fourth cynical character is Lady Pearl (Barbara Baxley), Haven Hamilton's paramour and proprietor of the Old Time Picking Parlor, over which she presides like a latter-day Texas Guinan. Her cynicism is the residuum of a dead idealism – literally killed off by the violence of the 1960s – for Lady Pearl was an unabashed supporter of the Kennedy brothers, especially John F. Kennedy. The Old Time Picking Parlor even has a poster of a smiling JFK

adorning a wall, and she later alludes to the Kennedys when Triplette arrives at Haven's barbecue to court him. But it is when she holds forth with what amounts to a political and philosophical soliloquy to Opal at another club, the King of the Road, that we see that for all her posing as the de facto queen of Nashville Lady Pearl is really an outsider herself. (Whether a BBC journalist or not, Opal does have a knack for getting people to open up.) Yet Lady Pearl resides in Nashville, and the only way she can gravitate to power is to align herself with Haven Hamilton.

Lady Pearl still grieves for the dead president after more than ten years, and laments that Tennessee did not vote for Kennedy in the 1960 election. She rattles off the state's exact vote counts for Kennedy and Richard Nixon, and goes on to blame Kennedy's loss on the preponderance of Baptists and their antipathy towards Roman Catholics. She also links Kennedy's loss with the state's low level of education, thus aligning herself with the more sophisticated Easterners who voted for him, and by and large populated his administration. At the beginning of this soliloquy Altman moves the camera in ever so slightly so as to frame Lady Pearl and Opal, their semi-preciousness relegating them to the back table of Haven's group. Pearl's speech is intercut with Bill's lament to the chauffeur, and Barnett's conversation with Connie White (Karen Black), to create simultaneity. Connie, another Nashville diva and rival of Barbara Jean, sits at Haven's table, along with Triplette. Within this extended group that includes Haven's son Buddy and Delbert Reese, Altman has configured two brief triumvirates based on the colour white. First, there are Connie White, Lady Pearl and Opal. But an opal is not necessarily white, and to replace her is Haven Hamilton, who not only dresses in white but drinks only milk.

This is also the scene in which Altman intercuts two different aspects of reality into the fiction. Sue Barton (*Nashville*'s publicist), playing herself, introduces Julie Christie (as herself) to Haven, Connie and the others. Earlier in the film she had introduced Elliott Gould to Haven. Neither Christie nor Gould have any real reason for being in Nashville, and their stepping into the fiction is gratuitous. Conversely, during this scene the fiddler Vasser Clements has been performing onstage – Altman even shoots him in close-up – and his inclusion (along with the bluegrass group Misty Mountain Boys and the songwriter Jonnie Barnett) enhances the realism of the *mise en scène*.

The key to the marriage of country and western music and politics is Haven Hamilton's pudgy lawyer, Delbert Reese. He is both a Nashville insider and someone looking to get close to the action of presidential electoral politics. It is Delbert who meets John Triplette at the airport and conducts

him around town, introducing him to various people, including Hamilton, and helping him to organize a benefit 'smoker' and the concert that caps the film. In his own way Delbert is as naive as Sueleen. He is the innocent dupe who has not only let the serpent into Eden but even given him a tour. The harried Delbert is not nearly as close to their children as his wife Linnea is (he has never learned sign language, so his communication with them is limited), and in the end becomes a cuckold. His own drunken, fumbling attempt at seducing Sueleen ends shamefully for both of them.

There are two other doubled figures: Kenny Fraiser (David Hayward) and PFC Glenn Kelly (Scott Glenn). Like the Tricycle Man, both wander about the film in and out of scenes, but neither is silent, and as the film progresses they both carry with them foreshadowing of the violence that marks the film's end. They give *Nashville* its suspenseful edge, much as the hapless Bill and Norman (David Arkin), the chauffeur who drives and accompanies Bill and Mary around town, are its comic relief. Altman professed not to be interested in the linearity of Alfred Hitchcock's narrative technique, but he used Hitchcock's blending of comedy and suspense, introducing it here as understated counterpoint.[5] Watching these two loners – PFC Kelly, with his fixation on Barbara Jean, and Kenny, whose car broke down on the highway to Nashville during the traffic jam – one begins to wonder what each is going to do next. Likewise, the Tricycle Man also has no apparent reason to be in Nashville, but his magic tricks, goofy smile and outlandish get-up are disarming and sincere.

Altman gives us a hint that things are not really so paradisiacal in Nashville when a drunken Wade shoves Kenny on to a table in the Old Time Picking Parlor. Wade, an African American, had been heckling the African American country singer Tommy Brown (Timothy Brown), deriding him as 'the whitest nigger in town', and Kenny tries to prevent him from following the singer outside. Other foreshadowing of the violence that lurks at the film's end includes Lady Pearl's two laments over the Kennedys and Mr Green being told of his wife's death just after he has spoken to Barbara Jean, who is leaving the hospital. One of the most powerful intimations of the climactic violence, which haunt the edges of the viewer's consciousness, is when PFC Kelly sneaks past a nurse and a security guard (who is busy describing his gun and the occasions when he has had to use it) to bring a handful of flowers to Barbara Jean in her hospital room. He maintains a silent vigil at her bedside while she sleeps, hands crossed over her breast, surrounded by flowers, with dim, overhead lighting. It looks more like a funeral home than a hospital room. Another is when Kenny, walking lonesome with his violin case in the

raucous Nashville Saturday night, pauses in front of the garage from which the Walker campaign sound truck daily emerges, and glances up at all the campaign signage. Less obvious, but equally powerful, is the linkage of aural and visual montage that is a clue to the assassination at the film's end. As Michael J. Shapiro describes the first part, 'In a seemingly trivial yet exemplary moment of filmic and aural montage . . . the scene cuts from a hospital, where an elderly husband [Mr Green] weeps over the news that his wife has just died, to a youthful, festive gathering in a music club in which someone is laughing in precisely the same rhythm as the husband's sobbing.'[6] In other words, this is an aural match cut. That 'someone' is Triplette and he is laughing at Opal's assassination theory, which she then explains. 'All these people here, in this country, who carry guns,' she says, 'are the real assassins. Because, you see, they stimulate other people who are perhaps innocent, and they eventually are the ones who pull the trigger.' The film then cuts to Kenny Fraiser speaking to his mother from the telephone in Mr Green's home, where he is renting a room, as L. A. Joan walks up to him and poses seductively on the edge of his bed.

Altman leaves us in no doubt about what day it is when Sunday morning rolls around. We see a stained-glass window showing Jesus holding a shepherd's crook in one hand and embracing a lamb in the other. This window is the central, larger portion of a triptych whose imagery makes it plain that this is a Roman Catholic church. We then see the entire nave with priest and altar boys at the altar. Among the congregation are Albuquerque's abandoned husband (holding rosary beads), Star; Lady Pearl, with her head covered; and a repentant, sad-looking Wade; Sueleen (also with her head covered) is seen singing in the choir. Next we see a mainstream Protestant church, Baptist perhaps. Its choir is much larger than that of its Catholic counterpart, signifying the predominance of that faith in Nashville. Delbert Reese and his two children are singing and signing 'Amazing Grace' (this image, at least, a refutation of the commentary that pronounced him a bad parent), and in the choir is Haven Hamilton, whose presence shows that this truly is the more important church. When the hymn ends the scene switches to an African American church and a full-immersion baptism. Again we see a choir, and there is Linnea Reese singing front and centre. Tommy Brown and his wife (uncredited), the film's other silent character, also attend the service. (The Browns' relationship to each other and to the larger, white world of Nashville mirrors that of the Washingtons in *McCabe & Mrs Miller*.) Lastly, we see the nondenominational hospital chapel, where there is no choir, just Barbara Jean singing a hymn while seated in a wheelchair. Among

the handful of attendees are her husband Barnett, Mr Green and PFC Kelly.[7] Among these four locations are scattered most of the Nashvillians and a couple of outsiders (Albuquerque's husband and PFC Kelly), and, being in Nashville, the scenes we see involve music. Together these scenes are the apex of Nashville-as-paradise. It is not a perfect place, for we see spouses and lovers worshipping apart; we see anxiety on some faces but bliss on others. Altman follows this montage with the ironic scene of Opal's first ridiculous stream-of-consciousness monologue into her tape recorder as she walks through a scrapyard past gigantic heaps of crushed cars. Trying to find the poetry and existential meaning hidden within the mundane, she intones: 'I'm wandering in a graveyard. The dead here have no crosses, no tombstones, no wreaths to sing of their past glories.' She then stumbles upon Kenny searching for a part for the car he had abandoned days earlier in the traffic jam. Later we see Opal delivering another stream-of-consciousness monologue into her tape recorder, in which she babbles about the colour yellow as she wanders past school buses in the lot where they are stored, ignoring the silent Tricycle Man, who is shaving.[8] Briefly highlighted in *The Long Goodbye*, and seen elsewhere in *Nashville*, the colour yellow has more importance though less subtle significance in *3 Women* and recurs in later Altman films.[9]

Nashville's sexual politics are sometimes funny, as when the slow-to-catch-on Bill complains to Norman the chauffeur that Mary is late to arrive at the club where they are hanging out, or when Opal wakes in the morning in Tom's bed and later admits to Bill and Mary that she has known Tom in the biblical sense; and sometimes pathetic, as when a drunken Delbert Reese hits on a humiliated Sueleen after driving her home from the smoker where she has stripped in front of businessmen to secure a gig singing at the benefit concert for Hal Phillip Walker. (Sueleen agreed to work the smoker under the misapprehension that she was going to sing.) There is an element of pathos in every one of Tom's sexual conquests, but his final one, Linnea Reese, seems, if only for the briefest moment, to turn the tables on him. Tom's public seduction of Linnea at the Exit/In is one of the finest examples of Altman's searching camera. Gathered in the club's audience are his Nashville sexual conquests, Opal and Mary, and L. A. Joan (yet another Altman trio of women), with whom Tom had been sitting before being called to the stage – each hoping that he has dedicated his song to her. When he announces his song's ironic title, 'I'm Easy', the camera is focused on L. A. Joan, but it seeks out all three women in the audience, lastly discovering Linnea, dressed in a white top (signalling her own Barbara Jean-like vulnerability) and sitting at the back of the club. It is on her that the camera slowly closes in and finally

settles. Yet when their tryst is over it is Linnea who has leached the irony from Tom's ballad.

The benefit concert for Hal Phillip Walker at the Parthenon (a full-scale replica of the ancient structure) coincides with Mrs Green's funeral, which is not attended by her niece, L. A. Joan. However, it is attended by Kenny. During the service Mr Green becomes fired with a righteous anger at his niece's self-centred antics. He leaves the funeral before it has ended to go in search of L. A. Joan, and Kenny tags along, seemingly the cooler head. Their quest takes them to the Parthenon – the concert being the happening event in Nashville that day, and even the grief-stricken Mr Green realizing that L. A. Joan is always on the lookout for the happening event – where their arrival brings all the two dozen characters in this ensemble film to the concert.

The main cast members are gathered on stage preparing to perform, overseeing the performance (Triplette, Delbert and Bartlett) or moving about the audience. Here we glimpse an irony: Tom and Mary are on stage but not Bill, the group's supposed spokesman who had negotiated the gig with Triplette. The camera spots the trio's heretofore schlub and cuckold picking his way through the crowd holding hands with L. A. Joan, leaving the viewer to assume they have spent the night together.

The shooting victim is Barbara Jean, whom Bartlett had engaged to sing at the concert after her poor performance (and slight nervous breakdown) at a show following her release from the hospital. This was a performance attended by both PFC. Kelly and Kenny. That Bartlett, though inadvertently,

Nashville: Tom Frank, Barnett and Buddy Hamilton carry a fatally wounded Barbara Jean off the stage.

sends her to her death is yet another connection with the St Barbara legend, the saint's father having turned her over to the Roman authorities for execution. The shooting occurs after Barbara Jean has sung two songs: a duet with Haven Hamilton and a solo performance. The shooter is not the perceived stalker, PFC Kelly, but Kenny. One assumes that Kenny has come to kill the politician and instead randomly shoots the beloved singer, but there is no evidence that Barbara Jean was not his intended victim. The film posits no answers. It can't, really, or rather Altman can't, because to do so would provide the pat ending to which he was philosophically opposed. As in *The Long Goodbye*, he shows the audience how violence in America can be sudden and senseless. All this is shown as though the viewer is a member of the concert audience. We see Kenny in medium shot and three-quarter profile as he removes the handgun from his violin case and fires at the stage. Barbara Jean's collapse is shown in extreme long shot.

Kenny also wounds Haven Hamilton in the arm. Recognizing that the shooting has signalled the end of the paradisiacal Nashville as he knew it, Haven takes the microphone to calm the crowd and refute his own fears. 'This isn't Dallas, it's Nashville,' he proclaims shakily. He then exhorts the crowd to sing, because that is what his Nashville is all about. Meanwhile a semi-oblivious Opal wanders through the crowd trying to discover what has just happened – further proof of her lack of journalistic skill.

It is Albuquerque who takes up Haven's challenge and the microphone, breaking into a rendition of 'It Don't Worry Me'. Halting at first, her voice gains power as the song progresses. Backing her is the Fisk University Choir, and it turns out that Albuquerque is an evocative singer, better actually than all the others except Barbara Jean. Over and over she sings while the camera moves about the audience to emphasize crowd reaction. The emotive power of the song and of her voice transforms the audience. The other performers have abandoned the stage with one exception, Sueleen. She stands off to the right, transfixed by Albuquerque's singing. Sueleen's impassive expression reveals her epiphany: the fates have ordained Albuquerque, not her, as Nashville's next sensation. Her impassivity, a natural result of her own shock at the violence, may also be the first step in the process of her transferral of allegiance from the dead Barbara Jean to Albuquerque, something the audience en masse also seems to be doing. Her remaining onstage is also a repudiation of Wade's warning: 'They're going to kill you in this town, girl.' In Altman's Nashville only the talented are killed. While the camera tracks back we see and hear Albuquerque in long shot, and then simply hear her as the camera pans upwards towards the sky.

AFTER SO SUCCESSFUL A CRITIQUE of the convergence of American politics and entertainment, in his next film Altman focused his creative eye on a particular aspect of those fields, celebrityhood. For that he chose the figure and the surrounding legend of 'Buffalo Bill', William F. Cody, one of the most recognizable people in the world at the dawn of the twentieth century. The clash of legend and history is what this next film is all about.

Altman was given his biggest budget to date for the film, approximately $6 million, and he hired two Hollywood legends, Paul Newman and Burt Lancaster, to play the roles of Buffalo Bill and Ned Buntline respectively. Joel Grey, only a few years removed from his success in *Cabaret*, played Cody's business partner and the Wild West show's producer and master of ceremonies, Nate Salisbury. While this was another film with a large ensemble cast, the narrative essentially follows only Buffalo Bill's story. Very loosely based on Arthur Kopit's play *Indians* (1968), the film was given the Wertmuller-esque title *Buffalo Bill and the Indians, or Sitting Bull's History Lesson* (1976) to counterpoint the nobility of Sitting Bull with the facade of Buffalo Bill.

Photographed 'entirely in telephoto, even [the] big wide shots, in order to compress [the depth of] images' and 'background everything, or at least . . . put foreground and background on the same plane', *Buffalo Bill* opens with the Altmanesque touch of a sombre voiceover prologue as a pioneer family is attacked by marauding Indians. The viewer may at first mistake this as a prologue to the film but it is really an introduction to a scene in Buffalo Bill's Wild West show.[10] As this continues, the cast list rolls on and we are given the actors' names and the roles they play, but not the characters' names. Thus, the Star instead of Buffalo Bill, the Sure Shot rather than Annie Oakley and the Legend Maker for Ned Buntline. Soon after the quirky list has ended and the rest of the major credits have rolled past, we discover the scene is only a rehearsal, although what proves to be a fatal injury to one of the Indian performers is real enough in the context.

Unfortunately, *Buffalo Bill* does not match this beginning. There are a number of reasons, including too many long shots and not enough of Altman's signature moving camera – though the first time we see Buntline, in a bar relating how he created the Buffalo Bill legend, the camera closes in nicely on him, recalling the way it closed in on Linnea Reese in *Nashville*. Another reason *Buffalo Bill* falls short of expectations is that by 1976 the idea of exploding the legends of celebrityhood seemed pale to an American public that had had its illusions of the u.s. presidency torn away, and Buffalo Bill's legend, already tarnished, not to mention deflated a half-century earlier by the poet e. e. cummings, was too far in the past. Likewise, the

public was sceptical of the simplistic concept of the noble savage, which the film promotes. Not that people necessarily disbelieved it, but rather they were exhausted by the didacticism and self-righteousness. Culturally speaking, *Buffalo Bill and the Indians* was about five years too late.

Altman characterized *Buffalo Bill* as an 'essay film', and that assessment is as good as any to explain why the film drifts along.[11] At heart Altman was not a polemicist in the mode of Jean-Luc Godard. What he avoided in *Nashville* crops up everywhere in *Buffalo Bill* as he abandoned the strategy of 'say[ing] things without saying them directly'.[12] What's worse is that exploding the legend of Buffalo Bill was a one-note deal. Yet after Ned Buntline does it in the film, we see a performer dressed as a Union soldier telling his version of the Cody legend. Thereafter it's just one revelation after another: Cody doesn't really have shoulder-length hair, he wears an extension; he can't jump his horse over a fence; his tracking skill is suspect when he fails to bring back Sitting Bull and his followers after they have briefly decamped from the show (they return on their own); and his famed marksmanship is aided by a scattershot gun. Except for his showmanship, everything about Buffalo Bill is fake, the film wants us to believe. And nothing is more false than his presentation of history in his Wild West show.

Enter Sitting Bull (Frank Kaquitts) to give Buffalo Bill (and us) a history lesson. Sitting Bull has agreed to join Buffalo Bill's show because he has had a dream that foretold he would meet President Grover Cleveland (Pat McCormick) at that location. (In the film, Buffalo Bill's Wild West show is not a touring show, but staged at a fixed location that is referred to as his camp.) In doing so Sitting Bull joins the growing list of silent and near-silent Altman characters. He communicates only through his 'interpreter', Halsey (Will Sampson), who during a conference with Bill and his associates announces: 'Sitting Bull says that history is nothing more than disrespect for the dead.'[13] Through Halsey, Sitting Bull corrects Buffalo Bill's re-enactment of the Battle of Little Big Horn, popularly known as Custer's Last Stand. (The year 1976 was also the centennial of the battle.) In the re-enactment Sitting Bull is described as a bloodthirsty warrior who personally led the slaughter of the u.s. 7th Cavalry. In fact, as Halsey points out, Sitting Bull was not present at the battle, but was praying and dreaming. Buffalo Bill prefers his version because it makes better theatre.

Altman and Paul Newman worked well together, but the latter only briefly caught the essence of the character. Newman was intent on exploding the celebrity of Buffalo Bill as a way of exploding his own celebrity myth, which had become a burden. But such a 'method'-trained actor surely must

Buffalo Bill and the Indians, or Sitting Bull's History Lesson: Buffalo Bill discusses reality versus image with his hallucination of the dead Sitting Bull.

have felt the tension between his style and the broad showmanship of the character he portrayed. There are a few scenes in which he touches on a truer Cody. One of them is the conference with Sitting Bull, who is negotiating for blankets for the Sioux. Buffalo Bill is told that there are only 106 Hunkpapa Sioux left at their encampment. Shocked, he whispers to an associate that five years earlier their number was in the tens of thousands. He stares, troubled, into space while his partner agrees to provide the blankets.

Another affecting scene is the one in which Buffalo Bill finally faces Ned Buntline, who had more or less taken up residence in the bar room attached to Cody's camp. Cody enters the bar following the reception for President and Mrs Cleveland (Shelley Duvall). (They had stopped off to see Cody's Wild West show as part of their honeymoon trip, and were confronted by Sitting Bull, who broke his silence to ask the president, through Halsey, to intercede on behalf of the Hunkpapa Sioux. But the pompous Cleveland fails to acknowledge Sitting Bull's request.) Inside the bar Buntline immediately begins to rhapsodize about Buffalo Bill's career and success. As he does so the camera is focused on Buffalo Bill's reflection in the bar room mirror – showing the viewer the image rather than the man. But Cody is not taken in by Buntline's easy way with words. In response to Buntline's observation that he hasn't changed, Buffalo Bill says: 'I ain't supposed to. That's why people pay to see me.' It is an admission that his stage persona has become his separate reality. Bill's back is to the camera, so we can't see his expression; Buntline's is one of momentary resignation. But it is only momentary; Buntline, in common with Buffalo Bill, likes to control his reality. 'Well,' he sighs, 'this has been the most soberin' experience I've ever had. Damn near

a religious awakening.' (Lancaster is here referencing, in words and tone, his title role in *Elmer Gantry*, 1960.) He walks up to Cody – this, too, we see reflected in the mirror – and toasts him: 'Buffalo Bill, the thrill of my life to have invented you.' After a few words with the bartender, Buntline (no longer in reflection) proclaims, 'I'm off to California to preach against the vultures of Prometheus.' He leaves the bar room, mounts his horse and does what Cody could not do earlier – jumps the fence and disappears into the night.

After this the action leaps ahead a few years. The show is more prosperous than ever, and although things have changed a bit, Cody is still frozen in the 'reality' of his legend and false history. Word comes to the camp that Sitting Bull has been killed. The shot cuts away to what appears to be Sitting Bull's grave with rocks piled on it, adorned with beads, feathers and the small wooden cross he wore when he performed in the Wild West show. The cross is an acknowledgement of Sitting Bull's conversion to Roman Catholicism a few years earlier.[14] Following this, we see what is simultaneously the most theatrical and the most cinematic scene in the film: Sitting Bull's ghost, ever silent, visits Buffalo Bill in the night. As Bill moves around the conference room delivering the film's key monologue, in which he seeks to justify himself and his career, Sitting Bull suddenly appears in various places throughout the room: sitting, standing, but always sombre and noble in full headdress. (Some have described this as a dream sequence, but the technique recalls Cathryn's hallucinations in *Images*.) Robert Kolker has pointed out that 'Bill is in love with the image of himself (he looks in mirrors and gazes at his portrait), and that image is turned into an ideology of supremacy, of victory and hegemony.'[15] But in reality it is William F. Cody who is in love with the literal and figurative image of Buffalo Bill. 'In a hundred years', he shouts to the ghost of Sitting Bull, whose silent presence annoys him, 'I'm still gonna be Buffalo Bill – Star', rationalizing the reward for the burden of playing the one role. At another point in his rambling discourse on his life and philosophy he gazes at a painting of Buffalo Bill on horseback waving his hat, and remarks: 'My God, ain't he ridin' that horse right? But if he ain't, how come all of ya took him for a king?' As he speaks, the dishevelled Cody is in medium close-up. When he finishes the camera tilts upwards to the image and we see 'Buffalo Bill' in close-up. Cody also seems to repudiate what he told Buntline earlier. 'Look at ya,' he tells Sitting Bull. 'You want to stay the same. Well that's goin' backwards.' The American frontier was rapidly disappearing, as Frederick Jackson Turner would famously proclaim in 1893, and the United States was rapidly becoming a place where Sitting Bull and Buffalo Bill were anachronisms.

How does Buffalo Bill face this? He presents an even falser history: a re-creation of a fight to the death between himself and Sitting Bull, now played by the physically imposing Halsey. The re-creation is billed as 'The Challenge for the Future'. Halsey's size makes Bill's victory (and the victory of white America over the Native American) appear that much more impressive – and false, like the hundreds of 'cowboy-Indian' films that preceded this one. *Buffalo Bill* ends with Bill removing 'Sitting Bull's' headdress in a ritual scalping to the cheers and applause of the audience while a close-up of Bill reveals his own addiction to the adulation. The sad thing is that the irony here, as throughout nearly all of the film, is much too obvious.

As with most Altman films, the lesser characters have their moments. Annie Oakley's (Geraldine Chaplin) legend is also skewered when she misses a target during the command performance for President and Mrs Cleveland and wounds her husband, Frank Butler (John Considine), in the arm. He is not only her manager but her assistant, the one who holds up targets or places cigars in his mouth for her to shoot. Butler is the film's comic relief, a bit of a rogue (he has got one of the other women in the show pregnant) and always nervous that Annie won't hit the mark. And in the end he is proven right. But even these moments cannot distract from the lack of synergy in the film. Its heavy-handedness undermines its contrarian nature. Despite being caught up in the country's bicentennial celebrations at the time of *Buffalo Bill*'s release, it is doubtful that anyone among the film's small initial viewership was unaware of the lies of history and the shallowness of fame.

6 Strange Interlude

WITH *3 WOMEN* (1977) Robert Altman turned away from the expansiveness of *Nashville* and *Buffalo Bill* and back towards the claustrophobia of his earlier 'small' films. The sense of dread and discomfort *3 Women* presents to the audience is relentless; the viewer feels the world closing in. Even the women's final liberation from patriarchy displays a contraction of their lives and independent personae, and in the end they are, inexplicably if not inevitably, intertwined. There are only three main settings in the film and the women – two of them, anyway – move around from point to point in this triangle, which folds in on them until in the end they all inhabit the same physical, psychological and emotional place.

In numerous interviews Altman related the genesis of *3 Women*: how its bare bones began as a dream within a dream. (So that in making the film Altman fulfilled a dream destiny much as Sitting Bull did in *Buffalo Bill*.) But *3 Women* can also be understood as the third film of a trilogy that also comprises *That Cold Day in the Park* and *Images*. These films explore obsession, psychosis, schizophrenia, claustrophobia and personality disorder, and the result in each is violence (or the hint of it). Another link between the three films is that mental illness strikes women each time. For all three films, but especially *3 Women*, an important predecessor is Ingmar Bergman's film *Persona* (1966), by the end of which the viewer is unsure – partly because of the film's disjointedness (where even the fourth wall is broken) and partly because of the characters', especially Elisabet's, reactions to Alma's violence – whether what one has witnessed actually occurred. In that film, Alma is the nurse/companion for Elisabet, a stage actress who, during a performance, lost her memory (later recovered) but either is unable to speak or chooses not to. They spend time together away from the clinical atmosphere

of the hospital in the home of Elisabet's doctor, who has absented herself. In their isolation Elisabet's silence proves overpowering to the talkative Alma. The questions for the viewer are slightly different by the end of *3 Women*, but no less enigmatic.

The three women to whom the title refers are Millie Lammoreaux (Shelley Duvall), Pinky Rose (Sissy Spacek) and Willie Hart (Janice Rule). Millie works as a physical therapist at a health spa in the southern California desert, whose clients are mostly elderly. She leads a vapid, essentially bathetic life that is centred on snaring a man. She is a constant talker whose banal monologues bore her co-workers (except Pinky) and neighbours in her apartment complex. Her language is the extroverted aspect of her personality, the cause and alleviation of her solitariness. Assigned to train Pinky at the spa, she goes on a little power trip vis-à-vis the newcomer. While the film's conventional opening shows Millie helping an elderly woman in the spa's pool, the music signals the weird direction *3 Women* will take. It is moody and suspenseful, although not so intently schizophrenic as the music in *Persona*. It is closer to that used in *Images*. The use of a flute as a musical harbinger connects the music of *3 Women* to that of *Images* as well as to the earlier *That Cold Day in the Park*. With each successive film, however, the music becomes less conventional.

Initially Pinky appears to be like anyone else on their first day at a job – shy and open to whatever helpful suggestions can make her transition easier. But soon we see that deeper than her shyness is an arrested childishness (she dresses like a girl, which highlights her small frame; she blows bubbles in her soda during her lunch break and afterwards spins around on a wheelchair; later she crawls on the ground into a tepee at the 'Dodge City' compound), and her openness is but a factor of the *tabula rasa* that is her personality at this time. There is a foreshadowing of Pinky's personality theft: when Millie takes Pinky to where the workers' uniforms are kept she remarks, 'You're a little like me aren't ya?', meaning they both have slim figures (Millie is quite a bit taller). Pinky smiles and responds, 'Yeah.' The line is a direct lift from the scene in *McCabe & Mrs Miller* where Mrs Miller outfits and convinces Ida Coyle (also played by Shelley Duvall) to join the 'profession'. Pinky quickly grows attached to Millie, but the latter is aloof at first. Millie ignores Pinky during the lunch break, just as she herself is ignored by her co-workers. Pinky does not mind, however; sitting at the next cafeteria table, she studies Millie.

As it turns out, Millie is the perfect candidate for victimization, ignored as she is by everyone else. When the hapless Millie needs a new roommate,

Pinky seizes the opportunity to share living space with her mentor. What seems superficially like a plot device to enable the two women to bond is a stalker manipulating her prey.

Their relationship is jogged when Millie introduces Pinky to her friends Willie and Edgar Hart (Robert Fortier). They own a roadhouse tavern in the desert, called Dodge City, and out behind the tavern is a shooting range, a dirt bike track and their home. When Pinky first sees Edgar he is wearing a gun belt with a revolver in the holster. He pulls the gun on the two women in a quick draw and the camera closes in on his gun hand. Millie explains to Pinky that Edgar used to be the stand-in for the star of a 1950s television show called *The Life and Legend of Wyatt Earp.* 'Stunt double', he corrects. So immersed is he in the cowboy persona that the tavern's name is derived from the Kansas town that was the setting of the television show. The immediate landscape around the tavern is as false as a television or film set: the big rocks are fake, as is the rattlesnake under one of them. Of course the viewer does not know this until Edgar lifts one of the rocks to reveal the rubber snake, making the moment another brief commentary on illusion versus reality. Pinky is at home with all this falseness. When Edgar confirms with her that her name is Pinky she tells him that it is really Mildred. Millie's reaction of incredulity at this announcement is spot on, as is her reaction moments later while watching the supposedly innocent Pinky quaff a mug of beer.

Where Edgar's introduction in the film is silly, Willie's is sublime. But the compulsively chatty Millie injects a bit of silliness to her entrance when she tells Pinky the obvious: Willie is pregnant. Willie is a painter whose work visually references a kind of pre-Columbian mythology. More than anyone else in the film she connects *3 Women* to Altman's previous films (not to mention *Persona*), and she achieves this by the motif of silence. Like *Nashville*'s Tricycle Man, Willie is memorable among the list of silent and near-silent characters in Altman's work. Her silence is a strategy not unlike the young man's silence in *That Cold Day in the Park*. Yet it complements Millie's garrulousness (and it is a stronger complement than that of their counterparts in *Nashville*, the Tricycle Man and Hal Phillip Walker). As well as being silent, she seldom strays from the desert compound.

In the scene when Pinky moves into Millie's apartment we see just how dominant the colour yellow is for Millie. It is everywhere: chairs, picture frames, bedspreads; even Millie's toothbrush is yellow. The effect is funny and visually cloying, and the colour's cheery symbolism superficially reflects Millie's optimistically vapid personality. Nonetheless, the colour is a symbol

of Millie's apartment as a refuge (for yellow has a mythological denotation of female energy) and foreshadowing of her destiny.[1] Pinky's moving in puts the two young women in a living situation parallel to that of Elisabet and Alma in *Persona*, where the proximity facilitates the personality theft. Initially the power in the dynamic belongs to Millie. She is older than Pinky, more experienced at work and the original tenant of the apartment. Millie even scolds Pinky for leaving a container of milk in the bathroom (the kind of mindless act a child or adolescent would perform). But just as in *Persona*, where Alma begins to dress like Elisabet, so Pinky begins to dress like Millie. In this Millie abets her when she gives Pinky her spare, yellow robe.

At first Pinky slowly acquires Millie's identity – telling Edgar her name is Mildred, 'accidentally' punching Millie's timecard at work instead of her own. This acquisition is accelerated after her suicide attempt.[2] The attempt is brought on by her disillusionment with Millie, who returns to their apartment with Edgar, intent on a liaison. A guilty Millie nevertheless scolds Pinky and all but orders her to move out of the apartment. The blocking and camera set-up in this scene are such that the two women are in the foreground, and we see Millie's face in the mirror in the background – an ugly reflection of her personality. Pinky leaves the apartment, climbs up on the rail and drops into the pool. A long shot of her floating face-down is broken by none other than Willie's cries for help (Willie and Edgar own the Purple Sage apartment complex), and the other residents come to her assistance. Pinky's suicide attempt, we discover in the next scene, leaves her in a coma.

On waking from the coma some days later, Pinky has undergone a personality change. First she denies her parents (Ruth Nelson, John Cromwell) are her parents when they visit her in the hospital room – and although neither Millie nor the viewer has any reason to believe they are not (except that they appear old enough to be her grandparents), their relationship to her is ambiguous. Little by little an increased aggressiveness marks her personality. During her convalescence at the apartment, Pinky completes her theft of Millie's identity and personality, and is actually more successful at being Millie than is Millie herself: the men of the apartment complex flock around her, and Edgar is also attracted to her. Pinky is now a sexy young woman rather than the little girl she had been. Her transformation is such that she even manipulates Millie into sleeping in the living room on the roll-away bed, where she herself was to sleep the night of Millie's aborted liaison with Edgar.

3 Women: the double image of Willie Hart as she stares at Pinky Rose in the hospital emergency room.

For Millie, who has taught herself to ignore and deny her neighbours', co-workers' and even her former roommate's disrespect, Pinky's new attitude fits right in with the reality of her relationships. Even when confronted at work with the fact that Pinky had stolen her social security number, she continues to defend her roommate, becoming so exasperated with her superiors that she quits her job, only to discover that Pinky has also stolen her car. (This after Millie has told the officers that Pinky doesn't know how to drive.) Millie confronts Pinky on the shooting range of the Dodge City compound. Here their roles are reversed. The first time we saw them on the range it was Millie firing away under Edgar's tutelage (and Pinky flinching when the gun fired); now it is Pinky with Edgar behind her (and slugging from his beer) as she fires away. Incidentally, whereas Pinky usually favours white or pale-pink dresses, she is now dressed in a hot-pink matching halterneck top and trousers, and Millie has that day forsaken her signature yellow. Still, Millie forgives and forgets, unequipped as she is to handle the kind of psychological change that Pinky is undergoing and unable to see that it is directed at her. When Millie notices the key to her diary on Pinky's bed she discovers that Pinky has not only been reading the diary (a fact the viewer already knows) but writing in it too. Upon reading it Millie discovers that Pinky has begun assuming her

identity: 'Maybe she'll [Millie] move out and I can have the apartment to myself again.'

Latterly, Millie begins questioning Pinky about her origins and why Pinky had passed off Millie's social security number as her own. During this dialogue Millie performs house-cleaning chores while Pinky reclines on her bed reading a magazine – a nascent mother–daughter relationship. Pinky objects and Millie says, 'I'm just trying to help you, Pinky.' At this Pinky literally gets in Millie's face and shouts, 'Will you stop calling me that? How many times do I have to tell you my name is Mildred? You got it? It's Mildred.' The closing in of the camera on the women during Pinky's sudden outburst heightens the creepiness of the identity theft and facilitates the viewer's empathy towards Millie. In fact, the camera moves in closer on Millie, who spots her diary on Pinky's bed and begins reading it aloud. Pinky hears her, returns to the bedroom and grabs the diary from Millie, saying, 'Don't you ever touch it again. You hear me?' She then takes the diary into the bathroom. The usually garrulous Millie is shocked into silence, and the camera again closes in on her.

From here on the film gets even stranger. In the next scene the two women are asleep, Millie on the roll-away bed in the living room and Pinky in the bedroom. Pinky has nightmares, and these flash on the screen.

3 Women: Pinky scolds Millie, making her identity theft complete.

The nightmare sequence, as even Altman admitted in various interviews, is not up to the quality of the rest of the film. Like most dream sequences on film, it is contrived. Pinky's nightmare consists of a montage of previously viewed and new (possibly deleted) scenes, including a shot of Willie's multiple reflection, which could not have settled into Pinky's subconscious because it coincided with her coma.[3] What the nightmare does is refocus Pinky's personality. Various parts of the montage are filtered through water (actually a 'wave machine'), signifying the amniotic fluid surrounding the recumbent woman's immanent personality. Altman has given us other water-filtered shots in *3 Women*, usually with an aquarium as the means, but also the Purple Sage apartment complex's pool. Superficially these contrast with the aridness of the social and physical environments, but here Altman tips the viewer as to the water's truer purpose in the film.

When Pinky wakes from her nightmare, frightened, some characteristics of her old personality have begun to fuse with her 'Millie personality' (although the viewer is initially unaware of this). She is a frightened woman-child. She asks Millie if she can sleep with her on the roll-away bed, and Millie makes room for her, her own first maternal act. As they sleep a drunken Edgar lets himself into the apartment with his passkey and, spotting the two of them together on the bed, concludes a sexual liaison has taken or is about to take place. He hints at a *ménage à trois*, is rebuffed and then admits that his wife is in labour. Millie, with Pinky in tow, hurries to the Dodge City compound.

The pregnant, nearly silent Willie, painter of abstract sand paintings and monsters on concrete, is really the glue that connects the story with its psychological underpinnings. Her silence is more active than Elisabet Vogler's in *Persona*, and whereas Elisabet has retreated from her acting, Willie has not forsaken painting. In fact her 'monster paintings' or murals are actually clues to the film's tension. They 'depict three reptilian women: one shows them at each other's throats; another shows two under the domination of the third; and both show all of them diminished by an enormous [priapic] male figure'.[4] Willie's silence is less of a taunt, as it is with Elisabet, than a survival mechanism-turned-rebellion in the masculine environment of the ersatz Dodge City, with its dirt bike trails and shooting range at the back. Her pregnancy symbolizes a prior, though possibly brief, acceptance of that world, and of Edgar in particular. Nowhere in the film do we see what passes for love or even desire between the two (rather like Barnett and Barbara Jean in *Nashville*). But when Willie sees Edgar come down the stairs from Millie's apartment after Pinky's suicide attempt, we observe shame on his face and

disappointment on hers. Their masks are off (Edgar often wears silver-framed sunglasses; Willie's face is usually impassive).

After jumping into the pool to help rescue Pinky, Willie was also brought to the hospital. She silently walks the halls of the emergency room in her hospital gown until, standing outside Pinky's room, she is seen reflected in a double-paned window (actually a window and a sliding glass door), her doubled image staring at the unconscious, helpless Pinky. The camera moves in for a close-up of the double reflections. (A minute or so later, reflected in the same window, can be seen a double image of Millie, again in close-up.) Reflections aside, we mostly view Willie as a lone figure, often in long shot, usually walking in the desert by their compound or painting her monsters on the side of the compound's drained pool or on the concrete patio. Her silence and her physical bearing reveal her pride. And her pride and independence are driven home when in long shot we see her lying on her bed giving birth alone.

Upon her arrival Millie takes charge, and the suffering Willie admits that she needs a doctor. Millie orders Pinky to go to the hospital. Her sudden turn towards responsibility recalls Pat Sheehan's organizing an ad hoc bucket brigade to extinguish the church fire in *McCabe & Mrs Miller* and Haven Hamilton's attempt to rally the crowd after Barbara Jean's shooting in *Nashville*. Yet Pinky stands there frozen, eventually retreating towards the car. She never goes for the doctor but instead watches the birth through the open door – as does the viewer. For the only time in *3 Women*, Altman has linked her with the audience as voyeurs. (Earlier, he had likewise linked the viewer and Millie when she opened her bedroom door and watched briefly as Pinky's elderly parents made love.) As we watch in long shot through the doorway, the anticipated childbirth turns into a protracted tragedy. The baby, a boy, is stillborn. Millie wraps the baby in a towel anyway and hands him to Willie, then slowly emerges from the house in semi-shock, covered in blood and afterbirth, her arms extended before her like a ghoul. Walking towards Pinky (and the camera), she is shaking and crying. Pinky sees the blood on Millie's hands and sheds a single tear. Millie slaps Pinky, transferring some of Willie's blood from her hand to Pinky's hair and face. The scene ends with a close-up of the silent, bloodied Pinky.

The film's lasting enigma lies in its final scene. Two men make a Coca-Cola delivery to the Dodge City 'saloon', where we see Pinky sitting at the counter reading a magazine. The delivery invoice needs to be signed and Pinky says, 'I'll get my mom', then raps on the window. Outside,

3 Women: Pinky watches as Millie attends Willie in labour.

mopping the patio, is Millie, whom we see through the window, dressed as Willie previously dressed, including her floppy sunhat. She comes in, and as she signs for the order one of the delivery men (Dennis Christopher) says, 'Sure is horrible what happened to old Edgar.' Millie in an eerily deadpan voice agrees: 'Yes. It was a terrible accident. We're all grieved by it.' As she speaks we see a close-up of Pinky, bent over her magazine but glancing towards Millie. The delivery man persists. 'I just don't understand it. Him bein' so good with guns and everything.' On the wall behind them are Willie's sand paintings, all shot up; earlier Altman had established that Willie is the best shot of the three women, and in retrospect teased the viewer with Edgar's portentously flirty dictum (to Millie): 'I'd rather face a thousand crazy savages than one woman who has learned how to shoot.'

The interior of the saloon exhibits Millie-as-Mom's touch: yellow tablecloths and decorations that sacralize the place as a female refuge. (Interestingly, the Coca-Cola delivery truck stands out to the viewer because it is vintage yellow and not red, perhaps as a compromise for the conveyance of the outside world into the now feminized compound.) The delivery man leaves, and Millie/Mom says to Pinky, 'Come on, Millie. You're going

to help me fix dinner tonight. The vegetables need washin'. Get that hair out of your face.' A passive Pinky-now-Millie follows her towards the house where on the porch swing sits Willie. Pinky/Millie joins her and asks her if she would like some Coca-Cola. Willie appears older after her ordeal. She takes the proffered mug of soda and says: 'Thanks, baby. I've just had the most wonderful dream.' Taking that last sentence at its most self-referential, some critics have argued that *3 Women* is a revelation of Willie's dream, which then makes Pinky's dream a dream-within-a-dream, just like Altman's. Robert T. Self argues that the dreamer could be any of the women, including Millie, because of 'the preponderance of yellow in the set design, props, and costumes . . . and her humorous fixation on that color'.[5] Millie/Mom calls them inside and explicitly orders Pinky/Millie to do a number of chores in the same tone she had ordered Pinky to fetch the doctor. Meanwhile, the camera pulls back from the porch, pans across the yard and settles on a pile of tyres. No more, it seems to say, will the dirt bikes race on their property. It is Willie who in a grandmotherly way delivers the film's final line – to Millie-as-Mom: 'Don't know why you have to be so mean to her.'

3 Women is the strangest of Altman's 1970s psychological trilogy because it has the fewest dots for the viewer to connect. *That Cold Day in the Park* explored isolation and obsession, and one could track the progression of the latter. *Images* dealt with schizophrenia, and the symptoms were evident almost from the film's outset. In both instances there was a revealed logic engendered by the protagonists' madness. In *3 Women* one can understand the logic of Pinky's craziness: she steals Millie's identity not for financial gain but rather to place herself somewhere psychologically. What seems like a wrong choice – Millie is a social loser – is actually a good choice (or as good as such a choice can be for Pinky) because Millie's social isolation leaves her vulnerable. Yet even Pinky's personality hinges on bouts of unconsciousness – her coma and nightmare – while Millie's and Willie's personalities (as well as those of most of the minor characters) are examples of Altman's hyperrealism, counterpoint to Pinky's identity switches and Edgar's ersatz machismo. Furthermore, unlike in its two predecessors, the violence at the end of *3 Women* is not shown; rather, it is alluded to in words and facial expressions as part of the film's ambiguity. In that sense it is less ambiguous than *Persona*, where the viewer is unsure whether violence has even occurred.

The women's disjointed transformations juxtaposed with the mention of violence ultimately leave the viewer disturbed. Giving birth to a stillborn

baby boy, assisting at the stillbirth and witnessing it was the catalyst that altered each woman's character. For Pinky, though, it was not the only catalyst. Her nightmare had sent her childishly back to Millie. The Pinky who witnessed the stillbirth witnessed it because she had reverted to the immature woman she was at the film's beginning. The flirtatious, car-stealing Millie was again buried within her psyche. What remained was her identity as Pinky/Millie.

The stillbirth also precipitated the surfacing of those aspects of the other women's personalities they had been denying. Millie becomes maternal, acquiring the role that seemed at the film's beginning destined for Willie but also filling a void that had existed since Pinky's hospital-room denial of her parents, while Willie, whose world is altered by the stillbirth of her child and the death of her husband, simply lets go of her angry independence. This also means the abandoning of her silence and her art, for which she no longer seems to have a need. The desert compound is a world without men (or even the baby boy); the landscape and their closed, restructured family are at once claustrophobic and liberating for the three women.

Because of the film's deliberately limited visual scope – there are scenes where Altman could have opened up the desert but chose instead to give us overhead shots or move in quickly with the camera to signify the claustrophobia – and the many interior scenes involving only two or three characters, there are few opportunities for Altman to pull off his trademark overlapping dialogue. In one or two instances when there are a number of people, most are quiet, intentionally ignoring Millie as she prattles on. Nevertheless, Altman's camera moves. It heightens the psychological tension with strategic close-ups, much as he did with *That Cold Day in the Park*. Two key places, however, where the camera is stationary are the long 'voyeur' shot of the stillbirth through the open doorway (although there is some cutting back and forth to Pinky's frozen fascination) and the long shot of the approaching delivery truck near the film's end. The former manipulates the viewer in a typical Altman manner, while the latter signals the women's new status: men come to them, not the other way around (for Millie), or they are of no interest because they are either too old (for Pinky) or irrelevant (for Willie). Many critics, notably Kaja Silverman, have commented on the rearranged family structure of grandmother–mother–daughter into which the women have realigned at the film's end. Interestingly, *3 Women* was marketed with a quasi-theological tagline – 'One woman becomes two; two women become three; three women become one' – implying a feminist Christian theme. It also echoed

an axiom attributed to the legendary ancient alchemist Maria Prophetissa, for whom Jungians, especially Marie-Louise von Franz, had an affinity: 'One becomes two, two becomes three, and out of the Third comes the One as the fourth.'[6]

7 Career Ebb

WITH *A WEDDING* (1978) Robert Altman played a game of Can-I-Top-*Nashville*? Over a four-year period his sound engineers, notably James Webb, had improved his Lion's Gate 8-Track Sound system, and Altman set out to expand its use. *Nashville* had shown what he (and the multi-track) could do with 24 characters. *A Wedding* doubled that: 48 speaking characters overlapping, though usually only fourteen had microphones on them at a given time.

The most important aspect of the film was that it confirmed for Altman the viability of his 'mural-film' – his apologue. It was not the story, which after all is really just about a wedding, but the characters' backstories – their secrets, their reactions to one another and their discomfort in the situation – that make *A Wedding* watchable again and again. Altman succeeded in turning the viewer into a wedding crasher, as invisible as the event's hired help. For some viewers (and perhaps critics) the lure was satire, but *A Wedding* was not pure satire or simply a comedy of manners – by then any film-goer clued in to Altman should have realized that he did not work in 'pure' forms. In fact *A Wedding* is primarily a farce, a genre much criticized over the centuries for its 'impurity'. Under Altman's direction it becomes even more impure, incorporating the above-mentioned genres. All of that, and the fact that the film covers an event whose duration is measured in hours, relieves it from any but the most comic sense of claustrophobia. In addition to the numerous storylines (the secrets) and the obvious technical aspects, *A Wedding* clearly references *Nashville* three times. The first reference seems offhand in that cars are choreographed. In the scene at the airport in *Nashville* various main characters, whether alone or in twos or threes, pull out of the car park simultaneously, briefly causing confusion and foreshadowing the

highway accident and traffic jam that are to come. In *A Wedding* we see the opposite. The cars carrying the wedding party and families from the cathedral to the mansion enter the driveway and circle the central grassy rotary in a precision ballet that is shot from above. The second reference is the highway crash at the end of *A Wedding* and the beginning of *Nashville*. The third reference is the unexpected deaths at the end of both films. Some cinéastes may also have noticed that *A Wedding* contains more than a few parallels with Pietro Germi's *Sedotta e abbandonata* (Seduced and Abandoned, 1964), the Italian comedy about a father's attempt to marry off his teenage daughter to the man who had impregnated her – her sister's fiancé. And at least one commentator, Gerard Plecki, compared *A Wedding's* satirical treatment of the American upper class to Jean Renoir's *La Règle du jeu* (The Rules of the Game, 1939).[1] However, it would be nearly a quarter of a century before the director's true homage to the Renoir classic appeared, *Gosford Park*.

The two families being united are the Sloan/Corellis and the Brenners. Years earlier Luigi Corelli (Vittorio Gassman), a waiter in a Roman *ristorante*, married into the Sloan family after he had impregnated Regina Sloan (Nina van Pallandt) during a trip she had made to Italy. After marriage, Luigi relocated to suburban Chicago and, despite fathering two children with Regina, remained the outsider (signified by his accent) among the upper-class Sloans. In the end Luigi, with brother Dino (Gigi Proietti) in tow, sloughs off his 'otherness' by abandoning the family and the mansion. The Brenners are new money (signifying gaucheness); he owns a trucking firm. The marriage ceremony takes place in a Chicago cathedral, presided over by the bishop (John Cromwell), and the reception occurs at the Sloan-Corelli suburban mansion.[2] Here new money bows to old, a tradition that pre-dates the one that dictates that the bride's family should host the wedding. But holding the reception in a mansion allows the characters (and the camera) more freedom of movement and setting changes than would a country club.

Altman shaded *A Wedding* with some autobiographical hues. Late in life he recollected that his father's family was 'similar to the Sloans'[3] and his paternal grandmother was called Nettie, as is the Sloan matriarch. Altman added another private reference: Corelli, of course, was the family name of his second wife.

There are a number of familiar Altman motifs in *A Wedding*: Christian imagery, mirrors, extensive camera movement that searches out its subject, overlapping dialogue, the silent character and the connective character – in this case the Wedding Planner (played by Geraldine Chaplin, whose Opal

A Wedding: the ceremony.

served the same purpose in *Nashville*). There is also a bit of slapstick (which Altman had not really used since *M*A*S*H*) and references to American television shows and films.

Not surprisingly, the film opens with the marriage ceremony. The opening shot, accompanied by a fanfare, reveals a cross high above the altar. The camera then moves down and retreats to present the cathedral's full majesty. The ceremony is punctuated by traditional comedy as the doddering bishop – a *commedia dell'arte* figure – fumbles his lines, forgets the bride's name and drops one of the wedding rings.

Another fanfare and a wide-angle lens also introduce the magnificence of the Sloan mansion, where the bedridden Nettie Sloan (Lillian Gish) presides. She is too ill to attend the ceremony, but through cross-cutting between the mansion and the cathedral we see that she dies at approximately the same time as the bride and groom complete their vows. Her death becomes one of the two worst-kept secrets at the reception, the other being the maid of honour's (Buffy) pregnancy.[4] Buffy (Mia Farrow) is the bride's older sister. She reveals her secret to the groom, whom she tries to convince is the father, though he knows that she has slept with other cadets from his military school. Throughout the film, the revealed secrets pile on top of one another. Mostly they are comic, but a few are genuinely sad. These latter, especially those coming at the end, reveal the film's cynicism towards marriage as opposed to merely lampooning the ritual. Yet because of these secrets the bride, Muffin (Amy Stryker) and the groom, Dino (Desi Arnaz Jr), are the least interesting people at their special event.

Buffy carries on the Altman tradition as the silent character of the film. Like the Tricycle Man and Willie Hart she is intriguing, and Altman

emphasizes her strangeness. In the scene where she enters a bathroom in the mansion after the ceremony and throws water on her reflection in the mirror, to which the camera then zooms to a close-up, the viewer is treated simultaneously to two familiar Altman motifs, the silent character and the reflecting surface, and a recognizable camera technique. Buffy speaks only to tell Dino that she is pregnant. Her intentional, manipulative silence recalls the young man in *That Cold Day in the Park* and to a lesser extent Willie Hart in *3 Women*. From the opening scene it is clear that she, rather than the bride, is her father's pride and joy – their relationship verges on incestuous. During the reception she drifts among the guests like a sprite, but a different side of her is brought to light when she poses topless for the crew filming the wedding, holding a bouquet and wearing a jerry-rigged veil. (She has superimposed herself over a scandalous painting of the bride in a similar pose, revealing that it was Buffy who actually posed for the portrait.) After her death, Nettie can also be considered a silent character, as a number of people drift in and out of her room, some realizing that she is dead and some not, but all revealing elements of their characters as they talk to her.

Altman must have drooled when he first saw the mirrored foyer to one of the mansion's bathrooms. The numerous full-length mirrors front cupboard doors that mostly store linen. Scenes in which rooms contain three or more full-length mirrors abound in the history of film, and they range from the comic (Chaplin's *The Circus*) to the dramatic and symbolic (Welles's *Citizen Kane*, Altman's own *Images*). Here Altman primarily uses the mirrored doors to advance the comedy: at different times we see various people, including the bishop, in states of urgency, confused by the choice of doors and what they expect to be behind the mirrors. But Altman also uses the mirrors for his particular way of presenting reality. When Dr Jules Meecham (Howard Duff), the lecherous, hard-drinking Sloan family doctor who is also Regina Sloan Corelli's personal Dr Feelgood, administers her a much-needed shot of morphine (her addiction is yet another family secret), we see it in reflection – the reflection being her true nature. We also see the reflection of Tulip Brenner (Carol Burnett), the bride's mother, who is clearly in a loveless marriage, after she has received a flower from Mackenzie Goddard (Pat McCormick), the groom's uncle, who has professed his sudden, impulsive love for her. Tulip literally lets her hair down and allows her sexual nature to come to the forefront of her personality, presumably after years of repression. However, this freedom is temporary, and by the film's end she has given in to her quasi-religious superstitions that God has sent her a message to break off her budding romance with Mackenzie.

The security team (Patricia Resnick, Dennis Franz, Margery Bond, John Considine) is another comic element (their reason for being there is funny enough, since the ceremony and reception are sparsely attended); they are an updated Keystone Kops. Fascistic and over-serious about their job, in two scenes in the gift room they exhibit the kind of tumbledown violence that characterized their silent predecessors. In both scenes they react violently to men they mistakenly perceive to be burglars: Snooks Brenner (Paul Dooley), father of the bride, and Dino Corelli, uncle and namesake of the groom.

In the end *A Wedding* sheds its farcical nature for tragicomedy. Critics chided Altman for the callousness the characters display at the end concerning the deaths of two of the characters, but in fact their callousness is really a reflection of the viewer's. The crash victims, out for a joyride in the newly-weds' car, were latecomers to the reception and unsympathetic characters. When it is ascertained that they and not the newlyweds have died in the fiery car accident there is collective relief, shared by the viewer, whom Altman has manipulated. Still, when the Brenners and Corellis decide to celebrate the 'good' news by drinking champagne, the film fires an over-the-top, mean-spirited and farcical arrow. *A Wedding*'s cynical ending, a comment by one of the bridesmaids to another on the beauty of the wedding versus the reality of marriage as the camera zooms out, achieves a partial recovery by bringing the viewer (to an extent) back to the point, but by then the message – the hollowness of the wedding ritual – seems an afterthought.

BY THE END OF THE 1970s Altman was ready to make another science-fiction film (if one considers *Countdown* as sci-fi), and as it happened one of his co-writers was Frank Barhydt Jr, son of Altman's Calvin Company mentor. The script they and Patricia Resnick wrote turned out to be based on a board game that Altman and others invented more or less simultaneously with the script. The film (and game) was called *Quintet* (1979), and Altman used an international cast led by Paul Newman and the Swedish actress Bibi Andersson. The strategy of the international cast worked to disorientate the viewer with different accents: *Quintet* is set in a dystopian future during an ice age that is gradually killing off humanity. It opens with two people, Essex (Newman) and a pregnant Vivia (Brigitte Fossey), trudging slowly across a frozen landscape to an unnamed, frozen city, where Essex's brother Francha (Tom Hill) lives. When they finally reach Francha they are invited to play a game of Quintet along with others who have gathered there. Essex admits that he has not played the game in years and is surprised that it is still popular, to

which Francha replies that there is 'nothing left but the game'. However, instead of playing, Essex goes out to purchase firewood.

The object of Quintet is to eliminate your opponents as you move, according to the roll of dice, around a pentagonal board. Each of the five players is the hunter and the hunted; the winner is the last player standing. (A sixth player joins the game when the original quintet is reduced to one.) Francha, a regular Quintet player in the city's 'casino', is part of the Quintet tournament that plays for keeps, hence his remark that there is 'nothing left but the game'. Each player has a list of other players – the so-called killing order – whereupon they hunt one another through the city's five sectors, marking the unnamed city as an outsized, frozen Quintet board. (*Quintet* was filmed among the abandoned buildings of Montreal's Expo '67.) The benign version of Quintet is played in a 'casino' as well as in individual dwellings, the casino scenes recalling the card room in *California Split*, with a number of players seated at different tables and a 'pit boss' announcing when a seat becomes vacant. However, this casino lacks the vibrancy of the card room (gloomy lighting accentuates its morbid atmosphere).

While out to get the firewood, Essex sees and hears an explosion across the way. Unbeknown to him, but not the viewer, a bomb has been tossed into Francha's living quarters. Essex hurries back to discover that everyone is dead, including Vivia, whose pregnancy is but a short-lived symbol of hope for humanity. The bomber, a Quintet player by the name of Redstone (Craig Richard Nelson), is this film's near-silent figure. Essex passes him as he hurries back to Francha's abode and surmises his guilt, or at least his complicity.

Redstone's intended victim was Francha, as part of the Quintet game taken to the level of reality. The rest were collateral deaths. Whereas the *California Split* poker players were in the respective games to win, the Quintet players are in the game to keep from losing. In the Quintet tournament in which Francha has become the first loser, the winning player merely maintains the status quo of remaining alive – but in a doomed world, everyone is preordained to lose. Society has become fatalist and nihilist, hence the game. It has also lapsed into a semi-technological state: there is electricity for lighting but not for heat. The only source of heat is fire, and even the clothing people wear is an imitation of medieval fashion. The bomb that kills Francha, Vivia and the others is really the only other example of sophisticated technology. The bombing of Francha's home elicits neither sympathy nor fear as explosions, heard elsewhere in the city, are common occurrences. The relentless cold has made the individuals indolent, uncaring of their fates beyond the game itself. There are hints of this in the beginning as Vivia and

Essex plod along outside the city, past frozen corpses being devoured by Rottweilers. Rottweilers also roam the city, surviving on corpses that no one has the will or energy to remove from the public space. When Essex returns to Francha's bombed-out quarters he surveys the scene as a pack of Rottweilers enters to devour the victims. But Essex keeps the dogs away from Vivia. The dogs are themselves quiet characters, neither barking nor fighting, simply roaming the city and its outskirts. When the camera is trained on them it is from afar; Altman refrains from zooming in on them.

Quintet's bleakness derives not just from the apocalyptic plot but from the plodding tempo that is a hostage as much of the environment as of anything else. Everyone simply moves more slowly on the snow and ice. Also, the overall whiteness of the land- and cityscapes gives a monochromatic feel to a movie filmed in colour, recalling the end of *McCabe & Mrs Miller*. Robert T. Self has pointed out that 'color, mood, and tone' are 'achieved through the use of an old still-photography diffusion filter'.[5] Altman and his cinematographer, Jean Boffety, also blurred the outer edges of the camera lens (by smearing Vaseline on it) to give the perimeter of each shot a frosted look. This served a number of purposes. It added yet another visual sense of the cold, and it focused the viewer's attention on the centre of the shot. It also presented the action as if through a window, thereby tricking the viewer into a sense of voyeurism. If anything, that strategy backfired on Altman, as it distanced the viewer too much to inspire any sympathy for the characters, their plight or their game. But the source of confusion for the audience is a lack of understanding of the game of Quintet, the motivating force of the film.

The story comes down to who is the best remaining Quintet tournament player: Deuca (Nina van Pallandt), Ambrosia (Bibi Andersson), Goldstar (David Langton), St Christopher (Vittorio Gassman) or Essex, who is drawn into the game. After eliminating Francha, Redstone, in turn, is murdered by St Christopher, who slits his throat. Essex comes upon the body soon after and discovers Redstone's player list and his personal Quintet playing pieces. At this point he decides to join the Quintet tournament. In doing so he assumes Redstone's identity, thus becoming another Altman double. His action is allowed by the game's adjudicator and embodiment of the society's evil decadence, Grigor (Fernando Rey).

St Christopher, the most interesting character in the film, is also Altman's most overtly ironic Christian symbol since the Last Supper tableau in M*A*S*H. And, like that tableau and like Barbara Jean/St Barbara in *Nashville*, death is at the core of his dual existence. He is both an expert Quintet player, ready to murder in the end-justifies-the-means tournament (he is the only tournament

player who kills two others), and a man who runs a mission house/church to rescue destitute citizens. He is also the only character to change his costume: when he kills Redstone he wears black; as he ascends a pulpit to deliver a sermon in the mission church he wears white. During his final confrontations in the Quintet tournament he wears a grey cloak. But no matter the colour of his garment, St Christopher wears crosses on his outer cloak and his hat, perhaps in recognition of his name, which means 'bearer of Christ'. Ironically, the sermon he delivers is actually a refutation of Christianity – quasi-Buddhist, but really New Age existentialism. Later, when Essex comes looking for St Christopher at the mission, we see him standing under a sign that bears the quotation, 'The earth is the cradle of the mind, but one cannot live in the cradle forever,' a translation from Konstantin Eduardovich Tsiolkovsky, the father of Soviet rocketry. (That quotation may be a clue to Altman's ambiguous contention that *perhaps* the film is set on another planet.) In the mission/ church we see the homeless approaching a vat of soup, arms outstretched, holding cups for the liquid to be ladled into. That scene has lost some of its chilling power over the decades, but in 1979, when *Quintet* was released, it was a visual reminder of the cultic mass suicide in Jonestown, Guyana, which had occurred the previous year.

No one falls for Essex's deception (although he does not know it), though Grigor, a kind of mad puppet-master of the game, acknowledges Essex's existential doubling by decreeing that since he, Essex, possesses Redstone's game pieces he is Redstone. This forces St Christopher to kill Essex/Redstone (in essence killing Redstone twice) if he is to advance in the tournament, because of the order of the kill list. The scene in which the two play cat-and-mouse over the frozen landscape recalls the running shootout between McCabe and the bounty hunters in *McCabe & Mrs Miller*, except that St

Christopher is done in not by Essex but by the landscape, a *deus ex machina* that refutes the viewer's expectations. Essex afterwards kills Ambrosia, the tournament's 'sixth player', before she can kill him to emerge as the tournament champion. He then abandons the city despite Grigor's arguments and appeals that he stay and continue playing. Confronting Essex in the casino, Grigor scoffs at his intention to travel north: 'You won't last a day and a half. You'll freeze to death.' Essex, personifying the last scrap of civilization's optimism and the film's ambiguous ending, responds: 'You may know that. I don't.' The scene ends with a slow zoom of the demonic Grigor standing behind the casino's warming fire, and the film ends with Essex trudging across the snowy terrain, his figure becoming smaller and smaller in the vastness. It is a scene that reformulates the ending of *Countdown*, presenting the optimism on Altman's terms.

A PERFECT COUPLE (1979) has the look and feel of a gentle romantic comedy, but, as in *A Wedding*, death in the penultimate scene suddenly transforms it into tragicomedy. This unexpectedness wrenches the viewer's emotions in a completely different direction, although the ending remains true to the genre. The story follows a familiar arc. Two people with different lifestyles meet through a video dating service, try too hard to connect, and fall in, out of and back in love. Alex (Paul Dooley) comes from a wealthy, conservative Greek-American family and helps to run the family antiques business. Sheila (Marta Heflin) is primarily a back-up singer in a funk rock band that lives communally in an old factory loft. The story is thus an updated *Romeo and Juliet*, and as such it works better than *The Delinquents* but far less well than *West Side Story*.

But this film, recalling romantic comedies of the 1930s and '40s, is also a musical in the style of *Nashville*, except that here the songs are sung either in band rehearsals or concert performance rather than clubs. Sheila's band, the clunkily named Keepin' 'Em off the Streets, is the film's version of the Greek chorus and its songs are the 'connective tissue'. (When Sheila steps out front to sing the lead on a song we glimpse the birth of drama, so to speak.) The problem is that the songs are too long (and too obvious), so that the commentary becomes a drag on the story.

One of the commonalities for Alex and Sheila is that each is caught in a cloying environment. For Alex it is the Old World-style family that eats, works and relaxes together; and although Sheila's 'family' seems looser, essentially their activities are circumscribed in the same way. Both groups

are dominated by patresfamilias: the Theodopoulos family is ruled by Alex's father, Panos (Titos Vandis), while lead singer Teddy (Ted Neeley) is the taskmaster of Keepin' 'Em off the Streets. Alex and Sheila are average-looking – the type of look that Altman generally but not always strove for in his characters during this period of his career. And of course what they have most in common is their loneliness, the thing that has driven them to the video dating service in the first place.

The film has the familiar Altman camerawork and overlapping dialogue, but his use of reflecting surfaces is moderated. There is some genuinely funny dialogue, especially the throwaway lines (mostly uttered by Alex), and three silent characters. One of these is Star (Melanie Bishop), Teddy's wife, who is an earth mother, always holding their baby, either sitting onstage or else moving about the set with the child as part of the interludes between songs. Her silence superficially appears submissive (especially when Teddy demands that she 'put down the goddamn kid and get me a beer'), like Colonel Blake's mistress in *M*A*S*H*, but her attitude and her pacing about recall *3 Women*'s pregnant Willie. Star's silence is also a strategy for maintaining her individuality among a group of musicians, much as Tommy Brown's wife's silence is in *Nashville*.

The other two silent characters are interesting for their narcissism. They are listed in the credits as 'The Imperfect Couple' (Fred Bier, Jette Seear). The Imperfect Couple appear throughout the film and are counterpoint to Alex and Sheila. They are visual representatives of what used to be called the 'beautiful people'. But more than photogenic, they are effortlessly in love, so much so that to them the rest of the world does not seem to exist. They are the people one sees on the street and is envious of when one is not in love. Meanwhile, in the manner of the romantic comedy, Alex and Sheila struggle every step of the way.

The Imperfect Couple are in the opening scene at a Los Angeles Philharmonic concert at the Hollywood Bowl – the setting for Alex and Sheila's first date. As the two hapless daters bumble their way through getting to know each another, the usual feckless communication cut short by a monsoon-like downpour that sends them and most others scrambling, the Imperfect Couple have come prepared with matching rain ponchos and an umbrella. Later, when Alex is rushed to hospital after being knocked unconscious by a poker-wielding Sheila (in a comedic 'I didn't really mean it' scene that recalls the film's screwball precursors), they are preceded in the cubicle by the Imperfect Couple. He is there because of a scratched cornea for which he is treated and given an eye-patch to wear that makes him look

A Perfect Couple: a date at the Hollywood Bowl is about to go awry.

even more dashing (which he intuits). Kissing, they ignore the doctor's final advice as they walk out of the cubicle.

When next they appear it is at a Greek restaurant, where Alex has taken another video service date (Ann Ryerson), he and Sheila having broken up. As the Imperfect Couple leave the restaurant the man drops something without noticing it. But Alex notices and runs after them in a failed attempt to return what turns out to be an invitation to a pre-tour press party for Sheila's band that Alex and his date decide to attend. For Alex, the emotional distress of seeing Sheila perform proves too much, and he leads his date out of the party. As the camera roves through the crowd it picks out the Imperfect Couple, who are connected enough to get in without their invitation, he, drink in hand, nodding recognition to others off-camera.

The Imperfect Couple appears on screen three more times. They browse in the showroom of the Theodopoulos antiques shop; they wait to check into a hotel where Sheila's band, on tour, is also checking in; and they are in the closing scene at the Hollywood Bowl, where their body language reveals that they are indeed the Imperfect Couple.

The film presents plot motivations that are unexplained and various tangents to the storyline, to which Altman seemed indifferent. One of the tangents is that two of the women in the band are lovers and one of them is pregnant – after a drunken tryst with another band member who is gay. They reveal this to Sheila and swear her to keep the secret from the dictatorial Teddy. And then, except for the occasional morning sickness, everything is fine. There is a second pair of lesbian lovers: Alex's younger sister Eleousa (Belita Moreno), a cellist in the Los Angeles Philharmonic and the one member of the family to whom he is close, and Mona (Mona Golabek), a pianist with

the same orchestra. The true nature of their relationship is less explicit (though they plan to move in together) and Eleousa's death – the tragedy near the film's end – cuts it short. Her death occurs when Alex is on the road following Sheila's band. He returns to see her coffin set up in the living room of the mansion in an old-style wake. Altman uses two quick zooms to provide an operatic feel to the scene. The first zooms in on Alex as he glances down into the living room from the second floor; the second zooms immediately from Alex downwards to Eleousa in her coffin, tracing a three-dimensional right angle for the viewer. From the coffin shot the film cuts to a montage of Eleousa. The emotional effect of this montage is similar to that Altman achieved in his montage near the end of the *Combat!* episode 'The Volunteer'.

Eleousa's death and Alex's subsequent disownment by his father leads to the final scene at the Hollywood Bowl – a nice dissolve from Eleousa in the coffin to Mona's hands moving gently on the piano keys – though we do not know how much time has elapsed. First we see the Philharmonic performing again, and Mona out front playing. This cuts, out of time, to Alex packing his things in his office overlooking the showroom, then back to Mona and the Philharmonic, with special attention to Eleousa's empty chair. The camera then pulls back to reveal that Keepin' 'Em off the Streets are also onstage with the Philharmonic, though they are not yet performing. Then another shot of Mona, only this time she is framed by the piano and its open lid. Behind her we see Star sitting off to the side with her baby, and from the wings emerges Sheila, who pauses, glances at the performance, then leaves the stage. The camera follows her as she weaves her way through the audience to find Alex, who has reserved seats for them both. They kiss in the aisle, take their seats and become the perfect couple as her erstwhile band, backed by the orchestra, performs the final song.

Altman provides a pop/operatic ending to disguise the fact that this type of film is supposed to end this way. The reverse *Romeo and Juliet* was never in doubt, though Eleousa's death is a shock despite Panos's earlier admission that she was gravely ill. But in keeping with his artistic philosophy that death was the proper ending to a story, Altman turned *A Perfect Couple* into a romantic tragicomedy whose plot feels correct for the clichéd reasons and false for the artistic ones.

ALTMAN'S POLITICAL SATIRE OF 1979, *HealtH* (also *HEALTH* or simply *Health*), takes the health industry as its extended metaphor. HEALTH conventioneers (as clunky as the band's name in *A Perfect Couple* – the

acronym stands for Happiness, Energy, And Longevity Through Health) have descended on the Don Cesar Hotel in St Petersburg, Florida, to elect the president of their organization and sell their products. From the outset the film introduces a favourite Altman motif – the female trio. The two major candidates, introduced on *The Dick Cavett Show*, are the octogenarian Esther Brill (Lauren Bacall) and the cerebral Isabella Garnell (Glenda Jackson).[6] Also present as a guest is Gloria Burbank (Carol Burnett), a deputy presidential adviser on health. Dr Gil Gainey (Paul Dooley, bearing a shock of white hair that is reminiscent of Elsa Lanchester in *The Bride of Frankenstein*), an independent candidate for president, interrupts the show's taping, protesting that he has not been allowed equal airtime. But more disastrous to the show's continuity is when Esther Brill suddenly falls into a catatonic state. Members of her entourage converge on her and the taping halts, but the loquacious Isabella Garnell is not to be denied. She continues her speech throughout the chaos. Her words are not the banalities uttered by Millie in *3 Women*, but they have the same effect.

Esther Brill is 83 years old but looks 30 years younger. The occasional catalepsy aside (she becomes catatonic five times during the convention), her formula for good health is sexual abstinence. 'Each orgasm shortens one's life by 28 days – one lunar month', she proclaims to her staff doctor (Ann Ryerson). Her campaign motto is 'The Pure President'. In addition to the doctor she has a few sycophants and a campaign manager, Harry Wolff (James Garner), who is Gloria Burbank's former husband. Isabella Garnell is an ascetic with only one staff member. Her demeanour is as high-toned as her speeches, which verge on the homiletic. Her campaign motto emphasizes this, labelling her the 'Voice of Vision'. Yet despite this there is no doubt that she is the more qualified candidate. It is unclear how serious Dr Gainey is. As the convention progresses he comes off as more the huckster promoting his Vital-Sea product. He even transparently fakes his death-by-drowning in the hotel pool.

Esther and Isabella are stand-ins for Dwight D. Eisenhower and Adlai Stevenson. Like Eisenhower, Esther is a parent figure whose charisma charms the electorate, while Isabella is the cool orator, as was Stevenson. In fact, some of Isabella's pronouncements and speeches are lifted from Stevenson. Probably more than any other aspect, the Eisenhower–Stevenson connection is responsible for the film's flatness. *HealtH* came out in 1980, but the electoral battles between Eisenhower and Stevenson were fought in 1952 and 1956. Given the events of the succeeding quarter of a century, few cared any longer about the outcome of those elections. And among Altman's core

HealtH: the endorsed candidates discuss health issues with a presidential aide on *The Dick Cavett Show.*

audience the Eisenhower–Stevenson connection may not have even been recognized – the hole in Isabella's shoe, an allusion to Stevenson, was an inside joke even then. The film more accurately parodied the upcoming 1980 presidential election, between septuagenarian and charismatic Ronald Reagan, the more technocratic incumbent Jimmy Carter and third-party candidate John Anderson. The hotel security team provides additional humour. The team is an allusion to the U.S. Secret Service and is as inept as the security team in *A Wedding*, and cornier. They prowl the convention floor dressed as vegetables.

Also attracted to the campaign is the hustler and political dirty trickster Bobby Hammer (Henry Gibson), hired by the mysterious 'Colonel Cody' (Donald Moffat), a behind-the-scenes conspirator. Both arrive at the hotel to ensure that Esther Brill wins the election. In a strange plot twist they focus their malevolence on Gloria Burbank, who has slowly come around to supporting Isabella Garnell's candidacy. First Hammer visits Gloria in her hotel room in drag, claiming that, like 'herself', Isabella has had a sex change operation. Then Gloria encounters Cody, who tosses out threatening hints while claiming to be the real head of the health organization and the conspiratorial power behind the White House. All along *HealtH* has strained for laughs, but here it has descended into such silliness that it no longer seems credible. Perhaps Altman felt that way too since, like *A Perfect Couple*, *HealtH* wraps up too quickly and neatly. Despite her bouts of catatonia, Esther wins the election by a landslide (echoing Eisenhower's two victories over Stevenson and foreshadowing Reagan's over Carter). And it turns out that Colonel Cody is in reality Esther Brill's crazy brother, Lester.

While Altman persistently directs the viewer's attention to the three women and their main characteristics – Esther's catatonia, Isabella's glossolalia and Gloria's nymphomania – there is a fourth woman on whom the film recurrently focuses: hotel public relations director Sally Benbow (Alfre Woodard). In *Robert Altman's Subliminal Reality*, Robert T. Self discusses briefly social critic bell hooks's notion of the 'oppositional gaze' vis-à-vis the minor African American characters in Altman's films. He writes, 'They represent figures within the story who designate an alternative gaze that deconstructs the narrative discourse in the first place – marginal, defensive, threatening, seeing.'[7] No character in an Altman film employs the oppositional gaze the way Sally Benbow does, though others, such as the Washingtons in *McCabe & Mrs Miller* and the Browns in *Nashville*, possess it, especially Tommy Brown's silent wife in *Nashville*, whose gaze is 'marginal' and 'seeing'.[8] Sally clearly regards the whole convention and election as a ridiculous offshoot of white culture. And since the convention and election are stand-ins for American presidential politics, her gaze and the opinion behind it are evocations of African American attitudes towards presidential politics in the years between the Civil Rights era and the election of Barack Obama, or at least Bill Clinton.

Altman employed his 'signature' techniques to good effect in this film. The moving camera and the overlapping dialogue (utilizing the occasional public-address announcement à la *M*A*S*H*) provide chaotic realism to the convention scenes. Talk-show host Dick Cavett's serving as a roving reporter on the convention floor allows a humorous but more personal look at the gathering. His presence in the film extends Altman's nascent mixing of reality with fiction begun in *California Split*. Altman honed his political satire later in the decade with *Tanner '88*, though *HealtH* marks the debut of the Allan Nicholls song 'Exercise your Right to Vote', which was used prominently in *Tanner*. The film also touches on the 'vast right-wing conspiracy' theory that Altman explored to less satirical but more paranoiac ends in *Secret Honor*.

If *HealtH* had been released to coincide with the 1980 presidential campaign, it might have had a better box-office reception. Instead it had very limited exposure. And despite a cast that included Glenda Jackson, Carol Burnett, James Garner, Lauren Bacall, Alfre Woodard, Paul Dooley and Henry Gibson, *HealtH* was never made available in either video or digital formats, as of this writing. It was the final film Altman directed for his own Lion's Gate Productions (though Lion's Gate was involved in post-production work on *Popeye*) and the last he directed for Twentieth Century Fox. Altman sold Lion's Gate Productions in 1981.

THE PROBLEMS THAT OCCURRED during the filming of *Popeye* (1980) have been well documented by Patrick McGilligan and others, and these troubles included Altman's clash with screenwriter Jules Feiffer.[9] Feiffer, playwright and long-time comic artist for the *Village Voice*, preferred the original 'Popeye' comic strip as conceived and drawn by E. C. Segar. It had a darker vision than the later, animated (and more popular) version. Although this darker version ought to have had a natural appeal to Altman, such a static basis could never appeal fully to a director for whom motion – visual and aural – was so important.[10] But the decision to make the film as a musical is what crippled the production. In Altman's previous musicals – *Nashville* and *A Perfect Couple* – the songs were presented in performance or in rehearsal. In *Popeye* they were presented more traditionally as soliloquies or large-ensemble numbers. Altman is on record as saying, 'I didn't want *Popeye* to look like a Broadway musical', but that is exactly the impression one gets – Broadway or Hollywood – whenever the songs are presented.[11] Other than his use of non-professional singers as his leads, his attempt to rework the Hollywood musical was more of a capitulation to the genre than anything else – though it may be parody articulated too close to the mark.

The dichotomy between Feiffer's darker vision and Altman's lighter one is presented right from the beginning. Suddenly the dark, lightning-charged, stormy sky that has been harassing a lone sailor rowing a dinghy on the sea (there is a brief moment when the dinghy disappears into a trough) turns into a blue, sunny day as the dinghy and the camera's focus turns to the town of Sweethaven. (Thus the opening visually serves up the cliché 'any port in a storm'.) The sailor, of course, is Popeye (Robin Williams), and he has arrived in Sweethaven in search of his long-lost Pappy, who had abandoned him years earlier. As Popeye rows closer and closer to the dock the citizens bustle about singing their national anthem, 'Sweethaven', whose ironic lyrics, reinforced by an upbeat melody, reveal the isolation of the port city and despotic rule under which the citizenry lives. Sweethaven, as Popeye and the viewer discover, is ruled by the shadowy Commodore (Ray Walston) through his iron-fisted sheriff, Bluto (Paul L. Smith).

Popeye also discovers that working for these two is a taxman (Donald Moffat). And since the raison d'être of a taxman is to collect taxes, he has enhanced his importance by taxing everything possible. (The taxman tools around Sweethaven on a steampunk trike, a prototype of the Tricycle Man's machine.) As a newcomer Popeye at first goes along with paying his taxes, but it is clear that his presence in Sweethaven will eventually upset the status quo. This, in itself, makes him an Altmanesque character.

Sweethaven, as many have noted, bears a strong visual and existential resemblance to Presbyterian Church in *McCabe & Mrs Miller*. Both are outposts: one a mining town at the edge of what is left of the American frontier, the other a dilapidated port town such as usually appear in literature and on screen. That we are later told the song 'Sweethaven' is the national anthem is a clue that the place is a sort of city-state or island-state, much like Malta, where *Popeye* was filmed. An interesting connection between Sweethaven and Presbyterian Church is the town drunk in each. Both are played by Robert Fortier, who wore the same costume in both films. Conceivably, he could be the same man. If so, in *Popeye* we get the comic rather than pathetic aspect to the character this time around.

With Altman, characterization and backstory (revealed or not) are a film's centre, and it is no different with *Popeye*. The casting of the leads – Robin Williams in his first film role and Shelley Duvall (as Olive Oyl) in her seventh and final film for Altman – gave the film added visual power as both, especially Duvall, bore strong physical resemblance to the cartoon characters. Their verbal asides, mostly wisecracks and mumblings, are not only spot-on characterizations of their animated counterparts but are made for Altman's signature audio style (and place them in a line of Altman mumblers that includes Elliott Gould's Marlowe and Warren Beatty's McCabe). At their best their physical antics encapsulate the essence of the animated version. Duvall, with her tall, rail-thin physique, was especially able to capture the twisty motions of the animated Olive Oyl. However, the film often displays elements that are too cartoonish, presenting the viewer with two-dimensional characters but expecting empathy.

Popeye: Popeye and Olive return to the Oyl boarding house after finding Swee'Pea.

It is the supporting cast that provides the film with its real interest. Olive Oyl's mother, Nana (Roberta Maxwell), father, Cole (MacIntyre Dixon), and brother, Castor (Donovan Scott), along with Olive run the boarding house where Popeye puts up. There are two other boarders – Geezil (Richard Libertini), a street pedlar, and the incomparable Wimpy (Paul Dooley), he of the signature line 'I'll gladly pay you Tuesday for a hamburger today.' Here, though, Wimpy is not the guileless panhandler depicted in the cartoons. Cole Oyl is distinctive because not only does he demand apologies throughout (much as the Taxman demands taxes), but his hairstyle is reminiscent of some of the munchkins in *The Wizard of Oz*. Including these five there are more than four dozen *commedia*-style townspeople in the cast (one of whom is named Pickelina), including the chief bottle washer and cook of his own café (and catering service), Rough House (Allan Nicholls), who, despite his name, remains blasé during a dust-up in his restaurant between Popeye and some bullies and even snoozes through Bluto's destructive tirade at the Oyl boarding house. There is the near silent Harry Hotcash (David McCharen), dressed like a character in *Guys and Dolls*, and we spot him trying to hide his thin frame behind light poles or holding a newspaper in front of his face to pass unnoticed. His costume defines his character, and the only time we hear him speak is to call the mechanical horse races at Sweethaven's gambling den-cum-brothel. (A kinky touch to the Popeye oeuvre.) Bear (John Bristol) is completely silent and described in the credits list as 'The Hermit'. He is always in the background or on the edge of scenes, but the camera never misses him. There is another near silent character and that, of course, is Swee'Pea, the abandoned baby who makes gurgling sounds and forms proto-words. (The infant who played Swee'Pea was Altman's grandson Wesley Ivan Hurt.)

These characters inform Sweetwater much as the supporting characters informed the mining town in *McCabe* or the army base in *M*A*S*H*. But more so than the supporting characters of those earlier films (or any previous Altman movie), they give *Popeye* the verve upon which the film ultimately leans.

Any viewer with the slightest familiarity with the Popeye cartoons could expect the Bluto–Olive–Popeye triangle and its outcome; the Altman-Feiffer twist was to make Popeye's long-lost papa (or 'Poppa'), Poopdeck Pappy, the mysterious Commodore. The final dramatic sequence is set off when Wimpy kidnaps Swee'pea and turns over the baby to Bluto. Gerard Plecki contended that the price for Wimpy's perfidy was a sack of 30 hamburgers (which would make it yet another Christian reference), but while

we see Bluto deliver the sack of burgers, the quantity is not mentioned.[12] Nevertheless, Altman did insert Christian imagery into the film. That evening, as the camera pans Popeye's makeshift dockside quarters right to left, we see what appears to be a cross atop a rusted metal container, which the daytime shot does not have. The pan creates a mural with Popeye in his hammock on the far left, agonizing over the loss of his adopted son and his own inadequacies. But in the end all is rectified in an unambiguous, un-Altmanlike way. Popeye as an agent of Sweetwater's revolution had already accidentally tossed the taxman into the harbour to the cheers of the no-longer-oppressed townspeople; a rehabilitated Poopdeck Pappy rescues Swee'pea while Popeye battles Bluto. Altman delivered a cartoon complete with a cheesy octopus prop and a sappy ending. His audience perhaps expected something a little more sophisticated, but the film's best lines are Popeye's and Olive's asides – throwaways, as they used to be termed.

On the technical side there are some nice visual effects: Bluto's anger upon seeing Popeye, Olive and Swee'pea where the camera moves from a close-up of the angry spurned fiancé to a shot of the trio from Bluto's point of view – everything is red. Or iris shots that never actually close the scene to blackness but instead reveal the next scene in the small circle – rather like a porthole – before widening. There is a second playing with colour at the film's end when Bluto chooses to swim away rather than continue fighting Popeye. We see his yellow figure swimming against the blue Mediterranean. But for some reason the pun is also delivered verbally by one of the characters – 'Look! Bluto has turned yellow!' – so that tiny pleasure is muted.

FOR THE REST OF THE 1980s Altman turned his attention primarily to theatrical adaptations for television or film. His only other feature of the decade was so unmarketable that it was not released for two years. *O.C. and Stiggs* (1985), based on stories published in *National Lampoon*, set out to satirize suburban American life in the early 1980s and parody the teenage movies that had become popular in that era.[13] Altman was again bending a genre, only this time the genre was a contemporary favourite for which the director bore no admiration. The result was a parody rather than a reinvention, for which it appears that Altman really did not have the heart.

Set primarily in and around the suburb of Scottsdale in Phoenix, Arizona, the story revolves around two friends, the eponymous O.C. (Daniel Jenkins) and Stiggs (Neill Barry), during the summer between their junior and senior years in high school. Their greatest joy in life is to prank and harass

the Schwab family, whose patriarch, Randal Schwab Sr (Paul Dooley), is the owner of an insurance agency and an Archie Bunker-like bigot. The reason for their animosity is that Schwab's agency has cancelled O.C.'s grandfather's (Ray Walston) retirement insurance, thus forcing his upcoming move to a nursing home since he cannot afford a home healthcare worker (a premise that anticipated the twenty-first-century healthcare debate in the United States). It will also force O.C.'s undesired move to Arkansas, since he lives with his grandfather. The two friends are also Afrophiles: O.C. is a fan of the Nigerian singer King Sunny Adé, while Stiggs has a fixation with Gabon and its leader, the autocratic President Bongo.

Initially, the viewer sees a shot of a tiny flag of Gabon attached to a car aerial as the car weaves through the streets of Scottsdale, while the soundtrack gives us a run-through of the dial on the car radio, in effect revealing the restlessness of a teenage boy searching for a good song. O.C. and Stiggs are driving to the Schwab mansion to harass the family. After they pull off a minor feat (they steal lobsters off the barbecue grill) and tap into the family's telephone line to call President Bongo in Gabon, the story moves to flashback and their summer high-jinks. Essentially these include numerous pranks on the Schwabs, including disrupting Lenore Schwab's (Laura Urstein) wedding; going to Mexico to attend a King Sunny Adé concert; staging a Sunny Adé concert of their own; befriending Schwab's smarmy but good-hearted neighbour (Martin Mull); holding a fake charity benefit at the Schwab residence; O.C.'s falling in love; and having enough money fall into their laps for O.C. and his grandfather to avoid having to leave their home.

This actually sounds like a teen movie of the period, and that (as critics noted) is the problem with the film. In *O.C. and Stiggs*, Altman presents a parody of a teen movie that is merely a bad example of it. Furthermore, the

O.C. and Stiggs: O.C. and Stiggs prepare to call Gabon after tapping into the Schwab phone line.

film's misogyny and homophobia pander to those it pokes fun at and drain the film of its satirical pretence.

O.C. and Stiggs also satirizes *Apocalypse Now*. Dennis Hopper's character, the whacked-out, marijuana-growing survivalist Sponson, is a comic take on his manic photojournalist in the earlier film. There is even a scene late in the film where Sponson and his survivalist buddy rescue O.C. and Stiggs from the Schwab residence via helicopter, complete with Wagner's 'Ride of the Valkyries' playing in the background.

Altman pokes a little fun at his own film *A Wedding*. The choreography of cars leaving the Schwab wedding ceremony parodies the choreography of cars arriving at the Sloan-Corelli mansion in the earlier film. Furthermore, the same actor, Paul Dooley, plays the father of the bride in both films. Schwab is a harsher, more mean-spirited version of *A Wedding*'s Snooks Brenner. For him the family scandal is not that his daughter is pregnant, but that his daughter has just married an Asian American.

O.C. and Stiggs has a few interesting moments and contains one perfectly subversive Altmanesque scene. In lighting out for a King Sunny Adé concert in Mexico, O.C., Stiggs and their slow-witted pal Barney (James Gilsenan) travel south by way of various rivers on which they float on inner tubes. In doing so they sneak across the border undocumented and in the reverse direction – the three suburban white boys are literally and figuratively 'wetbacks', the offensive term formerly applied to Mexicans who had entered the United States illegally. While in Mexico, they attend a fiesta where the concert is to take place, and Barney finds himself trapped in a mirrored funhouse room bathed in sickly green lighting. The side with the funhouse entrance is a glass wall so passers-by can watch the frustrations of those who get lost. There is a distorting mirror next to the entrance so that as an anguished Barney recites the mantra 'There's no place like home' (yet another *Wizard of Oz* reference), Stiggs admires his attenuated self in the mirror – Altman finally, and explicitly, admitting the purpose of his reflected imagery. But the film's truly transcendent moment comes when Altman again turns the viewer into a Peeping Tom.

The camera focuses on a man giving a political speech on television. His voice is familiar, but his face is not. The candidate, seated at a desk with the American flag behind him, spouts a conservative-libertarian mixture with which the elder Schwab is in total agreement. The camera then pulls back to take in the entire Schwab living room and family – Randall, his tiresome, dipsomaniac wife, Elinore (Jane Curtin), his nerdy son Randall Jr (Jon Cryer), his daughter Lenore and her husband, Frankie Tang (Victor Ho) – watching

television. (There is also in this scene a hint of incest between Schwab and his daughter, not unlike that between Snooks Brenner and his eldest daughter, Buffy.) Comparing the United States to the Roman Empire, the candidate queries rhetorically, 'Did art and literature and music save the Roman Empire?' ('Sure did not', Schwab answers.) 'Rome was full of statues, teeming with art . . .', the candidate continues as the camera reveals the bad art in the Schwab living room. The camera then pans to the left, and through the sliding glass patio doors we see O.C., Stiggs and their dates ('sluts', as the protagonists refer to them) sneak on to the Schwab property, intent on skinny-dipping in the Schwab pool. Only Randall Jr sees them, but as he tries to alert his father the elder Schwab shushes him for interrupting the speech (though he, himself, has been interrupting it). After the naked foursome jump into the pool the camera switches to a reverse angle perspective showing the television through a different set of closed, glass doors. Altman cuts back to the pool where O.C. and Stiggs also see the television and recognize the candidate and speak his name – Hal Phillip Walker (Thomas Hal Phillips), the disembodied political voice of *Nashville*. Unfortunately the film has too little of this kind of multi-layering, and in his rush to wrap everything neatly Altman neglected to (or perhaps deliberately chose not to) close the frame of the opening scene that reveals the body of the film as a flashback.

DURING THE YEARS between *Popeye* and the release of *O.C. and Stiggs*, Altman pursued other outlets for his creativity, and these included television. By 1980 the medium had changed drastically since Altman's firing by *Kraft* in the mid-1960s. Cable television offered broader freedom of expression than broadcast. Prior to directing *O.C. and Stiggs* Altman had directed two plays for HBO (Home Box Office), one of the earliest premium cable channels in the United States. During the years prior to the release of *O.C. and Stiggs*, and even after it was released, he continued to direct plays and plays adapted for television or film. These were generally smaller, more intimate works. Altman, who years earlier had vowed never again to work in television, now found the medium to his liking. For the rest of his life he would drift back and forth between the small and the big screens.

PART THREE
EXILE

8 The Play's the Thing, Part One: Television Work

ALTHOUGH HE EVENTUALLY managed to come up with the financing for *O.C. and Stiggs*, Robert Altman was pretty much persona non grata in Hollywood in the early 1980s after the string of films that concluded with *Popeye*.[1] Instead, he turned to theatre for his creative outlet, adapting dramatic works for television and film. His community theatre experience back in his Kansas City days was more than enough for a man of his confidence to parley with his artistic reputation, even a slightly damaged one. But there was another factor that played into this: the early 1980s was a time of experimentation and growth in the U.S. cable-television industry as it sought to capture viewers from the entrenched broadcast networks and independent channels. A production company that catered to the cable market, Alpha Repertory Television Service (ARTS), took a chance on two one-act plays that Altman had successfully staged for the Los Angeles Actors' Theatre in the summer of 1981.[2] These were *Rattlesnake in a Cooler* and *Precious Blood*, both by the actor/writer Frank South. Altman filmed both plays in Manhattan that autumn and they were shown on U.S. cable television in 1982, under the collective title *Two by South*.

Rattlesnake in a Cooler is a monologue about a Kentucky doctor (Leo Burmester) who throws over his practice and family to go out west and pursue his dreams, which are entwined with myths propagated by popular culture about the American West. These boyhood dreams, he reveals during the course of the hour, were inspired by a collection of Tex Ritter records he and his mother listened to. Altman's direction retains the feel of the work as a theatre piece while utilizing the visual flexibility of the camera. Initially it is not the man dozing on a wooden bench that Altman closes in on, but the radio/boom box, then a stool and a cowboy hat. Altman is directing the

viewer's eye, but not in a way that is radically different from how a member of a theatre audience might view the *mise en scène*. (In his earliest translations of theatrical dramas to television and film Altman felt his way through the transitions. His camera instinct, however, was enough to guide his aesthetics beyond that of merely filming a play.) The radio plays a song, and after a while a man descends the stairs (partially hidden by a wall) at the back of the set, and the camera pulls back to reveal more of the set. He is the embodiment of the singer/guitar player on the radio. The dozing man rises and sings a bit of a duet with him. Eventually the voice retreats up the stairs, and the man turns off the radio; the song ends abruptly. Light comes through a hole in the ceiling.

The unnamed man reveals that he is the middle-class son of a dentist and housewife; that he went to high school in Berea, Kentucky, then on to the University of Kentucky in Lexington and to the University of Kentucky medical school. Eventually he settled into a small practice in Boonesborough and married. As he tells his life story, the man enacts different characters, while the camera sometimes tracks him as he paces his tiny room, sometimes closing in on him. The pacing and the close-ups reveal the claustrophobia of the shack just as his life in Kentucky was claustrophobic.

When the man's narrative transports him to Colorado and New Mexico, his narrative becomes as expansive as the imagined setting, which the actual setting counterpoints. In New Mexico, he tells us, he and a friend run into trouble with the law, and the narrator bashes in the skull of a police officer with a tyre iron. While fleeing the crime their car runs out of fuel, but a carful of drunken cowboys pulls up and things take an even creepier turn for the narrator, including the appearance of a rattlesnake on the dashboard and a meaner rattler in a cooler in the car's boot. The upshot is that the storyteller is beaten by the cowboys and turned over to the police. What appeared to be his shack is really a prison cell, the 'window' in the ceiling closes, and the storyteller, his story up to date, ascends the steps. A moment later the ceiling trapdoor reopens and the storyteller's legs and boots dangle through it. While the boombox plays music the singer descends the stairs once again. The existential conclusion to which the erstwhile doctor's abbreviated autobiography points is that the failed pursuit of dreams, especially dreams engendered by mythology, leads to a claustrophobia that can be relieved only by death.

Precious Blood, the other half of the *Two by South* presentation, was a three-character play (Alfre Woodard, Guy Boyd, Leo Burmester) about 'conflicting memories of family and a rape'.[3] These two plays effectively

set Altman on his path of filming plays either for television or as features during the 1980s, occasionally making forays into theatre itself.

ALTMAN RETURNED TO TELEVISION three years after presenting *Two by South*. In those intervening years he had directed three adapted plays for feature films and had also directed two of these for stage (see Chapter Nine). His next television effort, *The Laundromat* (1985), was another one-act play – Marsha Norman's *Third and Oak: The Laundromat*.[4]

Altman's technique had evolved, enabling *The Laundromat* to have the more 'open' look that he strove for. It begins with a shot of a car pulling up to a laundromat. There are also shots of the building across the street, which houses a Mexican restaurant on the first floor and apartments on the second. Inside the too-bright laundromat a camera pan allows Altman to give the viewer a quick tour: washing machines, dryers, rolling laundry baskets, vending machines for washing powder and snacks, pinball machines (whose themes are Muhammad Ali and, coincidentally, Popeye), a wall clock, a radio and a sleeping attendant, who dozes in the tiny office. Again and again Altman will return the viewer's gaze to the attendant, who manages to sleep through the customers' shouting and laughing and the radio's ongoing music. By forcing the viewer to acknowledge the attendant's presence, Altman makes him a character in the scenario – another of his silent figures. The attendant awakens only at the very end, and even then remains silent. Throughout the film his opposite is the radio, which never shuts off. Disc jockeys speak, but mostly it is music we hear in the background, and most of the songs are sung by blues legend Alberta Hunter.

There is doubling and redoubling as one of the two main characters is Alberta Johnson (Carol Burnett), a middle-aged woman who seems as out of place in the laundromat, especially at three in the morning, as twenty-something DeeDee Johnson (Amy Madigan), unrelated to Alberta, seems to belong. DeeDee lives in one of the apartments across the street. The late hour and the garish lighting contribute to an ominousness which a quick shot of DeeDee's blood-stained panties, moments before she stuffs them into a washing machine, briefly reinforces. As the women become acquainted Alberta refers to the attendant as Sleepy, and this sets off DeeDee trying to name the Seven Dwarfs. Although this is original to the stage play it nevertheless recalls the cementing of Bill and Charlie's friendship in *California Split*. DeeDee is just as unsuccessful as they were. Alberta, a retired schoolteacher, then suggests DeeDee try naming seven U.S. presidents, a task at which the

younger woman succeeds only with Alberta's help. What is interesting is that neither woman places Lyndon B. Johnson or Andrew Johnson on the list, revealing their tenuous holds on the Johnson name.

Alberta and DeeDee each harbour a secret, and given the short duration of the play their secrets must unfold quickly. Nevertheless, there is enough byplay between the two women and a third customer of the laundromat that the drama flows evenly. Their secrets involve their husbands, and they are fairly easy to guess. In fact, DeeDee does guess that Alberta's husband is dead. Alberta is finally washing his clothes, sneaking out in the middle of the night to do so. She launders everything but the shirt he wore when he died, which she had brought along accidentally. DeeDee's secret is that her husband is unfaithful.

When an African American man comes in to do his laundry the tone takes another turn – reflecting Altman's use of American racial tension to manipulate the viewer's feelings – until DeeDee recognizes him as Shooter (Michael Wright), a popular local DJ who also does voiceover commercials for the Mexican restaurant across the street. Shooter's dialogue is loaded with double entendres (reinforcing another stereotype), and he trades them back and forth with DeeDee. But she remains faithful to her unfaithful husband.

During the revelations of their secrets Alberta and DeeDee move around the laundromat, but not so much as to strain credibility. It is Altman's camera that moves more fluidly for the viewer's eye, occasionally capturing the women in some wonderful frames: DeeDee's reflection in profile in the tiny mirror or, better still, Alberta's visage framed by the round window of an open dryer door. There is a bit of the two women talking over each other in a naturalistic manner, but the real overlapping is not dialogue but the women talking with the radio playing in the background. Sometimes during a silence you catch a bit of a song, and then you strain for a second or two to continue listening to it as the women's talk smothers it. (Neither Alberta nor DeeDee is interested in the music.) The songs themselves are keyed to the dialogue. With titles like 'Downhearted Blues', 'My Handy Man ain't Handy No More' and 'Black Man', Alberta Hunter is a sort of guiding light for the two women. It also replicates the way Altman made use of music as plot commentary in *A Perfect Couple*.

The Laundromat has an ending that is simultaneously feel-good and ambiguous. DeeDee has been glancing out of the laundromat window periodically, checking her apartment across the street to see if her husband has returned. Each time she sees the dark apartment her frustration and anger build. Finally, Alberta spots the apartment light and alerts DeeDee, who must

make short- and long-term decisions about her marriage. As for Alberta, she decides finally to wash her dead husband's shirt and cathartically dumps a nearly full box of detergent into the washing machine. As the suds overflow, both women erupt with laughter. The attendant awakens suddenly and grabs a mop.

IN 1987, SIX YEARS after he had filmed *Two by South*, Robert Altman again combined a pair of one-acts by a single author, this time Harold Pinter. The plays were *The Room*, Pinter's first work, written and produced in 1957, and the better-known *The Dumb Waiter*. Altman then combined them under the rubric *Basements* (not to be confused with another Pinter work, *The Basement*).

Except for the two exterior scenes that frame the film, *The Dumb Waiter* takes place in the basement of an abandoned building where two hit men, Ben (John Travolta employing a cockney accent) and Gus (Tom Conti), await their next victim. Unbeknown to them, one of them is the victim. This two-character play – or three if one includes the mechanical dumb waiter – is a darkly comedic meditation on the silent manipulation by the corporation vis-à-vis its workers. That the dumb waiter and the speaking tube are creaky throwbacks to an earlier mechanical era make it all the more ironic.

Altman's roving camera, the long shots he employs and the comic byplay between the two men relieves the setting of any sense of claustrophobia it might impart. In fact, the basement is large. When the dumb waiter (the device and the title a play on all Altman's silent characters) comes into effect the story takes on the tone of Charlie Chaplin's *Modern Times* (1936), only instead of an all-seeing boss barking orders from a video screen, an unseen third person sends down a menu order and later complains to Ben over the speaking tube about the poor quality of the milk and snacks sent up to the invisible and inaudible speaker, courtesy of Gus. That we can neither see nor hear the hit men's boss drives home the play's ominousness even as it adds another dimension to Altman's silent-character motif.

Ben and Gus take turns completing a simple jigsaw puzzle, recalling the jigsaw puzzle in *Images*. Ben times himself when he completes it, and afterwards Gus takes it apart. When Gus returns to the puzzle he discovers that a piece is missing. For Gus, the missing piece is a clue to his character and fate, and is in keeping with his sad-sack appearance, heightened by Conti's visage and his body language. Gus is the older comic foil who accidentally sends his gun up the dumb waiter.

The Dumb Waiter.
Gus and Ben receive
their first message
from the dumb
waiter.

Ben is the one in charge, despite being the younger of the two by at least ten years. He is the more senior man in the 'corporation'. This not unheard-of reversal is subtly justified by his blind acceptance of the situation. He is the company man, too callow to think otherwise. He never questions their circumstances or their existence the way the unsophisticated Gus does. His choice of reading material, a Fleet Street tabloid, reveals his own lack of sophistication, while his immaturity is exposed in his playing with his revolver – aiming it first at Gus and then pretending to commit suicide: pointing it at his temple, placing the end in his mouth and up against his chest.

Pointing the gun at Gus is a visual foreshadowing of the drama's climax, but it is not the only clue. The other is textual. When Ben and Gus run through the orders that Ben issues – their modus operandi is exactly the same for every hit – Gus notices Ben has forgotten to mention the point at which he unholsters his own gun. During this byplay of Ben running through the orders and Gus repeating them, we see the two hit men in close-up, Ben in tight close-up. Soon after this Gus loses his gun by accidentally placing it in the dumb waiter, which then rises. He thereupon leaves the basement; one assumes he has gone to retrieve his gun and see who is upstairs sending the messages and requests. His footsteps are heard crossing the basement ceiling. Immediately the whistle from the speaking tube blows and Ben, upon answering it, learns that the victim has arrived. He unholsters his gun, points it at the door, and a dishevelled Gus tumbles in. The close-ups Altman delivers parallel the close-ups during the instructions. Ben briefly lowers his weapon, but then raises it again. The camera then focuses on the dumb waiter. As it creakily descends we hear a single gunshot.

The film ends with an exterior long shot of Ben leaving the building and driving off down the snowy road just as a cleaning company van arrives on the scene. It appears to be a commercial company, but the audience, with information gleaned from Ben in a dialogue with Gus, knows that it is a division of the murder-for-hire corporation.

THE PRIMARY SETTING of *The Room* is a bedsit in a large lodging house. A middle-aged couple, Rose (Linda Hunt) and Bert Hudd (David Hemblen), occupy the room. Together they fulfil the Altman archetypes of talkative/silent characters. Rose dominates the opening scene (as she does the play) with her nonstop chatter and observations. While she talks Bert silently goes about his hobby of creating a model room inside a bottle – a hermetic symbol of their environment. In fact the drama opens with a close-up of a tiny table balanced upside down on a homemade instrument for placing miniature objects inside the bottle. Slowly the instrument is manoeuvred through the bottle's neck and into the miniature room, but Bert fails to place the table correctly. Undaunted, he merely takes a drag on his cigarette. The metaphor is deliciously obvious, but mitigated by close-ups of the bottle and the room's construction and decoration. Bert continues his work even after the arrival of Mr Kidd (Donald Pleasence), another occupant of the house, whom we had seen returning home earlier in the film's only fully exterior shot.

Mr Kidd had once lived in the Hudds' room but now resides in the basement. He tells a few stories about the room and the house in general before leaving. Soon after his departure Bert leaves to go to work; he is an independent truck driver. Not once has he spoken. We then see him outside, framed in the same window through which Rose views him.

The Room: Mr Kidd about to take his leave of Bert and Rose Hudd.

Soon the couple, Mr and Mrs Sands (Julian Sands, Annie Lennox), arrive in the room. The viewer has first seen them, as did Mr Kidd, through a window as they mount the front steps. (Windows serve the same function in this hermetic world as they do for Frances Austen in *That Cold Day in the Park*.) They are a young couple searching for the landlord, as they hope to rent a room in the building. They explore the building from top to bottom in search of the landlord – we are even given an overhead shot of them climbing the inside staircase. They wander about the basement while Mr Kidd is visiting the Hudds. They eventually amble to the Hudds' room, surprising Rose Hudd just as she opens her door. She invites them in to warm up. Mr and Mrs Sands, metrosexually chic and dressed in accessorized black leather, superficially represent gentrification (or the possibility of it), but the black they wear, far from evoking cool, is portentous.

They are an ominous couple, with violence lying just below the surface of their relationship – especially Mr Sands. A disembodied voice in the basement has advised them that a vacancy would soon open in the building. The vacancy, it turns out, is the Hudds' room. During their brief stay in the room Mr Sands picks up the room-within-the-bottle without noticing what it really is. He holds the bottle menacingly by the neck and waves it around before returning it to the table right-side up. As Rose returns the bottle to its horizontal position, a close-up reveals what the viewer has already surmised: the miniature room is in shambles.

Mr Kidd re-enters the room after the couple leaves. Both he and Rose are in an excitable state and their dialogue overlaps – each too busy relating their news to listen to the other. Finally Mr Kidd makes it clear to Rose that he is an intermediary for Mr Riley (Abbott Anderson), who has been living in the basement for the past few days and now desires to visit Rose. Rose agrees to the visit, although her assent is pro forma as, in cross-cutting, we see that Mr Riley has already exited the basement and begun slowly to ascend the staircase. Actually it is Riley's shoes and white cane we see – the latter a signifier that he is a blind man. After he enters the Hudds' room the viewer discovers he is black. His blindness prevents him from possessing the 'oppositional gaze', but in any case Mr Riley is a messenger, not a critic.

Mr Riley is an autochthonous figure risen out of the depths to call Rose to deny her present life and identity and return to her past. Seated in the Hudds' rocking chair (just before he entered the room there was a close-up of the tilted rocker in the room-within-the-bottle), he tells Rose that her father wants her to come home. He repeatedly calls her Sal, and she repeatedly asks him not to, finally scolding him the way Pinky had scolded Millie

in *3 Women*. Like the women of *3 Women* and Albuquerque and L. A. Joan in *Nashville*, Rose has reinvented herself. Throughout their conversation Rose has been alternating between anger towards this stranger in her home and flirting with the blind man. It is a funny yet pathetic flirtation. He cannot see her body movements, of course, nor her wry smiles, nor her hair after she has undone some hairpins. This last makes her cut a ridiculous figure, just as when, for naught, she puts her foot up on a chair and hikes up her skirt to show off a bit of leg. And although Mr Riley can undoubtedly smell the perfume she has put on, he fails to remark on it.

In the midst of Mr Riley's delivering his message, Bert Hudd returns. He speaks now, reassuring Rose that he is fine after driving his rounds. While listening to her husband, Rose seems to be afflicted with a temporary blindness. As he describes his driving, Bert picks up the bottle he had been working on that morning. During his soliloquy he appears not to have noticed Mr Riley, but when the latter addresses him ('Mr Hudd, your wife . . .') he cracks the blind man over the head with the bottle. Mr Riley is either unconscious or dead as Rose proceeds to fasten the three locks on the door, and a close-up of one of the locks is the final shot. Rose is determined to keep her past (her life as Sal) from drawing her out of the room and the future (the Sands) from displacing her.

ALTMAN'S FINAL PLAY ADAPTATION for television – in fact, the last play adaptation he directed for either the small or large screen – was Herman Wouk's *The Caine Mutiny Court-Martial* in 1988. The story already had a lengthy history. Wouk published the novel *The Caine Mutiny* in 1951. It won the Pulitzer Prize the following year. In October 1953 his play *The Caine Mutiny Court-Martial* premiered under Charles Laughton's direction in Santa Barbara, California. Then in 1956 the film *The Caine Mutiny*, directed by Edward Dmytryk, was released. The fictional story revolves around whether the executive officer of a destroyer/minesweeper in the Pacific Ocean during the Second World War had the right to relieve the ship's captain of his command during a typhoon. The guilt or innocence of Lieutenant Stephen Maryk (Jeff Daniels) hinges on the mental competence of the commander, Lieutenant Commander Philip Francis Queeg (Brad Davis).

Except for the excision of two characters, Altman's version follows Wouk's play faithfully. In fact, the actors were surprised that Altman did not want them to improvise any lines. The director's strategy was that the actors' discomfort with what was on the page would translate into discomfort in

The Caine Mutiny Court-Martial: Greenwald and his client, Maryk, listen to Lieutenant Commander Queeg's testimony.

the courtroom.[5] The play is set in the final months of the war. The wartime stresses are important to the drama because they give it a range of character motive and action that marks it as a complex companion (albeit without the religious orientation) to Altman's other court-martial work of 25 years earlier, 'The Long, Lost Life of Edward Smalley', also set, in flashback, during the Second World War. While the outcomes of the courts martial in 'Smalley' and *Caine* are the same – both accused are acquitted with the assistance of lawyers who pursue win-at-all-costs strategies – the results are different for the men and their lawyers. The remorse of Lieutenant Barney Greenwald (Eric Bogosian), Maryk's attorney, is very similar to that of Private Edward Smalley, only he does not let it simmer for twenty years. Whereas Smalley's guilt and remorse, with religious mania thrown in, eventually force him to confront the man who got him off on a technicality and want to kill him, Greenwald, emboldened by alcohol, attends a party in Maryk's honour in order to confront his client and other Caine officers who had testified against Queeg, especially Lieutenant Thomas Keefer, who, Greenwald reasons, had manipulated Maryk into committing the act of mutiny.

Altman's version of the final scene, where a drunken Greenwald convincingly discloses his suppositions and, indeed, calls Maryk a mutineer – thus implicating himself – reflects the whole frame of 'Smalley' in which the psychologically tortured man condemns his former military lawyer at gunpoint via the story's flashback scenes.[6] The difference between the two, and the difference between Altman's version of *Caine* and the film version, is that no one pays much attention to Greenwald as he issues his accusations.

He has to follow them, especially Keefer, through the crowd of revellers. Yet one cannot help thinking that his accusations will linger with Keefer, and particularly Maryk. From this one can only speculate on the ethical qualities of each man. In that, Altman delivered another open-ended conclusion. Conversely, at the end of 'The Long, Lost Life of Edward Smalley' we know that Smalley's action has altered his attorney's thinking.

Altman slips in overlapping dialogue at the beginning of *Caine* and during the final celebratory party scene, and during the second day of testimony the background rain is heard throughout. But otherwise the dialogue is crisp and clear, except for two instances when the ranking officer of the court (Michael Murphy) instructs a witness to speak up. The courtroom setting itself has the makeshift appearance of a wartime court martial. It is a made-over gymnasium – a basketball court with the witness stand at centre court. Tall windows grace the building so that during the first day's testimony the sunlight streaming through gives a hazy look to the prosecution witnesses' testimonies.

One can predict close-ups in a courtroom drama, and Altman has them along with low-angle shots, pans of the judges and, most interestingly, long shots. Together these give the work a more cinematic look, the long shots especially so. Sometimes the witness is framed from behind the judges' table. In one instance nearly the entire room is revealed, while connective dialogue between Greenwald and Maryk takes place so that one is temporarily at a loss for where to focus. Other long shots, through windows, reveal the various witnesses, including Queeg, waiting their turn to testify or their reactions after having testified – the viewer again a voyeur peeking at innocent and not-so-innocent men under stress. The point of view for these shots is from the courtroom floor, but the camera never shows anyone in the courtroom gazing up towards the windows. Only the camera's lens, and thus the viewer's gaze, is lifted in that direction. Other long shots include various entrances and exits to the building where the court martial is held and Greenwald's entrance to and exit from Maryk's party in the final scene.

The Caine Mutiny Court-Martial was the most complex of the play adaptations Altman directed for television. He met the challenge instinctively, and in following his instincts he allowed his camera free rein while inhibiting the improvisatory side of his nature with regard to the actors. It was a process that he had followed throughout the decade, and in this and the Pinter one-act plays it paid off with remarkable television.

9 The Play's the Thing, Part Two: Features Again

ROBERT ALTMAN'S FIRST THEATRICAL adaptation for film was Ed Graczyk's 1976 play *Come Back to the 5 & Dime, Jimmy Dean, Jimmy Dean* (1982). He had directed the Broadway production of the play, which had a nearly eight-week run at the Martin Beck Theatre during the late winter–early spring of 1982. Encouraged by that modest success and, no doubt, the filmic possibilities of the play's time shifts, Altman brought back the cast and filmed *Jimmy Dean* in approximately seventeen days. It was shot (by Pierre Mignot) in Super 16mm film, which was then blown up to standard 35mm.[1]

The story revolves around a group of friends and their devotion to the film star James Dean. Mona (Sandy Dennis), the most devoted and deluded of the group and a one-scene extra in Dean's posthumously released film, *Giant* (1956), is the president of the fan club Disciples of James Dean – a name that epitomized the transfigured Dean in their eyes. The story shifts back and forth between 1975 and various days and memories of 1955, including the fateful 30 September, the day James Dean died in a car accident. On that same day Mona has returned from college to the small town of McCarthy, Texas, having dropped out for health reasons, but really out of homesickness and possibly morning sickness. It also happens to be the night of a fan-club meeting. During the course of the film the viewer discovers that Mona, Sissy (Cher), Joanne (Karen Black) – former 'Disciples' – and Juanita (Sudie Bond), the proprietor of the five-and-dime where all the action takes place, all have secrets.[2] But unlike the secrets in *A Wedding*, none of them are humorous. Critics and others complained that *Jimmy Dean* is too problem-laden in the mode of Tennessee Williams or Edward Albee, but the layered dynamic of the problems and their revelations – all centred on the arrival of the mysterious Joanne – and the essential plotlessness are recurring elements in Altman's

films. Furthermore, the film again addresses the notion of celebrityhood and mythology: in revisiting the James Dean phenomenon, Altman explored it from the zealous fan's perspective.

The restriction of the setting actually heightens the effect of the movement of Altman's camera, especially as it seeks out the corners of the five-and-dime store. The opening shot, in 1975, has the camera pan slowly around the store. We see a shrine wall dedicated to James Dean, with streamers and other decorations, including the reunion announcement marking the twentieth anniversary of Dean's death, scheduled for that day. Beside the single set, the theatricality is exposed by the glimpse we get through the open door of the outside world. It is a brightly lit backdrop suggestive of the heat and aridity of the environment.

Following the pan around the five-and-dime, Juanita enters the store, turns on the radio to gospel music and switches on a backlit image of the Sacred Heart of Jesus that overlooks the room. Altman had previously used the Sacred Heart image in *Thieves Like Us*, where its symbolism is contrapuntal. In *Jimmy Dean* the image appears twice and is more than simply a subliminal prop. It is a symbol of hope: in Catholic teaching the Sacred Heart is a symbol of Jesus' love and compassion for humanity.[3] Sisterly love and compassion (along with self-accord) are the film's main themes, thus the symbol physically predominates.

Admittedly, the Sacred Heart is esoteric, but there is a pop-culture motif (popular in 1955 and somewhat less so in 1975) repeated throughout the film – the McGuire Sisters' song 'Sincerely'. As part of the soundtrack it is ironic commentary on the characters' words and self-images. But when

Come Back to the 5 & Dime, Jimmy Dean, Jimmy Dean: conflation of time and space – 1975 Mona in the foreground with the Disciples of James Dean in the background; Sissy and Joe are on the left.

it is sung, first by Sissy, Mona and Joe (Mark Patton), the only male Disciple of James Dean (they had an act back in 1955, with Joe in drag), and later by Sissy, Mona and Joanne, it is descriptive of their feelings for one another in the first instance, and of their relief at no longer having to carry the burdens of their secrets in the second.

The secrets are painful, and it was and continues to be the main criticism of the film and play that three of the four women should in the course of the afternoon pass through self-humiliation and come to terms with their lives. Juanita has been in denial for decades about the fact that her late husband, Sidney, was a drunkard. Sissy has kept hidden that she had had a double mastectomy (her large breasts the key to her hypersexual identity) and that her husband, the shallow and evil Lester T. Callahan, had abandoned her for that reason. And Mona must finally face the reality that her son, Jimmy Dean, is neither the son of the actor nor suffering from a learning disability or socialization disorder, as she has pretended. (Sissy actually mocks Mona's quasi-religious pretensions regarding James Dean, calling her Mona Magdalene.)

But the secrets and pretensions would have remained intact if it were not for the arrival of Joanne, dressed in white and enigmatic as she strolls about the five-and-dime surveying its displays. Her outfit references the 'white trio' in *Nashville*: Opal, Lady Pearl and Connie White (also played by Karen Black) and, in another sense, Barbara Jean. Joanne is the catalyst who alters the hermetic world of the five-and-dime store. The other two women at the reunion, Stella Mae (Kathy Bates) and Edna Louise (Marta Heflin), merely reinforce the relationships of the past. As teenagers the former bullied the latter, and she continues to do so twenty years later. In the end, though, Joanne's cathartic presence flips even their relationship upside down.

It is Joanne who reveals Sidney's drinking, who questions Sissy's story that her husband, Lester, is prospecting for oil in the Middle East, and reveals that Mona's life for the past twenty years has been a lie. But before she can do any of that she must disclose her own secret: that she was Joe. In one of the time shifts the viewer discovers that Joe had been raped by Lester T. Callahan, while another flashback reveals that Joe loved Mona and is the father of the nineteen-year-old Jimmy Dean.

The memories and time-shift effects are achieved with a mirror. In his previous films Altman used mirrors and/or reflective surfaces as commentary on reality as well as reflections of states of mind, but in *Jimmy Dean* the five-and-dime's mirror creates the reality for the viewer. The shifts back to 1955 are shown in a large mirror behind the counter.[4] Sometimes

Come Back to the 5 & Dime, Jimmy Dean, Jimmy Dean: in the foreground, a prone Sissy and Joanne flank Mona; in the background, Joe's image is superimposed over Joanne's reflection.

they are objective shifts, as when we first see Mona return to McCarthy after dropping out of college, other times they reveal a character's thoughts – usually Mona's or Joanne's. In the mirrored past the same actors play Mona, Sissy, Juanita, Stella Mae and Edna Louise; a male actor plays Joe. Beside the cosmetic differences, mostly slight, to delineate one year from the other, in 1955 there are heavy thunderstorms while severe drought plagues McCarthy, Texas, in 1975.

Throughout the film there are shifting relational triumvirates. Initially there is Juanita, Sissy and Mona – the three who have remained in McCarthy. Opposed to them are Stella Mae, Edna Louise and Joanne, the three who briefly return. But the second trio cannot hold its centre. Twenty years on, Stella Mae and Edna Louise have even less reason to abide each other, and the procreative Edna is the opposite of the infertile Joanne. Joanne, on the other hand, gradually ousts Juanita from the initial threesome, as the latter seems to admit when in the end she finally acknowledges Joanne's femininity (she addresses her as 'Miss') prior to leaving the five-and-dime. Mona, Sissy and Joanne stay behind.

Capping off the revelations of Mona's secrets, Jimmy Dean makes his escape from McCarthy by stealing Joanne's yellow Porsche (the sudden roar of the motor is followed quickly by the squealing of the tyres), the same type of car James Dean drove to his death. His escape, aided by Sissy we discover, only highlights the problematic nature of his 'character'. He and Lester T. Callahan, and Juanita's husband, Sidney, hover at the perimeter of the story. Sidney is sketched as the secretly alcoholic store manager, and this is the easiest to accept with Juanita in the role of his enabler. Lester as

the small-town bully and sadistic rapist is believable, but not as Sissy's husband. But the whole story worked up around Jimmy Dean is silly. It is too much of a stretch to believe that Mona's intellectually and emotionally competent son would bow to her self-serving delusions of him. Sidney is dead and Lester long gone from the scene, but Jimmy Dean has remained trapped in McCarthy as an object of his mother's manipulation. His existence beyond Mona's and Sissy's explications is revealed only when he steals the Porsche. As such, he is the film's unseen and unheard character. As a young man enduring nearly twenty years of his mother's imprisonment he is akin to the young man in *That Cold Day in the Park*, who, at the film's end, finds himself again silent and trapped by the older woman, Frances Austen. (As a visual referent to the earlier film, Sandy Dennis played both Frances and Mona.)

In the end, with Joanne having effected varying degrees of catharsis, another reunion is promised for twenty years in the future. Then Stella Mae, Edna Louise and Juanita leave. Mona, Sissy and Joanne remain with

Come Back to the 5 & Dime, Jimmy Dean, Jimmy Dean: Mona, Sissy and Joanne sing 'Sincerely' one last time.

nothing left to hide, the secrets of the past two decades revealed. At Sissy's insistence they perform their old McGuire Sisters act and sing 'Sincerely'. That is how the play ends, but Altman with his roving camera added a coda. As the women are performing their act in the mirror's reflection, the camera pulls back (and the song fades away) and once again pans slowly around the five-and-dime in the real present – showing 1975 to have been a flashback also. The place is deserted; the cobwebbed shelves are now empty; one of the ceiling fans has collapsed on to the floor; streamers, a crumpled newspaper and broken glass lie on the floor. The counter stools are missing their tops. There is even tumbleweed in the store. The drought has done its worst, possibly to the entire town. The coda suggests not merely the end of the five-and-dime era but the end of time as well. Altman described the ending as an 'emotional response that occurred to us'.[5]

SEXUAL IDENTITY WAS AGAIN one of the subtexts in Altman's next film, *Streamers* (1983), along with racial tension and the pressure of soldiers on the verge of being sent to a war zone – in this case Vietnam. The film takes place entirely within a barracks shared by Billy (Matthew Modine), Roger (David Alan Grier), Richie (Mitchell Lichtenstein) and Martin (Albert Macklin) and presided over by Sergeant Rooney (Guy Boyd). Altman opened up the set more than he did in *Jimmy Dean* by shooting some background shots through windows and some long interior shots to give the viewer a sense of the barracks' depth. The windows offer two diametrically different viewpoints: the shower room (a constricted place) and the camp outside the barracks (limited, possibly even illusory, freedom). The windows to the shower room and the camera shots therefore are obvious set-ups for audience and character voyeurism.

Although the stories are radically different, the structures of *Streamers* and *Jimmy Dean* are similar in that in both films an outsider – but not a complete outsider – alters the dynamic of a small group. In *Streamers* (the title refers to parachutes that have failed to open) Carlyle (Michael Wright), a fairly recent draftee housed elsewhere on the base, drifts in and out of the barracks, playing mind games with Richie, Roger and Billy. He essentially forces the last two to acknowledge Richie's homosexuality. For Billy and Roger, and even Richie, however, there is no catharsis as there is for the women in *Jimmy Dean*.

Carlyle is the aggressive African American urban male so often stereotyped in film and on television. We initially see him pausing outside the door

Streamers: Carlyle
(in reflection)
questions Roger.

of the barracks and looking in before passing on. He is the existential outsider
and he knows it. When he returns he is looking for Roger, another African
American with whom he wants to connect. But Roger is not in the barracks.
Carlyle leaves and returns a second time to find Roger standing before Richie's
open locker where he had shown Billy the photo of a naked pin-up model
that Richie had taped inside his locker door. For Roger this is proof that
Richie is not gay. When Carlyle sees the photo he immediately scolds Roger
about having a white woman for a girlfriend, an ironic comment on u.s. Army
society and American society in general. Altman's enhancement to this scene
is that Carlyle's face is seen reflected in the shaving mirror hanging inside
Richie's locker door. His aggressive and fear-tinged reflection displays the
oppositional gaze of the African American Everyman/Outsider, including
Roger (and Wade and Tommy Brown in *Nashville*). Thus the initial moments
of Carlyle's first conversation with Roger are choreographed verbally and
visually. The viewer has recognized from earlier scenes that Carlyle is natur-
ally aggressive while Roger's aggression, like Billy's, has been fashioned by
the army. Richie's aggression (actually passive aggression) is of a sexual
nature (as is Carlyle's), which Billy and Roger choose to deny or wilfully
misunderstand.

The threat of violence hovers constantly at the perimeter of the story.
Even before one realizes that Roger, Billy, Richie and Martin await impend-
ing orders to ship out to Vietnam, we see in the opening that Martin has
slit his wrist. Psychologically unable to handle the pressure of deployment,
he has opted for a different choice. Martin's bloody wrist, of course, fore-
shadows the story's actual violence. The claustrophobia of their small section

of the barracks, heightened by long shots of the room, echoes the fears in the soldiers' minds. And the degree to which that section entraps the protagonists is further highlighted by the framed shots through the windows of outdoor freedom: Roger and Billy playing basketball, a soldier and his girlfriend posing for photographs.

As originally noted by critics, *Streamers* is an anti-*M*A*S*H*. Its tone is dark and anxious; there is no 'black humour', let alone silliness, to offset the story's direction, and all verbal and visual signs point inexorably to death. But it is the visual treatment of blood that essentially differentiates *Streamers* from *M*A*S*H*. In *M*A*S*H* we see it spurting from a patient's artery, on the surgeons' operating gowns and on their hands. Although a visual horror for what it so obviously represents, it also signifies the not always successful heroic attempt to preserve human life. *Streamers* takes the viewer back a step. With the exception of Martin's gesture, wherever we see blood in *Streamers* it is the result of anger and stupidity. Billy's hand is cut by Carlyle; Sergeant Rooney's blood is left on the barracks floor. The latter especially is as undignified as the senseless murders, and when we see the bloodstain it bears the imprint of Sergeant Cokes's (George Dzundza) combat boot.

The violence is a result of Carlyle's inability to achieve insider status even after showing Roger and Billy a night on the town. His aggressive character appeals to neither: college graduate Billy does not understand Carlyle's rhetoric, while Roger chooses to ignore it. Roger's rejection of such separateness is how he copes with army life. His strategy is similar to Tommy Brown's in the otherwise all-white atmosphere of Nashville. Conversely, Richie gravitates to Carlyle's projection of personal power and his bisexual attitudes.

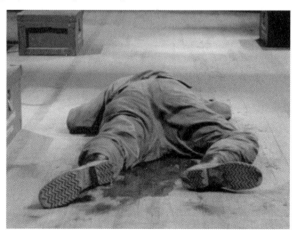

Streamers: Sergeant Rooney crawls away after being stabbed by Carlyle.

This sickens Roger and Billy, especially the latter. Words lead to harsher words, and during an argument Carlyle stabs Billy. The stabbing occurs with the lights on, unlike the stabbing near the end of *That Cold Day in the Park*, but the violence is briefly ambiguous, recalling the stabbing in 'The Long, Lost Life of Edward Smalley'. Less ambiguous is Carlyle's stabbing of Sergeant Rooney, who has come upon the scene. Rooney's death mirrors a wartime casualty (or even a noirish scene) as he crawls along the barracks floor, leaving a trail of blood from the wound in his stomach. Carlyle flees, but is apprehended by the military police. The war stories of sergeants Rooney and Cokes enhance the atmosphere of violence. Both men are drunk for the entire play, as if trapped in a rite of passage they are doomed to repeat. Cokes twice tells a story about his killing of an enemy soldier. Yet at the film's end it is a drunken Sergeant Cokes, afflicted with leukaemia and unaware of the murders of Billy and Sergeant Rooney, who achieves a cathartic, though ironic, moment regarding violence and mortality.

WITH *SECRET HONOR* (1984) a politicized Robert Altman continued filtering American society of the late 1960s to mid-1970s through his lens.[6] Subtitled 'A Political Myth' (a disclaimer prefaces the film), the sole character is Richard M. Nixon (Philip Baker Hall). No longer president of the United States, Nixon is angry and paranoid as he expounds on his downfall. *Secret Honor* was filmed at the University of Michigan, where, two years earlier, Altman had directed the Igor Stravinsky opera *The Rake's Progress* and also served as Marsh Visiting Professor of Communication.

Again, the action takes place on a single set, but Altman's camera allows the viewer the illusory freedom of soaking in the *mise en scène*. The set is the study of Nixon's San Clemente, California, home, to which he had retreated after resigning the U.S. presidency in August 1974. The camera comes to rest on a bank of four small black-and-white closed-circuit television monitors set on a long table. Mounted next to this set-up is a closed-circuit camera. (The camera and monitors were unique to the film version, allowing Altman additional and more dramatic cutaways.) On the wall above the monitors hangs a portrait of Henry Kissinger, Nixon's former national security adviser and secretary of state. (For two years he held the posts simultaneously.) Of all the ironies in Altman's film and television work, the positioning of this portrait may rank as the greatest. But Altman does not dwell on it. Instead he focuses on the monitors, judging that they have captured the viewer's attention and imagination. The monitor on the far left displays the feed from

the closed-circuit camera – the study. The others display the hallway leading to the study. Initially the viewer sees the monitor to the far right, but the shot pans one monitor to the left, where we see Nixon walking down the hall carrying a case under his arm. He pauses, looks furtively behind him, then proceeds down the hall's left wing. At this point the camera's focus has moved one more monitor to the left. Through this we see Nixon insert a key into a lock, and we actually hear the key. The camera moves away from the monitor and we see Nixon enter the study. It is a remarkable way of dividing up reality. And in *Secret Honor*, Altman is relentless in dividing the *mise en scène*'s reality with his moving camera. Nixon alters the picture on the three monitors receiving external feed, so that they too receive the feed from the study camera. Psychologically it is a triumph of his ego over his paranoia.

Nixon has entered his study late at night – the clock has struck ten – to make, of all things, a tape recording of his political legacy. After pouring himself a couple of drinks he opens up the case he had been carrying to reveal a revolver, which he then places on his desk. The ominousness of the gun, juxtaposed with the tape recorder, gives one pause. Will this be Nixon's Last Tape? Nixon begins fiddling with the tape recorder. His ineptness with the machine (unlike Samuel Beckett's Krapp) is one of the film's wry moments, leading one to postulate that his inability to record properly might have been the true cause of the infamous eighteen-minute deletion in one of the White House tapes.

Kissinger's is not the only portrait to adorn the study's walls. The others are former U.S. presidents: George Washington above the fireplace; Abraham Lincoln, whom the young Nixon admired, above the baby grand piano; Dwight D. Eisenhower, under whom Nixon served as vice president; and two Democrats, Woodrow Wilson and Nixon's predecessor, Lyndon Johnson. There are numerous family photos as well on the desk and wall, the most important of which is of Nixon's mother. Except for Washington and Lincoln, Nixon will address them all during the course of his verbal ramblings. In fact, the portraits serve the same purpose for Nixon that Suzanne's hallucinations served for her in *Images*, only inanimately and silently. *Secret Honor* exposes the inner turmoil of the protagonist using a strategy that upholds his personality: Nixon, the career politician, verbalizes his stress. Altman explained that the film was shot with a 'zoom lens and a jib arm in 16 mm'.[7] This allowed him to follow 'Nixon' as he stalks around the study becoming drunker and more paranoid as the film wears on. The zoom lens is used less on the actor than on the presidential portraits, the desk microphone, the closed-circuit camera and the bank of monitors, although Altman picked

his spots within the monologue and *mise en scène* where he chose to zoom in on Hall. There are a number of reasons for this. Up close Hall did not resemble Nixon very much, but he did more from medium and long range, and especially when his image is seen in the monitors. Also, Hall gives an electrifyingly physical performance. His Nixon is peripatetic, swinging his arms (sometimes violently), gesturing with his hands (sometimes elegantly) and dropping to his knees in prayer and supplication as he seeks to explain his political misdeeds. When the camera does zoom in on the actor the lack of resemblance is mitigated usually by the emotional and psychological anguish playing on his face.

Altman considered the monitors, the microphone and even Nixon's drink as 'character(s) in themselves'.[8] The drink may be a stretch but the other objects and the presidential portraits are the silent characters of the film. The camera introduces these ephemeral characters with close-ups or medium close-ups. It has long been acknowledged by film theoreticians that a close-up does more than focus the viewer's attention on the image – that it announces, so to speak, the presence of the image within the *mise en scène*. Thus, 'here are the monitors; here is the closed-circuit camera, the tape recorder microphone; here is Dwight D. Eisenhower; here is Lyndon B. Johnson; here is Henry Kissinger', and so on. At a glance it may seem that Altman is doing here the same thing he did when he focused his camera on the radio and the cowboy hat in *Rattlesnake in a Cooler*, but he unleashed his camera to pry, and these inanimate characters, like characters in most of his work, help propel the film. Trapped in his thoughts as he may be, Nixon is nevertheless not alone on this night. The microphone is the sympathetic listener, the camera the watcher, and the monitors relay the limited version of reality that the watcher takes in. On occasion Nixon addresses the microphone as 'Your Honor', as though speaking to a judge who will decide his legacy. He is there to defend his 'client', Richard M. Nixon.

Nixon launches into expletive-punctuated recollections of his life and career. In doing so he excoriates both Eisenhower and Kissinger – the former for his mistreatment of him, the latter because of his political treachery. It seems that Nixon keeps the portraits of these two, especially Kissinger, solely for the purpose of ranting at them. His reminiscences reveal a vulnerable Nixon, who is Oedipal, but also the more familiar paranoid Nixon, who is Faustian. Nixon, by his own consideration, sold his soul for a political career guided by the Bohemian Grove cartel.[9] Of that career he recounts his time as a California congressman on the House Un-American Activities Committee (HUAC); as Eisenhower's vice president, in which he was the administration

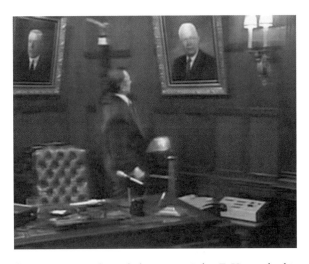

Secret Honor. Richard Nixon vents his spleen at his predecessor, Dwight D. Eisenhower.

outsider; his loss of the 1960 presidential election to John F. Kennedy; his defeat in the 1962 California gubernatorial election; his triumph in the 1968 presidential election; and the Watergate break-in in 1972. Hovering over all of this, and the reason for his taped recollections (or 'defence'), is his 1974 resignation of the U.S. presidency.

Although Nixon rebukes Kissinger for publishing his recollections of Nixon's final days in the White House – praying on his knees, talking to pictures of the presidents, drinking heavily and coming near cracking up – in fact all those things apply to him now in the study. But the heart of his recollections, he reveals, is that by controlling the leaking of the cover-up and other assorted political crimes that came under the Watergate rubric he was actually saving the republic from a descent into fascism. This is his 'secret honour'. His rationale is that the Bohemian Grove people planned to make him president for a third term, thus ensuring the prolongation of the money-making Vietnam War and mob-controlled heroin importation. He never does explain how the powers that be planned to abrogate the 22nd amendment to the United States Constitution, which limits a president to two terms, but never mind, for it seems more a part of his paranoid psychosis. And speaking of that, at one point the monitors go blank – a tamping down of the ego – whereupon Nixon grabs the revolver and stalks up to them, crouching low in front of them before returning to the control box near his desk to set things right.

As Nixon becomes drunker, more paranoid and seemingly more desperate, Altman cuts to more close-ups of the revolver; the gun he had

introduced in the beginning becomes more ominous with each rant and each close-up. Eventually pleading with his mother for advice, a suddenly calm Nixon walks behind his desk, lifts and cocks the revolver and puts it to his head. But rationality takes over and he throws the gun down. The people elected him all his life, the final time (1972) to the biggest majority in presidential electoral history. 'If they [the American people] want me dead, they'll have to do it.' He then swings his right fist in the air (a gesture he has used often during the course of the evening) and shouts, 'Fuck 'em!' The gesture and the shout are then shown on the monitors, but not simultaneously, rather each monitor in succession. And they are repeated and repeated again, finally with tight close-ups of Nixon as voices in the background chant 'Four more years! Four more years!' The medium, Altman seems to be agreeing with Marshall McCluhan, is the message. Certainly for Nixon it was. Although for Altman the message was always ironic.

LIKE HIS PREVIOUS theatrical adaptations to film, a secret lies at the heart of *Fool for Love* (1985). Here the secret is incest. But Altman's thematic contribution, the disparity between truth and memory, adds another dimension to the problematic triangular relationships of the three main characters. The added structural complications (including additional characters), in conjunction with Altman's opening overhead shots of the New Mexico desert (the desert seemed really to bring out the weirdness in the director) and floating camera, release the film from the stage confinement of a single motel room. Altman layered the play's sense of lostness with a look that is more cinematic than his previous theatrical adaptations. Yet most of the scenes take place within the compound of the El Royale Motel, plunked down in the middle of nowhere. The screenwriter was playwright Sam Shepard (who adapted his own play and performed the role of Eddie), and while he retained most of his play's dialogue Altman's camera expanded the meaning, sometimes as it contradicted the literalness.

Although the story revolves around May (Kim Basinger) and Eddie and their stormy, long-running on-again off-again relationship, it is the mysterious, wraithlike Old Man (Harry Dean Stanton) who is progenitor of their stories, separate and together; a trigger of their memories and desires; and the vortex of their love and hate for each other. Altman frames the film with his presence. Sometimes Eddie and May acknowledge that presence; at other times he is invisible to them. In one scene, upon finishing his own recollection of a time when May was a little girl, he seems simply to disappear briefly.

Fool for Love: Eddie as voyeur spying on May; in the window behind him are Young May and her mother.

At the beginning we see him emerge from his beat-up camper amid the detritus collected behind the motel, and at the end he retreats into it while the motel complex burns up, along with his camper. That destruction signals the exorcism of the ghost of the Old Man, Eddie and May's father, which is the only thing accomplished by Eddie's tracking down May. But perhaps that is enough, as each has begun their own journey down the road at the film's end.

Altman fleshed out and complicated the play's structure by filming the recollections of the three main characters rather than have them merely speak them. But the complications he adds to this are twofold: for instance, when we initially see May as a little girl it is in the present time at the El Royale. She and her mother and father drive up to the motel and take a cabin. The father leaves, but eventually returns and the family drives off. It is not until they drive off slowly, with the camera finally revealing the father's face – a younger version of the Old Man – that the viewer realizes who they are, for May as a child (April Russell) has been interacting with the adult May. What is more, the family drives off to become the visual re-enactment of one of the Old Man's memories. Altman referred to this visual structure turning in on itself as incestuous in its own right, and likened it to the structure of *3 Women*.[10] In this manner it also has a similarity to *Jimmy Dean*. But unlike those films, these memories bend time in on itself, specifically when May interacts with her younger self.

In the beginning one assumes that Eddie, an ageing rodeo rider (he arrives at the motel towing a horse trailer behind his truck and later practises his lassoing), and May are just another estranged husband and wife. Eddie's personality exudes danger, but instead he is the recipient of violence: May knees him in the groin; Martin (Randy Quaid) tackles him to the floor; and his erstwhile and possibly future girlfriend, the Countess (Deborah McNaughton), stalks him, shoots at him and shoots out the windscreen of his truck. The flashbacks reveal that May and Eddie are half-siblings, although they did not know each other until their teen years, when they became high-school lovers. The flashbacks are interesting because they allow Altman to expand the film's scope by occasionally delving into Eddie's, May's and the Old Man's pasts and by showing the disjunction between memory and reality. The stories the characters recite in their recollections do not agree with what appears on-screen, although May's recollection adheres most closely to the visual 'truth'. (Here, at least, Altman has engineered a cinematic triumph over the theatrical by presenting the visual rather than the verbal as the source of May's, Eddie's and the Old Man's true histories.) This supposition is reinforced by the Old Man's wince as May begins to reveal a memory near the film's end, a memory whose facts spill over into Eddie's memory. Eddie then completes the tale of his mother's suicide with the Old Man's shotgun. By that time a fourth speaking character has arrived, May's suitor Martin. Martin is a foil for Eddie, and his presence releases what humour lies in the situation and in May and Eddie – mostly the latter. His ineffectualness – May even refuses his offer of a lift while the motel burns – puts him in the same category as Frank Burns in *M*A*S*H*, Bill, the cuckolded folk singer in

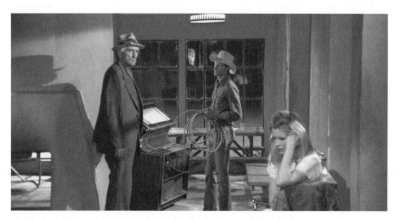

Fool for Love: history and memory play out for the Old Man, Eddie and May.

Nashville and Edgar Hart in *3 Women*. The difference is that Martin has less of an emotional investment in the story and in the others' lives.

While the film's sound was less natural, or anyway less Altmanesque, the camerawork was certainly anything but static. Although he seldom favoured composition over movement with regard to camerawork, the director changed cinematographers during the shoot to achieve the look he wanted.[11] Altman's son Stephen was the film's production designer and was primarily responsible for the film's look. The motel complex he designed had plenty of windows in the diner and the individual cabins. These windows allowed Altman's camera (and the viewer) to peer out and, more importantly, in. In what is the director's most audacious, and artful, endeavour to manipulate the viewer into an all-out voyeur, we see May through her motel window strip down to her slip and shimmy out of her underwear. This is the same view that Eddie sees. In fact, Eddie steals up to the window and Altman cuts back and forth between him and May, the watcher and the watched, to disguise his strategy vis-à-vis the film's viewers. Along with Eddie, we see May not only through the uncurtained window but through her open bathroom door, where she has retreated to wash herself in preparation for her date with Martin. Mumbling to herself the whole time, May washes first one foot, then the other, then her vulva. Eddie, we see, looks away at that moment and Altman, by the simple act of cutting away to Eddie, either allows or forces the audience, depending on one's point of view, to share Eddie's modesty.

But the voyeurism does not end there. The perspective of the reverse shots of Eddie is from inside May's room, in other words, out through the window. But over Eddie's shoulder we see across the courtyard into the motel room of the family that had checked in earlier. The Old Man-as-a-young-man has driven off, leaving May as a child and her youthful mother (Martha Crawford) behind. The camera (and the viewer) thus peers out of one window into another – into the past – and we see the woman slowly unrolling her stockings, first one then the other. That she wears knee-high nylons and not tights is a clue, like the vintage family car, that these people exist primarily (but not exclusively) in the past – although the eroticism of unrolling the nylons veils the clue.

The film's ending is visually Altman's but thematically Shepard's. With the El Royale Motel compound in flames – the fire having been caused by the indiscriminate gunfire of the silent Countess hitting the fuel tank of Eddie's truck – Eddie chases after his former lover on horseback. May, with packed suitcases, begins a long tramp in the same direction down the road, leaving a bewildered Martin to drive away from the conflagration

by himself. Only the ghostly Old Man remains. He plays his harmonica, just as he had at the film's outset, and disappears into his run-down camper a moment or two before it completely catches fire. While the Old Man is at last exorcised from May and Eddie, the half-siblings, yet to come to terms with their desire and hate for each other, have just taken their story further down the road.

BEYOND THERAPY (1987) was the last of Altman's features adapted from the stage, this time from the 1981 play by Christopher Durang. It is a farce-as-romantic-comedy and, as with his previous dip into the latter genre, *A Perfect Couple*, Altman got a little lost in it. In this film he entered Woody Allen territory, as it follows the chaotic amorous misadventures of neurotic New Yorkers and their existentially Freudian therapists.

The secret in *Beyond Therapy* does not remain such for long. In the first scene Bruce (Jeff Goldblum) tells Prudence (Julie Hagerty) that he is bisexual. They are on a blind date at a French restaurant, Les Bouchons, she having answered his ad in the personals column of *New York* magazine. Prudence does not take this news well. Her own neuroses begin to show on her face, and she cannot contain her homophobia. Bruce is quick to make the distinction between homosexuality and bisexuality, but Prudence is not mollified.

The film's relationships are incestuous: Bruce is in love with both his live-in lover Bob (Christopher Guest) and Prudence; Bruce's therapist, Charlotte (Glenda Jackson), eventually becomes Bob's therapist; Charlotte has been having daily afternoon 'quickies' with Prudence's therapist, Stuart (each oblivious to the other's visage, let alone their partner's mirrored professional life); Prudence and Stuart (Tom Conti) have also slept together; Andrew (Cris Campion), a waiter at Les Bouchons where everyone seems to gravitate, is Charlotte's son, and he eventually goes off with Bob. Furthermore, Bob's mother, Zizi (Geneviève Page), is also one of Stuart's patients. Zizi, a French émigré, also patronizes Les Bouchons, and the sight of her son's lover with a woman sends her directly to her therapist. There are couplings among the workers of Les Bouchons also, and the maître d' is also one of Charlotte's patients; in fact, his romance with the restaurant's female cloakroom attendant parallels that of Bruce and Prudence.

The Altman touches are plentiful in this screwball comedy of sexual liberation, and they add to the film's overall neurotic tone. Overlapping dialogue is heard during the opening credits, where all one can comprehend are disconnected snippets. There are strange reflections: Bruce is first seen outside

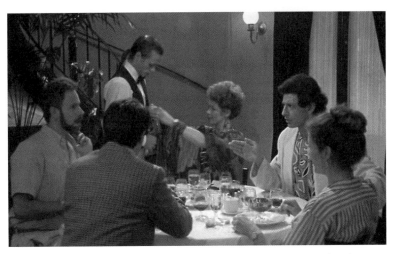

Beyond Therapy: dessert after the massacre – Stuart, Bob, Andrew, Charlotte, Bruce and Prudence.

the building as a ghostly reflection in the glass protecting a posted rundown of the restaurant's reviews, and a mirror mounted on the wall on the landing of the restaurant's spiral staircase momentarily disorientates the viewer when people ascend and descend. As in *The Long Goodbye*, the ongoing motif is a song. Here it is the George and Ira Gershwin classic 'Someone to Watch Over Me', the perfect song for neurotic lovers. There is also a silent character, a diner in Les Bouchons seated always at a centrally located table where he can observe the action and be observed. His actions are very mannered and his appearance is highly stylized: thin, elegantly dressed, bald except for a patch of hair grown out at the very back. His fashion sense anticipates Altman's *Prêt-à-Porter*, made seven years later.

The film's over-the-top, farcical nature allows it to poke fun at any and all subjects under the story's purview by playing up the usual stereotypes. First and foremost are neurotics and their therapists, but also the image of the Italian male lover – Stuart, Prudence's therapist, speaks with a phoney Italian accent and sees himself as a Casanova, though his problem is premature ejaculation. Rude French waiters and even the gullible Frenchman are highlighted. And in the never-ending sexual politics that grips the United States, gays and homophobes are also emphasized, especially in relation to neuroses. Neurosis, the film seems to be saying, is a function of the stress placed upon the homosexual by society, while homophobia is a neurosis among straight people. Bisexuality is the panacaea. At least that is the film's initial message. Bruce lays out a reasonably rational explanation of his bisexuality, though in fact for

much of the film he comes off (in terms the characters would understand) as a passive-aggressive manipulator.

There are two great scenes of anarchy; both are triggered by Bob and occur in Les Bouchons. The first occurs after his mother informs him of Bruce's blind date with Prudence. Bob leads his therapy group into the restaurant, hoping to catch his lover in the act of infidelity. In the second instance, near the film's end, a frustrated and jealous Bob, egged on by Charlotte, shoots Bruce, Prudence and other restaurant patrons with his starter pistol. However, the viewer knows it is a starter pistol so that the joke of this elaborate 'massacre', shown in slow motion, quickly wears thin.

In the end the film appears to have even made a farce of farce, but it has in common with many of its theatrical and cinematic predecessors an innate conservatism, as befits a romantic comedy.[12] It is over that conservatism that Altman stumbled. The film (and the camera) does not flow as freely as the story implies, while the ending completely fulfils the dramatic expectations of a romantic comedy. Bob goes off with Andrew while Bruce and Prudence plan their marriage and honeymoon in Paris, his bisexuality sublimated. No sooner are their plans made than their wish is granted. The camera slyly follows the couple as they slip out of Les Bouchons to reveal that they are transported from the Big Apple to the City of Light. And the theme song, 'Someone to Watch Over Me', previously sung by Linda Ronstadt and Lena Horne in the film's New York, is now sung by Yves Montand. While the credits roll the camera pans the city's rooftops, finally capturing within its frame the Eiffel Tower, the symbol of Paris's allure and a final Freudian joke. In fact, Altman filmed *Beyond Therapy* in Paris.

The final overhead shot of the couple is particularly fitting because Altman throughout seems to prefer to keep the audience at a distance, relying less on zooms and close-ups than in even his other adaptations. But then one never really does want to align oneself with the characters of farce.

EARLY FILM CRITICS and theorists were especially caught up with the aesthetic differences between film and theatre. A good deal of this was a response to the stationary camera and interior, stagelike sets of the earliest one-reel silent films. Rudolf Arnheim has pointed out that unlike stage directors, film directors can choose their (the camera's) distance from the subject.[13] It was Hugo Münsterberg who observed that a film 'can never give the aesthetic values of the theater; but no more can the theater give the aesthetic values of the photoplay'. It was probably this observation that led

Münsterberg to declare, rather dogmatically, 'If film were subordinated to the aesthetic conditions of drama it would become false.'[14]

Altman's theatrical adaptations for television and feature film exhibit a progressive awareness of the power of his medium to alter the 'text'. The textual alterations were largely visual – his moveable camera elevated even his earliest adaptations from being merely static representations. As the years passed, his camera gained even greater power. The twentieth-century film theorist Christian Metz pointed out that in the theatre, 'the word is sovereign.'[15] As noted above, Altman overthrew that sovereignty in *Fool for Love*, though he upheld it in *The Caine Mutiny Court-Martial*. And this explains the difference between his television and feature-film theatrical adaptations. In the former, language, if not supremely sovereign, is not so fiercely challenged either. The confrontation between language and image builds gradually in the television adaptations, and in this regard *The Caine Mutiny Court-Martial* is somewhat revanchist. In the features the camera and the image never relinquish power. (In *Secret Honor* the closed-circuit camera, though static, becomes an image, or a character.) They alter meaning and add inside jokes to the films.

ROBERT ALTMAN'S FINAL FILM WORK during the 1980s was neither an adaptation of a play nor a feature film. It was one of ten segments, directed by ten directors, that comprised the film *Aria* (1987), each segment the director's vision of an operatic aria.[16] For his segment Altman chose music from the Baroque opera *Les Boréades* (or *Abaris, ou Les Boréades*) by Jean-Philippe Rameau (1683–1764), the libretto of which is attributed to Louis De Cahusac (1706–1759). The opera was never performed during Rameau's lifetime, though it was briefly in rehearsal in 1763.

The film is set in Paris' Theatre le Ranelagh, built in the Baroque style in the early twentieth century. The obvious attraction of the theatre's interior aside, Altman may also have enjoyed working there knowing that in the mid-twentieth century Ranelagh had become one of Paris's premier art-cinema houses.

Altman opened *Les Boréades* with a shot of the ceiling and an explanatory quote: 'In the 18th century, it was considered chic for the rich to invite inmates of local insane asylums into their theatres for a pleasant afternoon of opera.' As the camera sweeps downwards showing the rear balcony and the main gallery, we see that the auditorium is indeed filled with inmates and denizens of the eighteenth-century Paris demi-monde – many in whiteface

or with heavily rouged cheeks.[17] The entire segment follows the crowd's reactions to the action onstage. Interspersed among them are aristocrats who enjoy both the opera and their afternoon of slumming. These include a woman and two young men in representation of three of the opera's characters: Alphise, the Bactrian queen, who by tradition must marry one of two men who happen to be Boreads, or sons of Boreas, the God of the North Wind.

These opening shots reveal that the viewer has come in on the entr'acte; the music to which the crowd is by and large listening avidly (though there are some stragglers from the buffet) is 'Suite des vents'. The title, literally suite of winds, refers to a storm, and portends the raucousness that will ensue in the theatre. In fact it begins before the suite concludes, when a dozing audience member – with aristocratic pretensions – has his wig pulled off and tossed around, to the delight of the others, until it is replaced, askew, on his head. The camera floats back and forth between the left balcony (facing the audience) down to the gallery, in the former giving the viewer a glimpse of three grotesque women. One straddles the balcony railing and lifts up her skirt to reveal stylized, preposterously sized knickers (an anachronism) with brightly flounced labia, while the others have tremendously outsized breasts and buttocks. Also pretending to be aristocrats, they taunt those in the

Aria: asylum inmates enjoy the opera *Les Boréades*.

gallery. Meanwhile, just behind them in the balcony the young woman has abandoned her two escorts, much as Alphise abandons the Boreads in the opera. All this takes place during the aria 'Lieu désolé', which by and large transfixes the crowd with the exception of the weird sisters and the woman and her suitors. When it ends, the crowd begins to applaud but the next aria follows immediately – 'Jouisson de nos beaux ans' (literally 'enjoyment of our beautiful years', but another sense of *jouisson* is orgasm). The crowd seems to take this advice to heart and their actions are a counterpoint to the music's tempo and melody: drinking, waving their arms, with the balconistas whipped into a sexual frenzy.

Except for the roving camera, there are few of Altman's trademarks here. The film is in fact more of a composition with movement than like anything else Altman had done to date. Since the film's action is all pantomime there is no dialogue; no dialogue, of course, means no overlapping dialogue. There are few close-ups. But where an audience of briefly released asylum inmates is at first restless and then boisterous – twice briefly we hear laughter and chatter, otherwise the boisterousness is conveyed visually – 'silence' is nevertheless conveyed by stillness. During the 'Suite des vents' we see a woman standing amid the crowd movement, transfixed by the music. She reappears at the end of 'Lieu désolé', this time foregrounded, posed in a very painterly way holding a silver tray with a pewter wine cup on it. But as mentioned, the applause for this is brief before the crowd (and the camera) moves towards the physical pleasures one would expect from those who are now given sovereignty over their actions. The entire segment is a single take, over six-minutes long, with Altman's camera movement, like a roving eye, dividing the shot. Eventually the camera moves back and upwards to pan the ceiling, returning from where it came a mere six minutes or so earlier and implying that the ethereal will again hold sway once passion is sated.

PART FOUR
THE PRODIGAL'S RETURN

10 Renaissance

ROBERT ALTMAN'S FINAL U.S. television project of the 1980s was a six-hour, eleven-part series for the cable channel Home Box Office (HBO) that mixed fiction and reality to a far greater degree than any of his previous work. In collaboration with Garry Trudeau, the creator of the Pulitzer Prize-winning comic strip *Doonesbury*, he made *Tanner '88*. Sometimes scripted, sometimes improvised, the series ranged from political drama to soap opera to *cinéma-vérité*. The storyline followed a fictional liberal congressman from Michigan, Jack Tanner, as he sought the 1988 Democratic Party presidential nomination. Although the idea originated at HBO and with Trudeau, the series' conceit is actually an enhancement of the mixing of reality and fiction that Altman had been doing for years and of the campaign of Hal Phillip Walker in *Nashville*. Coincidentally, Michael Murphy, the actor who played Walker's slippery point man John Triplette in *Nashville*, played Tanner. The series also reprises the song 'Exercise your Right to Vote' as Tanner's campaign song. It was first heard in *HealtH*.

The divorced Tanner has a teenage daughter (Cynthia Nixon), who injects herself into his campaign, and a military father (E. G. Marshall) whom he can never please. During the campaign he carries on an affair with a staff member from a rival campaign. Fortunately, the admixture of politics with fiction, reality and *cinéma-vérité* trumps the soap-opera aspect. *Cinéma-vérité* is concocted from the outset when Tanner is campaigning in the New Hampshire primary, the nation's first. There he encounters Republican Party candidates campaigning in their primary. These actual encounters and improvised dialogue involve Pat Robertson and Kansas Senator Bob Dole, coincidentally the 1996 Republican presidential nominee.[1] Tanner also meets Democratic politicians such as former Colorado senator Gary Hart

and Arizona governor Bruce Babbitt. In fact, his meeting with Babbitt is the highlight of the fifth episode, entitled 'Bagels with Bruce', in which the erstwhile candidate advises Tanner on how best to present himself to the people. So seamless is this blend of fact and fiction that it is impossible to tell if Babbitt went along with the conceit and advised the 'candidate' based on his own experience or whether he was reciting scripted lines.

As in *Secret Honor*, *Tanner '88* also makes use of television monitors as a way of mediating reality. The viewer 'watches' snippets of the three-way debate between the fictional Jack Tanner and the real Reverend Jesse Jackson and Governor Michael Dukakis (who became the Democratic Party's 1988 presidential nominee) on monitors set up backstage at the event. Presenting it as the national television audience would see it allowed Altman to edit Tanner into the real event. Later in the series, after Tanner has publicized his (celebrity) cabinet choices were he to win the nomination, the viewer also sees them on television reacting to being chosen and giving policy sound bites.

There is also faux *cinéma-vérité* in which a young filmmaker, Deke Connors (Matt Molloy), brought on board the campaign by Tanner's press representative to film campaign advertisement spots, is also making his own 'neo-reality' film about the campaign. His artsy spots range from unintentionally hilarious to creepy, but in one scene he manages to capture an unscripted Tanner that plays to the candidate's humanity. The scene is shot in such manner – awkward angles, the candidate sometimes walking out of the frame

Tanner '88: reality meets fiction. Arizona Governor Bruce Babbitt (left) advises candidate Jack Tanner as they walk along the Potomac River.

– as to appear to be true guerrilla filmmaking. Altman's direction is lost inside that of Deke, but it is Altman nonetheless.[2]

Altman truly shines as a *cinéma-vérité* director in the episode set in Detroit, a city that by 1988 was plagued by gun violence towards children. There, Tanner meets an actual citizens' group, SOSAD (Save Our Sons and Daughters), in one of the city's roughest neighbourhoods. The individuals, African American except for a white cleric, air their complaints to Tanner, telling him why they plan to vote for Jesse Jackson. As in the Bruce Babbitt episode, reality and fiction are seamlessly interwoven, making it weirdly compelling, especially when one or two less articulate people have their say. As Robert T. Self and others have pointed out, this scene is tricky in that there is little delineation between the fictional and the real. Specifically, was the entire rally a creation of the show or did Altman stumble upon it while filming in Detroit? Furthermore, this is the first instance in which Altman did not use celebrities (or, in the case of Amarillo Slim in *California Split*, celebrities within their fields) to mix the reality into the fiction. The scene (and the episode) ends with the discovery of another child's corpse in a nearby field. As emotionally manipulative as this is – one is never 100 per cent sure that it is a return to the fiction – it carries no less the dramatic shock than does Barbara Jean's assassination at the end of *Nashville*.

Nashville itself is the location of the second and third episodes in the series. The Tanner campaign has come to the country music capital for a fundraiser at the Opryland Hotel Pickin' Parlor. The name of the hotel's club references Lady Pearl's club in *Nashville*, the Old Time Picking Parlor, most likely intentionally since Lady Pearl was the most liberal and most political of the locals in that film. In a further echo of *Nashville* the second episode ends with a knife-wielding man being wrestled to the floor while Tanner is onstage making a short speech. The master of ceremonies at the event is the iconoclastic country music legend Waylon Jennings, who sings a Nashville-has-sold-out lament and later offers Tanner political advice.

By the second episode the press has caught on to the growing Tanner momentum, and we see journalists in full cry. The contingent runs the gamut from those sympathetic to Tanner's candidacy to the post-Watergate any-story-at-any-cost types. As the series progresses the last reporter standing is an NBC newswoman (Veronica Cartwright) – a comment on the primacy of television news (and the moving image) over traditional print journalism. Yet even she is trumped by the Tanner campaign when she is manipulated into going on air with a story fed to her. Her reporting makes

the procedural vote the Tanner campaign had been pushing for at the Democratic convention a fait accompli.

The project's *vérité* (and *faux vérité*) conceit – with which Altman's eavesdropping camera style was highly copacetic – and the real time in which it was aired reinforced the vital suspension of disbelief and allowed Altman to take his camera around the United States as it tracked the candidate. New Hampshire, Nashville, Washington, DC, Los Angeles, San Francisco, Detroit and Atlanta were the locales visited by the Tanner campaign. What emerged was the kind of extended film that Deke had hoped to make: to the very end the series comments on the relationship of the message and the medium. *Tanner '88* ends with a tight close-up of the defeated candidate's face as he lies in bed with his lover (Wendy Crewson), a former staff member of rival Michael Dukakis's campaign. The shot references the extreme close-ups of Brewster and Suzanne in bed together in *Brewster McCloud* and Mrs Miller's opium daze at the end of *McCabe & Mrs Miller*. Here, however, the primary emotion is resignation. Politics is a dead issue for the defeated candidate, and the soap opera indeed has triumphed.

THERE ARE ACTUALLY TWO VERSIONS of *Vincent & Theo* (1990), Robert Altman's dual biography of the post-Impressionist artist Vincent Van Gogh (Tim Roth) and his art-dealer brother, Theo (Paul Rhys): the four-hour European television production that Altman was hired to direct, and the feature version that he negotiated to edit from the longer version.

Since Van Gogh's troubled life has (at least since the 1934 publication of Irving Stone's novel *Lust for Life* and the 1956 film of the same name) taken on the heavy patina of modern legend, Altman and screenwriter Julian Mitchell avoid many traps by making the film a dual biography. However, they cannot resist the irony of contrasting Vincent's lifelong penury with the enormous sums for which his work has sold in the twentieth century. But they get that out of the way in the first few scenes, and at least one critic has pointed out the film's comparison to Altman's career-long plight to that point: 'The reflexivity here evokes the same question Altman's films have raised for more than 30 years: how to find financial backing to produce innovative art that is unpopular and misunderstood by the general public' – although some of Altman's unpopularity had to do with poor distribution of his films.[3]

Although certain recapitulations of Vincent's madness are inevitable, the film dwells more on the brothers' relationship. In order to do this, parallels are shown where Theo's emotional and career struggles are foregrounded.

Vincent & Theo: Vincent paints himself as a Pierrot after his lover leaves him.

The first and most visually interesting of the parallels, a homage of sorts to *Pagliacci*, occurs when Vincent's live-in lover, Sien (Jip Wijngaarden), a prostitute with two children, decides to leave him because life with him has become boring for her. The film cuts to Paris, where Theo's own live-in lover decides to leave him for essentially the same reason. Her sexual life, she discovers, will become boring because Theo has to recover (as it was then understood) from primary syphilis. Left alone, each man reacts in a similar way. Cross-cutting between the two we see Vincent sitting before a mirror, painting his face with white paint. We then see Theo standing before a mirror doing exactly the same thing with red maquillage. Cut back to Vincent, who runs a stripe of black paint down the bridge of his nose. Back to Theo, who applies white powder over his red face. Vincent's personality, revealed in reflection, is that of Pierrot with a touch of darkness to his soul. Theo, also in reflection, is the Harlequin seeking to mask his inner nature. But the mask is for himself and perhaps for Vincent. Later on, Altman uses a mirror for another psychologically obvious but nevertheless startling effect, when we see the reflection of Vincent in a cracked mirror lopping off his earlobe – a metonymic shot that recalls a similar one from Claude Chabrol's *Leda* (1959).

The parallels reveal more about Theo than about Vincent. That scene where Sien leaves begins with Vincent's return to the garret to find the baby crying while Sien sits at the table smoking. Vincent takes the child in his arms and calms him. Much later in the film, Jo (Johanna ter Steege), Theo's wife, is frustrated with their crying son, named Vincent. Theo takes

the baby from Jo, but cannot quieten the child. Immediately his brother shows up at the apartment and Theo hands the baby back to Jo in order to deal with the Vincent with whom he has the stronger emotional connection.

Altman hired numerous artists to make copies of Van Gogh's work, assuring them that the paintings would only be shot obliquely, so they need not worry about making exact copies.[4] Thus his camera does not dwell on them, and they are usually in the background of the scene. Occasionally the film offers its own interpretation of Vincent's work. The macabre painting of a skull smoking a cigarette is one such instance. Many see the image as further proof of Vincent's madness, although 'some interpret the work as being a statement of defiance against [his] faltering health.'[5] *Vincent & Theo*, however, focuses on only one cigarette smoker: Theo. Yet the film shows us over and over again how the brothers are linked by their emotionalism towards art. The first time we actually see *Skull with Burning Cigarette* is at the end of the scene in which Theo cannot quieten his son. It is Vincent who for once comforts his brother, on whom the pressures of marriage and career (and his latent syphilis, although the film does not yet bring out this aspect) are taking their toll. From a close-up of Vincent the camera tilts upwards slightly to the right so that over his shoulder we see the painting on the wall as an ominous foreshadowing. It is in the next scene that Vincent shoots himself. And after his burial the film quickly follows Theo's own precipitous madness and death nearly six months later.

One difference between the brothers is Vincent's religious mania. In their first scene together Theo mentions it. Later, with Paul Gauguin (Wladimir

Vincent & Theo: Vincent briefly comforts Theo.

Vincent & Theo: Pierrot in agony: Vincent returns to town after shooting himself.

Yordanoff), we see a shot of Van Gogh's *The Sower*.[6] Theo's shadow falls across the painting as he rolls a cigarette. Of the painting itself, Theo says, 'Christ the sower, Christ the sun', to which Gauguin responds, 'He sees Christ in everything.' Theo replies ironically, 'We're a very religious family'; but clearly Theo is simply trying to sell Gauguin the idea of joining Vincent in Arles.

Altman's instinctive camera movement not only homes in on characters at the right moment – the close-ups (as much as the reflected images) providing the viewer with the psychological underpinnings – it gives the viewer the sense of *trompe l'œil* as much as it places the characters and the viewer within the composed scene. It is as if Altman took a line of the film's dialogue as his working philosophy. During a moment of self-revelation, when he admits his love of and obsession with art, Theo describes a painting he had seen years earlier of a woman on a divan stroking her hair. 'I used to think', he says, 'if I could just walk into the painting, and shut the door, I could just stay there forever.' The film cuts to Holland, where Vincent is showing Sien and her daughter a circular seaside mural and diorama. So taken is the girl with the realism that she walks into the diorama, fulfilling Theo's dream. But Altman too seems taken with this line. As befits a film about Vincent Van Gogh, colour and light are practically characters in their own right. Many scenes are painterly in the Peter Greenaway mode, yet evoking Van Gogh's work. At their best these scenes, especially of Vincent in the fields (and most especially Vincent in a field of sunflowers), have the quality of paintings into which humans have stepped – a tribute to the contribution of cinematographer Jean Lépine.

Vincent & Theo is one of Robert Altman's underappreciated films. Perhaps this is because its genre is anomalous to his oeuvre, or perhaps because the film, like much of Altman's work, had poor u.s. distribution. Nevertheless, it was the final film of his so-called exile; it helped facilitate his return to the forefront of independent American and world cinema.

AFTER *VINCENT & THEO* Altman directed the William Bolcom opera *McTeague* (1992), based on the 1899 novel of the same name by Frank Norris. The Lyric Opera of Chicago had commissioned the work, and Bolcom suggested that Altman be brought in to direct. Arnold Weinstein and Altman wrote the libretto. It was broadcast on Public Broadcasting Service (PBS).

Altman's connection with Bolcom went back to his days at the University of Michigan, where he had directed Igor Stravinsky's *The Rake's Progress* in 1982. (In 1987 Altman also directed a production of *The Rake's Progress* for the Opéra de Lille in France.) In 2004, again under the sponsorship of the Lyric Opera of Chicago, Bolcom, Weinstein and Altman teamed up again to create an opera version of *A Wedding*, based on the 1978 film.

The year 1992 was also the one in which Robert Altman returned to prominence with *The Player*, a film about Hollywood that was at least as popular as *M*A*S*H* had been more than twenty years earlier. As with the earlier film, that popularity gave him cachet among his peers. With his reputation as one of America's pre-eminent film directors reinforced by *Short Cuts* (1993) and *Gosford Park* (2001), Altman rode that distinction for the rest of his career.

THE PLAYER (1992) was written by Michael Tolkin and based on his novel of the same name. With hindsight it seems to those who knew of Altman's irascibility towards Hollywood an impeccable melding of director and script. Rightly or not, critics deemed it Altman's brilliant 'comeback film' for its strong payback to the Hollywood establishment that had ostracized him for more than a decade. Of course that observation neglected the fourteen television and feature projects that Altman had directed from 1982 to 1990. What made the film ideal for Altman was that it impaled studio executives, for years Altman's real and perceived bêtes noires.[7] But it also put faces and voices, although anonymously, to screenwriters,

giving them the last laugh while ignoring directors in renunciation of the auteur theory.

From the very start one is let in on the postmodern, self-referential joke. The eight-minutes-plus opening begins with a shot of a painting of a film crew filming an actress. Over this a movie slate (for scene one, take ten of *The Player*) appears, and an off-camera voice announces, 'Quiet on the set.' *The Player*, then, is a film within a film entitled *The Player*. For the viewer, the film's self-reference dissolves slowly amid the back-and-forth movement, flowing camera and funny dialogue of the long take of everyday business on a studio lot, wherein no less than the chief of studio security, Walter Stuckel (Fred Ward), comments on the lack of long takes in contemporary American films. By contrast, he invokes Orson Welles's long take in *Touch of Evil* (1958). Simultaneously ironic and self-referential, Stuckel's observation places him within the Altman universe of cinephile characters. In many of Altman's later films characters discuss movies. For him, film, rather than television or literature, was the mode of entertainment by which people fashioned their tastes and measured their lives. Walter Stuckel is no different from Tulip Brenner in *A Wedding* in that they are both movie fans, both less extreme than Mona of *Come Back to the 5 & Dime, Jimmy Dean, Jimmy Dean*. But Stuckel is also a hook. From here on there are numerous verbal and visual references to cinema history, and these reinforce an 'insider' feeling in the viewer. The visual references are posters from Hollywood's 'golden era' and European cinema – *Laura* (1944) and *M* (1931) are prominently displayed – but also references to plot and characterization in *The Player*

The Player: Buck Henry pitches 'The Graduate, Part 2' to Griffin Mill.

itself. Altman himself downplayed the long opening in *The Player*, although the way his camera broke up the *mise en scène* was reminiscent of the work he had done five years earlier for the 'Les Boréades' segment of *Aria*. He also distanced himself from the long shot in *Touch of Evil*, characterizing it as 'grossly pretentious'.[8]

During the opening sequence the camera peers through a window into studio executive Griffin Mill's (Tim Robbins) office as he listens to story pitches from different writers. (The camera peeks not only into Mill's office but out of it as well. Later the camera will also peer out through a window of studio boss Joel Levison's (Brion James) office – but never into it – to offer a different view of the same confined world.) The first of the film's many cameos is the writer and actor Buck Henry pitching 'The Graduate, Part 2'. His premise is ridiculous, but the sequel is based on reuniting the three main stars – Dustin Hoffman, Anne Bancroft and Katherine Ross – from the original picture, which many viewers might not realize he co-wrote with Calder Willingham. Thus it is an inside joke, and that is part of *The Player*'s message: that Hollywood is filled with insiders telling inside jokes. A little later in this opening scene the camera again eavesdrops on Griffin Mill. We see other writers pitching story ideas, dropping actors' names and comparing their ideas to successful films. These writers are also cameo roles. One writing team turns out to be *Nashville* screenwriter Joan Tewkesbury and Patricia Resnick, co-writer of *A Wedding*. Notable in this pitch is the overlapping dialogue: the women and Mill all talking at once, explaining and clarifying the rudimentary story. Altman's erstwhile protégé, Alan Rudolph, also pitches a story to Mill. What these two story pitches have in common is that they depend on casting either Julia Roberts or Bruce Willis, two of Hollywood's most bankable names of the early 1990s.

Not too long after the extended opening sequence, Altman uses his overlapping dialogue technique as counterpoint to his camera and vice versa. At an outdoor bistro, the actor Burt Reynolds (in one of the film's better cameos) and another man sit at a table in the foreground. At a table in the background sits Joel Levinson. Larry Levy (Peter Gallagher), Griffin Mill's studio rival, has risen from Levinson's table to leave and stops at the Reynolds table to schmooze for a moment. Griffin Mill, who also has a meeting with Levinson, arrives soon after and schmoozes with Reynolds before heading on to his boss's table. The camera perspective remains with Reynolds and his lunch partner in the foreground as they engage in an acerbic description of Griffin's character, as Griffin, now in the background, greets others and his boss. The dialogue focus gradually shifts from the Reynolds table

to Levinson's. Reynolds and his friend remain in the foreground but now their bodies frame the table with Levinson and Griffin centred in the frame. As the camera zooms in slowly on Levinson and Griffin, the Reynolds dialogue recedes and is overlapped. The camera comes to a stop at a medium shot of Levinson and Griffin. Their conversation is now the only one we can distinguish clearly, but when it ends and Griffin Mill leaves, the camera pulls back to its original shot, and Burt Reynolds's voice is the last we hear. The technique is a more sophisticated version of the visual-audio swapping that Altman had used in the party scene of *Countdown*. Interestingly, Reynolds's lunch companion is the film critic Charles Champlin, who wrote some of the most scathing reviews Altman received in his career.

Griffin Mill's problem is not simply that everyone wants a piece of him, but that an anonymous writer wants a pound of flesh for the implied slight of not having responded to his script. The writer sends Griffin poison-pen postcards, which Griffin saves in his desk drawer. (Among the postcards is a book entitled *How to Write a Movie in 21 Days*.) Moreover, Griffin worries that his job is on the line when the studio lures Larry Levy from Twentieth Century Fox. These are two of the main strands of the plot: Griffin trying to discover the writer's identity and manoeuvring to keep his job. Regarding the latter, his callousness and deviousness, presumably the traits that helped him rise in the industry (with Griffin being a stand-in for most Hollywood executives), soon come into play.

Griffin's immediate concern is tracking down the writer, and he uses his secretary's computer and an industry reference book to do so. As noted, references to old films comment on the plot: on the wall by his secretary's desk is a framed poster for *Highly Dangerous* (1950), while in one of her desk drawers is a reduced image of the poster for *They Made Me a Criminal* (1939). Griffin discovers the writer's identity, David Kahane (Vincent D'Onofrio), and goes to his house that night.

As he approaches the house he calls the writer on the telephone. Kahane's live-in lover, June Gudmundsdottir (Greta Scacchi), answers and tells him that Kahane has gone to Pasadena to see the Italian neo-realist classic *Bicycle Thieves* (1948). Griffin keeps the woman on the line, all the time spying on her through various windows of the bungalow. The voyeurism is less erotic than when Eddie spies on May in *Fool for Love*, because its purpose is to initiate what the viewer can assume will become a romantic relationship, especially in the wordplay between Griffin and June. About this scene, Altman commented on the overt voyeurism, and the intent of it vis-à-vis the story: 'the shots through the windows . . . you're looking into an area

that you're not supposed to be seeing . . . We're really doing a little flirtation scene here.'⁹ Afterwards Griffin tracks down Kahane at the cinema (in which we see the final scene of *Bicycle Thieves*). He tries to sweet-talk the writer, who instead taunts him that he is on his way out at the studio. They argue further, and Griffin in a fit of rage murders Kahane. From here on *The Player* not only parodies the culture and output of the American film industry, but spoofs and pays homage to Altman's earliest Hollywood employer, Alfred Hitchcock. At one point the camera passes over a wall of photographs and focuses briefly on Hitchcock's portrait. In fact, collectively the ominous postcards are themselves an example of Hitchcock's famous device, the MacGuffin – something that is presented on film to keep the plot moving.

Griffin Mill soon discovers that he has murdered the wrong writer. This ties *The Player* in with the poster of *Laura* in Griffin's office, a film in which the wrong person is identified as the victim of a murder. The film's pace changes, as does the background music, with both contributing to the film's shift in mood. *The Player* is now a noirish comedy, the humour coming from the eccentricities of the supporting characters. Griffin makes it his first order of business to discover his antagonist's identity, which allows Altman to lead the viewer down a number of blind alleys. For example, we repeatedly see a man (Lyle Lovett) silently stalking Griffin. He even shows up at an industry event at the Los Angeles County Museum (a scene that Altman loaded with Hollywood stars), despite tickets for the event being hard to acquire. But when the stalker breaks his silence he reveals himself to be a Pasadena police detective. Briefly, the paranoid Griffin believes that an acquaintance (Dean

The Player: Griffin and June at David Kahane's funeral.

Stockwell) might be the postcard stalker, but he and his partner (Richard E. Grant) are simply trying to pitch a script, entitled *Habeas Corpus*. The title is a joke on Griffin's plight, but Griffin himself thinks the whole pitch is a joke and devises a plan to foist it on to his studio rival and their boss. In one brilliant scene of hypocrisy he not only accomplishes this, but manages to get his script-editor lover (Cynthia Stevenson) out of the way so as to pursue his romance with June Gudmundsdottir.

June is yet another Altman female cloaked in white. Kahane's description of her to Griffin as 'the ice queen' is perfect. Not only is she coolly detached, but when we see her through the windows of her house she is bathed in a bluish tint. Her detachment and the fact that she is an artist connects her with Willie Hart in *3 Women*, whose work, like June's, is unseen by the general public. But outwardly she belongs to a line of descent that includes *Nashville*'s Barbara Jean and Joanne from *Come Back to the 5 & Dime, Jimmy Dean, Jimmy Dean*.

To avoid the police Griffin takes June to a desert spa. On the way their car passes a rattlesnake sunning itself on a rock, an ominous reminder of the writer/stalker who earlier had placed a deadly snake in Griffin's car. That evening, at the spa, June wonders: 'Do places like this really exist?' 'Only in the movies', Griffin responds. Later, when discussing his job and his business with June, Griffin lists the script elements that Hollywood needs 'to market a film successfully: suspense, laughter, violence, hope, heart, nudity, sex, happy endings. Mainly happy endings.' Altman is here thumbing his nose at the studios, essentially explaining to his audience why his films have generally suffered poor distribution.

Of these elements *The Player* has lacked only the last two, so moments later Altman serves up a steamy sex scene between Griffin and June in which all we see are their heads. From the idyll of the spa Griffin finds himself in a police line-up at the Pasadena station. A witness to the murder of the writer has come forward (she walked past Griffin and Kahane just prior to their argument). When the witness incorrectly picks the police detective out of the line-up as the killer, Griffin is home free. Being the film's protagonist, he has elicited the kind of sympathy that the serial child-killer Hans Beckert elicits in *M*. Thus is revealed the connection, subtle and manipulative as it is, to the poster seen earlier in his office and the place card reading 'mr. m.' on their restaurant table at the spa.

A title announces that it is one year later. On the screen we see people who appear to be disconnected from the story, and as the camera pulls back we see that it is a film within the film, in fact *Habeas Corpus*. But the filmed

The Player: the happy ending, one of the key ingredients for a successful Hollywood film.

version differs from the pitch in that its emphasis is now lowest-common-denominator commercial rather than artistic. The requisite big stars, Julia Roberts and Bruce Willis, even deliver the happy ending. In fact, the deluded writer has surrendered his artistic integrity to Griffin's will (Griffin had suggested the ending), as has Larry Levy, who has produced what everyone is sure will be a successful film. Griffin has emerged as the studio boss and successfully buried his past: his old lover is fired; his erstwhile rival is now his toady; and he has bought a new car, married June and moved to a better neighbourhood. But success in Hollywood could crumble at any time. While driving home he listens via phone to a story pitch from none other than his old antagonist, who has re-emerged after lying low for the past year. Recalling the self-referential ending of *M*A*S*H*, the postcard writer pitches what in effect is the plot of the film one has just watched.[10] In fact the treatment is called 'The Player'. Griffin extracts a promise that the truth will stay hidden in the script and seals the deal as he pulls up to his mansion. A pregnant June meets him, they kiss among hundreds of roses in bloom and walk, arm in arm, to the house. *The Player* even delivers the Hollywood-standard happy ending in a corny but Altmanesque manner.

THE SUCCESS OF *THE PLAYER* was directly responsible for the financing of *Short Cuts* (1993), based on several of the minimalist, open-ended short stories by the writer Raymond Carver. The film is another apologue, inter-cutting nine storylines that occur over the course of a few days in Los

Angeles and which culminate in an earthquake. All the stories intersect with at least one other, whether by geographical proximity, by familial or professional relationship or by friendship. *Short Cuts* mirrors the outspread geography of the city itself even as it weaves disparate plotlines.

The film is set during the Mediterranean fruit-fly (medfly) infestation that was devastating California's agriculture in the 1980s. To counteract the medflies California used helicopters to spray the insecticide malathion at night-time. This was a controversial tactic that some thought potentially harmful to humans and other creatures. In the film's opening Altman shows a small fleet of helicopters roaming over and spraying greater Los Angeles. While the visual reference to *M*A*S*H* is obvious, the helicopters' structural purpose is to transport the viewer around the city's environs, introducing the film's storylines, between which Altman cuts back and forth. But they also give an ominous taste of things to come. A television news editorial favouring the malathion spraying is further 'connective tissue' in these introductory scenes in that many of the film's characters are watching the editorial as the helicopter blades churn overhead.

The editorialist is Howard Finnigan (Bruce Davison), and it is his family the viewer sees initially. Their story, and that of their neighbours the Trainers, are the most tragic of the film's nine tales (or groups of 'short cuts'). In just those few days seven of the nine families are touched, directly or indirectly, by death, although two of the families are unaware of it at the film's end. As a counterpoint to all this gloominess, some of the other stories reveal the goofy comedy of sex and love. But in the end even that comedy becomes deadly.

Unlike in *Nashville* there is no silent character making his way through this apologue. Perhaps the lack of one is Altman's wry agreement with the jazz singer Tess Trainer's (Annie Ross) observation to her daughter Zoe (Lori Singer) about Los Angelinos: 'All they do is snort coke and talk.' But, as with the helicopters, Altman did use certain other elements that evoked his previous work. When Ann Finnigan (Andie MacDowell) looks out through the window of her comatose son's (Zane Cassidy) hospital room (and we see the reflection of a nurse), it recalls the scene in *3 Women* where first Willie Hart then Millie Lammoreaux look in on a comatose Pinky Rose. And when Sherry Shepard (Madeleine Stowe), suspecting her husband, Gene's (Tim Robbins), infidelity, discreetly sniffs his fingers, it recalls May telling Eddie in *Fool for Love*, 'Your fingers smell', to which he replies, 'Horses.' She counters, 'Pussy.' More than the dialogue, Sherry and Gene recall May and Eddie in the scene's blocking, in the similar conflicted natures of the women, and

in the auras of suppressed violence both men exude. But these and other stylistic elements, including the overlapping dialogue – of which there is plenty – and the floating, tracking, zooming camera, take a back seat to the film's narrative structure.

Short Cuts is more dependent on the complicated structure of multiple, interacting storylines than are *Nashville* or *A Wedding*. Most of the stories in *Short Cuts* strive for their own unique endings even as the plots coalesce and separate. But Altman's filmmaking instinct was to balance the visual and the verbal. There are scenes that parallel other scenes even where the stories are disconnected. When Betty Weathers (Frances McDormand) comes out of the shower and turns off the television only to be startled by her young son (Jarrett Lennon) – whom she had thought was with her former husband – sitting on the floor behind her, it duplicates Ann Finnigan returning home from the bakery, hearing the television in the den and discovering her young son – whom she thought was at school – sitting on a sofa and beginning to experience symptoms of the head trauma he received by being struck by a car. When Zoe Trainer floats face-down and naked in a pool pretending she is dead, it echoes the unknown drowned woman floating face-up in a stream (discovered by three fishermen, Buck Henry, Fred Ward and Huey Lewis, who decide to not call the police immediately so as not to interrupt their fishing trip) – not to mention Pinky Rose floating face-down in the pool of the Purple Sage apartments in *3 Women*. There are other scenes, too, in which one story visually bleeds into the next in a more expansive use of the technique Altman had first employed in *M*A*S*H*.

Following another cry for help where she purposely cuts her wrist and hand with a shard of glass (recalling Martin in *Streamers*), Zoe eventually does commit suicide by leaving the car running in the garage while she

plays the cello. (As some commentators have noted, Altman uses a match cut to connect the scene in the garage with the smoky jazz bar where Zoe's mother is performing.) Tess's callousness upon hearing that their next-door neighbour, eight-year-old Casey Finnigan, has died from his injuries, pushes Zoe over the edge. The driver of the car that struck Casey is coffee-shop waitress Doreen Piggot (Lily Tomlin), the mother of Honey Bush (Lili Taylor), whose name is reminiscent of a Bond girl. The accident is ironic in that Doreen's husband, Earl (Tom Waits), is a boozy chauffeur. Honey and her wannabe make-up artist husband, Bill Bush (Robert Downey Jr), are best friends with Jerry and Lois Kaiser (Chris Penn, Jennifer Jason Leigh). (Critics immediately noticed the pun in Jerry Kaiser's name, Jerry being Second World War-era slang for German.) Lois runs a phone-sex service from her home, and Jerry owns a pool maintenance company. Two of his clients are the Finnigans and the Trainers. Meanwhile, the doctor who attends Casey in the hospital, Ralph Wyman (Matthew Modine), is married to an artist, Marian Wyman (Julianne Moore). Marian's sister is Sherry Shepard, wife of the unfaithful police officer Gene Shepard (a nod to the humorist Jean

Short Cuts: Stormy Weathers takes revenge on his ex-wife.

Short Cuts: a suicidal Zoe plays the cello one last time.

Shepherd). The woman Gene is having an affair with (who is also unfaithful to him) is Betty Weathers. Betty's former husband Stormy (Peter Gallagher) is one of the helicopter pilots spraying malathion over LA. Lastly, there are Stuart and Claire Kane (Fred Ward, Anne Archer), who meet and befriend the Wymans at a string quintet concert in which Zoe performs. Stuart is one of the fishermen who discover the dead body in the stream; Claire is a clown who performs for children at hospitals (she briefly meets Casey's paternal grandfather (Jack Lemmon) and Gene Shepard).

Short Cuts ends with an earthquake, a disaster that is potentially worse than the medfly problem. And in true Altman fashion the stories are unresolved. In fact, the disaster pushes some of the stories back into the quotidian, although the dual tragedies that mark the Finnegan and Trainer stories raise them above the commonplace at the film's end. One is left to ponder particularly the open-endedness of the Kaisers' and Bushes' interlocked stories in the aftermath of a young woman's death in Griffith Park during the families' outing. The long shot gives a slightly ambiguous feel to the event, not unlike the ambiguity Altman had evoked with previous killings seen in long shot. The viewer is never 100 per cent sure that the woman was not killed by falling rocks caused by the earthquake rather than a sexually frustrated Jerry Kaiser.

IN 1993 PBS AIRED two Altman-directed episodes for its performing-arts series *Great Performances*. These were 'Black and Blue' and 'The Real McTeague: A Synthesis of Forms'. 'Black and Blue' is a video reproduction of the hit Broadway (and Paris) revue that re-creates vaudeville and cabaret performance from the years between the world wars. It featured the original cast of singers and dancers performing to the music of Louis Armstrong, Eubie Blake, Duke Ellington, W. C. Handy, Big Maybelle and Fats Waller. The revue also featured skits. Altman's camera not only captured the performances, but revealed the performers backstage in moments of last-minute preparation or after-performance exhaustion. It also showed the performances from angles that could not be experienced by a theatre audience. Altman filmed the performance at the Minskoff Theatre in New York City in 1991. 'The Real McTeague' combines scenes from the opera *McTeague* with scenes from Erich von Stroheim's classic silent film *Greed* (1924) as the writer Studs Terkel reads excerpts from the original source material, Frank Norris's novel *McTeague* (1899).

AT THE HEIGHT of his renewed popularity Altman returned to France to make a film about the fashion industry. This was a project he had wanted to do for nearly a decade, since he was in Paris filming *The Laundromat* and *Beyond Therapy*. If Altman's intention (as it often appeared to be) was to ruffle feathers, then *Prêt-à-Porter* (1994) was a success, as it perturbed many in the fashion industry and left his audience questioning the point of satirizing a subculture that seems intent on biannually satirizing itself.[11]

Structurally, the film extends Altman's apologue style in what is probably his most overtly postmodern work. He quotes *Nashville* as well as other films of his, classic Hollywood and even the neorealist director Vittorio De Sica, while utilizing a now-familiar device of mixing real people in cameo roles with fictional characters. It all begins in post-Soviet Moscow, where Sergei (Marcello Mastroianni) silently purchases a pair of matching ties in the GUM department store (here referencing a scene in De Sica's 1970 film *I girasoli*) and then heads out for a stroll across Red Square. The camera then spins frantically 360 degrees around and around Red Square until we begin to see the picture transform from a snowy Russian early spring to a green Paris one. A shot of the Eiffel Tower establishes the new locale. Unlikely as it is that Altman was intentionally refuting a statement by the theorist Christian Metz, nevertheless by transporting the viewer (and the character) in this manner from one European capital to the other – and these two cities in particular – Altman did contradict Metz's claim that 'the autonomous shot cannot begin in Moscow and end in Paris.'[12]

It is fashion week in Paris and Kitty Potter (Kim Basinger), a television fashion reporter, has vowed to take her viewers behind the scenes. Throughout the film she interviews real and fictional designers and other notables.

Prêt-à-Porter: Elsa Klensch interviewed by her fictional alter ego, Kitty Potter.

Prêt-à-Porter: Altman's homage to De Sica.

This includes a meta-narrative 'doubling' in which she interviews Elsa Klensch, the CNN fashion reporter on which her character is based. (Klensch treats her like a rival and refuses to divulge any inside information.) In fact, Kitty is clueless about haute couture, and is only as good as the cue cards written for her by her assistant (Chiara Mastroianni). In this way she represents a more stylishly dressed Opal, the fake BBC journalist in *Nashville*. Like Opal, Kitty is a connecting thread, serving as a means of segueing from one designer or fashion event to the next.

Another element from *Nashville* is an airport scene in which the viewer is introduced to various characters as they arrive. Many of them are interviewed on the spot by the ubiquitous Kitty. The airport is also where Sergei clandestinely meets Olivier de la Fontaine (Jean-Pierre Cassel), the despised head of the French Fashion Council now married to Sergei's former wife, Isabella (Sophia Loren). It was to Olivier that Sergei sent one of the matching ties he had purchased in Moscow and, like a parody of a spy movie, the ties serve as recognition for the men. The two stop off at an airport lunch counter long enough for Olivier to buy a ham sandwich, which he takes back with him to his chauffeured car. As they travel from the airport to the city they get stuck in a traffic jam, à la *Nashville*. Moments after ordering his driver to find out the cause of the traffic jam, Olivier chokes to death on his sandwich, and a panicked Sergei flees the automobile, in the same way that Albuquerque, bent on stardom as a singer, flees her husband's truck. Up to this point Sergei has uttered very few words, and for the next hour or so of the film he operates as a silent character haunting the fashion shows and hotels in search of Olivier's widow, Isabella.

Yet another *Nashville* element is the cynical fashion photographer Milo O'Brannigan (Stephen Rea). He has his own agenda, much like *Nashville*'s cynical womanizer, Tom Frank. The twist in the later film is that instead of seducing three women as does Tom, three women – all top fashion editors – attempt to seduce Milo. During one of the seduction scenes, Cissy Wannamaker (Sally Kellerman) bares her breasts to Milo, just as 'Hot Lips' Houlihan (also played by Kellerman) did for Frank Burns in M*A*S*H. When Milo proceeds to photograph her, Cissy covers up and flops forward in protest, much like Houlihan did in the shower scene. Milo manages to take compromising photos of each of the three women, but in the end they turn the tables on him. 'Looks like a scene from *Macbeth*', Milo observes when the trio comes to exact revenge.

In a punchline to a joke to which Altman intermittently cuts away throughout the film, the least likely character turns out to be a transvestite. One first assumes that the woman he is involved with is his lover out on a shopping spree, but she is his wife, and the dresses and undergarments she purchases are for him. Altman had mined the ugly transvestite gag earlier in *California Split*, but when Major Hamilton (Danny Aiello), a fashion buyer for the Chicago department store Marshall Field's, goes out in drag for a night on the town with his wife (Teri Garr), he is photographed in a drag restaurant by news photographer Fiona Ulrich (Lili Taylor), dressed more as if she is shooting a combat zone than a Paris fashion show. This causes him consternation similar to the anxiety of 'Helen Brown' when Bill and Charlie, posing as phoney vice cops, interrupt his session with the prostitutes in *California Split*. As a photographer Fiona, like Milo, is a power broker in a society that is voyeuristic and image-driven.

There is also a bootmaker from Texas named Clint Lammeraux (Lyle Lovett) – a reference to Millie Lammoreaux, who had relocated from Texas to California in *3 Women* – while romantic mash-ups between homosexual and bisexual designers and their assistants recall the edgy sexual politics of *Beyond Therapy*. In addition to these elements from his earlier films, Altman also added sly references to other films, as he often did. During her failed seduction of Milo, Cissy calls him the quiet man – a reference to the 1952 John Ford drama of that name set in Ireland. And the name of Clint Lammeraux's mentor, Slim Chrysler, played by Lauren Bacall, is a reference to Bacall's first film, *To Have and Have Not* (1944), in which she played Slim Browning.

If the references involving Kellerman, Basinger and Bacall are based on their earlier work, none is more prolonged nor more of a homage than the seduction scene between Sergei (whom we discover was originally Sergio)

and Olivier's widow, Isabella. In a recapitulation that is reminiscent of the plot of Vittorio De Sica's film *I girasoli* (Sunflower, 1970), also starring Loren and Mastroianni, Sergei explains why he left Isabella on their wedding night and how he survived in Moscow. But their romantic scene together in which Isabella performs a striptease for Sergei is a direct lift from De Sica's *Ieri, oggi, domani* (Yesterday, Today and Tomorrow, 1963), again starring Loren and Mastroianni. But this time it is not the Loren character who halts the seduction (because of a suddenly recalled religious vow) but Mastroianni's. Sergei/Sergio falls asleep despite his sexual excitement. Earlier, Isabella had referenced the Loren style of the early 1960s in her timeless, classic fashion look (black hat and dress, for she is ostensibly in mourning) as she made her way around the different designer shows following her husband's untimely death.

Considering the film is about fashion, mirrors play a less prominent role than one would expect, especially from Altman. The viewer is made to confuse a reflection for reality at least once – a favourite Altman trick – but there are no extended shots of models peering at themselves or primping. They are solely in the hands of the designers, the hair stylists and make-up artists. The final, nude, show is a protest by the designer Simone Lowenthal (Anouk Aimée) in the face of her son (Rupert Everett) selling her company to Clint Lammeraux, whom she considers a fashion parvenu. Altman visually deconstructs the industry by reverting to his own favourite theme of audience voyeurism. But the voyeurism is not in watching Lowenthal's naked models on the catwalk. Rather, Altman frames it in his own terms. Instead of the designer appearing on the catwalk to take her bows, the backdrop with her logo is raised to reveal a window and there she sits, naked among the smiling, naked models. On the catwalk they were animated but stony-faced mannequins, but through the window they are all relaxed and simply themselves.

11 Crime, Punishment and Vaginas

WITH *KANSAS CITY* (1996) Robert Altman returned to the milieu of *Thieves Like Us* – Depression-era America. But the film was also a paean to his home town, where it was shot. For the script Altman enlisted his some-time collaborator and fellow Kansas City native Frank Barhydt Jr. Barhydt had co-written the screenplays for *Quintet*, *HealtH* and *Short Cuts*, and appeared briefly in *Tanner '88* and *The Player*. *Kansas City* would be Barhydt's final collaboration with Altman.

In the 1930s Kansas City, Missouri, was primarily known for two things: political corruption and jazz. Effectively, these were the city's white and black worlds – their cultures and spheres of influence. 'Boss' Tom Pendergast, an influential Democratic power broker who in 1932 had helped swing Missouri's vote for Franklin D. Roosevelt, dominated municipal and state politics. Pendergast, who ruled Jackson County (in which Kansas City is located) through the usual combination of graft and strong-arm tactics, was also a political mentor of Harry S. Truman, who eventually became Roosevelt's vice president and successor. The flip side of Kansas City life during this period was its attraction as a centre for great jazz music. Although much smaller in size than New York or Chicago, the city had a wide-open atmosphere (it was also a mecca for Midwest gamblers) that drew some of the greatest jazz musicians of the era, such as the pianists Count Basie and Mary Lou Williams, and saxophonists Coleman Hawkins, Ben Webster and Lester Young, not to mention the pianist Bennie Moten, a Kansas City native. That corruption and violence underpinned this world, too, was another of the city's open secrets.

Kansas City takes place over two days in 1934, when Robert Altman was nine years old and Frank Barhydt Jr not even born. Thus they fashioned a

Kansas City from stories, recollections and legends, sifting a city where, like many American cities of any size, black life operated in counterpoint to white life. What the film does behind the plot is show little points where those worlds touched each other, Altman effectively aiming a microscope on the Paris of the Plains. There is no admixture of fiction and reality in the film, but rather tender and rough historical re-creation in the great jazz scenes of the Hey-Hey Club and of a political operator who runs a crew of 'voters' throughout the city. As it turns out, the town's white and black worlds are both indifferent to the plight of Blondie O'Hara (Jennifer Jason Leigh), the film's protagonist.

Altman uses a cross-cutting technique that bends time, allowing the audience to see the cause and effect in non-chronological parallel lines until they converge, similar to but not an exact duplicate of the cross-cutting he used in *Brewster McCloud*. The film opens on a stormy November day with Blondie O'Hara entering the home of Carolyn Stilton (Miranda Richardson). Ostensibly there as a replacement manicurist for her sister Babe (Brooke Smith), Blondie has actually come to kidnap Carolyn. In a scene that clues in the reader to the backstory to Blondie's plotline, we see a young man loping down a street. As the film progresses we learn that this is Blondie's husband, Johnny O'Hara (Dermot Mulroney). Johnny has teamed up with a cab driver, Blue, to rob an African American gambler named Sheepshan Red (A. C. Smith). The trouble is that Sheepshan has come to lose his money in a dice game run by Seldom Seen (Harry Belafonte), a notorious gangster and owner of the Hey-Hey Club, where all of the film's jazz action takes place. Seldom Seen also owns the cab company for which Blue works. When Sheepshan complains to Seldom, and the latter discovers burned cork on Sheepshan's coat, it does not take long for Blue to spill the truth (off-screen) about the robbery. The burned cork was Johnny's attempt to disguise himself during the robbery. Unlike Blue he is not African American, but donned 'blackface' to pull off the crime.

The laudanum-addicted Carolyn Stilton becomes Blondie's kidnap victim because her husband is an adviser to President Roosevelt. In another bit of cross-cutting we see the officious Henry Stilton (Michael Murphy) striding through Kansas City's railway station on his way to Washington, DC. The station scene is interesting for the Democratic political rally taking place – this was the election that brought Harry S. Truman to the U.S. Senate – and for the fact that three Junior League women are searching for the pregnant fourteen-year-old Pearl Cummings (Ajia Mignon Johnson), who has come to Kansas City to have her baby in a segregated maternity home.

The Junior League women never find Pearl in the railway station (their search for her and subsequent events are an interesting subplot), but she is taken under the wing of a boy about her age carrying a saxophone – the young Charlie Parker (Albert J. Burnes), who was a native of Kansas City. Parker brings Pearl to, of all places, the Hey-Hey Club, where an array of musicians, including (the viewer is left to presume) Basie (Cyrus Chestnut), Williams (Geri Allen) and Webster, are in the process of assembling for an all-day and all-night jam session that will feature a cutting contest between the two premier saxophonists of the day, Lester Young and Coleman Hawkins. In fact, as Johnny O'Hara slinks down the street in the earlier scene he passes an advertisement for the contest. The young Parker cannot resist this line-up.

Altman returns to one of his favourite motifs, the mirror, in this film. Most remarkable is when we see Johnny O'Hara return home with Sheepshan's money belt. Still in blackface, he goes to the bathroom sink and begins washing the burned cork off, transforming himself back. As he does so, three of Seldom Seen's gangsters, one with the money belt draped over his shoulder, silently move into the background of the mirror's reflection, and the viewer knows along with Johnny that things are about to take a bad turn for him. Johnny's blackface is contrasted in cross-cut with Carolyn's face covered in cold cream, which she has applied just prior to Blondie's

Kansas City: Seldom Seen explains to Johnny O'Hara why he has not had him killed.

arrival at her house – the parallel recalling the Van Gogh brothers' use of paint and make-up on themselves. Eventually Carolyn removes the cold cream from her face before her own vanity mirror and, in the same bedroom, Blondie applies lipstick to herself while staring at her reflection in her compact mirror.

Johnny O'Hara and Seldom Seen are both reflected in a mirror in the room where Johnny is held hostage as he tries to bargain for his life. But when Johnny observes to the gangster, 'One way or the other you got my life', only Seldom's reflection is seen – a visual foreshadowing of what he will do with Johnny. Similarly, towards the film's end we see Carolyn Stilton and Blondie O'Hara reflected slantwise in a portable table mirror. Carolyn helps Blondie reassert the visual aspect of her remade self by applying peroxide to the latter's hair, and in the reflection she stands above in a dominant position to the trusting and naive Blondie.[1] Just prior to this the camera has focused on Blondie's gun and Carolyn's laudanum resting on the telephone table in Blondie's tiny living room. Both shots foreshadow the film's end.

Many of Altman's films offer references to Hollywood films of the 1930s and '40s (and occasionally foreign films), but with the exception of Mona in *Come Back to the 5 & Dime, Jimmy Dean, Jimmy Dean*, nowhere else in Altman's body of work is there a character as obsessed with movies and one particular actor as Blondie O'Hara. The focus of her obsession is the 1930s movie queen Jean Harlow, herself a Kansas City native. While passing the time waiting to contact Carolyn's husband, Blondie takes Carolyn to the movies to watch *Hold Your Man* (1933), starring Harlow and Clark Gable. Blondie has seen the film numerous times but Carolyn doesn't even know who Jean Harlow is, later rendering a verdict of her as cheap and brassy-looking, an opinion that raises Blondie's hackles. Even as she is walking up the cinema aisle to telephone Stilton at the appointed time, Blondie's eyes cannot stop watching a scene in which Harlow and Gable are reunited and, while they hold each other, Harlow proclaims: 'Everything's gonna be alright. I'm gonna have you, and you're gonna have me for always.' Blondie, accompanied by Carolyn, then goes to the lobby to continue her plan to free her husband – her own fictitious belief that 'everything's gonna be alright.'

Jennifer Jason Leigh presents a woman trying to push her way through life in the only manner she knows: by emulating her favourite screen actress. Blondie O'Hara is one of those Altman women who is not what she appears to be – or what she thinks she is. All her tough talk and actions cannot erase her vulnerability. Blondie often speaks in slang and euphemisms, although it is difficult to know the extent to which Hollywood dialogue (from which

she gets her cues) reflected American culture of the period or influenced it. Certainly some of Blondie's phrases, such as 'pinch hit' (to substitute for, taken from baseball) and high hat (to condescend towards, reputedly coined by the writer Jack Conway), were well-known usages of the period; the former still in use.[2] Others were at the very least popular film and pulp-fiction phrases and perhaps reflect the character's obsession with popular culture: 'take a powder', 'don't get cute', 'spit it out', 'funny business', 'a monkey's uncle' and 'a goner', all of which a contemporary audience has heard numerous times and readily understands. The most colourful phrase in Blondie's lexicon is 'yellow pants', which in the context that she uses it means to become so frightened that one wets one's pants – an entirely different take on the colour yellow for Altman.

Seldom Seen is the film's other colourful character. He and Blondie meet only once – when Blondie comes to the Hey-Hey Club to negotiate her husband's release. Blondie threatens to kill Seldom but is carried out of the club kicking and screaming by the unperturbed gangster's henchmen. During their dialogue the unremitting jazz that resonates throughout the film is heard in the background, but when Blondie throws her fit the music turns atonal. It is the only time the musicians acknowledge the world outside their music. In that same scene a young Charlie Parker gives a thumbnail portrait of Seldom Seen to the pregnant Pearl, with whom he is sitting in the mezzanine. Seldom is a ruthless gangster and it is said that he is 'seldom seen, but often heard' – a reminder of *Nashville*'s Hal Phillip Walker, but also perhaps of Altman himself, whose films were seldom seen because of poor distribution. In the context of this film the gangster is seen as well as heard often. Seldom tells jokes, philosophizes about the greed of white society (ignoring, of course, his own greed as a gangster), advises and loans money to the hapless gambler Sheepshan Red and wonders out loud just how he is going to dispose of Johnny O'Hara. Since he never leaves (except on one occasion) the Hey-Hey Club – a fiefdom he controls – he has no need of the oppositional gaze.

In the scene where Johnny and Seldom briefly share reflection space in a mirror, Johnny ironically refers to himself as Seldom's slave, which draws laughter all round. But it doesn't convince Seldom to spare his life. He turns to one of his henchmen and says: 'That doctor friend of Benny Moten's . . . Tell him I want to talk to him.' The camera then cuts to Johnny and zooms in on him. The loquacious swindler is silenced by the implication. The dialogue implies that Seldom wants the doctor to use his surgical skill to send Johnny to his grave as painfully as possible. Actually, this is an

anachronism. What it refers to is the doctor's incompetence in removing Benny Moten's tonsils, which resulted in the pianist's premature death. But that took place in 1935, and *Kansas City* is set a year earlier.

When Johnny is finally reunited with Blondie in their home, he is cut up badly and dying. She has just combed out her newly-bleached hair and, in a white dress, is in her platinum-blonde glory when he arrives. Not only were the tables turned on Johnny's big plans, but on Blondie's too. They are not going to have each other for always, as the movie sentiment went, unless it is in the afterlife. For as she implores Carolyn to help her save the dying Johnny, the laudanum-calmed woman picks up Blondie's gun and shoots her in the back of the head, doing what Blondie had threatened to do to her. Thus Carolyn, at least when she is under the influence of laudanum, is not what she appears to be either. Blondie, for her part, is another of Altman's martyred women in white, in another unforeseen act of violence.

Kansas City traces a line of connection between the federal government and the Mafia. To rescue his wife, presidential adviser Henry Stilton contacts the governor, who contacts Tom Pendergast, who in turn contacts a local Mafia boss and Democratic ward heeler to make things right. All along Blondie has been under the mistaken belief that the movers and shakers will follow her logic, but it is only Carolyn Stilton's safety they care about. Even Johnny believes the 'Italians' would not stand for a white man being killed by African American gangsters, but Seldom recognizes it as a bluff, even if Johnny himself does not.

In later commentary Altman admitted how much the film's music influenced its structure: 'I tried to write this film like jazz and I tried to shoot it that way. In other words, I have lines and there is a plot with definite suspense. There is a beginning, a middle with stopping points, and an ending, but in between, I let the actors go off on these riffs, just like they do in music.'[3] Or just like they do in many other Altman films.

For many viewers the film's most memorable scene was the re-creation of the historic saxophone duel between Lester Young (Joshua Redman) and Coleman Hawkins (Craig Handy). The cutting contest (as it was called) lasts nearly five minutes and is the musical highlight of a movie filled with superlative evocations of great swing jazz. Whether deliberately or not, the film shows the saxophonists playing in the opposite styles to the characters they portray. That is, Lester Young in his porkpie hat plays a 'hot' saxophone while Hawkins, stripped down to his vest, plays the 'cool' saxophone. The music was so integral to the film and so wonderfully re-created that Altman decided to reproduce the *Kansas City* jam session in the Hey-Hey Club as

Kansas City: Lester Young and Coleman Hawkins battle it out for saxophone supremacy.

a mock-documentary for PBS. *Jazz '34: Remembrances of Kansas City Swing* (1997) was the last of Altman's PBS specials. It used some of the film footage and footage that was edited out of *Kansas City*, with brief introductory narration by Harry Belafonte. There are also various voiceovers about the city's jazz scene, but it is unclear whether these are anonymous quotations or fictional 'remembrances'. Altman supposedly used a short entitled *Jammin' the Blues* (1944) as his model for this 75-minute jazz film.[4] To many critics of the time, especially those who disliked Altman's editing technique in *Kansas City*, *Jazz '34* was the definitive look at Kansas City's sinful heyday.

A tracking shot of a Kansas City street during the period opens the film, and the camera comes to rest in front of the Hey-Hey Club, with the sign at the front advertising the legendary battle of the tenor saxophonists Lester Young and Coleman Hawkins. Over this is Belafonte's narration, and then the camera is inside the club. With assistance from the voiceovers Altman again constricts time, as the jam session lasts days. There is another saxophone duel besides the Young–Hawkins one, but it is one of *Kansas City*'s deleted scenes. As in the feature, the music is itself part of an overlapping dialogue, especially between soloists and the other musicians egging them on. Some of *Jazz '34*'s shots are pregnant with meaning but only if you have seen *Kansas City*. Notably these include two shots of the young Charlie Parker up in the mezzanine. Both times he has his saxophone at hand. In the first we see Pearl beside him; in the second, a tighter shot, Parker has fallen asleep in the midst of the all-night session. The final shot, of a bass duet with drums, piano and clarinet, is taken from the feature and again extends into

the credit roll. Barely noticeable in the background is Seldom Seen counting his money.

AROUND THE TIME ALTMAN directed *Jazz '34* he also produced an anthology series, *Gun*, broadcast in the spring of 1997 on the ABC television network. It revolved around a handgun and the uses to which its various owners put it. (The familiar chorus of The Beatles' 'Happiness is a Warm Gun', performed by U2, is heard prior to each episode.) Altman directed only the second of the series' six episodes, entitled 'All the President's Women', the wryest episode of the anthology. Its themes of power and infidelity parody President Bill Clinton's travails during the period. The episode is set in Texas; the gun inexplicably shows up in different states from episode to episode.

The gun initially belongs to Parker Tyler (Nicolas Coster), president of the Buena Vida Country Club. (His name is a nod to the twentieth-century film critic, novelist, poet and editor Parker Tyler.) While out on the country club's golf course he hits his ball into the rough. On retrieving the ball he sees that a snake (referencing both *Rattlesnake in a Cooler* and *The Player*) has nestled around it, whereupon he gets the gun and begins blasting away. His first shot merely wounds the snake, which then strikes him, thus causing him to shoot himself in the foot. Tyler succumbs after realizing two clichés in a matter of seconds, and the episode's tone is set. His golfing partner, Bill Johnson (Randy Quaid), succeeds him as country club president – much like Texan Lyndon Johnson succeeded to the U.S. presidency following the violent death of his predecessor. In fact Bill's name is an amalgam of presidents Clinton and Johnson.

The gun, however, has disappeared, only to be sent to Bill's mistress, Phyllis Tyler (Jennifer Tilly), daughter of his predecessor. Meanwhile, Bill's wife, Jill (Daryl Hannah), has received the empty clip – sent to her in an identical box as the gun. The next day, Bill discovers that his former mistress, Paula (Sean Young), has received the bullets. (Jill, Phyllis and Paula are yet another of Altman's female triumvirates, but not the only one in this story.) Not to be dissuaded, Bill has begun flirting with his new intern, Marcy. Bill's other women include Genny (Dina Spybey), a flirtatious woman at the club, and Frances Tyler (Sally Kellerman), Parker's widow, who discovers Bill's involvement with her daughter.

Everything comes to a head at Bill's 'inauguration' party at the country club. Expecting an assignation with Genny, Bill is lured out on to the seventh tee. Instead Frances shows up brandishing the gun and forces Bill to strip

Gun, 'All the President's Women': five of the president's women forego the festivities on the golf course.

before handcuffing him to a golf-ball washer. She then tosses down the gun and exits. Jill arrives next, vents her anger at Bill for his infidelity and aims the gun at him. A blast of fireworks intimates to the audience a gunshot. Meanwhile another trio of Altman women, Paula, Phyllis and Genny – Bill's past, present and future mistresses – sit at the bar planning their revenge against him (like the three fashion editors in *Prêt-à-Porter*). Eventually Frances joins them, and they are the only four guests who do not traipse up to the seventh tee as part of Jill's inauguration surprise for her husband. The rest of the celebrants discover a naked Bill, whose exposure in both senses is the ultimate humiliation. A coda reveals that Sally Jefferson, a staff worker at the country club and another of Bill's former lovers, was behind the plot to expose Bill. (She is African American and a clear reference to Sally Hemings, Thomas Jefferson's longtime slave mistress.) While the episode's charm relies mostly on its plotline, its critique of Bill Clinton's shenanigans did burnish Altman's feminist reputation.

ALTMAN'S NEXT PROJECT was the straightforward thriller *The Gingerbread Man* (1998), about a womanizing criminal lawyer with a knack for getting guilty clients off on technicalities. Rick Magruder (Kenneth Branagh) finds himself enmeshed in what at first appears to be a simple case of remanding an old man in state custody on charges of mental incompetence. But the film's twisting plot soon turns into kidnapping and murder, against the backdrop of an impending hurricane. *The Gingerbread Man* is based on a story by the

novelist John Grisham, but the legal setting is the only thing that remained from Grisham's script. (Grisham disassociated himself from the project.)

That Altman directed such a connect-the-dots narrative flies in the face of his own stated preferences. Nevertheless, there are some nice Altman touches. These include a long opening sequence in which the camera glides over a strange-looking terrain, following a river (presumably the Savannah) until finally coming to focus on a lone red Mercedes-Benz cruising down the road on its way to Savannah, Georgia, in and around which the action is set. As the camera closes in on the car the background radio chatter becomes clearer, and it turns out to be an interview with Magruder, who has just got another sleazy client off on a legal technicality. The Mercedes is Magruder's, and the camera follows it to its destination.

Other familiar Altman touches include the overlapping dialogue at Magruder's surprise victory party (in his spacious office), and plentiful use of the voyeuristic camera. In one scene the audience, then Magruder himself, peeps at his lover/client Mallory Doss (Embeth Davidtz) as she strips off wet clothes. We see her first through the open doorway to her bedroom, then, after she has closed the door, the relentless camera moves to the side to reveal yet another doorway to her bedroom, this one hung with beads to give the illusion of privacy. Mallory is later seen naked through a broken window, while cross-cutting reveals her father's escape from a mental hospital through a window. Her father, Dixon Doss (Robert Duvall), had been put away for stalking her. In a Hitchcock-like take, Magruder's children and a children's television programme are framed in a motel-room

The Gingerbread Man: a distraught Magruder shoots Dixon Doss.

window. This is the set-up. A few moments later, after a truck has blocked our vision of the window, we (and Magruder) again see through the window, but the children are missing.

Altman also uses a wall mirror to substitute a reflection for reality, and the rear-view and side mirrors of Magruder's Mercedes offer the viewer brief, slanted (and psychologically revealing) images of the protagonist, reminiscent of the use of a car's rear-view mirror in *Images*. The film's use of television recalls two of Altman's earlier films. When we see the three televisions in Magruder's ex-wife's home all tuned to the same station – a news recapitulation of Magruder's recent legal victory – this recalls the television news in *Countdown* bringing that film's viewers up to date on the backstory, and the monitors in *Secret Honor* showing the same image. With the exception of the motel-room television tuned to a children's programme, these are the only television sets in the film that are not playing news about the impending Hurricane Geraldo or its effects as it hits the mainland. Televisions in seven different locations, some shown more than once, provide bulletins as the storm (almost a character in its own right) becomes ominous in the film. These television warnings, although scattered over the course of the film, recall the numerous television sets tuned into Howard Finnegan's pro-malathion editorial at the beginning of *Short Cuts*.

One thing Altman did not do in this film was repeat the mistake he had made in *3 Women* of showing a character's dream. In the scene in which Dixon Doss's escape from a mental hospital is cross-cut, Mallory wakes from a nightmare, hints to Rick, her bedmate, of childhood abuse by her father, and then goes to the window as the wind from the incoming storm kicks up. It's a fine example of Altman revealing something without saying it. But in light of the plot outcome it is also another example of Mallory Doss's manipulation of Rick (and Altman's of the viewer).

Thrillers are all about audience manipulation, which Altman had never had a problem with, but the pedestrian method of manipulation this film follows is un-Altmanlike because it lacks intelligence, or the appearance of such, on the protagonist's part. A lawyer known for getting his clients off on technicalities fails to perform due diligence on his virtually unknown client, her hostile witness ex-husband (Tom Berenger) or her mentally unstable father, despite the doubts of his assistant, Lois Harlan (Daryl Hannah), and Clyde Pell (Robert Downey Jr), a private investigator who works for Magruder. Even the young man in *That Cold Day in the Park* understood Frances Austen (his captor) better than the sophisticated Magruder understands Mallory Doss.

The rain and wind, overcast skies and abundance of night-time scenes take the film into noirish terrain that Altman enhances with his use of shadows cast across the characters. One scene in particular, a brainstorming session involving Magruder, Lois and Clyde in Magruder's inner office after his arrest (for killing Dixon Doss, whom he believed incorrectly had kidnapped his children), involves a 90-degree camera pan so that the light streaming through the windows casts horizontal shadows from the Venetian blinds across the three people, but especially on Magruder, on whom the camera then slowly zooms to a close-up. The stripes of light and darkness symbolize in the best Fritz Lang manner Magruder's lack of innocence and his emergence from his naivety. Unfortunately, Altman's technique cannot make up for an intellectually undemanding narrative that includes a car chase and a fight to the death on an offshore rig during a hurricane, offering the special effect of death by flare gun.

IN *COOKIE'S FORTUNE* (1999), set and filmed in the town of Holly Springs, Mississippi, Altman again mined, although archly, the Southern Gothic aesthetic. Jewel Mae 'Cookie' Orcutt (Patricia Neal) is the matriarch of a family composed of her two nieces – the manipulative Camille Dixon (Glenn Close) and the manipulated Cora Duvall (Julianne Moore) – and a great-niece, the hard-living Emma Duvall (Liv Tyler, who bought a fresh-faced and fresh-voiced naturalism that is reminiscent of Shelley Duvall in *Brewster McCloud* and *Thieves Like Us*; her character's name may even have been a tribute to Altman's earlier ingénue). Added to this family is Willis Richland (Charles S. Dutton), an African American who is Cookie's best friend and lives in a wing of her house. Willis is the film's 'connective tissue'. Traipsing around Holly Springs as he does, he is a physical connection between the town's white and African American communities. Within the film's scope Willis knows everybody in the small town.

As with *Nashville*, the story covers five days. Here it begins on the evening of Good Friday and ends on Easter Tuesday. On that first evening we see Willis's distorted face filtered through the glass of a jar containing hard-boiled eggs set on the bar in a mostly empty blues club. The distortion gives a quick hint to his mood of the moment: he is slightly tipsy from whiskey. Meanwhile, a number of the white townspeople have gathered at the First Presbyterian Church, where they are rehearsing the Easter play (to be performed on the following Monday) – Oscar Wilde's *Salomé*, adapted by Camille Dixon, who is also the play's director. By imposing her directorial

will and 'co-authorship' on the script, and by the fact that *Salomé* is an unlikely choice for the holiday, liable to leave audience expectations of symbolic rebirth unfulfilled, Camille connects to Altman himself. Her sister Cora has the title role. Outside the church on a sign announcing the play's rehearsal is the thought for the day and the film's theme: 'Pride and Pretense are the jockeys of misfortune.'

After he makes his rounds of the town Willis returns to Cookie's home, where he sneaks in through the kitchen window – a kind of misdirection that along with Willis's drinking and swiping a half-pint of bourbon from the bar (he replaces it the next day) leads the audience to believe he is a petty criminal. (Willis's action also recalls a drunken Sergeant Cokes climbing through the barracks window in *Streamers*.) But when the feisty Cookie enters the scene, the viewer is quickly disabused of that notion. Their patter reveals that they are close friends.

The ageing Cookie so pines for her dead husband, Buck, that she decides to do away with herself and join him in the afterlife. Her disjointed responses to Willis the next day, while revealing to the viewer that she is at peace with her decision, trouble Willis. When Willis leaves to run some errands in town, we see Cookie framed in the same kitchen window Willis had crawled through the previous night. The camera's point of view is outside looking in, but this is no voyeuristic shot. It is a portrait of an old woman bidding her close friend goodbye. The viewer is aware of the deeper meaning and can read the scene for all its pathos. When next we see Cookie she is writing her suicide note to Willis; she then slowly ascends the stairs to her bedroom. Her tired, slow, final climb up the stairs recalls the doddering Bishop's slow climb up the interior stairs of the Sloan-Corelli mansion in *A Wedding*, but without the humour.

Cookie's Fortune:
Cookie and Willis
discuss old times.

Simultaneous to this (and to the costume fitting for the Easter play – all three scenes shown in cross-cut), Willis has gone to visit Emma Duvall to ask her to join him and Cookie for Easter dinner the next day. This scene contains a number of verbal ironies. Emma claims her mother, Cora, called her a worthless tramp. But when Willis corrects her that it was her Aunt Camille, Emma replies, 'Same difference.' A few moments later, when Willis is trying to convince Emma that Cookie is getting old and needs her, Emma counters that Willis is there for the old woman. Willis humbly says, 'I'm not exactly family', and Emma responds: 'Yes you are. To Aunt Cookie you are. To me and her you are always family. You know that.' After Emma accepts the invitation, an overjoyed Willis exclaims, 'Cookie gonna be in heaven.' The film then cuts back to Cookie inside her bedroom. She places a necklace around her neck, lies down on the bed, arranges a feather pillow over her face, and fires one of Buck's revolvers into her head. We hear the shot and see the feathers fly up and her suicide note blown off the night table. Cookie's death in bed is yet another reference to *A Wedding*, where the matriarch Nettie Sloan also died in her bed, albeit peacefully.

Later that day Camille discovers Cookie's body and the suicide note when she goes to Cookie's house to retrieve a crystal bowl for her holiday dinner (to which neither Cookie nor Emma have been invited). Camille hurriedly swallows the note and convinces her persuadable sister to go along with her plan to make Cookie's suicide appear to be a murder and burglary to maintain the family dignity. Camille stage-manages the whole thing, including swiping Cookie's necklace and a few other items and tossing the gun into the bushes. Cora goes along with it because she does whatever Camille tells her to do. (The townspeople consider her to have an intellectual disability.)

When the police and then Willis finally arrive at the house the latter is charged with the crime because his fingerprints are on the gun, having cleaned it the previous evening while talking to Cookie. But none of the officers, especially Willis's fishing buddy Lester (Ned Beatty), believe Willis is a killer. The impulsive Emma decides to get herself arrested in solidarity with him. After Camille's blood type is identified on a glass shard from the shattered bowl at the crime scene and other evidence against her is revealed, the police arrest her for murder during the performance of *Salomé*.

The only person who can exonerate her is Cora, who comes to the police station to give her statement the next day, still dressed as *Salomé*. Throughout the rehearsal scenes and the play itself Cora appears most psychologically integrated when acting the role of the temptress. Now she repeats what

Cookie's Fortune: Willis and Emma share an Easter meal in jail.

Cookie's Fortune: Cora and Camille clean up the 'crime scene'.

Camille had told her to say: that Cookie was murdered (although Camille, herself, has told the investigator the real story). But the look on Cora's face when she explains to Camille what she has told the police reveals an awareness of the irony of the situation. Camille is left to atone for her sins of 'Pride and Pretense'. She is last seen lying on her cot, a pillow over her face and her arm extended in the way that the dead Cookie's had been.

Cookie's Fortune is dotted with irony, visual jokes and, as already suggested, references to earlier Altman films. When Cookie's lawyer comes to her house to retrieve her will it turns out Cookie had kept it along with other important papers in – where else? – her cookie jar. Camille, who is present, is caught unawares. After the lawyer leaves she begins pulling out other papers from the jar, just as the police arrive, and is caught with her hand in the cookie jar. This visual cliché recalls the 'All the President's Women' episode of *Gun* in which Parker Tyler is not only 'snake bitten' but 'shoots himself in the foot'.

It is also revealed just prior to Camille's arrest that she, not Cora, is really Emma's mother. The implication is that Camille even 'authored' her relationship dynamic with Emma in the interest of propriety. In fact the dynamic between Camille, Cora and Emma is an inversion of that of Millie, Pinky

and Willie at the end of *3 Women*. The predominance of the colour yellow is another connection to *3 Women*: yellow is one of the symbolic colours of the Easter season, but Camille's car is also yellow, as is the abundant crime-scene tape that she is forever ripping up. This latter action, taking into account the mythic symbolism of yellow, serves as a clue to Camille's personality and character. Overwhelmed with pride, she has forsaken her female creative (in this case procreative) energy – denial of the responsibilities of parenthood being far more common among males than females.

The final scene shows Willis, Emma, Lester and the lawyer fishing off a dock. But Emma gets up and leaves them for a tryst with her police-officer boyfriend (Chris O'Donnell). Like 'Hot Lips' Houlihan in *M*A*S*H*, she simultaneously is and is not 'one of the boys'. Throughout the film fishing has been a verbal metaphor for truth and friendship – more than once Lester announce his faith in Willis's innocence because 'I've fished with the man.' The final shots are of floats bobbing on the serene water: for everyone except Camille, Holly Springs has returned to normal. The serenity is also a contrast with the hurricane-whipped water in *The Gingerbread Man*, symbolizing the basic artistic differences between the films. Both Rick Magruder and Mallory Doss get what they deserve at the end of *The Gingerbread Man*, in a pat ending designed to bring closure to the thriller and fulfil the audience's moral expectations. But the ending of *Cookie's Fortune* only appears to fulfil expectations. Emma is happily in love and the innocent Willis has been freed. However, the not-so-innocent Camille remains in prison for a murder she did not commit. The happy ending is misleading.

ALTMAN STAYED WITHIN the old Confederacy – this time Dallas, Texas – for the setting of *Dr T and the Women* (2000). The title and setting are more than coincidentally similar to 'All the President's Women', since both were written by Anne Rapp. Dr Sullivan Travis – Dr T – is a society gynaecologist whose life suddenly becomes complicated. Or rather, he finally becomes aware of the complications of his life. Because of his facility with a speculum and his easy-going demeanour, Dr T (Richard Gere) fancies himself an expert on women. To his male buddies he proclaims the uniqueness of the individual woman. But deep down, deeper than he realizes, he does not believe or perhaps fully understand that platitude.

In some ways *Dr T and the Women* is both a homage to George Cukor's film *The Women* (1939) and a corrective to it. *The Women* features an all-female cast playing mostly society women. And although a good deal of the

film is set in Reno, Nevada, where many of the women are awaiting divorce, the rivalries all seem to be centred on men. In *Dr T and the Women* there is rivalry among women for Dr T's time and services. After an opening scene of Dr T examining a woman (his face first glimpsed between her spread thighs), along with accompanying dialogue that establishes some of the people in Dr T's life, the film cuts to Dr T's waiting room, where, as the credits continue to roll, Altman delivers some of the best overlapping dialogue of his career. Gradually the overlapping becomes more intense, and the women begin crowding the nurses' station, until the whole scene collapses into cacophony.

But the film is indeed about women (and Dr T's relationship with them). In scene after scene, many in Dr T's waiting room, Altman literally packed the screen with women. These include the Dallas shopping mall where Dr T's wife, Kate (Farrah Fawcett), and her sister Peggy (Laura Dern) have gone to meet Kate and Dr T's daughters, Dee Dee (Kate Hudson) and Connie (Tara Reid), to choose cutlery for Dee Dee's upcoming wedding. All the shoppers in the mall are women. Dee Dee, it turns out, is an alternative cheerleader for the Dallas Cowboys Cheerleader squad, and there is an extended scene of their rehearsal. Other women-filled scenes include the bridesmaids' dress fittings and the bridal shower. All but two of the patients at the psychiatric hospital to which Kate has been confined after her nervous breakdown are women (although the orderlies are men), and the majority of Dee Dee's wedding guests are female.

Dr T takes refuge in golfing and duck hunting with his three male buddies. To them he is Sully – only ironically does one of them call him Dr T. The uber-confident gynaecologist spouts his philosophy of women to his friends in the country-club locker room. (The country-club setting is another connection with 'All the President's Women'.) 'Women,' he proclaims, 'by nature they are saints. They're sacred and should be treated as such.' Moments later the irony of that statement hits him in the face when the country club's new assistant golf pro, Bree (Helen Hunt), tells him that the police have arrested his wife for dancing naked in the shopping-mall fountain.

We see Kate slowly disconnecting from her family and from the situation in Tiffany's (although she has the wherewithal to understand the silliness of the saleswoman's name being Tiffany) while her sister and daughters sample the free champagne and examine cutlery. Kate wanders off and begins an Isadora Duncan-like dance around the fountain, trailing her scarf before jumping into the fountain and stripping off her clothes (with a Godiva chocolate shop in the background). So begins Dr T's troubles with women. Kate's psychiatrist, Dr Harper (Lee Grant), conjectures that Kate suffers from

a 'Hestia complex', a psychological condition of upper-middle-class women who are loved too much and have (or are generally given) all the material comforts they might want. Kate follows the 'classic pattern' of regressing psychologically into a virginal childhood. (Hestia was the Greek goddess of the hearth, whose Roman counterpart, Vesta, was also the protector of virgins.) Indeed, when Dr T visits Kate at the hospital she introduces him to her fellow inmates as her brother. The conclusion of all this is that her problems are the result of his treating her as 'sacred'. But another aspect of this character is that Farrah Fawcett, who plays Kate, is mocking and shedding her own manufactured image as a sex symbol in much the same way that Paul Newman had mocked his stardom in *Buffalo Bill*. Throughout the film Kate neither looks, nor acts, nor wants to be sexy. And that message is delivered to Dr T unequivocally.

In addition to his patients constantly clamouring for their appointments, his daughters and his quietly alcoholic, occasionally falling-down sister-in-law, Peggy, vie for his attention. (Peggy is getting a divorce and has moved into his home with her three small daughters.) Meanwhile, the complications of Dr T's life mount in proportion to his obliviousness: Kate, although she seems unable to make such a decision, has decided she wants a divorce; Connie intimates to her father that Dee Dee may be a lesbian; his office manager, Carolyn (Shelley Long), makes a late-night play for him, which ends in her embarrassment; and he never does catch on to Peggy's drinking problem. What he does have is a brief affair with Bree, a woman who is the polar opposite of Kate. She is strong and independent and willing and able to play the field.

A storm during Dee Dee's outdoor wedding ceremony is the catalyst for the film's climax. Storm clouds roll in and the wind kicks up just as the bridesmaids make their entrance. The foreboding winds get stronger and stronger, signalling the dissolution of Dr T's personal and professional lives as his daughters and other women clue him in on the realities of their lives. As the rain comes down heavily and wedding guests and others scramble for cover, Dr T experiences what he believes is an epiphany, jumping into his convertible and driving to Bree's apartment. There he confesses that he wants her to run away with him. Her reaction to his arrival is a tip-off (to the audience) that something is amiss. He promises to take care of her, but she asks, 'Why would I want that?' And it is here that Dr T has his real epiphany. He drives off into the storm, which is now a tornado.

With understatement, Altman here presents an anomalous ending with regard to his oeuvre. It is a kind of *Wizard of Oz* fantasy, in which Dr T

Dr T and the Women: Dr T drives into a tornado.

drives into the twister and is lifted up inside it. We see him spinning and spinning, eventually tossed out of his car. The next scene shows that the storm has passed, and the camera surveys the wreckage of Dr T's car and his morning coat hanging on a bush. Three Mexican girls, replacing Dr T's three nieces, come upon the scene. One of them appears to be able to read and understand Dr T's car registration (DR T), so that when the fantastically, or perhaps miraculously, unscathed Dr T (again Altman's weirdness in the desert) lifts himself off the ground he follows the girls back to the pueblo, where he discovers a woman in labour. The three women attending her are overjoyed that he is there, and he quickly falls into his professional role. He washes his hands (and in doing so removes his wedding ring), but he does nothing that the women themselves could not have done: he simply urges the pregnant woman to continue pushing (*'Mas, mas!'*) and catches the baby as it is born. The viewer witnesses the birth, not exactly shocking, but still an unlikely sequence even to a late twentieth-century film audience. It is the most powerful scene of Altman's career – again, not for the shock value but for the naturalism.[5] The newborn is a boy, and for this miracle Dr T is joyful, for the baby is a signal of his own rebirth. (The birth also rectifies the stillbirth of the boy in *3 Women*.) As the women stream out of the hut announcing the birth, the helicopter-mounted camera pulls away and moves rapidly back over the desert.

The early scene of the overlapping dialogue in Dr T's waiting room, so classically Altman, with the camera movement to match until the women themselves converge in a nattering of complaints upon the beleaguered staff, and this penultimate scene of childbirth redeem what is essentially a film that strains to be quirky. In the former, Altman puts his stamp on the film

by giving the audience what it has come to expect after all these years. And he does it beautifully – an aural and visual ballet. In the latter, Altman renounces his own philosophy of death as the proper ending to a story. The childbirth makes one forget, for a moment, the unreality of Dr T dropping from the sky. Nevertheless, the fantastic ending is anomalous to Altman's body of work, just as the film is anomalous to this chapter.

ON ITS RELEASE, *Gosford Park* (2001) entered the subjectively critical debate about which of Robert Altman's films was his masterpiece. This beautifully photographed (the cinematographer was Andrew Dunn) and elegantly paced film was Altman's turn at the drawing-room murder mystery whose best-known practitioner in print was Agatha Christie. Indeed, *Gosford Park* is set during the heyday of the genre. It contains the classic elements: the closed society of the upper class and their servants, and multiple characters with motives to kill the victim. To these the film adds a few outsiders, brief comedic counterpoint to the drama and a postmodern outlook that goes beyond the notion of the humanity of the servant class and actually has one of its members 'solve' the crime. The film contains parallels with Jean Renoir's film *La Règle du jeu* (The Rules of the Game, 1939), such as the shooting party, the initial rainstorm, the arrival of the guests and, of course, murder – for revenge in *Gosford Park*, out of jealousy in *La Règle du jeu*. It compares and contrasts the dual worlds of upstairs and downstairs even more strongly than did the earlier film.[6]

Sir William McCordle (Michael Gambon) is the bullying paterfamilias of the estate, Gosford Park. That he has earned his wealth and title places him, in his mind, above nearly all the rest, while his prickly character marks

Gosford Park: downstairs.

Gosford Park: upstairs.

him from the outset as the victim-to-be. Among the possible suspects are Anthony Meredith (Tom Hollander), who has come to spend the weekend at Gosford Park with his wife, Lavinia (Natasha Wightman), but whose real intention is to convince Sir William to back his business proposition. Another is Freddie Nesbitt (James Wilby), who thought he was marrying into money when he married his plain wife, Mabel (Claudie Blakley). Freddie has come to importune Sir William for a job. There is also the ultra-snobbish Lady Constance Trentham (Maggie Smith), who has been living on an allowance supplied by Sir William, but during her stay at Gosford Park is told by Sir William's wife, Sylvia (Kristin Scott Thomas), that he plans to end the largesse. Lady Sylvia herself is a suspect for the same reason that some of the downstairs people may be suspected of the murder: Sir William has been enjoying *droit du seigneur* with members of his house staff for decades.

The Altman touch shows early on, when Lady Constance's mansion is reflected in a puddle during a heavy rainstorm, and moments later when class difference is displayed. Lady Constance's new maid, Mary (Kelly Macdonald), standing umbrella-less in the storm, waits for her employer so as to escort her to the car that will take them to the Gosford Park estate. Lady Constance pretends obliviousness to her maid's plight. On the way they briefly meet two outsiders, the Hollywood producer Morris Weissman (Bob Balaban) and his valet, Henry (Ryan Phillippe), accompanied by the stage and screen star Ivor Novello (Jeremy Northam).[7] The trio is also en route for a weekend at the mansion. In terms of Altman films, as a character Ivor Novello is in the tradition of Count Basie, Coleman Hawkins and Lester Young in *Kansas City* and Buffalo Bill, Annie Oakley and Sitting Bull (among others) in *Buffalo Bill and the Indians*. Novello provides the link between the Hollywood outsiders and the other guests. And, as Altman admitted, the use

of Novello as a character also allowed the insertion of period music.[8] In addition to being an actor, Novello was a well-known singer and songwriter. In the film the character entertains his fellow guests (with many of whom he is on intimate terms) by performing some of his songs during cocktails and after dinner.

Gosford Park: the discovery of Sir William's corpse.

Altman again had some visual fun with mirrors. In Morris Weissman's room there are three and we see his valet reflected simultaneously in two of them. This is a character clue, because it turns out that Henry is not who he claims to be. We also see Lady Constance, in reflection, putting on her jewellery and powdering her face in preparation for the evening. Otherwise the mirrors reflect the luxury of the mansion.

Wealth aside, the most obvious point of contrast between upstairs and downstairs is the discretion of the downstairs people and their almost innate ability to keep their own and especially their employers' secrets – at least when the setting is not intimate. Upstairs, the characters are anything but discreet, from treating the servants as invisible (which is how the secrets trickle downstairs in the first place) to blurting out problems at the dinner table and insulting fellow guests in the drawing room.

In a scene of aborted sex between Sir William and a member of the kitchen staff the viewer again becomes voyeur, seeing it through a doorway. Ironically, it is Lady Sylvia who twice has sex with the 'help' – Weissman's valet, Henry – although after the murder he unmasks himself as an actor studying for the role of a valet. Weissman is a producer of Charlie Chan films who has finagled an invitation to the shooting weekend to observe the upper class in action. His next film, *Charlie Chan in London*, is to be a murder mystery in which the famous detective solves a crime set in a country house.[9] Weissman,

himself a comic figure at whom droll wit is directed, spends a good deal of his time on the phone discussing the film, its plot and casting possibilities. In one scene Weissman, again on the phone, discusses the possibility that the valet, not the butler, be the murderer in his Charlie Chan picture just as Sir William's valet (Derek Jacobi) walks past him to be interrogated by the police inspector.

When a dozing Sir William is stabbed in his study we see only the unknown perpetrator's hands and feet – à la Bresson. He retrieves the knife he had secreted away, puts on gumshoes to soften his footsteps and protect his own shoes from the mud, and enters the study through the French window. The stabbing is quick and the unidentified perpetrator leaves immediately. While this is going on the majority of guests are in the drawing room either playing bridge or listening to Ivor Novello sing, as are most of the help. This piece of Christie-like misdirection allows the viewer the opportunity to rule out the majority of suspects. When it is later discovered that Sir William had been poisoned and was already dead when he was stabbed, the viewer must, of course, expand the suspect list.

A bumptious police inspector (Stephen Fry) provides additional comedy. And while the local constable (Ron Webster) exhibits a better understanding of police work, it is Mary who is the film's true detective. She is a keen observer and listener – when Henry reveals himself to be an actor it is Mary who claims, offhandedly and credibly, that she knew his Scots accent was phoney – with an honest and discreet demeanour that invites others to reveal their secrets to her. Thus she discovers not only who stabbed Sir William, but who poisoned him and why they did it. It is to Mary that Mrs Wilson (Helen Mirren), the Gosford Park housekeeper in charge of the maids, reveals that she and the cook, Mrs Croft (Eileen Atkins), with whom she has a fractious relationship, are sisters, and that Sir William impregnated both women decades earlier. Mary is also the conduit by which the audience learns disconnected secrets about Sir William and other members of upstairs society, including her own employer, Lady Constance.

Although it is the constable who reveals the butler's (Alan Bates) secret – that he is the only member of the staff with a police record, for being a conscientious objector during the First World War – the film ends with doubt that the police will discover the identity of Sir William's murderer. As the constable notes, poison was ubiquitous at Gosford Park; everyone had access to it. Discretion being the unwritten code of downstairs morality, the ending hints that the secret, as much as it is known downstairs, will remain there. Certainly Mary has no incentive to reveal what she knows. As

much as the act of Sir William's murder was revenge, the cover-up is class warfare. His death foreshadows the end of the old system – even Lady Sylvia acknowledges that she may shutter the house.

Altman had nothing but praise for the professionalism of the cast, arguably the finest ensemble he ever worked with, feeling that the theatrical backgrounds of many of the actors dovetailed nicely with his techniques. Thus they were able to improvise dialogue and stay in character when outside the scene's focus to ensure dramatic viability before the roving camera and zoom lens. About the camerawork, Altman revealed: 'I decided to do what I had done in *The Long Goodbye*, that is, "We're going to move the camera constantly, but arbitrarily, not in any rhythm that you would think belongs to the action."'[10] Of course, *The Long Goodbye* and *Gosford Park* were not the only films in which Altman did this, but by 2001 the critics and general audience had finally caught on to the less precise naturalness of his camera.

12 Death is the Only Real Ending

FOLLOWING THE SUCCESS of *Gosford Park*, Robert Altman again mixed reality with fiction in his ballet film, *The Company* (2003). This time the emphasis is on the reality as the film follows a season of Chicago's Joffrey Ballet. The second of Altman's 'body films' (after *Prêt-à-Porter*), *The Company* has the flimsiest storyline of any Altman film, being 180 degrees from Michael Powell and Emeric Pressburger's melodramatic *The Red Shoes* (1948). As the title denotes, the entire company rather than an individual is the focus, although one of its dancers does come forward as a sympathetic protagonist. Loretta 'Ry' Ryan (Neve Campbell) is dedicated to her art (although no more so than anyone else in the company), has an apartment adjacent to an elevated train line (signifying her lowly status) and works as a waitress in a punkish hipster club when she's not rehearsing or performing.

The ballet company's artistic director is the charismatic Alberto Antonelli (Malcolm McDowell), based on Gerald Arpino, the Joffrey Ballet's actual artistic director at the time.[1] Antonelli's habit of sitting on a turned-around white chair while viewing dance practice was definitely borrowed from Arpino, and while some scholars interpreted the company members' reference to him as 'Mr A' as a connection to Altman, the appellation is more likely another reference to Arpino.

Antonelli is caustic but a charmer at heart – a man who can massage the egos of dancers and choreographers, stage parents and financial backers. Yellow is Antonelli's dominant colour (it is also seen in performers' costumes and placed more subtly elsewhere in the film). Nearly always he is adorned with a yellow scarf; in some scenes he wears a yellow T-shirt or yellow fleece; even the curtains in his office are yellow. Yet for Antonelli the colour is not so all-encompassing as it is for Millie Lammoreaux in *3 Women*.

The Company: Antonelli enthuses over Ry's performance in Grant Park.

Despite the fact that Antonelli is not a cheery person, the colour is a key to his personality, especially in light of the mythological connotation of yellow as a symbol of female, or creative, energy. In this sense Antonelli's fixation with yellow is in keeping with his persona as the ballet company's artistic director. Unlike Camille Dixon in *Cookie's Fortune*, Antonelli embraces the mythic in his life and uses it to create a persona that is, at heart, sincere.

Ry is the only fictitious dancer in the film. The rest are actual members of the Joffrey Ballet, as are the ballet mistresses and masters. Also featured as themselves are the choreographers Lar Lubovitch and Robert Desrosiers. In one scene Lubovitch is working with two dancers on a piece when he notices that one of them, Maia (Maia Wilkins), appears to be covering an injury. He then replaces her and her partner with Ry and her partner, Domingo (Domingo Rubio). In this, as in other scenes of the film, there are things going on in the background, typical in Altman films since *The Delinquents*, giving a naturalistic feeling and depth to the action. Here Alec (Davis Robertson), Maia's partner, comforts her while in the foreground Ry and Domingo take direction from Lubovitch. Ry and Domingo go on to give an outstanding, though unlikely, performance in Chicago's Grant Park during a driving rainstorm with heavy winds. The dance, with piano and cello accompaniment of 'My Funny Valentine', is a foreshadowing of Ry's private life. Fortunately, the film arrests quickly this lurch into star-is-born territory; Ry and Domingo are members of the Company.

When Ry meets Josh (James Franco) in a neighbourhood bar, Altman's camera orchestrates a ballet of flirtation to the background music of 'My Funny Valentine' (sung by Elvis Costello). Josh watches as Ry shoots pool. The camera directs the viewer's attention to Ry; the lyrics, of course, fit her perfectly: 'My funny valentine, sweet, comic valentine / You make me smile

with my heart.' A wry-looking Josh seems to be falling immediately in love. Then, 'Is your figure less than Greek?' Of course it is – Ry is a dancer. 'Is your mouth a little weak?' Ry is shown in profile.

The following morning Josh wakes in Ry's apartment. In the background is an instrumental jazz version of 'My Funny Valentine'. As with 'The Long Goodbye' in the film of the same name, 'My Funny Valentine' is a recurring motif, although not as tenacious. It is the backdrop to the progression of Ry and Josh's relationship. There are also two vocal versions – by Lee Wiley and the classic take by Chet Baker. Their little dance of love and lust aside, and despite Ry being a focal character in the film, she is one of the least realized female leads in Altman's work.

The Joffrey Ballet is the film's real star, and Altman films the company in all its incarnations: company gossip, the scrambling about in men's and women's dressing rooms, preparation for rehearsal, rehearsal itself, performance, backstage during performance and theatre dressing rooms. In this the film owes a debt not only to 'Black and Blue', but to Altman's other films that gave the viewer backstage glances, from *Buffalo Bill* to *Prêt-à-Porter*. But with *The Company* Altman took that strategy a step further. Matching the performance with the rehearsals allows the audience to glimpse the organic growth of a piece. This technique is especially interesting when we see the rehearsal and performance of 'The White Widow', in which a dancer uses a suspended rope as her partner. Dressed in a white camisole and a billowy white skirt, she is yet another of Altman's women in white – and a silent one too. We also see individual tragedies: one dancer snaps her Achilles tendon during rehearsal; another is becoming too old to dance and is resistant to change; yet another is just not good enough for a particular section of a dance. All three are replaced expeditiously and without fanfare. The dance must be performed – the Company is all.

Thus the film's most important scenes are the ballets themselves. Altman and his cinematographer Andrew Dunn filmed them from a number of angles, including overhead, using a four-camera set-up. Most of the time quick cuts substituted for his moving camera. When he does put his camera lens in motion it is for long shots: panning the performance from behind the audience so that the point of view is that of an audience member, or panning from stage to audience with an overhead shot. It is the dancers who are in motion so there is no time for the camera to zoom in slowly on any particular person, although he occasionally cuts quickly to a dancer's face. The performances are beautiful and the cutting and camerawork balance the naturalistic with the cinematic. It is also another contrast with *The Red*

Shoes, which employs camera tricks that are obvious interruptions of the performance. Altman simply filmed the performances and presented them from various viewpoints, although not in their entirety. Robert T. Self has described the result as a *pas de deux* 'between the company's dancing and Altman's style'.[2]

The final ballet is a revival of Robert Desrosiers' *The Blue Snake*. We initially see Desrosiers in conference with Alberto Antonelli and his lieutenants, in which Antonelli reminds the choreographer to be budget-conscious. In another scene he explains the ideas behind the piece to the assembled dancers; he works with various dancers, including Ry; and he is backstage during the performance. Ahmed Hassan and John Lang composed the original score for the piece. For the version in *The Company* Van Dyke Parks wrote the music. The dancers in *The Blue Snake* are dressed in mythical and symbolic costumes, and Ry, doing a solo performance, is dressed in purple with a purple helium-filled balloon attached to her head. Unfortunately for Ry, she falls during her performance and injures her shoulder. Quickly Desrosiers hustles Maia onstage to fill the void as the music continues, and it is she who takes the bow with the other dancers and Desrosiers while Ry, strangely not unnerved by her injury, is comforted backstage by Josh and her parents.

Although the story involving Ry and Josh is weak, the film's fictional aspects nevertheless reference mythic proponents of the notion of the Company. This in turn strengthens the whole idea of what the dancer's world is. Altman romanticized it through the beauty of the performances without glamorizing it. It may be that there is no middle narrative ground between *The Red Shoes* and *The Company*. If that is the case the latter, benefiting from the former, errs – when it does so – less flamboyantly. Then again, it may also be simply the differences between Powell's and Pressburger's temperaments and directorial skills, and those of Altman.

TANNER ON TANNER (2004), Altman's final television project directed for the Sundance cable channel, reunited him with a number of people who had worked on *Tanner '88*, including the writer Garry Trudeau and the actors Michael Murphy and Cynthia Nixon. The title refers to the documentary that Alex Tanner (Nixon) is making about her father's failed bid for the 1988 Democratic presidential nomination. That she is making a film about her father, her political ideal, is one of a number of hints at Alex's Electra complex. However, Altman and Trudeau were content merely to throw out

such hints. The four-episode series follows its predecessor's pattern of mixing real politicians and journalists with fictional characters. And like *Tanner '88* it was filmed and broadcast during a U.S. presidential election year.

This time around Jack Tanner (Murphy) is now a professor of political science at Michigan State University. Alex Tanner is also in academia; she is a documentary filmmaking professor at New York's New School. After a term of viewing and analysing documentary films with her students, Alex issues them school equipment to make their own films. On the blackboard behind her she has chalked up platitudes: 'Think Brave', 'Shoot Brave', 'Be Brave'. She urges them to 'bring back brave footage'. Her problem is that she has not followed her own advice. Her documentary, *My Candidate*, flounders at a rough-cut film festival and, on audience member Robert Redford's advice, she decides to refocus the film by having her father discuss political campaigning with past and present politicians. This provides Alex and her crew with a reason to travel to the Democratic National Convention in Boston. Two of the members of Alex's team, producer Andrea Spinelli (Ilana Levine) and cameraman Deke Connors (Matt Molloy), had worked for the original Tanner team back in 1988; Andrea was the ditziest member, and by the end of the series Deke was estranged from the campaign. So for viewers of the original it must have seemed a pleasant if awkward surprise to see them working for Alex. A third member is soundman Salim Barik (Aasif Mandvi), who, whether in New York City or Boston, is profiled by the police in the post-9/11 world. Meanwhile, NYU student filmmaker Stuart (Luke Macfarlane) is making a documentary about Alex making a documentary.

The first episode is the best of the four, providing clues to the series' overall theme of reality versus illusion in life and politics. Jack has come to New York to attend the film festival, and because of a hotel glitch ends up spending the night at Alex's studio loft, which is shared by everyone (except Andrea). He awakens the next morning to the unmistakable sounds of a man and woman making love, and as he wanders around the loft the sounds become more intense. Altman here relies on a purely aural voyeurism that temporarily transforms Tanner into a mystified but no less voyeuristic character. He finally stumbles upon Deke Connors editing a porn film. (It's his 'day job'.)

Later in the episode the film crew for some reason is dining at the fashionable Manhattan restaurant Elaine's. Jack Tanner is sequestered at a corner table with former New York governor Mario Cuomo, who is engaged in a critique of President George W. Bush's policies. When Cuomo observes, 'It's not difficult to fool people in political campaigns', Tanner quietly nods

his assent. The implication is that Bush lied to the people during his presidential campaign in 2000, and is continuing to lie during his re-election campaign, but the larger implication is that all politicians lie during their campaigns, including the noble Jack Tanner in 1988 (and, by extension, Cuomo himself).

Underlying the film is a lurking cynicism, away from which the obvious plot-points and the mixture of reality and fiction serve to direct the viewer. Jack Tanner echoes this cynicism in Alex's film: 'There are no moral victories in politics,' he declares. 'There's only winning.' This realpolitik ethos pretty much dovetails with Cuomo's observation at Elaine's, but Alex is too bewitched by her admiration for her father to catch the implication.

Alex bumps up against reality at the Democratic Convention, where hers is one of 40 documentary crews. Furthermore, she is an outsider (although she does not immediately recognize her status) whose retired politician father cannot simply pull strings for her. Alex fails to get interviews with a number of politicians and political observers, including then-senator John Kerry, the presumptive party nominee. Jack Tanner's 1988 campaign manager, T. J. Cavanaugh (Pamela Reed), never even broaches the idea to her new boss, Kerry. When Alex does have the opportunity to film her father and Governor Howard Dean together, the interview is interrupted by MSNBC journalist Chris Matthews, who pulls Dean away for a more important interview. Her cluelessness echoes Opal's in the final scene of *Nashville*. Alex even misses her father's discussion with congressman Richard Gephardt.

One of the most pathetically funny scenes of the series involves a mix-up between Alex and Alexandra Kerry (the senator's daughter), who is also making a documentary. The two have scheduled the same interview room

Tanner on Tanner: Alex gets the word to drop the explosive footage of her father's rant from her film.

at the same time for an unlikely interview with Ron Reagan Jr, son of the 40th president. They decide to hold a dual interview, and this highlights Alex Tanner's plight – she is narcissistic and concerned with a past failed campaign in an environment that is all about the present and the future. Whereas Alexandra Kerry questions Reagan about Republican opposition to stem-cell research, Alex Tanner asks him about his childhood as the son of a candidate and president. Her point of view is anchored in the past, as is that of her film. The interview descends into argument (between the two interviewers) and chaos.

Alex is so eager to be the subject of a film that her ego spills over into *My Candidate*, conducting interviews instead of letting conversation flow naturally between her father and other politicians. Despite this, she does have some brief but good footage of her father criticizing Kerry for mimicking the Bush administration over the Iraq War. But that footage later proves incendiary. Tanner has been inching himself back into the game by doing what politicians do – schmoozing with other politicians and staff members. In one scene that skirts irony for realpolitik, he helps T. J. Cavanaugh get the wording down for the Iraq section in Kerry's nomination acceptance speech. In another take on reality and fiction, Tanner's 'contribution' turns up word for word in Kerry's actual, televised acceptance speech.

As in *Tanner '88*, the use of real people playing themselves falls into two categories: those who interact with the fictional characters and those who are shown at the convention, usually speechifying. Of the first four conventioneers we see, there is a progression in status, beginning with Senator (and 2000 vice-presidential candidate) Joseph Lieberman, former vice president (and 2000 presidential candidate) Al Gore, former president Jimmy Carter and former president Bill Clinton. Excerpts from convention speeches given by the last three are incorporated nicely into the story, as is then-senator Barack Obama's speech. (Joseph Biden, also a senator in 2004, is seen working the convention floor.)

The series' overarching cynicism, first exhibited by the Cuomo quotation, is driven home in the final episode, appropriately titled 'The Awful Truth'. In it we see Alex and her team deciding how best to use the footage of Jack Tanner excoriating Kerry over the latter's Iraq policy. But soon after this she is called to a meeting with her father and T. J. Cavanaugh. Tanner tells her that he is in line for the job of assistant secretary of state with a portfolio for Middle East affairs. But the problem is that rant of his. He needs Alex to delete the footage from her film. Alex is righteously angered by the request and storms out of the meeting. Nevertheless back at home she asks Deke to

run the footage without the crucial scene. Moments later she watches her father on a television talk show denying he had input into Kerry's acceptance speech and supporting Kerry's Iraq policy. In the end the idealist is a pragmatist. It is about winning the election, not claiming the high ground.

The only one around her who seems to have an idea of Alex's ineptness as a documentary filmmaker is Stuart, whose guerrilla-style filmmaking, reminiscent of Deke Connors in *Tanner '88*, captures Alex in her vulnerable and unguarded moments. When she (and the rest of her documentary-making class) views Stuart's film, Alex is struck with a second shock of reality. Although it is only in rough cut, it is still better than her film (actually, *My Candidate* is a shambles). Stuart has exposed Alex's egotism and her lack of focus. She comes off as clueless about documentary filmmaking (a jibe at film schools), especially in her bumbling, fractious manner at the convention, whereas his own ego is only subtly revealed (in his humiliation of her) and goes unnoticed by his classmates and Alex. His singular focus on her is not exactly what she meant when she encouraged her students with her 'brave' platitudes, and at the series' end she is left entangled in her political and personal disillusionment.

A PRAIRIE HOME COMPANION (2006) is based on the popular weekly radio show of the same name, hosted by Garrison Keillor (G.K., as his fictional alter ego is called in the film), for more than three decades on National Public Radio. The film's conceit is that it is the final night for the radio show: a Texas corporation, now the show's parent company, plans to close it all down.[3] Thus the film's tone is wistful and elegiac. We learn all this through the narration of Guy Noir (Kevin Kline), one of Keillor's best-known comedic characters, now reified on the screen. In a contrast with his more straight-forward counterpart, Philip Marlowe in *The Long Goodbye*, modernity has made a complete anachronism of Guy Noir. No longer strictly a private investigator, he has taken a job as a security man for the radio show. Nevertheless, he exists explicitly in his space and time, warped as it is. His suit is decades out of fashion, as is his patter, and even his desk and work area backstage at the Fitzgerald Theatre in St Paul, Minnesota (named after native son F. Scott Fitzgerald, whose silhouette adorns the marquee), are from another time. He carries a hip flask from which he occasionally swigs, and when we first see him it is through a window of Mickey's Diner, where he is downing a cup of coffee. The long shot of the diner replicates Edward Hopper's famous painting *Nighthawks*.

A Prairie Home Companion: G.K. and the Johnson Sisters onstage.

A Prairie Home Companion offers numerous quotations from Altman's own films. These references dovetail with his familiar cinematic techniques, fully matured for decades and employed masterfully. The shot of Guy Noir through the diner window sets up the viewer as a Peeping Tom, if not exactly a voyeur – a classic Altman move. It also signals the viewer's ability to drift backstage (drifting the way the camera drifts) and witness the performers when they are not performing, as well as the stage manager and others doing their jobs. The backstage shots place the film in a long line of Altman's 'entertainment films', including *Nashville*, *Buffalo Bill*, *A Perfect Couple*, *Prêt-à-Porter* and *The Company*. In one scene, a backstage conversation between cowboy entertainers Dusty and Lefty (Woody Harrelson, John C. Reilly) is seen only in mirrored reflection (like Guy Noir, they are fictitious radio characters), recalling a reflected conversation near the end of *Thieves Like Us*.

The ubiquitous camera movement provides different visual perspectives, especially of the radio-show performances, while the overlapping dialogue gives that touch of Altman realism to a film that was actually not very realistic. The best instance is when the singing sister duo Rhonda (Lily Tomlin) and Yolanda (Meryl Streep) Johnson (echoes of the Johnson women in *The Laundromat*) talk over each other while telling family stories to Yolanda's teenage daughter, Lola (Lindsay Lohan). More subtle is when backstage talk crosses with onstage performance, or, subtler still, when it overlaps with the stage manager's intercom announcements. These announcements provide the sense of real time to the film in the way that some of the *Tanner '88* episodes occupied real time, and when they are heard clearly, that is not overlapped, they recall in spirit, though not in tone, the PA announcements of *M*A*S*H*.

Not all the aspects of *A Prairie Home Companion* reference Altman's hits or even acclaimed films. With his shock of white hair, Guy Noir provides

a visual reminder of Dr Gil Gainey in *HealtH*. The opening credits aurally backed by a run along the radio dial – signifying the setting of the film – copies the opening of the seldom-seen *O.C. and Stiggs*.

After Altman's 'middle period', in which he directed the large- and small-screen adaptations of stage plays, he generally abandoned some of his earlier cinematic tropes. These include the use of Christian, primarily Roman Catholic, imagery and the silent (or nearly silent) character. The nearly silent character is revived in *A Prairie Home Companion*, much the same way as in *Prêt-à-Porter*. In both films the characters speak occasionally to explain their lives, but for the most part they stalk their 'quarry'. Sergei (Sergio) in *Prêt-à-Porter* moves among fashionistas, seeking the appropriate moment to approach Isabella; in *A Prairie Home Companion* Asphodel, the Angel of Death (Virginia Madsen), moves freely among the performers and stagehands during the show's final performance.[4] Sometimes she is seen and interacted with – notably by Guy Noir, G.K., Molly the stage manager (Maya Rudolph) and the Axeman (Tommy Lee Jones). Most often she moves about on the set (which duplicates the actual radio set) and backstage unnoticed. This duality recalls the surreal, out-of-time Old Man in *Fool for Love*.

Just as Sergei tells his story to Isabella, Asphodel tells hers to G.K.: how in her mortal incarnation she had been Lois Johnson (yet another Johnson woman!), who died in a car crash while listening to 'A Prairie Home Companion' on the car radio as she drove to a tryst with her lover. The revelation of what she does as an angel, besides claiming human lives, is a kind of verbal nod to Altman's Catholic past ('tears on statues'). And although she is the Angel of Death, Asphodel is not responsible for the cancellation of the radio show. However, she does claim a life – that of the elderly Chuck Akers (L. Q. Jones), who dies in his dressing room just after performing A. P. Carter's 'You've Been a Friend to Me' and while awaiting a romantic rendezvous with the show's lunch lady, Eileen (Marylouise Burke). Asphodel's cool demeanour and her appearance – she is clad in a white trench coat over a black dress and wearing black pumps – is reminiscent of June Gudmundsdottir in *The Player*. Asphodel is Altman's final woman in white, a line that stretched back more than 30 years, beginning with Mrs Miller. Although Asphodel explains herself to G.K., it is Guy Noir, no less, who works out what she is, and who enlists her in a last-ditch attempt to save the show. Theirs is a partnership of chromatic opposites that plays to the yin–yang of their personalities.

Arriving nearly at show's end is the Axeman, the corporate troubleshooter in charge of closing down 'A Prairie Home Companion'. Just as Asphodel is

a reincarnation of June Gudmundsdottir, the Axeman is Griffin Mill, the callous corporate executive whose only concern is the bottom line. He is older than Mill, fatalistic and a realist when it comes to the passage of time and the ending of all things (including his own life), but just as clueless about art. The Axeman, as the personification of corporate philistinism, neither recognizes a bust as being the image of F. Scott Fitzgerald nor is aware of Fitzgerald's literary achievements. Acting on Guy Noir's plan, Asphodel does claim the Axeman, but not even his death can alter the fate of the show. The story is wrapped up in voiceover narration by Guy Noir as he noodles on the grand piano upon which sits Fitzgerald's bust, on the nearly bare stage, as movers strike what remains of the set. He plays a melody accompaniment while singing the first verse of the seventeenth-century English poet Robert Herrick's 'To the Virgins, to Make Much of Time', before taking the bust in true tough-guy style, to accompany him for a drink.[5]

That the film gives us a fictional 'A Prairie Home Companion' broadcast, complete with backstage shenanigans, relieves it from the unrelenting pessimism in which its theme could have easily enveloped it. The Johnson Sisters are funny onstage and off, and Yolanda's daughter Lola even manages to rise from her teenage angst-ridden preoccupation with writing poetry and song lyrics obsessed with suicide. The singing cowboys, Dusty and Lefty, provide the film's most hilarious scenes, especially their final song, a medley into which they weave bad, but earthy, jokes. The film's sentimentality is mostly conveyed through the songs but is offset by wisps of cynicism and fatalism either voiced or personified by Guy Noir, G.K., the Axeman and Asphodel.

There's a coda. A few years later G.K., the Johnson Sisters and Guy Noir (dressed in his same suit) are sitting in a booth in Mickey's Diner. The Johnson Sisters are pitching a reunion tour to which G.K. agrees, but not Guy Noir,

A Prairie Home Companion: the Axeman sits with the Angel of Death.

when in come Dusty and Lefty, who have heard about the tour and want to join up. Lola also arrives, but the years have changed her into a financially astute businesswoman who pops in only to get her mother to sign over power of attorney to her. Moments after she leaves Asphodel arrives and the camera, communicating her point of view, tracks slowly towards the others, to all of whom she is visible. Lefty and Dusty are no longer seen, and no one speaks (the triumph of the silent character after all!), although Guy Noir gestures briefly and nervously. There is a cutaway to the exterior of Mickey's Diner (from which perspective even the others are missing) as the camera moves towards an overhead shot. But this is not the end of the film, which then cuts to a group performance of the final show's final song, 'In the Sweet By and By', as the credits roll. The performance is a comment on the fate of us all, specifically Asphodel's last clients.

is made even more bittersweet by the fact that during its filming Robert Altman was terminally ill with leukaemia. There was some doubt that he would be well enough to complete the project so, for insurance reasons, Paul Thomas Anderson was hired as standby director.[6] Altman not only completed the film, but between the time of *A Prairie Home Companion*'s completion and its release on 9 June 2006 he also directed Arthur Miller's *Resurrection Blues* at London's Old Vic theatre. He had also begun sketching out plans for his next film, tentatively titled *Hands on a Hard Body*, about an endurance contest in which entrants vie to remain the last person standing with his or her hand on a brand-new car in order to win the car.[7] But that film was never made.[8] Robert Altman died on 20 November 2006. It is not too much of a stretch to think of *A Prairie Home Companion*'s elderly Chuck Akers as a stand-in for Altman himself. Thus might Asphodel's comforting line sum up the 81-year-old Altman's attitude to what awaited him: 'The death of an old man is not a tragedy.' But, of course, sometimes it is.

References

Introduction

1 Judith M. Kass, *Robert Altman: American Innovator* (New York, 1978), p. 9.
2 Quoted in Alan Karp, *The Films of Robert Altman* (Metuchen, NJ, 1981), p. 86.
3 Robert T. Self, *Robert Altman's Subliminal Reality* (Minneapolis, MN, 2002), pp. xiii, 270.
4 Kass, *Robert Altman*, p. 178.
5 Quoted in Karp, *The Films of Robert Altman*, p. 67. The quotation comes from Kael's *New Yorker* review of *McCabe & Mrs Miller* of 3 July 1971.
6 For more on Altman's 'show-business films' see also Patrick McGilligan, *Robert Altman: Jumping Off the Cliff* (New York, 1989).
7 In *Short Cuts* and *Dr T and the Women* the party is cancelled. The nature and effect of these cancellations are completely contrasting – in the former depressing, in the latter liberating.
8 Quoted in Kass, *Robert Altman*, p. 22.
9 Ryan Gilbey, *It Don't Worry Me: The Revolutionary American Films of the Seventies* (New York, 2003), pp. 121–2.
10 Helene Keyssar, *Robert Altman's America* (New York, 1991), pp. 226–7.
11 Quoted in McGilligan, *Robert Altman*, p. 85. Part of McGilligan's interview with Barhydt, including the above quotation, can be heard at the WCFTR website, https://mediaspace.wisc.edu/media/Barhydt/o_u7iyjin8 (accessed 13 July 2015).
12 Robert Altman audio commentary on Disc 4, *Combat!: Season 1, Campaign 1*. Altman comments on the episode entitled 'Cat and Mouse'.
13 Quoted in David Breskin, *Inner Views: Filmmakers in Conversation*, expanded edn (New York, 1997), p. 271.
14 Quoted in Kass, *Robert Altman*, p. 15.
15 Kenneth McKee, 'Foreword', in *Scenarios of the Commedia dell'Arte*, trans. and ed. Henry F. Salerno (New York, 1989), p. xiii.

16 Quoted in Aljean Harmetz, 'The 15th Man Who Was Asked to Direct *M*A*S*H* (and Did) Makes a Peculiar Western', *New York Times Magazine* (20 June 1971), reprinted in David Sterritt, ed., *Robert Altman: Interviews* (Jackson, MS, 2000), p. 9.

17 Keyssar, *Robert Altman's America*, p. 292. The specific film Keyssar was discussing was *Quintet*.

18 Quoted in Connie Byrne and William O. Lopez, '*Nashville*', *Film Quarterly*, XXIX/2 (Winter 1975–6), reprinted in Sterritt, *Robert Altman: Interviews*, p. 23.

19 Robert Altman quoted in Mitchell Zuckoff, *Robert Altman: The Oral Biography* (New York, 2009), p. 213.

20 Excluding, of course, his Calvin Company work.

21 Comparing Altman's films, especially those of the 1970s, with those of his American contemporaries Scorsese, Coppola, Friedkin and Penn reveals that violence and cynicism were the rule rather than the exception in their artistic outlooks.

22 Quoted in Breskin, *Inner Views*, p. 273.

23 Robert Bresson, *Notes on Cinematography* (*Notes sur le cinématographe*), trans. Jonathan Griffin (New York, 1977), p. 10.

24 Quoted in James Monaco, *How to Read a Film: Movies, Media, Multimedia*, 3rd edn (New York, 2000), p. 410. Bazin himself was not an auteur critic.

25 Robert Phillip Kolker, *A Cinema of Loneliness: Penn, Kubrick, Scorsese, Spielberg, Altman* (New York, 1988), p. 305.

1 Kansas City

1 Patrick McGilligan, *Robert Altman: Jumping Off the Cliff* (New York, 1989), p. 19.

2 Mitchell Zuckoff, *Robert Altman: The Oral Biography* (New York, 2009), p. 50.

3 See Zuckoff, *Robert Altman*, p. 60.

4 Mark Minett, 'Robert Altman's Early Career', Wisconsin Center for Film & Theater Research, http://old.wcftr.commarts.wisc.edu/collections/featured/altman/kansascity (accessed 13 July 2015). Other Internet sources, notably www.imdb.com, list the film as being directed by Maurice Prather and released in 1950.

5 With the exception of *The Magic Bond*, which can be found online (in two parts) within the Prelinger Archive of the Internet Archive (www.archive.org), *Modern Football*, posted on YouTube (www.youtube.com) (both accessed 3 July 2015), and excerpts from *The Perfect Crime*, posted on the Wisconsin Center for Film & Theater Research website, my information about Altman's Calvin films comes from McGilligan, *Robert Altman*, and from David Thompson, ed., *Altman on Altman* (London, 2006), pp. 12–15, 260–61.

6 McGilligan, *Robert Altman*, p. 555.
7 Minett, 'Robert Altman's Early Career'; 'Kansas City: *The Perfect Crime*', Wisconsin Center for Film & Theater Research website (accessed 13 July 2015).
8 Quoted in McGilligan, *Robert Altman*, p. 555.
9 Russell received the best supporting actor award for his work in *The Best Years of Our Lives*; Lantz was not an amputee.
10 A clip of *The Model's Handbook* can be found online at the Wisconsin Center for Film & Theater Research website (accessed 13 July 2015).
11 Likewise, the film's release year is disputed. It most probably, as McGilligan believes, came out in 1951. Others have given 1954 and 1956 as its release year.
12 Thompson, *Altman on Altman*, p. 15.
13 Quoted in McGilligan, *Robert Altman*, p. 113. On the previous page McGilligan estimated the film's budget at $45,000.
14 Judith M. Kass, *Robert Altman: American Innovator* (New York, 1978), p. 42.

2 Journeyman's Blues

1 'The Young One' and 'Together' can be found online at www.hulu.com (accessed 13 July 2015).
2 The number of episodes he directed is unclear because he may not have received on-screen credit.
3 Altman directed the pilot episode of *The Gallant Men*, another Second World War drama, which premiered the same month as *Combat!*, October 1962. It lasted one season only.
4 Robert Altman audio commentary on Disc 4, *Combat!: Season 1, Campaign 1*. Altman comments on the episode entitled 'Cat and Mouse'.
5 Whenever German or French was spoken in these episodes no subtitles were used.
6 Robert Altman audio commentary on Disc 2, *Combat!: Season 1, Campaign II*. Altman comments on the episode entitled 'Survival'.
7 Also in the background, at a different camera angle, is an unbroken stained-glass window.
8 Quoted in Helene Keyssar, *Robert Altman's America* (New York, 1991), p. 52, from an interview by David Denby in *Atlantic Monthly* (March 1971).
9 Patrick McGilligan, *Robert Altman: Jumping Off the Cliff* (New York, 1989), p. 256.
10 See Norman Kagan, *America Skeptic: Robert Altman's Genre-Commentary Films* (Ann Arbor, MI, 1982), pp. 1–16, for a discussion on the anti-technology attitude of *Countdown*.
11 Robert Phillip Kolker, *A Cinema of Loneliness: Penn, Kubrick, Scorsese, Spielberg, Altman* (New York, 1988), p. 311.

12 The woman's paying for a prostitute for the young man is also in Richard Miles's novel.

3 *M*A*S*H* and its Immediate Successors

1 From a novel by Richard Hooker, the nom de plume of H. Richard Hornberger, with W. C. Heinz.

2 Richard Hooker, *M*A*S*H* (New York, 1968), p. 9.

3 Altman claimed that many of the announcements came from an old almanac, while the film announcements were read off old posters. See Harry Kloman, Lloyd Michaels and Virginia Wright Wexman, 'A Foolish Optimist', *Film Criticism*, VII/3 (Spring 1983), reprinted in David Sterritt, ed., *Robert Altman: Interviews* (Jackson, MS, 2000), p. 115.

4 Robert T. Self, *Robert Altman's Subliminal Reality* (Minneapolis, MN, 2002), p. 36.

5 They are ordered to report for 'short-arm inspection', the term 'short arm', of course, being slang for penis.

6 Although the context is different, the line is from the novel, as is Colonel Blake's reply: 'Goddamn it Hot Lips, resign your goddamn commission.' See Hooker, *M*A*S*H*, p. 124.

7 It is also fair to say that the rehabilitation of Major Houlihan's reputation began when she was given the appellation 'Hot Lips'. Many within the inner circle of the 4077th bore nicknames: Hawkeye, Trapper John, Duke, Painless, Lt Dish, Radar, Dago Red and Spearchucker. As Hot Lips, Major Houlihan was allowed entry into this group. This contrasts with the fate of her erstwhile lover, Major Burns, who was not given a nickname.

8 Since he is presumably a Roman Catholic, Painless's belief that he is homosexual would have engendered feelings of guilt and sin. This, then, explains his initial revelation of impotence to the chaplain.

9 In that era Last Supper scenes appeared in films as divergent as Luis Buñuel's *Viridiana* (1961) and Robert Aldritch's *The Dirty Dozen* (1967).

10 This sigh references the morning sigh of Scarlett O'Hara after spending the night with her estranged husband, Rhett Butler, towards the end of *Gone With the Wind* (1939).

11 See Louis Giannetti, *Masters of the American Cinema* (Englewood Cliffs, NJ, 1981), p. 419.

12 In 2005 the Houston Astrodome served as a temporary shelter for evacuees from Hurricane Katrina. In 2013 a citywide referendum to renovate the structure was defeated and demolition of the stadium seemed likely. In January 2014 the Astrodome was added to the National Register of Historic Places, but its fate is undecided at the time of writing.

13 Interestingly, it was presumed that Altman's primarily white audience would not understand the ironic significance of this song for the scene. As the band

plays and struts and the drum majorettes dance, the credits flash on the screen not only the song's title but in parentheses its unofficial title – 'Black National Hymn'.

14 In discussing Altman's genre films Helene Keyssar has observed, 'The attributes of each of these films that suggests these categories are obvious on viewing the films . . . but . . . each film extenuates the characteristics of the genre such that the mold no longer looks like itself.' See Helene Keyssar, *Robert Altman's America* (New York, 1991), p. 14.

15 This bleakness perhaps influenced the bleak western setting in the film *Dead Man* (1995), directed by Jim Jarmusch.

16 Christian Metz, *Film Language: A Semiotics of the Cinema*, trans. Michael Taylor (New York, 1974), p. 38n.

17 Cleanth Brooks, *William Faulkner: The Yoknapatawpha County* (New Haven, CT, and London, 1963), p. 326.

18 Jean-Paul Sartre, 'Time in Faulkner: *The Sound and the Fury*' ('À propos de *Le Bruit et la Fureur*. La temporalité chez Faulkner'), trans. Martine Darmon et al., in *William Faulkner: Three Decades of Criticism*, ed. Frederick J. Hoffman and Olga Vickery (New York and London, 1963), pp. 225–32.

19 Brooks, *William Faulkner*, p. 326.

20 Fyodor Dostoevsky, *The Double* (*Dvoinik*), trans. George Bird, in *Great Short Works of Fyodor Dostoevsky* (New York, 1968), p. 39.

21 This clue was pointed out by Alan Karp in *The Films of Robert Altman* (Metuchen, NJ, 1981), p. 138.

22 See Mitchell Zuckoff, *Robert Altman: The Oral Biography* (New York, 2009), pp. 241–2.

23 See Gerard Plecki, *Robert Altman* (Boston, MA, 1985), p. 53.

4 The Neo-noir Director

1 Quoted in Daniel O'Brien, *Robert Altman: Hollywood Survivor* (New York, 1995), p. 53.

2 Although the radio drama (1948–51) incarnation of Marlowe, starring Gerald Mohr, acquired some of the Hammer style.

3 For a technical discussion of flashing, see Edward Lipnick, 'Creative Post-flashing Technique for *The Long Goodbye*', in *American Cinematographer* (March 1973), pp. 278–81, 328, 334–5. The article is also reproduced as a special feature on the *The Long Goodbye* DVD, MGM Home Entertainment, 2002.

4 Quoted in Lipnick, 'Creative Post-flashing Technique'.

5 Colin Burnett, '*Journal d'un cure de champagne*: DVD Review', *Offscreen*, VIII/4, April 2004, www.offscreen.com.

6 Robert Altman interview in 'Rip Van Marlowe', special feature on *The Long Goodbye* DVD, MGM Home Entertainment, 2002. Altman reiterated this idea

of transforming the audience, if only briefly, into voyeurs in David Thompson, ed., *Altman on Altman* (London, 2006), p. 84.

7 Patrick McGilligan, *Robert Altman: Jumping Off the Cliff* (New York, 1989), p. 368.

8 Thompson, *Altman on Altman*, p. 82.

9 Robert Altman claimed that this was the first time he had used eight-track recording with microphones placed around the set. Commentary, special feature on *California Split* DVD, Columbia TriStar Home Entertainment, 2004.

10 Commentary, special feature on *California Split* DVD, Columbia TriStar Home Entertainment, 2004. Walsh had previously told Patrick McGilligan that he wrote this dialogue. See McGilligan, *Robert Altman*, p. 376.

5 Paradise Lost

1 Connie Byrne and William O. Lopez, '*Nashville*', reprinted in David Sterritt, ed., *Robert Altman: Interviews* (Jackson, MS, 2000), p. 20.

2 TVC Labs developed the now-obsolete process of Chemtone, or Chem-Tone, in the mid-1970s. It was designed to increase film speed and facilitate location shooting. As well as *Nashville*, the process was made use of initially in *Harry and Tonto* and *Taxi Driver*.

3 Robert T. Self, *Robert Altman's Subliminal Reality* (Minneapolis, MN, 2002), p. 36.

4 Aryeh Grabois, *The Illustrated Encyclopedia of Medieval Civilization* (London, New York and Jerusalem, 1980), p. 95. Information was also gleaned from 'St Barbara', *New Advent Catholic Encyclopedia*, www.newadvent.org (accessed 13 July 2015).

5 He had also done this in *The Long Goodbye*, *California Split*, to a lesser extent in *McCabe & Mrs Miller* and, in a weirdly different way, *Brewster McCloud*.

6 Michael J. Shapiro, 'Robert Altman: The West as Countermemory', in *Cinematic Thinking: Philosophical Approaches to the New Cinema*, ed. James Phillips (Stanford, CA, 2008), p. 54.

7 The camera finds and closes in on Private Kelly and Mr Green, who are sitting together. Strangely, Mr Green mentions that he had a son who died in the South Pacific during the Second World War. This seems unlikely, as Mr Green himself appears old enough to have fought in that war, not his son. Why Vietnam was avoided even in passing is unknown.

8 Yellow, often described as a cheery or 'mellow' colour, evokes the optimistic side of Opal's personality.

9 For a discussion of the colour yellow in *Nashville*, see Helene Keyssar, *Robert Altman's America* (New York, 1991), pp. 147–9.

10 Robert Altman quoted in Harry Kloman and Lloyd Michaels with Virginia Wright Wexman, 'A Foolish Optimist', *Film Criticism*, VII/3 (Spring 1983),

reprinted in Sterritt, *Robert Altman*, p. 113; Robert Phillip Kolker, *A Cinema of Loneliness: Penn, Kubrick, Scorsese, Spielberg, Altman* (New York, 1988), p. 312.

11 See David Thompson, ed., *Altman on Altman* (London, 2006), p. 100.

12 Quoted in Keyssar, *Robert Altman's America*, p. 52, from an interview by David Denby in *Atlantic Monthly* (March 1971).

13 The juxtaposition of their two names, Sitting Bull, or Bull, and Halsey, was a corny joke many in 1976 would get, but is probably lost on most viewers today. William Frederick 'Bull' Halsey was a u.s. Navy admiral in the Pacific theatre of operations during the Second World War. Coincidentally, he had the same first and middle names as Buffalo Bill Cody.

14 Buffalo Bill also converted to Roman Catholicism, just before his death in January 1917.

15 Kolker, *A Cinema of Loneliness*, p. 360.

6 Strange Interlude

1 See Joseph Campbell, *The Inner Reaches of Outer Space: Metaphor as Myth and as Religion* (New York, 1988), p. 98. This meaning of yellow symbolism of course does not obtain across cultures or through the centuries. For another interpretation of yellow see Shannon Del Ross, 'The Use of Myth and Archetype in *The Yellow Wallpaper*', *The Literary Yard*, http://literaryyard.com (accessed 13 July 2015).

2 Not all critics agree that Pinky's plunge into the pool is a suicide attempt.

3 This is not to say that the omniscience is solely responsible for the failure of the dream sequence.

4 Robert Phillip Kolker, *A Cinema of Loneliness: Penn, Kubrick, Scorsese, Spielberg, Altman* (New York, 1988), p. 372.

5 Robert T. Self, *Robert Altman's Subliminal Reality* (Minneapolis, MN, 2002), p. 66.

6 Arthur I. Miller, *Deciphering the Cosmic Number: The Strange Friendship of Wolfgang Pauli and Carl Jung* (New York, 2009), p. 186.

7 Career Ebb

1 Gerard Plecki, *Robert Altman* (Boston, MA, 1985), p. 107. The book pre-dated the release of *Gosford Park* by sixteen years.

2 Filmed on location at the Armour mansion in suburban Chicago.

3 For a little more on this see David Thompson, ed., *Altman on Altman* (London, 2006), p. 113.

4 By contrast, Don Vincenzo's death near the end of *Seduced and Abandoned* is kept secret so as not to disrupt the wedding.

5 Robert T. Self, *Robert Altman's Subliminal Reality* (Minneapolis, MN, 2002), p. 59.

6 *The Dick Cavett Show* was a cerebral talk show.
7 Self, *Robert Altman's Subliminal Reality*, p. 275.
8 For more on the Washingtons' oppositional gaze, although he does not use the term, see Michael J. Shapiro, 'Robert Altman: The West as Countermemory', in *Cinematic Thinking: Philosophical Approaches to the New Cinema*, ed. James Phillips (Stanford, CA, 2008), p. 59.
9 See Patrick McGilligan, *Robert Altman: Jumping Off the Cliff* (New York, 1989), pp. 491–513.
10 Altman discussed briefly the notion of the dark vision for the film and its metamorphosis into something lighter in David Thompson, ed., *Altman on Altman* (London, 2006), p. 120.
11 Quoted ibid., p. 121.
12 Plecki, *Robert Altman*, p. 122.
13 *National Lampoon* was an irreverent, humourous magazine published from 1970 to 1998. It was based on the *Harvard Lampoon*.

8 The Play's the Thing, Part One: Television Work

1 Despite being critically panned, *Popeye* actually turned a profit.
2 Alpha Repertory Television Service soon after merged with the Entertainment Network to become the Arts & Entertainment Network, A&E.
3 It is unavailable for viewing. This quotation is from Patrick McGilligan, *Robert Altman: Jumping off the Cliff* (New York, 1989), p. 521.
4 *Third and Oak: The Laundromat* was written and initially performed with *Third and Oak: The Pool Hall*. The two-act play was simply titled *Third and Oak*.
5 David Thompson, ed., *Altman on Altman* (London, 2006), p. 143.
6 Or, given the chronology of the two dramatic works, the narrative frame of 'Smalley' reflects the ending of *The Caine Mutiny Court-Martial*.

9 The Play's the Thing, Part Two: Features Again

1 David Thompson, ed., *Altman on Altman* (London, 2006), p. 129.
2 Five-and-dime stores, also called 'five and ten', were inexpensive shops whose origin dated to the late nineteenth century. Essentially, they were the precursors of the present-day dollar stores or pound shops.
3 'Devotion to the Sacred Heart of Jesus', www.newadvent.org (accessed 13 July 2015).
4 See Thompson, *Altman on Altman*, pp. 129–30, for Altman's brief description of the technique he used to achieve the mirror effect in this film.
5 Quoted in Gerard Plecki, *Robert Altman* (Boston, MA, 1995), p. 130. On the same page Plecki also quotes Altman on the ending of *Come Back*

to the 5 & Dime, Jimmy Dean, Jimmy Dean as occurring 'maybe 20 years later – or that's the way it always was'.

6 Altman had also directed a stage version of the play off-Broadway in New York City.

7 Quoted in Thompson, *Altman on Altman*, p. 135. A jib arm is a camera crane mounted on a tripod.

8 Quoted ibid. The notion of inanimate objects as characters in a film may have its genesis with the poet Vachel Lindsay, who discussed it briefly in his book, *The Art of the Moving Picture* (New York, 1915).

9 This is a reference to a group of rich and powerful men who gather annually at a privately owned California campsite called Bohemian Grove.

10 See 'Robert Altman: Art and Soul', interview on *Fool for Love* DVD; also Thompson, *Altman on Altman*, p. 139.

11 There are other instances in which Altman favoured composition over movement. The Last Supper scene in *M*A*S*H* is one (although even there the actors 'fell into' the tableau). Many of the outdoor scenes in *Vincent & Theo* belong in this category.

12 For more on the conservative nature of farce see Chapter Two of Jessica Milner Davis, *Farce* (London, 1978).

13 Rudolf Arnheim, *Film as Art* (Berkeley and Los Angeles, CA, 1971), p. 82.

14 Hugo Münsterberg, *The Film: A Psychological Study* (New York, 1970), pp. 60, 72.

15 Christian Metz, *Film Language: A Semiotics of the Cinema*, trans. Michael Taylor (New York, 1974), p. 53.

16 The other nine directors were Nicolas Roeg, Charles Sturridge, Jean-Luc Godard, Julien Temple, Bruce Beresford, Franc Roddam, Ken Russell, Derek Jarman and Bill Bryden.

17 A number of the actors in *Beyond Therapy* appeared in the 'Les Boréades' segment.

10 Renaissance

1 In 1988 Robertson was a Southern Baptist minister who campaigned for the Republican Party's nomination for president of the United States.

2 For more on Deke as Altman's alter ego see Robert T. Self, *Robert Altman's Subliminal Reality* (Minneapolis, MN, 2002), pp. 131–2.

3 Ibid., p. 186.

4 David Thompson, ed., *Altman on Altman* (London, 2006), p. 149.

5 'Skull with Burning Cigarette', Vincent Van Gogh Gallery, www.vggallery.com (accessed 13 July 2015).

6 One of two painted at Arles in November 1888. This is the one that is now in Zurich.

7 With the notable exception of Alan Ladd Jr at Twentieth Century Fox in the late 1970s.
8 Quoted in Gavin Smith and Richard T. Jameson, 'The Movie You Saw is the Movie We're Going to Make', *Film Comment*, xxviii/2 (May–June 1992), reprinted in David Sterritt, ed., *Robert Altman: Interviews* (Jackson, MS, 2000), p. 165.
9 Quoted in Self, *Robert Altman's Subliminal Reality*, p. 222.
10 Christian Metz refers to the circularity of this type of narrative as a 'mirror construction' where the ending 'establishes and explains the conditions that produced the instance of recitation'. See Christian Metz, *Film Language: A Semiotics of the Cinema*, trans. Michael Taylor (New York, 1974), p. 17.
11 In the United States, *Prêt-à-Porter* was entitled *Ready to Wear*.
12 Metz, *Film Language*, p. 211.

11 Crime, Punishment and Vaginas

1 Blondie has short brown hair during most of the film. Her remaking of herself puts her in the category of Altman women that includes Albuquerque, L. A. Joan, Joanne, Millie and Pinky.
2 For the reference to Conway's coining the term 'high hat' see H. L. Mencken, *The American Language*, 9th edn (New York, 1945), p. 560. 'High hat' is also used in the Coen Brothers' period gangster film *Miller's Crossing*.
3 Quoted in Robert T. Self, *Robert Altman's Subliminal Reality* (Minneapolis, MN, 2002), p. 9.
4 Jonathan Rosenbaum, 'Let the Music Do the Talking', *Chicago Reader*, www.chicagoreader.com (accessed 13 July 2015).
5 Altman was not the first to show a childbirth on-screen. That may have been Dziga Vertov in *Man with a Movie Camera* (1929), although Vertov captured the moments just after the newborn emerged, when the midwives were unwrapping the tangled umbilical cord.
6 Nine years after *Gosford Park* was released the screenwriter, Julian Fellowes, created the popular television serial *Downton Abbey* (ITV, 2010–).
7 Ivor Novello (1893–1951) was a Welsh actor, born David Ivor Davies. Amid the film's credit roll is a disclaimer that Novello was never in attendance at a country mansion when events of the like of *Gosford Park* took place.
8 See David Thompson, ed., *Altman on Altman* (London, 2006), p. 200.
9 This film was actually made in 1934.
10 Quoted in Thompson, *Altman on Altman*, p. 197.

12 Death is the Only Real Ending

1 Gerald Arpino was co-founder of the Joffrey Ballet and served as its artistic director from 1988 (upon the death of Robert Joffrey) until 2007. He died in 2008 at the age of 85.

2 Robert T. Self, 'Art and Performance: Consolation at the End of Days', in *Robert Altman: Critical Essays*, ed. Rick Armstrong (Jefferson, NC, 2011), p. 166.

3 See Richard R. Ness, '"Doing Some Replacin'": Gender, Genre, and the Subversion of Dominant Ideologies in Musical Scores', in *Robert Altman: Critical Essays*, ed. Armstrong, p. 54, for similarities between *A Prairie Home Companion* and *Corn's-a-Poppin'* (1951), the latter co-written but not directed by Altman.

4 In the credits Asphodel is listed as the Dangerous Woman.

5 That verse reads: 'Gather ye rosebuds while ye may, / Old time is a-flying: / And this same flower that smiles today / Tomorrow will be dying.'

6 Anderson's films include *Boogie Nights* (1997), the Altmanesque *Magnolia* (1999), *There Will Be Blood* (2007), which was dedicated to Robert Altman, *The Master* (2012) and *Inherent Vice* (2014).

7 See Mitchell Zuckoff, *Robert Altman: The Oral Biography* (New York, 2009), pp. 501–4.

8 *Hands on a Hard Body* was also a 1997 documentary about an endurance contest. In 2013 *Hands on a Hardbody* became a Broadway musical.

Bibliography

Altman, Robert, commentary, special feature on *California Split* DVD
(Columbia TriStar Home Entertainment, 2004)
—, commentary, special feature on 'Survival' Disk 2, *Combat!*: Season 1,
Campaign II
—, interview in 'Robert Altman: Art and Soul', on *Fool for Love* DVD
—, 'Rip Van Marlowe', special feature on *The Long Goodbye* DVD
(MGM Home Entertainment, 2002)
Anderson, Edward, *Thieves Like Us* (London, 1999)
Armstrong, Rick, ed., *Robert Altman: Critical Essays* (Jefferson, NC, 2011)
Arnheim, Rudolf, *Film as Art* (Berkeley and Los Angeles, CA, 1971)
Breskin, David, 'Robert Altman', in Breskin, *Inner Views: Filmmakers in
Conversation*, expanded edn (New York, 1997)
Bresson, Robert, *Notes on Cinematography* (Notes sur le cinematographie),
trans. Jonathan Griffin (New York, 1977)
Brooks, Cleanth, *William Faulkner: The Yoknapatawpha County*
(New Haven, CT, and London, 1963)
Burnett, Colin, '*Journal d'un cure de campagne*: DVD Review', *Offscreen*,
VIII/8, April 2004, www.offscreen.com
Byrne, Connie, and William O. Lopez, 'Nashville', *Film Quarterly*,
XXIX/2 (Winter 1975–6), reprinted in *Robert Altman: Interviews*,
ed. David Sterritt (Jackson, MS, 2000)
Campbell, Joseph, *The Inner Reaches of Outer Space: Metaphor as Myth
and as Religion* (New York, 1988)
Chandler, Raymond, *The Long Goodbye* (New York, 1992)
Del Ross, Shannon, 'The Use of Myth and Archetype in
The Yellow Wallpaper', *The Literary Yard*, 25 May 2013,
www.literaryyard.com
'Devotion to the Sacred Heart of Jesus', New Advent Catholic Encyclopedia,
www.newadvent.org

Dostoevsky, Fyodor, *The Double* (*Dvoinik*), trans. George Bird, in *Great Short Works of Fyodor Dostoevsky* (New York, 1968)

Giannetti, Louis, *Masters of the American Cinema* (Englewood Cliffs, NJ, 1981)

Giddins, Gary, 'Buffalo Bob and the Van Goghs', in Giddins, *Faces in the Crowd: Players and Writers* (New York and Oxford, 1992)

Gilbey, Ryan, *It Don't Worry Me: The Revolutionary American Films of the Seventies* (New York, 2003)

Grabois, Aryeh, *The Illustrated Encyclopedia of Medieval Civilization* (London, New York and Jerusalem, 1980)

Harmetz, Aljean, 'The 15th Man who was Asked to Direct *M*A*S*H* (and Did) Makes a Peculiar Western', *New York Times* Magazine, 20 June 1971, in *Robert Altman: Interviews*, ed. David Sterritt (Jackson, MS, 2000)

Hooker, Richard, *M*A*S*H* (New York, 1968)

Kagan, Norman, *America Skeptic: Robert Altman's Genre-commentary Films* (Ann Arbor, MI, 1982)

Karp, Alan, *The Films of Robert Altman* (Metuchen, NJ, 1981)

Kass, Judith M., *Robert Altman: American Innovator* (New York, 1978)

Keyssar, Helene, *Robert Altman's America* (New York, 1991)

Kloman, Harry, Lloyd Michaels and Virginia Wexman, 'A Foolish Optimist', *Film Criticism*, VII/3 (Spring 1983), reprinted in *Robert Altman: Interviews*, ed. David Sterritt (Jackson, MS, 2000)

Kolker, Robert Phillip, *A Cinema of Loneliness: Penn, Kubrick, Scorsese, Spielberg, Altman* (New York, 1988)

Lardner, Jr, Ring, *I'd Hate Myself in the Morning* (New York, 2000)

Lindsay, Vachel, *The Art of the Moving Picture* (New York, 1915)

Lipnick, Edward, 'Creative Post-flashing Technique for The Long Goodbye', in *American Cinematographer* (March 1973), pp. 278–81, 328 and 334–5

McGilligan, Patrick, *Robert Altman: Jumping Off the Cliff* (New York, 1989)

McKee, Kenneth, 'Foreword', in *Scenarios of the Commedia dell'Arte*, trans. and ed. Henry F. Salerno (New York, 1989)

Mencken, H. L., *The American Language*, 9th printing (New York, 1945)

Metz, Christian, *Film Language: A Semiotics of the Cinema*, trans. Michael Taylor (New York, 1974)

Miles, Richard, *That Cold Day in the Park* (New York, 1965, 1974)

Miller, Arthur I., *Deciphering the Cosmic Number: The Strange Friendship of Wolfgang Pauli and Carl Jung* (New York, 2009)

Minett, Mark, 'Robert Altman's Early Career', Wisconsin Center for Film and Theater Research, http://old.wcftr.commarts.wisc.edu/collections/featured/altman

Monaco, James, *How to Read a Film: The World of Movies, Media, and Multimedia*, 3rd edn (New York, 2000)

Münsterberg, Hugo, *The Film: A Psychological Study*, reprint of *The Photoplay: A Psychological Study* [1916] (New York, 1970)

Ness, Richard R., '"Doing Some Replacin"': Gender, Genre, and the Subversion of Dominant Ideologies in Musical Scores', in *Robert Altman: Critical Essays*, ed. Rick Armstrong (Jefferson, NC, 2011)

O'Brien, Daniel, *Robert Altman: Hollywood Survivor* (New York, 1995)

Phillips, Gene D., *Creatures of Darkness: Raymond Chandler, Detective Fiction, and Film Noir* (Lexington, KY, 2000)

Plecki, Gerard, *Robert Altman* (Boston, MA, 1985)

Rosenbaum, Jonathan, 'Let the Music Do the Talking', *Chicago Reader*, 7 May 1998, www.chicagoreader.com

'St Barbara', New Advent Catholic Encyclopedia, www.newadvent.org

Sartre, Jean-Paul, 'Time in Faulkner: *The Sound and the Fury*' ('À propos de *Le Bruit et la Fureur*. La temporalité chez Faulkner'), trans. Martine Darmon et al., in *William Faulkner: Three Decades of Criticism*, ed. Frederick J. Hoffman and Olga Vickery (New York and London, 1963)

Searls, Hank, *The Pilgrim Project* (New York, 1964)

Self, Robert T., 'Art and Performance: Consolation at the End of Days', in *Robert Altman: Critical Essays*, ed. Rick Armstrong (Jefferson, NC, 2011)

—, *Robert Altman's Subliminal Reality* (Minneapolis, MN, 2002)

Shapiro, Michael J., 'Robert Altman: The West as Countermemory', in *Cinematic Thinking: Philosophical Approaches to the New Cinema*, ed. James Phillips (Stanford, CA, 2008)

Silver, Alain, and Elizabeth Ward, *Film Noir: An Encyclopedic Reference to the American Style* (Woodstock, NY, 1979)

'Skull with Burning Cigarette', The Vincent van Gogh Gallery, www.vggallery.com

Smith, Gavin, and Richard T. Jameson, 'The Movie You Saw Is the Movie We're Going to Make', *Film Comment*, XXVIII/2 (May–June 1992), in *Robert Altman: Interviews*, ed. David Sterritt (Jackson, MS, 2000)

Sterritt, David, ed., *Robert Altman: Interviews* (Jackson, MS, 2000)

Thompson, David, ed., *Altman on Altman* (London, 2006)

Zuckoff, Mitchell, *Robert Altman: The Oral Biography* (New York, 2009)

Filmography and Television Work

The following is a complete list of Robert Altman's feature films and later television work. The Calvin films listed are only those discussed, as are the early television shows.

Selected Calvin Films

Honeymoon for Harriet (1948)
Modern Football (1951)
The Sound of Bells (1952)
King Basketball (1952)
The Last Mile (1953)
Modern Baseball (1953)
The Dirty Look (1954)
The Builders (1954)
Better Football (1954)
The Perfect Crime (1955)
The Magic Bond (1956)

Feature Films

The Delinquents (1957, 75 minutes)
The James Dean Story (1957, 82 minutes)
Countdown (1968, 101 minutes; UK distribution 73 minutes)
That Cold Day in the Park (1969, 110 minutes)
*M*A*S*H* (1970, 116 minutes)
Brewster McCloud (1970, 105 minutes)
McCabe & Mrs Miller (1971, 121 minutes)
Images (1972, 101 minutes)
The Long Goodbye (1973, 112 minutes)

Thieves Like Us (1974, 123 minutes)
California Split (1974, 111 minutes)
Nashville (1975, 159 minutes)
Buffalo Bill and the Indians, or Sitting Bull's History Lesson (1976, 123 minutes)
3 Women (1977, 124 minutes)
A Wedding (1978, 125 minutes)
Quintet (1979, 118 minutes)
A Perfect Couple (1979, 111 minutes)
HealtH (1980, 96 minutes)
Popeye (1980, 114 minutes)
Come Back to the 5 & Dime, Jimmy Dean, Jimmy Dean (1982, 109 minutes)
Streamers (1983, 118 minutes)
Secret Honor (1984, 85 minutes)
O.C. and Stiggs (1985, released in 1987, 109 minutes)
Fool for Love (1985, 107 minutes)
Beyond Therapy (1987, 93 minutes)
Aria (1987, 90 minutes): Altman's segment, 'Les Boréades' (6 minutes)
Vincent & Theo (1990, 140 minutes; television versions 194, 197, 200 minutes)
The Player (1992, 124 minutes)
Short Cuts (1993, 188 minutes)
Prêt-à-Porter (Ready to Wear) (1994, 133 minutes)
Kansas City (1996, 115 minutes)
The Gingerbread Man (1998, 114 minutes)
Cookie's Fortune (1999, 118 minutes)
Dr T and the Women (2000, 122 minutes)
Gosford Park (2001, 137 minutes)
The Company (2003, 112 minutes)
A Prairie Home Companion (2006, 105 minutes)

Selected Early Television Work

Alfred Hitchcock Presents (1957–8)
'The Young One' (1 December 1957)
'Together' (12 January 1958)

Bus Stop (1961–2)
'A Lion Walks among Us' (3 December 1961)
Robert Altman directed a total of eight episodes of this anthology series

Combat! (1962–3)
'Forgotten Front' (2 October 1962)
'Rear Echelon Commandos' (9 October 1962)
'Any Second Now' (23 October 1962)

'Escape to Nowhere' (20 November 1962)
'Cat and Mouse' (4 December 1962)
'I Swear by Apollo' (11 December 1962)
'The Prisoner' (25 December 1962)
'The Volunteer' (22 January 1963)
'Off Limits' (19 February 1963)
'Survival' (12 March 1963)

Kraft Suspense Theatre (1963–4)

'The Long, Lost Life of Edward Smalley' (12 December 1963)
'Once Upon a Savage Night' (2 April 1964)
Footage was added to 'Once Upon a Savage Night' and it was released
 theatrically later in 1964 as *Nightmare in Chicago*

Later Television Work

Rattlesnake in a Cooler (1982)
Precious Blood (1982)
The Laundromat (1985)
The Room (1987)
The Dumb Waiter (1987)
The Caine Mutiny Court-Martial (1988)

Tanner '88 (1988)

'The Dark Horse' (15 February 1988)
'For Real' (14 March 1988)
'The Night of the Twinkies' (12 April 1988)
'Moonwalker and Bookbag' (2 May 1988)
'Bagels with Bruce' (16 May 1988)
'Child's Play' (6 June 1988)
'The Great Escape' (20 June 1988)
'The Girlfriend Factor' (11 July 1988)
'Something Borrowed, Something New' (17 July 1988)
'The Boiler Room' (11 August 1988)
'The Reality Check' (22 August 1988)

Great Performances

'Black and Blue' (17 February 1993)
'The Real McTeague: A Synthesis of Forms' (26 May 1993)
'Robert Altman's Jazz '34' (29 January 1997)

Gun (1997)

'All the President's Women' (10 May 1997)

Tanner on Tanner (2004)

'Dinner at Elaine's' (5 October 2004)
'Boston or Bust' (12 October 2004)
'Alex in Wonderland' (19 October 2004)
'The Awful Truth' (26 October 2004)

Acknowledgements

I begin by thanking Vivian Constantinopoulos at Reaktion for taking on this project and shepherding it through many stages. Her guidance has been very much appreciated. I also want to thank Aimee Selby for her invaluable editing and suggestions. I am grateful to Charlotte Chapman for her perceptive copy-editing and Rosanna Lewis for her keen-eyed proofreading. I hope all three enjoyed reading the book. I owe thanks to Mark Ekman, Jane Klain and Richard Holbrook of the Paley Center for Media in New York City for their assistance and conversation regarding Robert Altman. Thank you also to Mark Minett, who, during his tenure at the Wisconsin Center for Film and Theater Research, clarified a number of points concerning Altman's early work; Mary K. Huelsbeck, assistant director of WCFTR, for her assistance; Rick Prelinger for his early advice; and Harry Kloman for answering a silly question promptly. I also want to thank everyone who listened (patiently, eagerly or merely quietly) to my various ideas about Robert Altman's work. Lastly, any errors in this book are mine only and I challenge anyone who thinks otherwise.

Index